**CULTURAL POLITICS IN THE
MAKING OF BLACK BRITAIN**

ROOTS&
CULTURE

EDDIE CHAMBERS

I.B.TAURIS

LONDON · NEW YORK

Published in 2017 by
I.B.Tauris & Co. Ltd
London • New York
www.ibtauris.com

Copyright © 2017 Eddie Chambers

International Library of Cultural Studies 40

ISBN: 978 1 78453 616 9 HB
978 1 78453 617 6 PB
eISBN: 978 1 78672 074 0
ePDF ISBN: 978 1 78673 074 9

A full CIP record for this book is available from the British Library
A full CIP record is available from the Library of Congress

Library of Congress Catalog Card Number: available

Typeset by Newgen
Printed and bound in Great Britain by T.J. International, Padstow, Cornwall

MIX
Paper from
responsible sources
FSC
www.fsc.org FSC® C013056

Contents

List of Illustrations

Black: For Those Who Have Been for Generations in 'The Lower Case'

The use of the word 'black'/'Black' as an adjective, noun, or *racial* descriptive is more often than not a complicated matter. As a *raced* descriptive, the word can imply a subaltern classification, even as it might signify, for others, a proudly chosen designation. Perhaps particularly mindful of the subaltern classification, individuals to whom the term is assigned might, for various reasons, be somewhat sceptical of what they possibly see as its imposition. Furthermore, the grouping together of disparate individuals under the descriptive of 'Black' is perhaps further problematic, suggesting as it does a stable demographic, existing across continents, and across decades or centuries. The readers of this book will likely be mindful of these considerations.

In *Roots & Culture: Cultural Politics in the Making of Black Britain*, the issue of upper-case B or lower-case b in the writing of the word 'Black/black' is of some importance. The book has used 'Black', with an upper case B, to refer to individuals and communities of specifically African-Caribbean background. Like others, such as Lori L. Tharps, I believe that, 'When speaking of a culture, ethnicity or group of people, the name should be capitalised. Black with a capital B refers to people of the African Diaspora. Lowercase black is simply a color.'[i] In pursuing this strategy, I am mindful of the efforts of Marcus Garvey, one of whose biographers made mention of his

> demand [made in 1920] that the word 'Negro' be spelled with a capital 'N,' in keeping with the dignity and self-respect of the New Negro. Over the next decade, this campaign to capitalise 'Negro' was generally successful, at least in the United States. In 1929 the New York State Board of Education ordered that all New York schools must teach the spelling of 'Negro' with a capital 'N,' and the next year the *New York Times* followed suit, 'in recognition,' as a *Times* editorial explained, 'of racial self-respect for those who have been for generations in "the lower case"'[ii]

Throughout this text, I choose to write 'Black' with a capital B and this has been retained throughout, except in direct quotations in which the word 'Black' or 'black' has been left as it was originally written.

i Lori L. Tharps, 'The Case for Black with a Capital B', http://www.nytimes.com/2014/11/19/opinion/the-case-for-black-with-a-capital-b.html?_r=0, accessed 29 April 2016

ii E. David Cronon, 'Up, You Mighty Race!', *Black Moses: The story of Marcus Garvey and the Universal Negro Improvement Association*, University of Wisconsin Press, 2nd edition, 1972: 67

Acknowledgements

In researching and writing this book, I have incurred a number of debts of gratitude. I would, in the first instance, like to thank Baillie Card, formerly of I.B.Tauris, for taking such care and attention in the ways in which she has guided this project. She took a pronounced interest in facilitating my access to many of the images reproduced in this book. I would similarly like to thank Lisa Goodrum for diligently guiding the manuscript in its final and critically important stages. Anna Coatman, formerly of I.B.Tauris, must be thanked, for responding with warmth and enthusiasm to my original proposal. My profound thanks and gratitude are extended to my dear friend and colleague Professor Cherise Smith, who has been such a steadfast supporter of my work over the years that I have been at the University of Texas at Austin. She has, at every turn, encouraged me to be the scholar I am. I owe her boundless thanks. I am enormously grateful for the support that has been extended to me through the John L. Warfield Center for African and African-American Studies at the University of Texas at Austin.

I am particularly grateful to Stephen Cashmore, my subeditor, whose rigour, objectivity and proficiency have, once again, improved the flow of this book enormously. Stephen gave my manuscript an extraordinarily close reading and in so doing, significantly enhanced the text. His remarkable attention to detail and his sensitivity to the nuances of each chapter are things I came to value.

For help in identifying and sourcing images for this book, a number of individuals are to be thanked. I would like to thank Dennis Morris for giving me permission for his photograph of Linton Kwesi Johnson, on the cover of *sounds* magazine, to be reproduced in this book. A special word of thanks goes to Isabelle Chalard, who facilitated the permission given by Dennis Morris. I'm grateful to Claire Weatherhead, Permissions Manager, Bloomsbury Publishing Plc, who so generously facilitated permission for me to reproduce the front cover of *Wisden Cricket Monthly*, May 1980. Chris O'Brien

of Greensleeves Records must be thanked for giving permission for the reproduction of the cover of Tippa Irie's 'Complain Neighbour' in this book, whilst Chris Lane of Fashion Records must be thanked for giving permission for the reproduction of the cover of Smiley Culture's 'Cockney Translation' in *Roots & Culture*. Rebecca Gibbs, Sales and Marketing Executive, Syndication, Guardian News and Media Limited responded promptly to my request to reproduce the 1971 *Observer* magazine cover that appears in this book. I owe her thanks. A warm note of appreciation must go to Linton Kwesi Johnson for giving me permission to reproduce the lines of his poetry in Chapter 4 of this book. A special note of thanks, gratitude and appreciation must go to Professor David Scott, of Columbia University, for his generous support.

I am grateful for a University of Texas at Austin Subvention Grant awarded by the Office of the President.

Preface

This book is about the cultural formation of Black Britain. It seeks to address the questions of how and why a distinct cultural identity, centred on African-Caribbean experiences, took such dramatic and definitive shape during the 1970s, leading in turn to an unprecedented period of Black-British creativity during the early to mid 1980s. How and why did a group of people, who had in many respects been brought up under the British flag, upon arrival in Britain come to have such markedly different cultural formations, as compared to their white counterparts who were raised under the very same flag, albeit on home soil? And how did this generation of Caribbean immigrants give birth to a generation of British born and/or raised youngsters who would come to fashion a cultural identity that was in so many respects unlike that of their white fellow citizens, with whom they had gone to school and, on the face of it, shared so many experiences? The late 1970s and early 1980s marked a moment of particular intensity regarding manifestations of Black consciousness. While much of this consciousness bore the hallmarks of a generation ill at ease, bridling against a somewhat ill-fitting garment of Britishness, it is right that we do not lose sight of the fact that Black Britain of the late 1970s to mid 1980s – as a consequence of this consciousness – gave birth to an extraordinary breadth of creativity. Art, music, poetry, theatre, literature – all these fields reflected not just the fractiousness of being Black and being British, but also reflected an as yet unsurpassed and unrivalled period of creative brilliance.

While this book is about manifestations of culture and cultural identity, at every turn experiences within the social, political, and educational arena have a bearing on the narratives of *Roots & Culture*, so much so that ultimately it may not be possible to entirely separate that which is *social* and *political* from that which is *cultural*. This is hardly surprising because time after time, experiences reflecting the somewhat marginalised status of Black-British youngsters had a direct bearing on matters of their cultural identity.

For example, the widespread unemployment and under-employment from which Black youth suffered meant that they had more time on their hands to reflect on matters of group identity – in some instances consciously, in other instances less so.[1] Such reflections, both individual and group, led to pronounced formulations and expressions of cultural identity. Likewise, with gainful employment frequently being somewhat elusive, Black youth often found that their visibility on the streets meant that for extended periods of time they were subject to greater attention from the police. In this respect, unemployment meant more than simply a lack of earned income; it became, simultaneously, a state of being which created its own conspicuous presence on the streets – a presence that the police were wont to view as suspicious, delinquent and resulting from a freely chosen form of idleness. In turn, this *harassment* contributed to particular cultural expressions that bridled against such treatment. Indeed, it could be reasonably conjectured that it was the very intensity of experiences within the social and political realm that led certain Black people to articulate these experiences in song, in verse, in art.

Conversely, activities by Caribbean migrants and their children that we might ordinarily assign to the *cultural* arena had a habit of having direct consequences that gravitated towards the *political* arena. The playing of supposedly excessively loud music, most frequently reggae, at house parties, was one example of this. With access to traditional entertainment venues and facilities being routinely denied to Black people, the house party became a dominant means through which migrants socialised with each other. White neighbours frequently complained about Black people's partying, thereby creating, from the 1950s onwards, something of a perennial source of friction that led to police intervention which ranged from summary arrests to full-blown raids in which records and amplifying equipment were wantonly destroyed. Such incidents indicated the dramatic morphing, or overlapping, of the cultural and the political.[2]

Even the sorts of dwellings in which significant numbers of Black-British people were housed (or were put) assumed important dimensions, as regards the development of a cultural identity. In disproportionate numbers, Black-British people found themselves living in those parts of cities scarred by bloated income differentials and urban deprivation. Often the architecture of these spaces – particularly high-rise

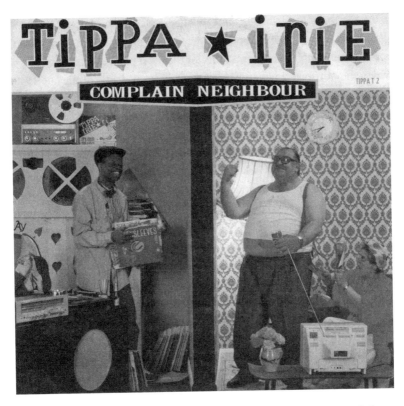

Figure 1: Tippa Irie, 'Complain Neighbour' (UK Bubblers, 1985) record sleeve, Courtesy of VP Music Group Inc.

tower blocks – resembled what London reggae group Aswad memorably described as 'a concrete situation… a ghetto in the sky'.[3] Local councils' housing strategy has often been to place Black people and others in what are often *sink estates* or charmless brutalist boxes in which those with few housing options are forced to live literally on top of one another. Not only did hapless residents have to live cheek by jowl in such housing, there were often few amenities, such as good schools, good shops, good health care, libraries, parks or gardens in close proximity to these *concrete jungles*. Such were the brutal spaces in which Black Britons were sometimes obliged to live, spaces in which distinct cultural sensibilities germinated.

While there is an attractive alliteration in the terms Black-British and Black Briton, and although this book carries the subtitle *Cultural Politics*

in the Making of Black Britain, in reality the reader will probably notice that all of the book's narratives centre on decidedly English (or England-based) occurrences and developments. This for the most part reflects the extent to which the northward penetration of Caribbean migrants of the late 1940s to early 1960s ended somewhat abruptly around the Leeds/Bradford area, while the westward penetration for the greater part extended only as far as cities such as Bristol and Cardiff. The Black-British settlement centred on a number of the major concentrations of urban development, beginning with the capital, and extending to the Midlands, Greater Manchester and its surrounding towns, the towns and cities of Yorkshire, Merseyside, and, as previously mentioned, Bristol and Cardiff. In contrast, Scotland and vast swathes of Wales, the English northeast and southwest, have no real parts to play in this book's narratives.[4] The gravitation towards industrial areas reflected post-war Britain's labour needs, as regards manufacturing, transport and the service sector.[5] With rare exceptions, these narratives hardly venture west into Wales or north into Scotland. In that sense, it might be more accurate to speak of ...*the Making of Black England*, or even *Inglan*.[6] But notwithstanding the dramatic contribution of Linton Kwesi Johnson's poems such as *It Dread Inna Inglan (for George Lindo)*[7] and *Inglan is a Bitch*[8], or Rudy Narayan's *Black England: A Reply to Enoch Powell*,[9] there remain marked parochial sentiments attached to the adjective *English* and the noun *England*.

Furthermore, even though many would, almost intuitively, regard England/Inglan as the place in which they were domiciled, the strong suspicion exists that few if any Black-British-born people would signify or designate themselves as primarily *English*, or would choose *England* as their primary point of geographic or national identity and location. They would instead, one suspects, identify or signify themselves as being *British* if pushed or prompted. Similarly, they would instead, one suspects, identify or signify *Britain* as their primary point of geographic or national identity and location.[10] Although the reasons for a resistance to the label of *Englishness* as opposed to Britishness, (or a preferred, considered, use of *Britain* rather than *England*) might be imprecise and, indeed, ultimately ambiguous, the differences between *English* and *British* and between *England* and *Britain* matter enormously. Consequently, in this book, *Britain*, as a national and a geographic entity (and as an attendant signifier

of identity) is preferred to *England*, the latter having arguably even greater and more pronounced connotations of insularity, jingoism and racism than the former. It is for these reasons that this study is subtitled '*The Making of Black Britain*'. Similarly, although there is – again, arguably – a widespread ambivalence among some Black people about identifying themselves as *British* in any unadorned, unembellished or unhyphenated sense, in the absence of any single, widely accepted alternative signifier, this study uses the term *British*, in relation to *Black-British* people. It does so in the knowledge that many of those to whom the term is applied might well find the term to be somewhat lacking, to varying degrees.

According to Home Office figures, some 95,350 Caribbean immigrants made their way to Britain between 1955 and 1958. Two of these people were my Jamaican parents, Nehemiah Hilkiah Chambers and Cleo Loppeta Chambers (née Hudson). I was born, at home (37 Lower Villiers Street, Blakenhall, Wolverhampton) in 1960 and consequently *Roots & Culture* represents not only the biography of a generation but also, in parts, my own personal history. My parents became constituents of Enoch Powell, Member of Parliament for Wolverhampton South West, during which time he made his infamous 'Rivers of Blood' speech, foretelling dire consequences for Wolverhampton itself, and for the nation, as a result of immigration. I was seven when Powell made this speech and although my siblings and I went to the otherwise pretty much all-white infants and primary school literally down the road from our home, Powell could under other circumstances have been referring to the Chambers children when he opined 'It almost passes belief that at this moment twenty or thirty additional immigrant children are arriving from overseas in Wolverhampton alone every week – and that means fifteen or twenty additional families a decade or two hence.'[11]

Of course, pretty much everyone born into the African Diaspora can lay immediate claim to all sorts of dramatic histories – slavery, empire, colonialism, migration, and so on. In that respect, my own story, my own history, is one that I share with a great many others. Our individual births represented not just one more human being on the planet, but a particular manifestation of the rolling consequences of seismic, traumatic events set in train several centuries ago. While this book seeks to document the cultural aspects of the group identity of a particular generation, it is perhaps

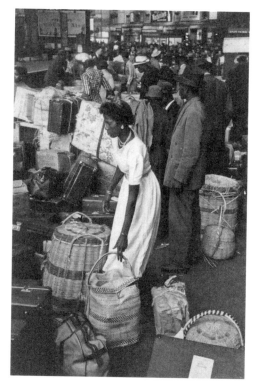

Figure 2: 1956, West Indian immigrants arriving at Victoria Station, London. The photograph was taken for the feature by Hilde Marchant, 'Thirty-Thousand Colour Problems', *Picture Post, Hulton's National Weekly*, 9 June 1956.

a task for historians of the future to determine or identify the cultural aspects of subsequent generations of British-born people who lay claim to African-Caribbean ancestry, but for whom the countries of the Caribbean or Africa from which their grandparents or great grandparents came were not much more than places on a map. After all, much to the declared consternation of Enoch Powell, many of my generation are now not only parents themselves, but in many instances, grandparents.

In 1952, the wholesale clampdown on Caribbean immigration was still a decade away. At that time, so *Picture Post* magazine reported, 'Five hundred West Indians are coming to Britain every month' and the only hoped-for development being relied on by the British government to stem

what was already being described as a 'steady influx' in need of 'control', was sufficiently discouraging news of life in Britain making its way back to Jamaica. Wrote *Picture Post*, 'Government departments refuse to control immigration of these British subjects. Only if people in Jamaica realise that life in Britain is stern and hard, say the Colonial Office, will the steady influx die down.'[12] The feature concluded with the pithy question, 'But can you stop people believing in the Promised Land?' Little more than three decades later, however, many of the children of these Caribbean immigrants were aspiring to an altogether different Promised Land – the mythical Rastafarian homeland of Africa, and Ethiopia in particular.[13] Within a generation, parental hope and optimism gave way, in substantial measure, to their children's despondency and alienation, which in turn was to be displaced by an astonishing embrace of Rastafari[14] and other signifiers of Blackness. This book is the story of how this happened, what factors were involved, and what was to flow from this fascinating and unique moment in Britain's history.

Introduction: England Isn't Home[1]

Thus far, for Britain's Black population, the 1980s has proven to be arguably the most creative and significant decade in their history. It was after all a decade that witnessed the astonishing and dynamic emergence of a new generation of Black-British people. Largely born and/or brought up in Britain, the children of Caribbean migrants, these people simultaneously challenged existing notions of Britishness, even as they embodied new, dynamic late twentieth century versions of British identity. This book argues that Black creative activity of the 1980s and related developments in Black cultural identity are most effectively understood in the context of the decade that preceded it, the 1970s. *Roots & Culture* seeks to chronicle the extraordinary blend of social, political and cultural influences of the mid to late 1970s that gave rise to Black Britain of the 1980s. In some ways, this is a story of changing identities, from those imposed or assumed, through to those boldly chosen or embraced. In this compelling narrative, Britain's post-war immigrants most frequently described themselves, and were in turn described as, *West Indians*. The dominant (or 'host') society was wont to assign this label, not only to the immigrants themselves, but perhaps more troublingly, to the *British* children of these immigrants. Well into the 1980s it was customary for press, media and sociologists alike to refer to Black Britons of all ages as *West Indian*.

In time, Black people of a younger generation wrestled themselves free of the term and gravitated instead to *Afro-Caribbean*. This embrace of 'Afro' reflected an earlier embrace of the label in the US, where Afro-American had become the signifier of choice for much of Black America. But Afro-Caribbean, much like Afro-American, proved to be a nomenclatural resting place rather than a final destination and, in time, *Afro-Caribbean* became *African-Caribbean* or *Black-British*. *Roots and Culture* explores the part that culture and the arts played in this fascinating narrative of evolving nomenclature and the identities that informed these changes. The British Empire, migration, Rastafari, the Anti-Apartheid struggle, reggae music, the coming of Margaret Thatcher and the popular expression of anti-immigrant sentiments, the then ascendancy of the West Indies cricket team – all these contrasting factors, and others, have a part to play in this compelling story of the ways the African Diaspora further mutated to give rise to Black Britain.

What factors led to the proliferation of astonishing *counter-cultural* creativity amongst Black Britons during the early 1980s? And why did a generation of youngsters born and brought up in Britain emerge into adulthood with such markedly different terms of reference to their white counterparts? Whilst sharing a number of cultural similarities to the wider social environment, the Black-British experience took notable account of factors such as Black Power, Rastafari, counter-cultural music, and an overarching sense of exile and displacement. This story has perhaps the unlikeliest of origins: the post-war immigration to Britain of tens of thousands of Black Caribbean migrants, from the late 1940s to the early 1960s.[2] 'Unlikely' because these immigrants had been brought up and educated to regard themselves not as 'Caribbean', or 'West Indian', or even 'Jamaican', 'Trinidadian', or 'Barbadian' (or its more popular abbreviation, 'Bajan'), but instead, to regard themselves as British. As literal members of the British Empire, they were after all, moving from one part of that Empire to another, to the epicentre of the Empire, the 'Mother Country'. The flag with which they were most familiar was the Union flag; the stamps they used bore the head of the British monarch, as did the pounds, shillings and pence they used as currency. The schoolbooks they had used were those used within, or supplied by, the British education system, and no end of other aspects of public life bore evidence of the extent to which English-speaking Caribbean

countries were in effect outposts of Britain. Young men and women from various parts of the British Empire had, just a few years earlier, enlisted in Britain's war effort,[3] and these volunteers included significant numbers of Caribbean-born people. Despite Marcus Garvey's protestations, from 1914 onwards, that the world's diasporic Africans should, first and foremost, regard themselves as sons and daughters of the African continent,[4] these migrants arrived as British people, many of them knowing as much about, and glorying in Britain's history, geography, systems of government, sports, and cultural heritage as any white British-born person. Caribbean migrants could and did demonstrate a profound respect, admiration and affection for Britain and its major institutions, including the monarchy.

Those arriving on the *Windrush* are often referred to as 'Jamaican', though in actuality the vessel's passengers came from several different Caribbean countries. Perhaps one of the most distinguished passengers was the Calypsonian who went by the name of Lord Kitchener. Such lofty monikers were, at the time, not unusual.[5] The celebrated Trinidad-born Calypsonian had been christened Aldwyn Roberts at the time of his birth in 1922, though he became better known by his stage name Lord Kitchener, a homage to Field Marshal Horatio Herbert Kitchener, 1st Earl Kitchener, who was born in 1850 and went on to a venerable and legendary career as a senior British Army officer and colonial administrator. Kitchener the soldier won fame throughout the British Empire for the parts he played in British military campaigns in the Sudan, the Boer War and finally World War I. Journalists, photographers and camera crews, one of which filmed an exchange between a reporter and Lord Kitchener, greeted the arrival of the *Windrush*. When prompted by the reporter, Lord Kitchener offered a rendition of his song; 'London Is the Place for Me'. It was a song that celebrated the extraordinarily high esteem in which Black sons and daughters of the British Empire, such as these Caribbean migrants, held London. Sang Lord Kitchener,

London is the place for me
London this lovely city
You can go to France or America, India, Asia or Australia
But you must come back to London city
Well believe me I am speaking broadmindedly

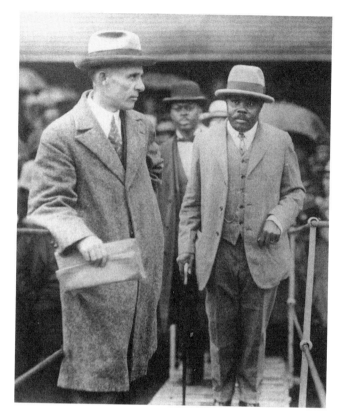

Figure 3: November 1927, Marcus Garvey being deported from the US, via New Orleans, Louisiana. It was reported that several hundred Black people stood in the rain for hours to bid farewell to him.

> I am glad to know my Mother Country
> I've been travelling to countries years ago
> But this is the place I wanted to know
> London, that's the place for me.

Perhaps the ugly prejudice and discrimination that Caribbean migrants faced was way over the horizon, because Kitchener's homage to London continued,

> To live in London you are really comfortable
> Because the English people are very much sociable
> They take you here and they take you there

And they make you feel like a millionaire
London, that's the place for me.[6]

Paeans such as this, expressing love, loyalty and devotion for Britain and its institutions, were not uncommon. Another Trinidadian-born Calypsonian, George Browne, better known as Young Tiger, recorded a remarkable document of and commentary on the coronation of Her Majesty the Queen, shortly after the occasion itself, in 1953. The song captures not only a sense of the majesty and pomp that surrounded the event, but also a singular pride at having been present. Included in the song were the lyrics:

I took up my position at Marble Arch
From the night before, just to see the march
The night wind was blowing, freezing and cold
But I held my ground like a young Creole
I was there (at the coronation)
I was there (at the coronation)
My stoic stance soon paid dividends
For I saw them coming around the bend
Then I perceived in all her glory
The golden coach with Her Majesty
She was there (at the coronation)
I was there (at the coronation)
Her Majesty looked really divine
In her crimson robe, furred with ermine
The Duke of Edinburgh, dignified and neat
Sat beside her, as Admiral of the Fleet
He was there (at the coronation)
I was there (at the coronation)[7]

And yet, the migrants' Britishness was neither respected nor recognised by the vast majority of white Britons, and at every turn they found themselves being treated not as fellow Brits, but as foreigners to be kept at arm's length and regarded as delinquent, sinister and, perhaps most damaging of all, a 'problem'. The disdain in which Caribbean migrants were held was matched only by the profound ignorance of white British people about the history, geography, systems of government, sports, and cultural

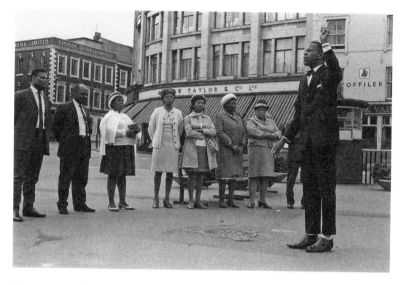

Figure 4: An Afro-Caribbean Christian church group holds an evangelical meeting in Derby town centre on a Sunday afternoon, 1970.

heritage of the countries of the Caribbean from whence the immigrants came. Given these formidable factors, the likelihood of skin colour having a near-irrelevant consideration in the make-up of British society in the 1950s and 1960s was slim to non-existent. A generation of people whose loyalty to Britain often seemed to exceed that of their white British-born counterparts gave birth to a second generation of people who, in large numbers, were at best ambivalent about their Britishness. Most damaging of all, it appeared that many white Britons were similarly sceptical of the extent to which Blackness and Britishness could peacefully co-exist within the same body, be that body a single entity or a collective one. In the 1970s, Britain's cities were festooned with ubiquitous National Front stickers that declared 'If They're Black, Send Them Back!' even as Black-British reggae group Matumbi was singing, 'Black man, go back where you come from, go back home.'[8]

When the *Windrush* generation of Caribbean migrants arrived in Britain, they rapidly responded to the challenges and peculiarities of the often frosty and unwelcoming environments they encountered. Instead of attending the white churches that failed to extend to them warm welcomes,

6

these migrants set up their own congregations, first meeting in each others' flats and houses, then meeting halls, before finally establishing their own churches. (On occasion, small congregations of Caribbean migrants held open-air church services in town centres, though this was, in the main, a means of proselytising. Having come from devoutly Christian communities, Caribbean migrants arrived in a country in which its white citizens were becoming increasingly ambivalent about organised religion, leading to a dramatic flipping of the proselytising script.) Instead of attempting to frequent existing bars, public houses and dancehalls from which they were routinely denied entry or given poor service, Caribbean migrants set up their own music parties, again within their homes, before West Indian Social or Sports Clubs and other more formally constituted spaces were established. In time, the manifest failures of the British education system to effectively teach the children of these migrants would lead exasperated parents to set up alternative Saturday schools and other such projects. And in response to the reluctance of white barbers to cut Black people's hair (and a corresponding lack of faith in the services offered by white hairdressers) Black hair salons and barbershops were established, either as cottage industries or in premises more publicly located. The Black barbershop, and other initiatives established by migrants represented more than just much-needed amenities; they also represented spaces of cultural comfort, and, crucially, affirmation of self. With the animation of such formidable factors, the birth of Black Britain, though perhaps unlikely, may also have been inevitable. Intriguingly, whilst subsequent generations of Black Britons may have found themselves somewhat disillusioned and alienated from mainstream British politics, many Caribbean immigrants had a much less questioning attitude towards participation in the electoral process.

To this end, perhaps the only facet of British public life with which Caribbean migrants kept faith was in the realm of the franchise and the ballot box. Caribbean immigrants on the whole overwhelmingly voted Labour and were unflinching in their support for the party, despite the ways in which the Labour Party was as willing to play fast and loose with the politics of immigration as much as their Conservative opponents. On this point, Chris Mullard noted, 'In return for our support [for the Labour

Party] (and many black people actively canvassed for the Labour Party) we received harsher treatment than any imposed by the Conservatives.'[9]

The Black presence in Britain stretches back centuries and millennia. There has hardly been a time during which significant numbers of Black people have not made Britain their home, through birth or through travel, in a variety of its forms, including those enslaved Africans brought to British shores in servitude and bondage. At various times in British history, the Black population has been notable, sizeable and conspicuous. And yet the mid twentieth-century Caribbean migrants came not to swell the existing numbers of Black Britons, but came, most commonly, to work and earn money, before heading back 'home'. Most frequently, these migrants imagined their stays in Britain would be in the order of five years or so. This, they imagined, would give them enough time to earn good amounts of money with which to return to their respective countries and, with their financial solvency, avail themselves of further prosperity. But these migrants found their presence in the United Kingdom to be a more protracted one than they first imagined, with no pronounced agenda of assimilation amongst the pioneering generation of immigrants, it is perhaps not surprising that the task, or challenge, of forging new British identities fell to the children of these immigrants, who by and large had no other country to call home.

Within two or three decades, Caribbean migrants had, literally and metaphorically, given birth to Black Britain, and this book sets out to offer a close reading of the cultural factors that led to the creation of this distinct, powerful, cogent and resonant new entity. In the 1950s, when numbers of Caribbean migrants came to Britain, there was no such entity as Black Britain. Nor did such a thing exist in the 1960s. Yet the 1970s saw the astonishing emergence of not only a distinct Black-British identity, but within a few years, the emergence of incredible artistic and cultural practices that reflected on this curious though compelling new state of being. One might perhaps have imagined that Black youngsters, born into the same country as their white peers, would grow up to be near-indistinguishable as British citizens, given that their parents embodied a frequently unequivocal notion of Britishness and given that skin colour is a flimsy, superficial and unstable criterion with which to distinguish one human being from another. And yet, by the mid to late 1970s, Black Britons had embarked

on an agenda of formulating distinct and often racially charged identities. Theatre, poetry, literature, music, and the visual arts all witnessed striking, fascinating articulations of creativity, leading to an as yet unsurpassed period of socially engaged artistic brilliance. A potent set of factors, fermenting in the 1970s, gave rise to the astonishing range of articulations offered by artists and others during the first part of the following decade. This book focuses on the coming of age of Black Britain, and the ways in which a poet such as Linton Kwesi Johnson perfectly reflected the aspirations, as well as the discontent, of an intriguing new European presence. A number of factors set the scene perfectly for the unmistakeable emergence of Black Britain and its distinct cultural identity during the 1980s.

Roots & Culture: Cultural Politics in the Making of Black Britain seeks to present a nuanced and comprehensive account of the emergence of Black-British identity, particularly during the 1970s into the 1980s. It will explore and examine not only what happened in that critical decade, the high points, the low points, the advances, the setbacks that shaped Black-Britain, but also the singular *creativity* of Black-British artists that emerged from that fascinating period. Societal racism and discrimination by the so-called 'host' community has a central part to play in this story. From the 1950s onwards, politicians, the media, the police, and many other agencies and individuals demonstrated a marked reluctance to accept migrants of Caribbean background as British, as equals. The resulting alienation found extraordinary expression amongst the second generation and this book sets out to identify, discuss and contextualise the factors that led to the creation of a fractious yet highly-charged, culturally nuanced, new component of the African Diaspora. This book reflects on what led to an astonishing period of creativity amongst Britain's Black population during the early to mid 1980s.

A number of books have been written that seek to chronicle the history of the Black presence in Britain. Likewise, several publications exist that seek to chronicle something of the history of Black artists, or Black theatre, or Black music, and so on, in Britain. There is, though, no substantial single-authored volume that seeks to create a narrative around the cultural evolution of Black Britain, wherein a distinct community of peoples moved from being *West Indian* to being *Afro-Caribbean* to being *Black-British*, all within the space of two generations. Hugely important narratives regarding

history, identity, belonging, and diaspora emerged in the 1970s and this book assembles these narratives in the context of the story of how Black Britain came to be. Black Britain did not always exist. This book looks to chronicle the remarkable ways in which Black Britain came to be and the part that cultural politics played in this.

The book is divided into this Introduction and eight chapters. Chapter 1, 'De street weh dem seh pave wid gold'[10] offers an overview of the shared experiences and senses of alienation and disappointment that characterised the lives of Caribbean migrants. The chapter argues that the impulse to travel overseas for work is something that lay at the heart of the Black Caribbean experience, and had a compelling precedent in the migratory impulses of workers such as those who went to help build the Panama Canal. But whilst Caribbean labourers were in effect summarily repatriated following the completion of the canal, Britain was to become something of a more protracted, enmeshed and complicated destination for the mid-twentieth-century's Black migrants. Mention was made, earlier in this introduction, of the ways in which Britain's post-war immigrants most frequently described themselves, and were in turn described as, West Indians, and the dominant (or 'host') society's propensity to assign this label, not only to the immigrants themselves but perhaps more troublingly to the *British* children of these immigrants. Indeed, the use of the label *immigrant* (together with its assortment of troubling and negative associations) was to all intents and purposes, throughout the 1970s and early 1980s, applied to black-skinned people in Britain irrespective of the specifics of their place of birth.[11]

All of this book's chapters mention or in some way address the somewhat *raced* ways in which the term *immigrant* existed within Britain. Immigrants to Britain, over the course of many centuries, included such groups as Huguenots, Jews, Celts and Saxons, and in more recent decades a renewed Jewish presence, as well as Irish, Italians, Poles and others. Yet within a generation or two, these groups were, on account of their whiteness, by and large able to shed the largely pejorative label of *immigrants* and assume an unfettered version of Britishness. Not so African, Caribbean and Asian people, who have tended to find that their colour of skin prevents such a fluid assimilation into Britishness. Consequently, as discussed in several of this book's chapters, Black immigrants and their

offspring have inevitably maintained a particularly conspicuous presence which, together with related prejudices of the so-called 'host' community, has contributed to Black people not readily being regarded as British in the same ways as their white compatriots, irrespective of pretty much any consideration except, perhaps, that of sporting success. In this troubling pathology, *immigrant* tended to equate to *Black person*, which in turn tended to equate to *problem*.

> In official language the label [immigrant] had become synonymous with black Commonwealth immigrants. It had become a camouflage word describing black groups as responsible for the main social, economic and political problems facing society.[12]

At every turn, circumstances, dominant pathologies, events and experiences all combined to ensure that Black youngsters' experiences of being British were markedly different, and decidedly fractious, compared to those of their white counterparts. Few events, it seemed, played a *positive* part in the early experiences of these youngsters' parents – the migrant generation – as they sought a better life and an affirming sense of place; not even such major events as independence coming to Caribbean countries such as Jamaica and Trinidad in the early 1960s. Independence was a moment of some euphoria for many people in these countries, suggesting as it did a coming of age for these nations and an unshackling from colonial rule. But people continued to leave Jamaica and Trinidad after these countries gained independence in 1962. Furthermore, independence did not facilitate an expedited return home for migrants. Indeed, independence in some ways seemed to solidify a profound disconnect between migrants and their countries of origin, as it conferred a curious status, amongst those in the Caribbean, of visiting tourist on migrants who returned home for visits. (This is a point touched on in Chapter 2). Similarly, those relocating back to Jamaica and other Caribbean countries were often regarded as expatriate foreigners, rather than returning sons and daughters of the respective countries. Such considerations made for vexing experiences for Caribbean migrants, further emphasising an inability to think of home in any absolute and settled way, thereby leading to a unique sense of cultural identity.

Chapter 2, 'Towards the Black 70s', looks at the emerging Black-British cultural expression of that decade and examines the many forces that

contributed to Black-British creativity and identity during the 1970s and beyond. How and why a generation of Britons of Caribbean birth gave rise to a generation of Black youngsters who were seemingly ambivalent about their Britishness is explored in this chapter. At pretty much every turn, Black people in Britain found it necessary to fashion cultural ways of being that differed markedly from those of the wider community. Racism and discrimination had, of course, many parts to play in this, and it was from both the responses to, and the consequences of, such insistent treatment that a sophisticated, profound and resilient cultural identity emerged. Consequently, cultural expression by Black people in Britain was, by the mid 1970s, being steered down what amounted to a path of separate development, notwithstanding certain cultural commonalities with the wider society. Within the space of no more than a couple of decades, the cultural distinctness and the cultural separateness of Black Britain was a matter of fact.

As with other spheres of public life, such as education, employment, housing, sports, and so on, one might have expected, by the mid 1970s, that British manifestations of cultural identity and artistic expression, from literature through to theatre through to the visual arts, would all be fully *integrated*, paying no heed to skin colour or supposed racial difference. This, however, was certainly not the case and multiple realities revealed or betrayed the extent to which formidable obstacles lay in the way of all Britons sharing commonalities of opportunity, experience and expression. For better or for worse, separate spaces and locations, separate cultural expressions and separate channels for Black creativity indicated the extent to which Black Britain was a somewhat separate and different entity to the rest of Britain. The mid to late 1970s represented an era in which Black Britons proved to be extraordinarily adept at shoring up their own senses of identity and this chapter seeks to locate and unpick these strategies, as they culminated in a particular emergence in the 1970s.

Chapter 3, 'Rasta This and Dreadlocks That', looks at an extraordinary cluster of factors: Rastafari, the Dread culture, reggae music and identity in 1970s Britain. The chapter looks at the pronounced hold that Rastafari had on young Black Britain in the 1970s and early 1980s. This decidedly strange, profoundly counter-cultural expression had emerged in Jamaica earlier on in the twentieth century, and no end of young Black Britons

sought refuge in its ideologies, its lifestyles, and its music. Rastafari represents one of the most fascinating belief systems across the entire history of the African Diaspora. An extraordinarily potent and diverse range of factors and influences contributed to the emergence and development of Rastafari, which

> ...drew upon a magical realist world of influences from an Ethiopian king to the Mau Mau fighters of Kenya. Inspiration came from animism, the Bible, Marcus Garvey, Hinduism (the sacred smoking of marijuana, vegetarianism and meditation).[13]

The embrace of Rastafari is of critical importance in this book's narratives, primarily because Rastafari provided a compelling and indeed, mesmerising template for those Black youth for whom Britishness was an ill-fitting garment. Caribbean migrants were on the whole deeply religious, and remained, to varying degrees, steadfast in their Christian faith, across a range of denominations, many of them Pentecostal in orientation. With its language of exile, Babylon and salvation, Rastafari was in many respects easily understood and easily embraced by those who, to one extent or another, had drifted away from or rejected outright the organised religion of their parents. With its appeal to Blackness, the centrality of a mythical African homeland, the persuasive language of sufferation and downpression, and pulsating, perfectly crafted reggae music, from the mid 1970s onwards for a period of about a decade Rastafari and the attendant Dread culture carried the swing.

Within the mindset and consciousness of Rastafari, *culture* was not something that Black people simply embodied or carried with them, irrespective of time, place, circumstance, conditioning, etc. Instead, *culture* was what Black people had to *reclaim*, if they were to achieve true enlightenment as exiled children of Africa. Inevitably perhaps, Afrocentric consciousness emerged as the apparently most plausible route to this. As with so many other instances, African-American manifestations of the late 1960s to mid 1970s had rehearsed these cultural politics, when Afro hair, the wearing of dashikis and the adopting of African-sounding names had become the norm for significant numbers of African-American individuals. These things had their place among Black Britons also, but it was the influence of reggae and Rastafari that most enabled Black people to echo reggae group Black Uhuru's triumphant sentiment of resistance: 'my

culture is growing stronger and I hope I never surrender.'[14] Adherents of Rastafari were not alone in regarding culture as a *material* form of resistance to Babylon. No less a figure than Amilcar Cabral, one of Africa's foremost anti-colonial revolutionaries of the mid-twentieth century had insistently posited that 'To live your culture in an oppressed society is itself a revolutionary act.'[15] Furthermore, to those Black Britons who felt their struggle for dignity was related to political struggles elsewhere in the African Diaspora, Cabral gave succour by asserting that, 'national liberation was necessarily a cultural act.'[16] The similarly iconic Malcolm X had, or developed, a comparable attitude towards cultural identity. Paraphrasing Amiri Baraka, James Smethurst noted,

> ...one obvious conclusion drawn from [Malcolm X's] position that African Americans constitute a nation is that they have a distinct culture, one that needs to be strengthened and developed in ways that reinforces its independence from 'white' culture. Again, late in his life, and perhaps influenced by his contact with younger nationalists, Malcolm X saw this culture as African at base and advocated a reclamation and renewal of this base through a migration back to Africa 'culturally, philosophically, and psychologically'.[17]

Utilising a well-known bible story, British reggae group Steel Pulse memorably likened the Black man returning to his culture as a prodigal son returning to the fold of familial, sustaining embrace: 'Prodigal has returned to his culture, prodigal has returned, give him water...'[18]

Chapter 4, 'Leggo de Pen', looks at the fascinating manifestation of language in the cultural evolution of Black Britain. Mid 1970s Britain and Jamaica saw the emergence of a new group of poets who unashamedly embraced patwa as a foundational aspect of their poetry. In so doing, these poets, spearheaded in Britain by Linton Kwesi Johnson, elevated the supposedly rough speech of Jamaican peasants to the status of preeminent counter-cultural articulation. Within the United States, poetry had emerged as one of the foundational art forms of the Black Arts Movement of the mid 1960s to mid 1970s. Many poets declared their art form to be as relevant to Black people as any other, and boldly challenged the association of poetry with rarefied,

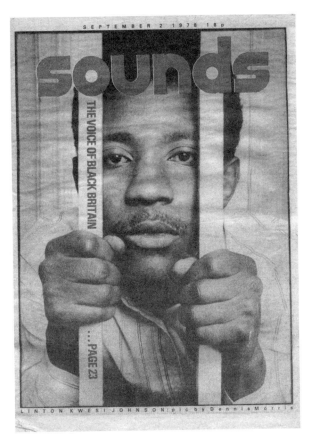

Figure 5: 'Linton Kwesi Johnson, Poet of the Roots', *sounds* music magazine cover, 2 September 1978.

ivory tower environments – an association that effectively alienated poorer and working-class people from the art form. And it was during this period that a fearless, devastatingly articulate poet of the people, Gil Scott-Heron, emerged. Here was a poet who not only spoke the people's language, but saw, and condemned, the wider society for its chronic dysfunctionality, a state of being the society itself seemed blind to. Heralding the emergence of another fearless, devastatingly articulate poet of the people, the cover of *sounds* (a British music magazine) of 2 September 1978, carried a full-page photograph of Linton Kwesi Johnson, a British poet of Jamaican origin.[19]

The cover photograph, taken by Black-British photographer Dennis Morris, trailed a substantial feature on Johnson in that issue. The photograph appeared to show Johnson holding on to and looking out from behind two vertical bars, giving the appearance of a prison cell. The cover declared Johnson to be 'The Voice of Black Britain'. Within the text itself, this sentiment was reiterated, with Johnson being introduced as 'The first artist to deal with the reality of the Black experience in Britain.' By the early 1980s, a number of books had been written that sought to articulate or comment on the nature of the 'Negro', 'Coloured', 'West Indian', 'Black', 'Afro Caribbean', or 'immigrant' presence in Britain. However, these books were in the main of a sociological bent and, pretty much without exception, framed the new Black presence as a 'problem'. Relatively little appeared in print that sought to discuss the multi-dimensional importance of cultural politics in the formulation of a unique *Black-British* identity. And yet, as magazine features such as the one on Linton Kwesi Johnson demonstrated, by the late 1970s artists using a variety of media were producing dynamic, charged expressions that earnestly and cogently reflected on an intriguing new presence, and the somewhat fractious experiences of the children of Caribbean migrants, who routinely cast themselves, and were in turn cast, as strangers in a strange land. At the heart of dub poetry (the art form with which Johnson came to be associated) lay a profound embrace of Afrocentric or Black consciousness, which did much to strengthen and carry forward Black-British cultural identity of the mid–late 1970s onwards.

Chapter 5, 'Africa: The Call of the Continent', looks at the intriguing place of Africa in considerations of cultural politics in the making of Black Britain. As mentioned earlier, the great Pan-Africanist Marcus Garvey had, from 1914 onwards, been at pains to stress that the world's diasporic Africans should, first and foremost, regard themselves as sons and daughters of the African continent. During the 1970s, a formidable cocktail of Africa-related influences served to emphasise the extent to which the continent, its histories, its ongoing challenges, and its emerging place in the world all served to comprise a hugely important dimension of Black-British cultural identity. The chapter's first section reflects on a defining moment in this book's narrative: the screening on British television of Alex Haley's *Roots*. These passages discuss the extent to which memories

of slavery, much like notions of Africa, began to take centre stage in 1970s' Black-British identity. Discussions or recollections of slavery had had little to no place in the public discourse or in the national culture of Caribbean countries in the mid-twentieth century. However, within a couple of decades, slavery had taken centre stage in the identities of many of the children of Caribbean migrants. And in this regard, the screening of *Roots* was of the utmost importance and was a significant factor in crystallising of a young Black-British identity in the mid to late 1970s. The screening on national television (in the mid 1970s) of the American dramatisation of Alex Haley's book *Roots* was something that animated and exercised Black Britain, though others were also affected or influenced by the screening. Through the experiences of a captured young African man and the subsequent brutality of his passage into slavery, *Roots* told an American story of the slave trade, slavery and the parts these things played in the making of America and American history. *Roots* was a family history, as traced, imagined and embellished by American writer and journalist Alex Haley. Through the recollections of his older relatives and other areas of research, Haley was able to create an American history, a family tree, with the brutal experience of slavery and the slave trade as a compelling, if uncomfortable, foundational aspect. In so doing, Haley demonstrated and reaffirmed that the experience of slavery was not just historical. It was instead very much an animated and consistent ingredient in the present-day identity of Black people, both in the United States and further afield – in this instance, Britain. Again, it was Rastafari that had encouraged New World and other diasporic Africans to, in the words of Burning Spear, 'remember the days of slavery'.[20]

Elsewhere, within the same time period – the mid 1970s – the sufferation and downpression of Black South Africans, under the apartheid system, as well as the experiences of the frontline states, struck particular chords with Black-British people. The Soweto uprising, the murder of Steve Biko, the continued incarceration of Nelson Mandela and a number of his colleagues and fellow activists – these things combined to act as a touchstone for the Black diasporic identity that Britain gave rise to. Other manifestations of a new orientation towards Africa, discussed in the chapter, include Africa Liberation Day and *Festac'77*, a major festival of arts and culture presented by the Nigerian government in 1977.

Festac'77 afforded significant numbers of Black arts professionals in the diaspora an opportunity to travel to Nigeria (in the case of some individuals, to *return* to Nigeria). For many of these persons, *Festac'77* gave them their first opportunity to visit the African continent. *Festac'77* was a phenomenally important endeavour, which sought to be truly international and global in its embrace. However, this presented its Nigerian organisers with something of a conundrum: how do you recognise countries which don't in turn properly recognise their Black citizens? The question was far from merely academic, and was perhaps more moral in its leaning. After all, both South Africa and Rhodesia were in this respect renegade states, and the same could be said of countries such as Australia, the USA and, closer to home, Britain. To this end, *Festac'77*, more than six years before Benedict Anderson's book was published, fashioned its own *imagined communities*, or invented countries. Hence, the birth of Black Britain was given a major and most singular fillip, by its recognition/creation at *Festac'77*. Nothing symbolised the emergence of Black Britain at *Festac'77*, and the corresponding wedge being driven, during the 1970s, between Britain and its Black citizens, more than the absence of a flag behind which Black Brits could march and parade at the extravaganza's ceremonies. At a time when no end of dazzling, visually charged flags of recently independent countries of Africa and the Caribbean had joined the world of vexillology, the pointed absence of the Union Flag spoke volumes and was in marked contrast to Black-British athletes' wrapping themselves in the British flag, which became, in the 1990s, a predictable and familiar trope.

Thus Chapter 5 explores the various parts that Africa, as a continent, as an idea, as a source of identity, played in the lives of young Black Britain. Again, considerations of Rastafari have a profound part to play, as it frequently and insistently located the quest for equal rights and justice, as well as a mythical African homeland, at the heart of its consciousness and teachings. Africa had had little to no place in the public discourse or in the national culture of Caribbean countries in the mid-twentieth century. Within a couple of decades, however, *Africa*, through an appreciation of new found histories of slavery, through rallying to solidarity campaigns such as Africa Liberation Day, and through other factors discussed in the chapter, had taken centre stage in the identities of many of the British-born children of Caribbean migrants.

Another important factor in this book's considerations relates to the ways in which the inner city urban environment became, for Black youth, not so much a proxy battlefield as a literal one. Black-British youngsters frequently found themselves engaged in the contesting of territory with the police, who symbolised, represented and embodied the state at its most menacing, obstructive and abusive. A sympathetic feature on Black-British youth's experiences with racism, appearing in the United States in 1976, baldly stated that, 'Whilst racism is the source, the police (bobbies) seem to be the most obvious instrument serving its interests. An undercurrent of police-Black youth hostility pervades the community and shows no sign of dissipating.'[21] It was in the mid 1970s that the riot became an important expression of resentment, antagonism and exasperation for Black youngsters, most noticeably around the battles that characterised the Notting Hill Carnival of 1976. It was these dramatic events that led to the feature quoted above.[22]

Chapter 6, 'Fyah!', looks at the ways in which the criminalising and demonising of young Black males both led to, and was a consequence of, the flashpoints of tension that have periodically benchmarked the Black-British experience, and the ways in which such flashpoints of tension contributed to a somewhat fractious but tangible sense of identity. 'Fyah!' explores the ways in which the cataclysmic events of 1980 and 1981 – the riots in Bristol and Brixton respectively – were the first time Black Britons saw an aspect of themselves and their fractious presence burst upon the television screen and occupy significant column inches in the nation's newspapers. For a brief, intense period of time thereafter, the riots and their aftermath had a marked influence on many aspects of Black-British cultural identity. To this end, a number of Black-British artists, poets, photographers and filmmakers all reflected on, in singular and important expressions, the violence and menace that shadowed the lives of so many Black youngsters, particularly males, and the response of some of these males to this – the riot.

As mentioned at the beginning of this Introduction, thus far, for Britain's Black artists, the 1980s has proven to be the most productive and significant decade in their history. Chapter 7, 'Picture on the Wall', chronicles and explores the ways in which this book's discussions were made manifest in the practices of Black-British artists, with particular reference

19

to the visual arts and the extraordinary, unapologetic, defiant emergence of 'Black Art'. Though pronounced manifestations of fractiousness might have been the hallmark of the Black-British experience of the 1970s and early 1980s, there is no denying the astonishing breadth of phenomenal art that the era gave rise to. By reaching into history towards episodes such as slavery and colonialism, by reaching across the ocean and drawing inspiration from the Black Power and Civil Rights struggles, by finding common cause with the anti-apartheid struggle, by using the culture, lingo and mannerisms of Rastafari, Britain's Black artists found inspiration and turned that inspiration into some of the most astonishing work that Britain has seen. Previous generations of Black artists had been markedly reluctant to name their practice as 'Black' or in any way racialised. This for the most part reflected the specific and wider hopes of Caribbean, African and South Asian migrant artists to be treated as equals, and judged on the integrity and calibre of their practices alone. By the early 1980s, however, a new generation of younger artists willingly came together under the banner of 'Black Art', thereby emphasising the extent to which *race* had become something of a preeminent and defining factor in the lives of many of the children of Caribbean migrants.

Until a new generation of practitioners emerged in the early 1980s, Black artists had, as just mentioned, been somewhat reluctant to name their practice with a racialised or politicised prefix. They were similarly reluctant to explicitly place social or political narratives at the core of their practice. John Lyons hinted at the profound changes that the profile of Black artists in Britain went through, between the early 1970s and the early 1980s. He did so by contrasting the impulses, sensibilities and activities of London-based Caribbean-born artists and intellectuals who created mechanisms of mutual support, from the mid 1960s to the early 1970s, with an altogether different body of practitioners that emerged in the early 1980s. Making mention of an importance exhibition of work by Caribbean artists in England, held at the Commonwealth Institute in 1971,[23] Lyons contrasted the exhibition with a markedly different type of Black artists' practice, a decade or so later.

> Caribbean artists and writers like the Barbadian poet, Edward Kamau Brathwaite, the Jamaican novelist Andrew Salkey and John La Rose, the Trinidadian activist and poet, came together

in 1966 to form the Caribbean Artists Movement. It was a coterie which, in the fostering of mutual respect and support, created confidence by maintaining cultural identity in a Eurocentric milieu fraught with numerous dangers of misappropriation. It also attempted to establish for Caribbean peoples in Britain a point of cultural reference. The Caribbean Artists Movement brought together a group of artists in an exhibition 'Caribbean Artists in England' mounted in the Commonwealth Institute Gallery in 1971... What started in 1971, significantly in the Commonwealth Institute Gallery, as relatively benign self-assertion was, within a decade, superseded by exhibitions of works of a politically rhetorical character by young Black artists of the generation born in England as British citizens. Unlike their parents and grandparents, whose illusion of England as the mother country was shattered by the stark realities of racism, these young Black-British artists had the right by birth to claim England as their home.[24]

Chapter 8, 'Failing the Cricket Test', looks at a hugely important influence, concurrent with other developments: the 1970s and 1980s' ascendancy of the West Indies cricket team. Colin Babb succinctly noted the relevance and importance of cricket in the fashioning of Black-British cultural identity:

> During the 1970s and into the 1980s, some Caribbean youth in Britain were expressing anger and disillusionment towards a lack of opportunities, a sense of social alienation, conflict with extreme right wing political organisations and perceived harassment from inner-city police forces. For some, West Indian cricket offered a powerful representation of black pride, achievement and a direct connection to their Caribbean heritage.[25]

Cricket, perhaps much more than any other sport exported to the colonies by the British Empire, existed as a sort of proxy war of competing identities. In 1950, the West Indies cricket team beat England for the first time on English soil. Such a victory confirmed the cricket pitch as a battleground as viable for political and social tussles between colonial masters and colonial subjects as any other, particularly given the distinctly blunt manifestations of social and colour hierarchies, and given that anti-colonial/pro-independence struggles across the Caribbean and elsewhere were gathering momentum. The successes of West Indies cricket continued to be

an unstoppable and substantial source of pride and identity for Black people throughout the Caribbean, and, crucially, their families and friends in Britain. Furthermore, for Black players and fans alike, cricket 'was viewed as one of the few arenas in which a black person could compete with a white person on the basis of equality.'[26]

It is fascinating that the extent to which second generation Caribbean people in Britain were familiar with the rules of cricket, or the extent to which they were ongoing cricket fans, was pretty much a lesser concern. What was significant was that the success of the West Indies cricket team offered Black-British people of all age groups an opportunity to express an unapologetic, proud and above all collective sense of identity. A win by the West Indies on English soil equated to special moments of pride to be savoured by all manner of Black people throughout the land. Conversely, a defeat meant enduring barbed, pointed jibes that went way beyond innocuous banter. The distinguished, accomplished West Indies cricketer Wes Hall 'recalled how he was often reminded by West Indians he met in Britain that if the West Indies team were defeated by England, they wouldn't go back to work the following morning. Taking a day off work was better than enduring the humiliation and ridicule from their English work colleagues.'[27] In this regard, the social impact of cricket on Black-British communities of Caribbean descent is an important component of this *Roots and Culture* narrative, particularly relating to developing identities during the 1970s and beyond.

'(Dawning of a) New Era' is a song by British ska band, the Specials, that was released in 1979, in the heyday of the group. To describe the group as a ska band might in actuality be somewhat lacking, as groups such as the Specials blended local Coventry and West Midlands musicians and singers from different racial backgrounds as much as they blended musical influences, including those from Jamaica, alongside forms of music that had emerged in Britain and elsewhere in the world. Thus, though paying distinct homage to ska, a music genre that had originated in Jamaica in the late 1950s and was the forerunner of rocksteady and reggae, the Specials embodied a uniquely British form of musical expression. As such, the Specials were a fitting symbol of some of the ways in which the new Black presence, whilst still evolving, even so existed in a noticeably energetic, probing, though nevertheless

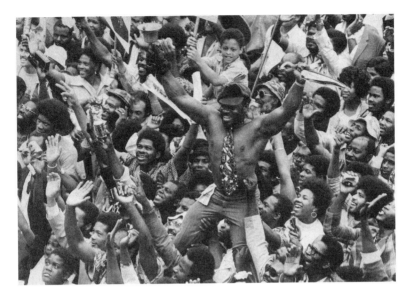

Figure 6: 27 August 1973: Fans of the West Indies cricket team celebrate their win over England at Lord's cricket ground, London.

quite settled state of being, unashamedly characterised by pronounced notions of cultural and racial hybridity. Social mobility and political advancements might, for Black Britons, have remained as elusive as ever, but in other respects, they were, during the 1970s and on into the 1980s, able to forge an identity every bit as important as those forged by African descendants in countries such as Brazil and the United States. This book's final chapter reflects on this seismic '(Dawning of a) New Era'.

Like so much street lingo, the expression 'roots and culture' has no straightforward translation into what might be termed 'standard' English. The term, popular amongst certain circles of Black-British youth in the late 1970s and 1980s and emanating from a variety of reggae tracks, came from Jamaica and meant to be in touch with one's roots, to have attained a certain level and type of consciousness, and to have an appreciation of the importance of Black history and culture in the construction of one's identity. In time, *roots and culture* became a particular genre of reggae music, distinguished by *upful* and *conscious* lyrics of Black pride and righteousness. The term 'roots and culture'

represents a particular period of British manifestations of African-Caribbean cultural intensity and resonance that this book seeks to historicise.

The study set out in the pages of this book will seek to emphasise the extent to which language itself was a particularly important component of this narrative. The *Windrush* generation had been brought up to embrace the finer points of elocution and took it for granted that distinct pronunciation and articulation in the King's or the Queen's English was the hallmark of culture and respectability. Indeed, these immigrants often spoke with a far higher standard of English than many white, British-born people. These Caribbean migrants were of the view that speaking in anything other than 'good' English would deny their children professional and societal advancement. Simply put, the second generation was often discouraged, in the strongest terms, from speaking in, or mimicking, Jamaican or Caribbean *patois* (patwa or patwah). And yet, as discussed in Chapter 4, by the end of the 1970s patwa had become an important signifier and conveyor of Black-British identity. Poets such as Linton Kwesi Johnson had elevated this supposedly subaltern means of verbal communication into a clear articulation of Afrocentric or Black consciousness and a credible, respectable element of the English language. Caribbean-based intellectuals, writers and novelists had always had, by and large, a pronounced respect for folk culture, including language. But this tended to set them apart from much of the rest of polite society, which in the mid-twentieth century was scornful of patwa. But as disrespected and scorned as it was, patwa became, for many Black youngsters, an important and vital lexicon of coded vernacular expression.

Wherever possible, this book draws from contemporary sources relating to the subjects it discusses. (That is to say, texts such as magazine articles written and published at particular moments during the course of this book's timeframe). Though such texts frequently reveal – at sometimes inadvertently or unconsciously, at other times explicitly – prejudices that were dominant at the time (particularly with regards to matters of terminology, *race*, culture, and so on), they nevertheless embody a *usefulness* that often far exceeds much contemporary scholarship relating to the subject, mindful as it so often is about the need for a certain political correctness in both its language and assertions.

1

De Street weh Dem Seh Pave Wid Gold

Black people have been present in Britain for many centuries, going back as far as Roman times. Whilst this presence has historically ebbed and flowed, it was not until the relatively recent period of the mid-twentieth century that Britain's Black population swelled significantly and, within a period of little more than a decade, came to represent an intriguing and somewhat conspicuous new aspect of the British populace.[1] Britain has of course, since the earliest times, been the destination – temporary or otherwise – of a long line of peoples.[2] Among them are Huguenots, Jews, Celts and Saxons. In more recent decades, we can also speak of Irish, Italians, Poles and others. The crucial difference between these groups and immigrants of African, Caribbean and Asian backgrounds is the pretty blunt one of skin colour. While white immigrants within a generation or two have become assimilated and accepted as British, Black immigrants and their offspring have inevitably maintained a particularly conspicuous presence that has contributed to them not readily being regarded as British in the same ways as their white compatriots.[3] This systemic, perennial impulse to regard those with visibly darker skins as somehow embodying different traits and characteristics has meant that the gradual formation of a separate cultural identity for Black Britons was, perhaps, inevitable. At every turn, certain

pathologies ensured a persistent *othering* of Black people, with cultural consequences that this book seeks to examine.

The narratives that this book seeks to understand began in the years of Caribbean migration to Britain from the late 1940s through to the early 1960s. In 'The Caribbean Community in Britain', the Trinidadian-born journalist Claudia Jones noted, in fascinating detail, the demographics of this period of immigration.

> Immigration statistics, which are approximate estimates compiled by the one-time functional West Indian Federation office (Migrant Services Division) in Britain, placed the total number of West Indians entering the United Kingdom as 238,000 persons by the year 1961. Of these, 125,000 were men; 93,000 women; 13,200 were children, and 6,300 unclassified. A breakdown of the islands from which these people came showed that during the period of 1955–61, a total of 142,825 were from Jamaica; from Barbados, 5,036; from Trinidad and Tobago 2,282; from British Guiana, 3,470; from Leeward Islands 3,524; from the Windward Islands, 8,202, and from all other territories, the sum total of 8,732.[4]

To understand the push-pull factors that contributed to Caribbean migration, we need to look at conditions that existed in Jamaica and, to varying degrees, other Caribbean islands and countries, in the years following the end of World War II. Those in the English-speaking Caribbean had, as was mentioned in the Preface, been brought up under the British flag, so much so that many of the young men of the British Caribbean, like their white British counterparts, enlisted for duty in the war effort. In the words of Robert Winder,

> Britain, [in the years following war's end] though far off, was now an attainable destination for more than just the odd writer or cricketer. It was also, thanks to the empire, much more familiar. The colonial administration had given West Indians a grounding in Queen and Country, in Shakespeare and Tennyson, in W. G. Grace, *Kennedy's Latin Primer* and the Lord's Prayer. They had grown up singing 'There'll Always Be an England' and 'Land of Hope and Glory' at assembly. Many of their Christian names – Nelson, Milton, Winston – derived

from British heroes. A reverence for Britain had been carefully planted. Now, modern steamships brought the land within reach.[5]

Another commentator, Ernest Cashmore, alluded to the affinity with Britain with which those in countries such as Jamaica had been inculcated. In his book, *Rastaman: The Rastafarian Movement in England*, he quoted a gentleman who recalled, 'In Jamaica children are taught all about Britain, its history, its heroes, etc. So coming over here we knew what to expect, or at least thought we did.'[6] Such sentiments are reflected in a feature on 'coloured' immigration in an edition of *Picture Post* magazine of 1949. Early in the piece, the writer, Robert Kee, noted that 'it is important to remember that all colonial coloured people, of whatever origin or class, have been brought up to think of Britain with the greatest pride and affection as 'The Mother Country.' (West Indians even talk of Britain as 'home'.)'[7]

While these sentiments allude to the *pull* factor – that is to say, that which, in part at least, attracted would-be immigrants to Britain, there was also a concurrent *push* factor, laid out by Winder in similarly cogent and lyrical terms. Writing specifically about post-war conditions in Jamaica, Winder noted:

> The Jamaica they [West Indian troops] returned to was still devastated after the tremendous hurricane of August 1944 – the worst for forty years. Ancient trees had been toppled, fruit groves trampled; roofs had been whipped off like napkins. Even before the storm, the economy was in tatters. The price of sugar – by far the dominant export – had sunk to the point where the crop was hardly worth harvesting. Fields of cane ran wild and died, and there was no work for the men who once hacked sweetness from the hills. The Caribbean tourist boom was a long way off. The Western bourgeoisie couldn't yet run to swanky winter breaks on these palm-fringed beaches. Aside from a tiny trade in coffee and rum, there was little to do but subsist on fish from the ocean, and whatever mangoes, bananas, maize or breadfruit poked through the rubble.[8]

In 1949, Robert Kee described the economic challenges of life in Jamaica, faced by many, in stark terms. Referring in part to migrants such as those who had in the previous year come to England on the *Empire Windrush*,

27

Kee stated, 'These have come here partly because of the economic impoverishment of their own country (the unemployed figure for Kingston, Jamaica, alone is 70,000.)'[9] This figure represented a significant proportion of the city's labour force. In so many ways, beginning with the widespread implementation of the use of enslaved Africans in the latter half of the seventeenth century, issues of labour and employment had always been vexatious in the Caribbean. Enslaved Africans had been brought into the region for no other reason than to work the plantations and sugar mills, or otherwise attend to serving the master class, the *plantocracy*. The end of slavery in the early decades of the nineteenth century, and the technological developments in manufacturing and harvesting processes, meant that a massive proportion of the Black populations of Caribbean countries effectively and rapidly found themselves either unemployed, or pitiably under-employed. Upon the abolition of slavery, businesses that had relied on wageless labour to turn profits thereafter became, for some of their owners, liabilities rather than assets. As a consequence, labour and employment in the Caribbean became difficult and aggravating issues. Thus, the Caribbean has long since been a region with a surfeit of labour, and consequently a region from which labour has been exported.

> The only valuable export was labour. Caribbean workers knew all about this: they had known little else. Even within their own islands they often had to trudge for miles in search of piecework on the plantations, and for years they had been hopping over to Florida to pick fruit. In the first half of the century, up to 150,000 Jamaicans (a tenth of the population) went job-seeking in North and Central America. Many had been ferried to Panama to dig the canal.[10]

Though reflecting no end of deeply troubling pathologies around race, freely expressed at the time, the book *The Panama Canal* written by Frederic J. Haskin and published in 1913, at just about the time when this monumental feat of engineering and construction was completed, is an invaluable reference to Caribbean workers' involvement in the enterprise. According to Haskin,

> The Government paid the West Indian labourer 90 cents a day, furnished him with free lodgings in quarters, and sold him

three square meals a day for 9 cents each, a total of 27 cents a day for board and lodging. On the balance of 63 cents, the West Indian negro who saved was able to go back home and become a sort of Rockefeller among his compatriots. His possible savings, as a matter of fact, were about two and a half times the total wages he received in his native country.[11]

Later on in his references to workers from the Caribbean, Haskin claimed that those 'negroes [who] were industrious, constant, and thrifty … saved all they could, worked steadily for a year or two, and then went back to Jamaica or Barbados to invest their money in a bit of land and become freeholders and consequently better citizens.'[12] It was then reported that 'The negro laborers at first were obtained by recruiting agents at work in the various West Indian Islands, principally Jamaica and Barbados. The recruiting service carried about 30,000 to the Isthmus, of whom 20,000 were from Barbados and 6,000 from Jamaica.'[13] Earlier in this particular chapter, Haskins had stated that, 'The West Indian negro contributed about 60 per cent of the brawn required to build the Panama Canal.'[14]

There was one other significant reason why migrants from the British Caribbean wanted to enter whatever labour market there might have been in Britain. Frankly, there were precious few other destinations open to them. The USA had instigated draconian restrictions that limited Caribbean migration to a derisory annual figure.

> The door to North America was quickly shut by the McCarren (sic) Walter Act in 1952, which limited the number of British West Indians who could settle in the USA from 65,000 a year to only 800. People turned instead to Britain and exercised their rights, as their passports indicated, as 'British subject, Citizen of the United Kingdom and Colonies.'[15]

Another commentator put the figure of Caribbean immigrants allowed into the USA by the McCarran Walter Act at a far lower figure, though this was likely to be on account of the act allowing for 100 persons per Caribbean territory, per year. However, his sentiments of migrants' expected citizenship were consistent with the other such views expressed.

> Unaware of Britain's hostility towards immigrants, the first large group of West Indians who stepped off the *Empire Windrush*

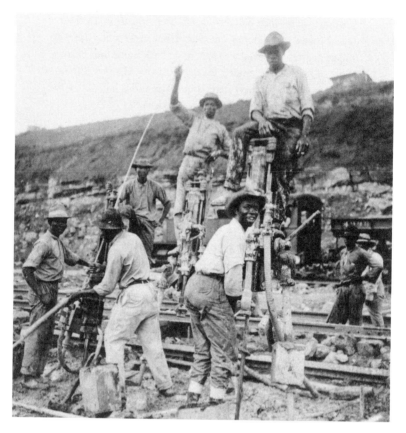

Figure 7: Construction workers boring through rock with tripod drills during the construction of the Upper Miraflores, Panama Canal.

in June 1948 thought they were 'coming home'. Some of them had spent the war years in the R.A.F., stationed in Britain, and all of them had been brought up to believe that England was the 'Mother Country'. Prevented from going to the U.S.A. by the McCarran Walter Act (1952) which restricted immigration from the West Indies to a hundred a year, most of the West Indians who followed the pilgrims' boat expected to be welcomed in Britain and felt they had fulfilled their dreams.[16]

Incidentally, Black dissatisfaction and unhappiness at what were regarded as dreadful conditions and treatment were not confined to mid to late

twentieth-century Britain. The great Jamaican-born Pan-African visionary and agitator for Black rights, Marcus Garvey, was dismayed at the conditions he encountered and observed among the Jamaican labourers referenced by Winder. In his mid twenties, Garvey travelled to Costa Rica. One of Garvey's biographers noted,

> The United Fruit Company was currently expanding its operations in Costa Rica and Garvey's uncle secured a job for the Jamaican as timekeeper on one of the company's banana plantations. The plight of the Negro field workers, many of them his countrymen, only increased Garvey's determination to improve the lot of Negroes everywhere.[17]

Garvey subsequently travelled to Bocas-del-Toro and Colon, Panama, where,

> [He] observed with great indignation the inferior status of Negro workers on the Panama Canal, which was nearing completion at the time. From Colon, Garvey moved to Ecuador, where he observed Negro labourers being exploited in the mines and tobacco fields, and then went on to compare conditions in Nicaragua, Honduras, Colombia, and Venezuela. His widow [Mrs. Amy Jacques Garvey] records that 'sickened with fever and sick at heart over appeals from his people for help on their behalf' he returned to Jamaica.[18]

Another Garvey, Mrs. Amy Ashwood Garvey, (the first wife of Marcus Garvey, and, in her own right, a Pan-Africanist, activist and feminist) had significant connections to Panama. Born in Jamaica, 'She was raised in Panama, where her father operated a print shop.'[19] Predictably, Garvey's reported horror at the plight of Black workers on the construction of the Panama Canal contrasted with the benevolent tone of the confident claim, made at the time of Garvey's visit when construction of the Canal was nearing completion, that Black workers were treated well. Upon completion of the Canal, it was claimed that the worker from the Caribbean, upon repatriation, would 'miss the life on the Isthmus. He was worked harder, he was treated better, and he was paid higher wages there than he ever will be again in his life.'[20]

In many respects, the appeal of Britain can be set against Caribbean memories of earlier migrant experiences in Latin America, and in this regard migration to Britain promised to be an altogether different, and much better, prospect for post-war migrants than the woeful conditions Garvey observed on his travels in Central America. After all, the omens were good, and in the words of Winder many of these Caribbean migrants left their respective countries 'with a bolstered self-confidence and a sense of equality.'[21] Trevor Carter referenced the jolt that disabused Caribbean migrants of whatever good omens they may have been encouraged by, before their migration. 'What we were unprepared for in Britain was racism. We knew that it operated – and was even legalised – in the States; indeed, some of us had chosen to come to Britain precisely because we believed racism did not exist here.'[22] But perhaps the most profound and formidable *push* factor was the deeply traumatic effects and consequences of slavery itself, which though having been abolished for well over a century, had poisonous effects that lingered still.

> For people with birthrights so gnarled by slavery that they felt rootless and exiled even at home, for whom even their own sun-kissed islands smacked of imprisonment, the prospect of crossing the ocean to make their own way in the world was hard to resist.[23]

Notwithstanding the migrants' cultural grounding that they shared with white Britons, at every turn factors presented themselves that mitigated any prospect of colour-blind cultural and social assimilation. Though Britain had not before (and indeed, not subsequently) played host to a body of immigrants whose loyalty to Britain, as stated earlier in this text, often seemed to exceed that of their white British-born counterparts, this loyalty and familiarity with British institutions was neither respected nor reciprocated. The point about Caribbean migrants' loyalty to Britain has been stressed repeatedly by a range of writers and researchers. For example, '… many Anglophone Caribbeans displayed a remarkable loyalty to Britain in both world wars and showed a fierce adherence to British educational, social and political institutions.'[24] As mentioned in the Introduction to this book, these immigrants found themselves being treated not as fellow Brits, but as sinister foreigners, to be kept at arm's length and regarded

as delinquent and, perhaps most damaging of all, as a 'problem'.[25] Though those migrating to Britain included many who were, or had aspirations to be, educated professionals, the host community found itself unwilling or unable to appreciate the earnestness with which these immigrants sought not drama or confrontation but social assimilation and prosperity through employment. Many barriers to this aspiration existed, ranging from petty or not-so-petty prejudice against those deemed as unwelcome foreigners, through to widespread manifestations of what was known as the 'colour bar'.

Of course, Caribbean migrants who had worked in the Jim Crow South, or had some familiarity with the distressing treatment of Black workers in the countries of Central America referenced earlier, were perhaps not surprised at the prevalence of racism, even though they expected better from the British people. What was however an undoubted surprise, was the profound ignorance of white British people about the history, geography, systems of government, political personalities, sports, and cultural heritage of the countries of the Caribbean from which the immigrants came.

> We, who had been brought up on English history and literature, had to come to terms with the blanket ignorance of the English themselves of the whereabouts of the West Indies, never mind our history and culture. A typical response to discovering that a workmate came from Trinidad, for example, was, 'Oh, that's just north of Nigeria, isn't it?'[26]

Right from the earliest days of Caribbean migration to Britain, immigrants found themselves having to exercise a form of double consciousness; needing to demonstrate a familiarity with such things as British mores, culture, and societal structure, while at the same time retaining a sense of identity as Jamaicans, Trinidadians, Bajans, and so on. Needless to say, white Britons saw themselves as having no need to reciprocate, or embrace anything other than the mono-culturalism and insularity in which they had so self-evidently been steeped. This double consciousness strategy was alluded to by Trevor Carter: 'As for those of us who had come to Britain to fulfil dreams ... to belong to a society which we thought we knew, we came to the conclusion that we had to operate both inside and outside the institutions of that society at the same time.'[27]

Given these formidable factors, the likelihood of a shared, mutually enriching culture being embraced by British people of different *racial* backgrounds was slim to non-existent. Likewise, the immigrants found that there were, by and large, no aspects of British public life, amenities, housing, schooling, and so on in which skin colour did not factor. Furthermore, they found it always to be the case that skin colour factored in ways that disadvantaged them. It is appropriate to mention, at this point, that Caribbean migrants found themselves not only victims of the host society's prejudices and ignorance, but simultaneously caught up in party political machinations, in which immigration came to be consistently framed by both government and opposition parties as something that needed to be contained, controlled, or even reversed. The demonisation of immigrants and foreigners was to become a perennial feature of public and political discourse, something that has not changed since the mid-twentieth century to the present time.

Chris Mullard, remarking on these matters, noted that as early as 1958, 'Politicians began to change their minds about immigration as public opinion against blacks hardened.'[28] This same commentator reported that by the end of 1958, Conservative Party politician Patricia Hornsby-Smith 'told the House that Commonwealth immigration was giving the government a 'headache''[29]. Mullard, elaborated on the extent to which the issue of immigration control was rapidly descending into bald sentiments that regarded Caribbean migrants as an unvarnished problem.

> In October 1958... [Lord Home, the Secretary of State for Home Affairs] 'admitted to a Canadian audience that 'curbs will have to be put on the unrestricted flow of immigration to Britain from the West Indies'. Such a statement from a senior member of the government, together with an anti-immigration motion passed at the party conference later in the month, committed the Tories to a policy of immigration control.[30]

Perhaps because 1961 was a peak year, of sorts, for Caribbean migration, the following year marked the beginning of the end of such relatively large-scale movement of peoples, the closing of the door resulting from a certain type of political interference.

The Half-Open Door. In 1962 Britain's Conservative government passed the first Act restricting the entry of Commonwealth citizens to Britain. Intending immigrants were henceforth required to obtain work vouchers and these were not to exceed a figure of 30,000 a year.

Although the Labour Party opposed restrictions as being 'disastrous to [Britain's] status in the Commonwealth,' it introduced even tougher measures of its own after winning the 1964 election. Work vouchers were reduced to 8,500 a year and were made available only to those Commonwealth citizens with industrial skills or professional qualifications.

... Perturbed at the possible consequences of another large immigrant influx, the government allowed free entry only to those Commonwealth citizens whose grandparents had been born in Britain.[31]

Such blatantly discriminatory governmental manoeuvring confirmed to Caribbean migrants the extent to which they were subject to the vagaries of a negative obsession with immigration. Furthermore, white immigrants (i.e. those who could prove their grandparents had been born in Britain) were in effect given a free pass. The closing of the door on Caribbean immigration marked a decisive point in the beginnings of the formulation of a distinct Black-British culture. Quite simply, this was because those Caribbean people already resident in Britain were, by and large, henceforth cut off, quite literally, from family and friends still in the Caribbean. As early as 1952, Caribbean immigrants were being described as having, 'severed their roots in their own country.'[32] With little or no prospect of family members, no matter how beloved, being able to freely or easily come to Britain, the country's fledgling Black community had to call on its own resources to continue to establish itself. With no immediate access to more numerous and concentrated pockets of African Diaspora peoples, particularly in the Caribbean, Black-British people had to rely on themselves for a sense of group identity. In this regard, Caribbean peoples were perhaps at a greater disadvantage than African people residing in Britain. Writing in 1949, Robert Kee made mention of the ways in which discrimination faced by Black migrants represented the shattering of a 'deep emotional illusion'[33] which was 'particularly true of the West Indians, who no longer

have the tribal associations and native language which can still provide some fundamental security for the disillusioned African. The West Indian disillusioned with Britain is deprived of all sense of security.'[34] This point is of critical importance because the quarantining of Black Britain has meant that distinctly and uniquely *British* manifestations of Blackness have been the order of the day, over the course of the past half-century or so.

There were ways in which this isolating of Black Britain, rather than enhancing integration, had, perhaps counter-intuitively, the opposite effect. British-born Black people became an unfathomable and deeply suspect anomaly, as far as white Britons were concerned. Herein lay one of the fundamental reasons why a distinct Black-British culture would emerge and bloom during the mid 1970s to mid 1980s. With Black Britons simply not accepted as being British, the development of a separate and distinct cultural identity was perhaps inevitable.

> We are different from our parents in many ways. The only home we know is Britain. We are more difficult to understand than the black immigrant. A black immigrant often speaks another language. He may wear different clothes, he may eat different foods. All in all he will most definitely have a different life pattern from a white Briton. But a Black Briton...
>
> He will be British in every way. He will possess understandable values and attitudes; he will wear the same dress, speak the same language, with the same accent; he will be as educated as any other Englishman; and he will behave in an easy relatable way. The only thing he will not be is white.[35]

The people of the Caribbean had long since found ways of coming to terms with the splintered nature of their existence. The uprootedness caused by slavery, the need for them or their family members to travel abroad seeking work, the sponge-like ways in which influences from other environments, such as music, were absorbed and translated – all these factors and others had lead, perhaps improbably, to people in the Caribbean not only coming to terms with their multi-dimensional existence, but thriving on it. A similar process – of coming to terms with, and seeking to thrive on a somewhat splintered and disregarded existence – would be clearly discerned in the cultural growth of Black Britain. One Black person, speaking with Trevor Carter, opined that 'The survival kit of black people is

that we are experts on alternatives. It is an unconscious lesson of colonialism to find alternative ways of existing in a hostile environment, whether you're talking about food, school, culture or church.'[36]

Notwithstanding this pronounced process of constructing something whole, something unique and something vibrant from fragments of existence, history and circumstance, there remained, amongst many Black Britons, a palpable sense of the injustices of the immigration clampdown. In 1980, Basement 5, a radical reggae punk fusion band from London founded in 1978, released an album that included a blistering track titled 'Immigration'. The song raged against the compulsion and indeed the consequences of Caribbean people being separated from loved ones and being forced 'to live separate lives'. 'Immigration, immigration, d'you know what's it's like? Immigration, immigration you spoil many lives.'[37] Other people in Britain were able to take for granted access to mothers and fathers, siblings and other family members. Not so many Caribbean people who had settled in Britain before the door to Britain slammed shut, or the drawbridge pulled up.

The consequences of the relative isolation of Britain's Black population, together with the concurrent and perennial demonisation of immigrants was to have a profound effect on the development of a Black-British cultural identity. From the 1960s onwards, as punitive immigration acts were brought into force, Black-British people found themselves cast as symbols or representatives of the very people Britain wanted to keep out of the country.

> The consequences of an immigration policy based officially on colour is not only cruelly arbitrary in operation (every coloured immigrant is a suspected evader) but disastrous for coloured people already in this country, a quarter of whom have already been born here. They become 'the sort of people we don't let in the country now', implying that they are here on sufferance and very much as second-class citizens.[38]

In the early 1960s, a tangible sense of Black-British cultural identity was still some years off. In part at least, one reason for this was that a great many Caribbean people had envisaged their sojourn in Britain lasting no more

than five years. As much as they might have grown up with a substantial sense of being British, and as much as they might have relished the prospect of life in the *Mother Country*, the intention of returning home after five fruitful years was common. Throughout the 1960s and well into the following decade, immigrants nursed a hope, an intention, of returning home as successful venturers whose subsequent homes and furnishings would bear ample evidence of access to an availability of consumer goods that were not yet a widespread feature of the Caribbean shopping experience.

Apocryphal tales among certain Caribbean families have persisted well into recent years, of this or that elder keeping a trunk in their bedroom, or elsewhere in their homes, in which was stashed cellophane-wrapped household goods and other consumer items that were to be taken back home when the day of departure finally arrived. At times a certain pathos, or a certain grim humour, would tinge such stories, as by the 1970s and 1980s relatively few Caribbean people or families had mustered the wherewithal or the means to return home permanently. Indeed, even some of those who did get it together to return home also found themselves the subject of apocryphal tales of them high-tailing it back to the relative certainties of life in Britain. Even before the middle of the 1960s, Caribbean migrants, having returned home, were said to be toing and froing, seeking an elusive sense of settlement. One such person was cited by Nancy Foner in her text on Jamaicans in Britain, published in 1977.

> Several people I interviewed in London had gone home to settle but returned. 'I went home in 1964,' one woman told me, 'but I get accustomed to life here. There is nothing to do there and things are so expensive. Besides, I have more freedom to do what I want [here in Britain].'[39]

It is with good reason that Ernest Cashmore wrote of the hopes of some Caribbean migrants returning home:

> They came to England, as did most migrants, hopeful in their expectation of improved social conditions and a better chance for their children. Whether planning to settle permanently in the new country, or remain temporarily with a view to a future return, enriched after a profitable adventure, the migrant looked to the new environment as a source of hope.[40]

As referenced earlier in this chapter, the reported experiences of Caribbean workers on the construction of the Panama Canal might have acted as a blueprint for this hope.

> Every ship that went back to Barbados or to Jamaica [from the building of the Panama Canal] carried with it some who had made what they considered a sufficient fortune. Every community possessed those who had gone to Panama with only the clothes on their backs, a small tin trunk, a dollar canvas steamer chair and, mayhap, a few chickens; and who had come back with savings enough to set them up for life. This fired dozens from each of these same communities with the desire to go and do likewise.[41]

Towards the end of his chapter dedicated to 'The Negro Workers', Haskins had claimed that the worker from the Caribbean who had saved his wages 'retires to be a nabob'.[42]

The process of coming to terms with the realisation that their sojourn in Britain might be somewhat longer than originally anticipated varied from one Caribbean migrant to another. For some, the taking on of mortgages put paid to the notion of a brisk departure. For others, raising families and having children in school likewise functioned as a process of staying put. Other factors existed, but perhaps one of the most poignant was that many Caribbean migrants struggled to become or remain economically viable, rendering as fanciful the very idea of returning home for good, with money in their pocket. As Trevor Carter reflected,

> By this time, [1968] however, most of us had faced up to the fact that we were here for good. The three, four and five years we had originally intended to stay were long gone. Our children and their future were here. Our struggles and commitments were here. And of course, for some of us, our mortgages were here and hardly likely to be charitably withdrawn should we pack up and go home.[43]

Even as early as 1952, a number of Caribbean immigrants were perceiving themselves as being in financially reduced circumstances, in which 'Some yearn to go back home, but they cannot save the passage money'.[44] The realisation among Caribbean migrants that they might be in for a longer stay

than anticipated clashed directly with their distinct hope of going home (or going 'Back a Yard', as reggae group In Crowd memorably framed it, in their hit of 1978)[45], to live – or at least, towards the end of their lives, to die and be buried. Not unexpectedly perhaps, caught between these pressures, Caribbean migrants were obliged to fashion for themselves a culture that took account of a potent cocktail of hopes and realities.

Though no end of hard times lay ahead, the late 1950s and 1960s represented difficult days for Caribbean migrants. On the one hand, 'tens of thousands of blacks arriving in the 1950s and 1960s met with disquieting receptions',[46] yet on the other hand there had not yet developed a common group identity rooted in Blackness or what might be called a pan-British-Caribbean consciousness. On this point, Ernest Cashmore noted that, 'mere blackness was insufficient to bring together the fragmented groups of West Indians in England'.[47] It should be remembered that for most St Lucians, their first substantial contact with Trinidadians occurred following migration. The same could be said of Guyanese people in relation to Jamaicans, Grenadians in relation to Bajans, Antiguans in relation to Dominicans, and so on. This maintaining of loyalty along specific lines of country of origin was referenced by Trevor Carter, who noted that, in Britain,

> Dozens of small organisations sprang up based on the island loyalty of those who had come here from various parts of the West Indies. Groups like the Trinidad and Tobago Association and similar organisations for people from Jamaica, Guyana, Dominica and Monserrat (*sic*) all attracted their members.'[48]

The lack of familiarity that Caribbean people from different islands had with each other, prior to coming to Britain, was put into particularly vivid terms in a text published in 1966, which quoted Sir Learie Constantine as saying, 'A West Indian from one island may be as much a stranger to his brother West Indian from another as a Geordie is to a Hungarian.'[49] Caribbean people were themselves acutely aware of notions of national difference, which had, in some respects, a particularly geographical application. For example, though Cuba was in so many ways the giant of the Caribbean, many people from Jamaica, the largest English-speaking of the Caribbean islands, referred to migrants from the range of countries in the

Lesser Antilles as 'small island' people.[50] While there existed, between the late 1950s and early 1960s, attempts to create a West Indies Federation, these attempts were not successful and it was within Britain that many Caribbean people had their first sustained contact with fellow migrants from other islands and countries of the region.[51] Furthermore, it was within Britain that many Caribbean people came to understand that they were, above all else, as far as the dominant society was concerned, *black*, or *negro*, or *coloured*, as much as they were *West Indian* or *immigrant*. Whatever other identities – individual or otherwise – such as country of origin, religion, political affiliation and so on that these migrants might possess counted for nothing in the minds of white Britons. Orville Bryon, a Trinidadian, reflected that,

> I thought that it was time to visit the so-called Mother Country known to us as England. I arrived here in 1960 and found, for the first time in my entire career, that I am a black man. This shocked me deeply because the impression we have in the West Indies is that we are welcome in England any time, since we are supposed to be Commonwealth citizens, how wrong we were.[52]

Though *shadism* or *colourism* (broadly defined as the diminished or elevated differentiation of individuals based on their perceived or apparent skin tone, leading to discriminatory pathologies and assumptions based on such colour or shade coding) was common in the Caribbean, even this ever-present signifier of difference amongst Caribbean migrants was not recognised by white Britons, who remained ignorant of its existence and manifestations. It may have been no bad thing that the Caribbean's *pigmentocracy* was something white Britons were not conscious of, but in the Caribbean itself, it was something few people, if any, were unaware of. While intra-communal manifestations of shadism existed amongst Black migrants themselves, the wider community was unaware of its existence, an ignorance that perturbed at least some migrants. In 1966, with pronounced exasperation, 'a West Indian housewife in Liverpool' protested "We are all lumped together as the same coloured person. It doesn't make any difference how light or dark [you are], or where you come from: you're still *coloured* to them." '[53] Caribbean migrants who had achieved and secured professional and academic qualifications set great

41

store by such things, but even such achievements were not enough to signify individual difference amongst Caribbean migrants, as far as white Britons were concerned. Furthermore, this perceived homogeneity carried with it a downward oriented designation of social status. 'Whatever their shade and whatever their achievements, Jamaicans in England tend to be viewed as lower class and inferior by most English people.'[54] As reported by Richard Hooper, 'This habit of "lumping together" overlooks... the vast differences amongst West Indians themselves.'[55] Thus migrants came to appreciate that their *assumed* identities, which often ran along country-specific delineations, had to compete with socially *assigned* identities, in this case, the somewhat non-differentiating label of *West Indian*. This reflected white British people's pathological inability to differentiate one Caribbean migrant's national background from another's, despite strong signifiers such as different accents and differing levels of elocution. These complications meant that it would fall to the children of these Caribbean migrants to fashion a political and cultural identity that would both undermine the *West Indian* designation and pretty much render as irrelevant the delineation of identity along the lines of the specific and individual countries of birth of their parents. As noted by Ernest Cashmore, 'Young West Indians saw themselves not as fractionated and culturally diverse but as one people, sharing similarities of backgrounds, of present circumstances and, more importantly, of future.'[56]

As first mentioned in one of the footnotes for the Preface to this book, in the late 1940s the Black population of Great Britain was 'estimated by both the Colonial Office and the League of Coloured Peoples at about 25,000, including students.'[57] Furthermore, this demographic was said by the same source to be 'distributed over the whole of Britain.'[58] Compared to other episodes of migration throughout history, or indeed, specifically throughout the twentieth or twenty-first centuries, this was, by any stretch of the imagination, a small number. A Black population of 25,000 represented a more or less insignificant percentage of the overall British population, which by 1950 numbered some 50 million. A great many of Britain's politicians and leaders have, over the course of many decades, sought to advance the view that controlling or limiting immigration is prerequisite to harmonious *race relations*, integration, and so on.[59] One such comment, embellished by other, somewhat troubling sentiments

quoted in the above footnote was Margaret Thatcher's comment in 1978 that 'if you want good race relations, you have got to allay peoples' fears on numbers.'[60]

But when Britain's Black population was at a paltry 25,000, including students,[61] these immigrants encountered pronounced hostility, discrimination, and out and out racism from a white population disinclined to readily accept Black people into their midst. At this time, 'the majority of the colonial coloured people of this country [were] Africans or West Indians'[62] and they faced what one sympathetic commentator called a 'distressingly simple'[63] problem, symptomatic of other equally formidable challenges. This was the problem of housing. Wrote Robert Kee, 'It is often extremely difficult for any coloured man – student or not – to find a furnished flat or room in England. Even the Colonial Office often has difficulty in placing a coloured man in lodgings.'[64] This point was subsequently reiterated when Kee stated baldly (regarding 'coloured workers' in towns and cities such as Wolverhampton and Birmingham), 'it is almost impossible to find accommodation for them.'[65]

Within just about a year of *Empire Windrush* docking at Tilbury, pronounced manifestations of discrimination against Caribbean migrants had pretty much become a persistent feature of British society and the towns and cities to which these migrants tended to gravitate. Having survived one winter, the migrants' experiences of discrimination became such a conspicuous feature of their presence that the *Picture Post* was able to trail, on a July 1949 front cover, a feature which baldly asked, 'Is There a British Colour Bar?'[66] The question was, of course, somewhat rhetorical. Accompanied by the characteristically perfectly composed and highly effective photojournalism of Bert Hardy, the six-page feature saw itself as conducting 'a survey into this dangerous and important question.'[67] Just over three years later, a similar feature in the same magazine (but this time with photographs by Charles Hewitt) again titled its feature with a question furtively alluding to the existence of prejudice amongst white British people: 'Breeding a Colour Bar?'[68] The first of these features, though seeking to be upbeat in its tone, contained a number of passages and sentiments that effectively captured the disappointment and significant difficulties experienced by Caribbean migrants from the then British Empire.

Figure 8: A group of West Indian men enjoying a game of snooker in a colonial hostel in Leaman Street, London. The photograph was taken for a feature by Robert Kee, 'Is There a British Colour Bar?' *Picture Post: Hulton's National Weekly*, 2 July 1949.

> The coloured worker arriving in this country with many illusions will find that he has not only to deal with a different labour situation from that which he anticipated, but also a threefold prejudice (social, in housing, and in employment).[69]

There was no getting away from the extent to which an ever more explicit dislike of Black people found popular and persistent expression in Britain. Migrants from the Caribbean had of course come from countries in which those with darker skins were regarded by the social elite as possessing certain, by and large unfavourable, characteristics, merely on account of the darkness of their skins. Similarly, those with lighter skins were assumed – by themselves as much as by others – to inherently possess all the favourable characteristics associated with privilege, leadership, status and good breeding. In Britain however, colour prejudice was of a largely different order.

> Dislike of coloured people is based, first of all, on the difference in colour of skin. According to the Oxford psychologist Dr Henri Tajfel: There are deeply rooted beliefs sanctified by

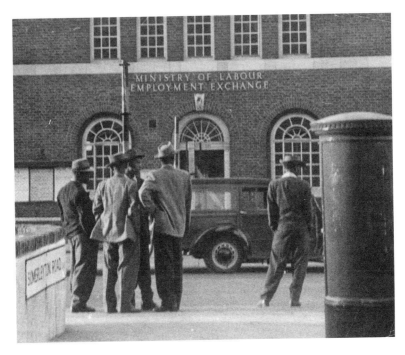

Figure 9: Men outside Brixton Labour Exchange, 1955.

> tradition and even built into the everyday language that 'black'
> goes with all sorts of personal characteristics ... lower intelli-
> gence ... prominence of sex in an individual's life, or a tendency
> to be violent'. To back up this feeling of 'black' equals 'inferior-
> ity' there are crude forms of racist theory.[70]

British-born or raised Black youngsters came to find that pathologies
of racism were readily assigned to them, just as much as they had been
assigned to their parents, by the dominant society. One might perhaps have
expected British-born Black people to be extended a notion of Britishness
that rendered skin colour irrelevant. In actuality, it was the very Britishness
of these youngsters that seemed to exacerbate a certain suspicion amongst
fellow white Britons. Equally as unfortunate, it was the Britishness of
Black-Britons that was accentuated by the people with whom they came
into contact, when they travelled abroad to countries of the Caribbean or

Africa. Finding themselves alienated at home on account of their Blackness, and regarded as 'English' in *Black* countries such as Jamaica, Black-Britons found themselves in a unique no-man's-land, in which they had to fashion for themselves a distinct cultural identity, with its own frames of reference. As Chris Mullard noted,

> There is no guarantee that we will be suddenly accepted in, say Jamaica, as Jamaicans. We will probably be considered oddities – black men who look West Indian but who speak with an English accent, who think like Englishmen, who live and dress like Englishmen, and who therefore cannot fully relate to their new environment.[71]

Mullard could have added, for good measure, that white Britons were also minded to regard Black Britons as oddities – black men who look West Indian but who speak with an English accent. Thus, it was not only hapless Caribbean migrants who found themselves disconnected from the countries of their upbringing. Their children also found that they could only occupy or visit countries such as those of the Caribbean, with a certain Britishness accompanying them, something that set them apart, even from family members in those countries. Thus, *Britishness* was always something that confused and complicated the identities of Black people with whom it was directly associated. In order to minimise confusion, one early magazine feature on Caribbean immigration sought to differentiate between white Britons and Commonwealth Britons, given that both sets of people were, technically and actually, *British*. A 1965 feature on 'Britain's coloured immigrants' in the *Listener* magazine carried the following note of clarification:

> The term 'white British' has to be used here because all our Commonwealth immigrants are British – a fact that is conveniently forgotten at times. The British Nationality Act (1949) reads "The expression 'British subject' and the expression 'Commonwealth citizen' shall have the same meaning."[72]

But Black-Britishness was then, and was to remain, a curious, unresolved and decidedly vexatious condition. Furthermore, the children of these Caribbean migrants were to inherit and retain a similarly unresolved form of Britishness, but were able, during the mid to late 1970s, for a period of

a decade or so, to fashion their Blackness and their Britishness into something dynamic, nuanced and layered.

The 'threefold prejudice (social, in housing, and in employment)'[73] referenced above carried consequences and repercussions that affected both first and second generation Caribbean peoples in Britain. Hooper's text discussed the ways in which, try as they might, the vast majority of Caribbean workers were viewed as unskilled, irrespective of what training, qualifications and experience they might have secured before coming to Britain. This directly led to a situation in which 'the skilled man is forced to earn his bread and butter by taking unskilled work.'[74] Again, directly, this had the result that, 'the stereotype of the coloured worker being unskilled is further reinforced in the minds of other workers, the public, and management, so that the next skilled coloured worker who comes along has even less chance.'[75] Furthermore,

> This bounces back not only on successive waves of immigrants from abroad but also, and this is more unfortunate, on successive generations born and educated in Britain. The new generation of coloured teenagers which is now coming up through our schools is in danger of being treated as unskilled second-class labour because of the stereotype. Already in Liverpool (which has a coloured population dating back at least two generations) there is evidence that the British-born school-leaver with a black face and a Liverpudlian accent does not get an equal chance when it comes to apprenticeships. When one considers that a quarter of the present coloured population is under school-leaving age, this could be an explosive issue.[76]

Hooper's comments were more prophetic than he possibly realised. In previous paragraphs, he had made mention of the 'vicious circle' in which Black migrants were trapped, as regards housing. The 'extreme difficulty' alluded to earlier, which characterised attempts by 'any coloured man – student or not – to find a furnished flat or room in England' was replicated in the related realm of home ownership. Again, there were to be consequences and repercussions that affected both first and second generation Caribbean peoples in Britain.

> Having been refused a room by the local people, [the immigrant] is forced to buy a house. But finding a house is not easy. Middle-class areas strongly resist any 'invasion' of coloured people, and estate agents, the immigrants believe, back up

this resistance. 'I went to an estate agent', said a West Indian in Birmingham, 'who told me I couldn't get a house in a certain area like Hall Green or Acock's Green. They directed me to Balsall Heath and places like that'. So the coloured man is forced to go to a run-down area of the town and buy there.[77]

Hooper then went on to mention the difficulties of immigrants accessing mortgages, and when they were able to secure mortgages, these were often at extraordinarily less favourable rates than those offered to white Britons. In a great number of instances, and as a direct consequence of intractable discrimination, properties that Caribbean migrants could obtain were subject to multiple occupancy.

But the moment [the immigrant] overcrowds his house like this, the local white people's resentment burns even more strongly, and they now, in their turn, the wheel having come full circle, dislike even more vehemently having coloured people in their houses or buying up property in their street.[78]

In his book, *Black Britain*, Chris Mullard outlined something of the challenges Black people faced in both renting and buying property. In the rental sector, 'Discrimination in housing operated at three levels: local authority, individual landlord, and at the level where landlords would accept black tenants – but only at a price.'[79] Echoing Hooper's findings of seven or so years earlier, Mullard continued,

A further iniquity existed in the private sector, namely discrimination by estate agents. Here many estate agents, some acting on clients' instructions, some not, refused to sell houses to black buyers in certain 'middle class' areas. The argument went that house prices would fall if blacks bought property in desirable residential areas, that blacks were dirty, likely to let the houses go to ruin, and that they would fill them with other black people…

This forced blacks to consider buying property only in areas which estate agents recommended, namely those areas where other blacks lived – the slums.[80]

In time, in a profound and audacious manner, second generation Black youngsters would seek to reimagine these economically and socially

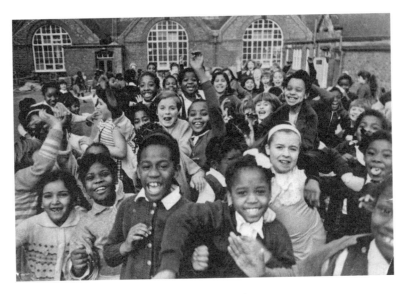

Figure 10: School children, Birmingham, November 1965.

disadvantaged *ghetto* spaces (which tended to be under-resourced and over-policed) as counter-cultural zones of resistance and positive affirmation of identity. In the words of Trevor Carter, 'Communities which had been grim ghettoes in the fifties grew into powerful political and cultural symbols for the black population.'[81]

By the mid to late 1970s, it could be said that those born to parents who were Caribbean immigrants were 'now in the process of emerging as Black Britons, rather than as "second generation immigrants".'[82] This point is of incalculable importance in this book's narrative, because it would, in almost all senses, fall to British-born and raised Black people to undertake or decisively continue the process of nation-within-a-nation building.

> The 1971 census showed that a much greater proportion of our community was under 25 years old than in the population as a whole or than in other 'immigrant' groups. Over half our community was under fifteen: more than double the national figure.[83]

49

Nearly a decade earlier, another researcher had couched this information in equally stark terms. 'In 1951 there were 15,300 West Indians in Britain, but two decades later 446,200 people of West Indian origin lived here, of whom 226,800 were born in the United Kingdom (Lomas 1973, p. 39).'[84]

2

Towards the Black 70s

While the arrival of the *Windrush* signalled the beginning of a relatively brief but nevertheless pronounced period of Caribbean migration, Black people's experiences in Britain have consistently been characterised by either being denied the possibilities of unbridled integration, or being perceived by white Britons as being temporary residents. It was to be a generation before this British certainty of the Black presence being little more than a temporary one was emphatically overturned, and this through the emergence of a generation of Black people, British by birth.

Negroes in Britain, a book written in 1947 and published the following year, included the following summary of the Black presence, as it was constituted in the aftermath of World War II.

> In addition to the several thousands of West Africans, West Indians, Arabs, Indians, Chinese, etc., who, as seamen, have made permanent or temporary homes in the ports, other coloured 'immigrants' into Great Britain comprise several hundreds of university students, a number of professional people, doctors and lawyers from various 'coloured' countries of the Empire; numbers of men and women, mostly from the West Indies, in various branches of the entertainment industry; and

51

others fulfilling private or miscellaneous roles in a variety of occupations from wardens of hostels to racecourse touts. During the Second World War, the total was substantially increased by the arrival of over one thousand technical and skilled workers from the Colonies to work mainly in British ordnance and aircraft factories. In addition, several hundreds of foresters from British Honduras worked in camps in Scotland and northern England.[1]

As cognisant of British culture as many of these people may have been, the British reply to this familiarity was an explicit and unashamed manifestation of racism and prejudice, as outlined in parts of the previous chapter. Little's study noted that

> English people in buses or trains will get up and move to other seats if a coloured person sits next to them; very often a coloured person searching for lodgings will find the door slammed in his face. There are hotels, dance halls, and restaurants who will refuse him admittance.[2]

In so many ways, these experiences of being bluntly and unceremoniously denied service was reflective of the Jim Crow manifestation of segregation, concurrently being enforced across much of the Southern parts of the United States. Discrimination was to remain a systemic experience of Black Britons, though Black youngsters of the 1970s were to take the discrimination faced by their generation and boldly use it as an expression of their cultural identity. With assimilation long since abandoned as a hopeless prospect, there was perhaps a certain inevitability of a separate and distinct cultural identity being fostered by Black Britain. This shift towards the defiant creation of a 'Black' identity amongst Black youth in Britain was widely observed. Writing in 1979, Len Garrison stated that he believed, 'we are observing in Britain among black youths... a reaction against assimilation and a shift towards separation.'[3]

In seeking to identify the route to cultural autonomy taken by Black Britain, it becomes apparent that pretty much every group experience of Caribbean migrants propelled them away from, rather than drew them towards, a general British cultural identity. In addition to the factors referenced in Chapter 1, it must be acknowledged that the types of white Britons

the immigrants were exposed to in Britain uncoupled, within the minds of migrants, the hitherto presumed linkage between whiteness and the loftiest ideals of culture. One researcher into the experiences of Jamaicans at home and in Britain claimed it to be

> true… that most [Jamaican] villagers had an unquestioning acceptance of the superiority of white skin. This white bias was reinforced by the fact that the few whites with whom they had contact – estate owners, ministers of religion, doctors, and lawyers – they met in a dependent and subordinate position. And most of these whites conformed to the villagers' stereotype: they were well off, maintained a middle class or upper-class life style, and either were English or had acquired English culture [leading villagers] to believe in the superiority of white skin and white (European) culture.[4]

In contrast, the whites that Caribbean migrants encountered in Britain were of altogether more modest, working class stock, with lives characterised by lack of finances and lack of opportunities for social and economic advancement. Apocryphal tales abounded among Caribbean migrants about the shock of encountering white Britons as baggage handlers at sea terminals or railway stations, and as dustbin men and street sweepers in Britain's town and cities. In the Caribbean, such labour was the preserve of those with darker skins, while those with white skins assigned to themselves the tasks of leadership.

Trevor Carter couched this rude awakening in the following terms.

> The vast majority of white people with whom we had contact in the West Indies were part of the ruling class. Our teachers, our employers, our political and economic controllers, all represented Britain and had given us virtually the only picture of Britain and the British we had.
>
> The first shock when we arrived was to see white men working as dockers and porters. We didn't expect white people to be doing those kinds of jobs or providing a service for black people. Yet there they were, not only willing to carry our suitcase, but also waiting for a tip.
>
> A friend who landed in Liverpool remembers the first shock of seeing white people scrubbing floors: 'I had never seen them

work before.' One of the first images which jolted me soon after arriving was the sight of the red, raw and swollen hands of char-ladies: I had been so strongly conditioned to equate white skin with beauty that I was shocked. Not only were we surprised to find a white working class, but astonished to see anything which did not conform to the picture of well-being and advanced civi-lisation with which we had grown up.[5]

Caribbean migrants were far from impressed with what they frequently regarded as poor or non-existent standards of hygiene amongst the white Britons with whom they came into contact. In food shops, in the work place, and elsewhere, migrants were often appalled at what they witnessed, regarding the handling, preparing and consuming of food. The idea of eat-ing fish and chips out of newspaper was the sort of thing that bemused these migrants. At a time when the average white working-class man appeared to have only one suit – the one in which he was married being the one in which he was buried – Caribbean men, even the ones who could seemingly ill afford a wardrobe full of snappy clothes, distinguished them-selves as sharp and stylish dressers, compared to their white compatriots. Thus Caribbean migrants rapidly found themselves being disabused of any pretence they might have had that British culture was inherently refined and lofty. This in turn led Black immigrants to reconsider their cultural identity and the ways in which this might now manifest itself in Britain. With the supposed inherent loftiness of white culture being exposed as a sham, and white British working-class culture being rather too uncouth for the likes of most Caribbean immigrants, it fell to these migrants to fash-ion new cultural identities, a process continued or accelerated, in dramatic fashion, by their offspring.

> Much of the mystique of whiteness to Jamaicans has in fact been undermined in England. Because Jamaicans face such widespread discrimination in England and because white skin is no longer necessarily linked with other attributes of status and power, Jamaican migrants are not so awed by whiteness in England. While the whites encountered in Jamaica were usu-ally in positions of prestige and authority, in England they are nearly all members of the working class. Indeed, judging by the migrants' former criteria, English working-class whites do not

merit deference... they have, beside their skin colour, none of the characteristics (wealth, good jobs, education, or cultural traits) which deserve respect.[6]

This point is of enormous importance to this book's narratives because Caribbean migrants' apparent disillusion with whiteness, this disappointment resulting from the discovery that something like whiteness was not as good as migrants had previously believed it to be, led to a certain Black consciousness. 'And because they receive unequal treatment on the basis of their skin colour, a good number are, for the first time, seriously questioning and challenging the inferiority of blackness.'[7]

Apart from having to rapidly come to terms with the process of re-evaluating the complexities of white British culture and its possible unsuitability, Caribbean migrants also had to contend with the process of moving from rural spaces in their home countries, to decidedly urban spaces in Britain. Very much at home within rural Caribbean spaces, these migrants had to fashion for themselves lives overwhelmingly characterised by the built, urban environment, the *concrete jungle*, when they settled in Britain. Not only that, but they also had to come to terms with the added complication of the British countryside being an actual and notional space from which they as Black people were to be excluded. Frankly, whatever views of the English countryside they saw on their journeys by road or rail into towns and cities from the sea terminals at which they disembarked, was as close as Caribbean migrants tended to get to the countryside. Henceforth, Caribbean migrants were obliged, as mentioned, to come to terms with the realisation that the urban space – and a certain racialised quarantining within those urban spaces – would be a feature of their presence within Britain.

> The train journey from Plymouth to Paddington was remarkable for the sight of the English countryside with its well ordered and laid out farms. The vast majority of us never saw the countryside again for years, as our lives were to be trapped in the inner-city areas.'[8]

The perpetual exclusion of Black people from the British landscape continued to be a characteristic of their general presence in Britain, and it remains so to the present day. This matters because the soul, the heart of the British

nation is frequently perceived (and indeed, has been illustrated through the extensive genre of English landscape painting, particularly of the eighteenth and nineteenth centuries) as residing within its wide, open countryside spaces. According to this mindset, the modern city was an anomaly that did little or nothing to affirm the nation's identity, being too *urban*, too *mixed*, too *modern* to suit the purpose of notional and national belonging and identity. The countryside, on the other hand, generated readings and meanings suggestive of the 'green and pleasant land' evoked by William Blake in his short poem written in the early nineteenth century, 'And did those feet in ancient time'. Such emotive references lay at the heart of the British people's self-image and were, apparently the very essence of Englishness. It was a vision of Englishness from which Black people were excluded.

One other important dimension of Black people's virtual exclusion from the countryside was the holidaying factor. Black Britons continue to avoid taking holidays in beautiful rural parts of Britain such as Devon and Cornwall, the Scottish Borders or Highlands, the Peak District or the Lake District. An obvious concern was not wanting to encounter additional racism, or venture into spaces that represented a fear of being conspicuous, in ways over and above such challenges in the urban spaces they routinely occupied. This *fear* was by no means irrational. Certain adverse mannerisms tended to dominate white people's encountering of a Black person, or Black people, in spaces Black people were not *expected* to occupy. Remaining in inner city areas, or travelling to respective home countries for holidays, sometimes meant – however superficially – taking one's place alongside people of a similar skin colour. Sokari Douglas Camp made mention of the contrast between returning to the area of Nigeria in which she was born, and the sorts of hurtful experiences Black people were susceptible to when they ventured into the British countryside.

> What is wonderful about being [in Nigeria] is that you don't stick out. You can go to any event and there's a sea of black people and you just become part of a big crowd. Wherever I go here, I stand out. And it's not just a feeling; it's real. Well, I mean, you can be running in the countryside [...] and the countryside is lovely because there are all these beautiful walks and things and I run out of the bushes and there's some poor white couple and they get such a look of fear on their face and you think, I'm sure

if I was a white person running they'd just say hello. But because I'm a black person they go, 'Oh, shock'. And that's a drag [...] because fancy just being a shock. That doesn't tell you anything about a person. [...][9]

Though they were often viewed and treated as tourists when they returned to the countries of their birth,[10] Caribbean migrants preferred to spend their holidays visiting relatives back home. Furthermore, these migrants preferred to spend their money on such overseas trips, rather than on holidays in Britain, or indeed holidays in Europe. For some, it was only under exceptional circumstances such as bereavement or the unexpected serious sickness of a loved one that monies could be found for emergency travel to Jamaica, Barbados, or wherever. Day trips to British seaside resorts aside, precious few Black people were minded to take the sorts of traditional holidays that many economically stable white Britons now availed themselves of. This staying put brought up a hitherto unmentioned class dimension. Irrespective of colour, working-class people of modest means tended to occupy the city in week-in-week-out, month-in-month-out ways, seldom venturing beyond clearly demarcated zones. It was within these zones that particular cultural formations germinated and were inculcated.

By the mid to late 1970s, the political and cultural manifestations of the Black presence in Britain was beginning to undergo seismic shifts, reflecting the transition from 'West Indian', to 'Afro Caribbean' to 'Black-British'. Though some might take issue with the claim about a commonality of presumed identities, there was much within this passage from Mike Phillips and Trevor Phillips with which to concur.

Caribbean migrants became black people during the decade of the sixties, and by the end of the seventies we had begun to share the same assumptions about our national status as our white compatriots. That is to say, we became black Britons. This was a fundamental change, driven by the generations who had arrived as children, or had been born in Britain. In later years it became conventional wisdom to describe this as a kind of generation gap, as if the experience had effected a complete separation between older and younger migrants in their understanding of British society and their response to their environment.[11]

Reflective perhaps of their somewhat tenuous hold on British citizenship, immigrants from the Caribbean overwhelmingly self-identified as *West Indian*. Simultaneously, the label of *West Indian* was also an imposed one, and this perennial need to use history's most sizeable misnomer as a descriptive of British-born Black people was something that continued well into the 1980s.[12]

A major feature in an *Observer* magazine of late 1971 reflected the extent to which Britain's Black communities were, in the 1970s, in both transition and turmoil.[13] Reporting on the draconian immigration controls that restricted Caribbean immigration, even as it demonised those already here and even more alarmingly perhaps, those born here to Caribbean parents, the feature reported that:

> West Indian immigration has now been almost stopped: fewer than 300 voucher-holders were admitted last year. West Indians see these controls as a form of rejection, of betrayal. Unlike the Asian immigrations, West Indians did not come to this country simply for economic reasons. They came because their passports were British and because they had been taught in school that Britain was their mother country, and their history was part of hers.[14]

The feature continued

> But those who expected a warm welcome from the British were soon disillusioned. So were those who hoped for good jobs. Compared with the rest of the working population, a disproportionate number of them are labourers...[15]

Indicative of their particularly shabby treatment in the labour market, the text reported that 'in 1968 and 1969 more than twice as many West Indians left Britain for Canada alone as were admitted to Britain for work.'[16]

The label and self-identification of Caribbean immigrants as *West Indian* was arguably not as problematic as the telling assigning by British society of the term *West Indian* to the British-born and British-raised children of these immigrants. As mentioned the use of the term *West Indian* to describe Black-British youngsters continued well into the 1980s, further emphasising a considerable fissure between Blackness and Britishness. Black Britons bridled against the constraining and alienating designation

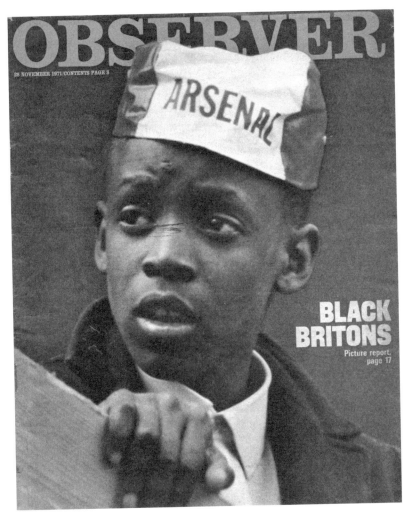

Figure 11: London, a young West Indian Arsenal supporter cover of the *Observer* magazine, 28 November 1971.

of themselves as *West Indian* and it was in this context that the term *Afro-Caribbean* gained both currency and favour as the 1970s progressed. At every turn, Caribbean migrants and their British-born or raised children were in perpetual danger of being shortchanged by the range of labels seemingly created with the intention of keeping them at a distance from

British society. *Immigrants* was a term that was freely applied to those coming in from the Caribbean, even though many were technically and actually *British*, on account of their upbringing, the passports they held, and so on. And while no end of white immigrant groups could, and indeed did, shed the immigrant label within a relatively short space of time, it was a label that black-skinned Britons found very difficult to shake off.

It was as if the designation of the label immigrant would perpetually roll down through the generations, retaining its problematic and primary associations with *race*, rather than being a disinterested term relating to international movement. As one commentator, Gordon Lewis, noted, 'The black immigrant comes to feel less like a West Indian in English society and more like a black man in a white society.'[17] Further, as Nancy Foner put it, 'in the eyes of most English people, Jamaicans, as black people, are all one.'[18] In this respect, unsuspecting immigrants, mistakenly believing themselves to be arriving as *British*, found a somewhat blunt notion of blackness foisted upon them by a host population disinclined to be mindful of such factors as individual identity. These migrants were obliged to come to terms with the process of suddenly finding themselves black in ways that they were not expecting. In some senses, their children would, in due course, be obliged to go through a very similar process. Bridling against the term *immigrant* led Tabby Cat Kelly to protest, in his British reggae release of 1979, 'Don't Call Us Immigrants' (written by T. Kelly, Arawak Records, produced by Dennis Bovell). The song had the potential to stake a claim on Britishness, but such was Black Britain's tenuous hold on citizenship and a sense of belonging that the song declared 'Nuh call us no immigrants. We are West Indian.'

The other term that pointed towards a formidably constraining pathology of dismissal of Black Britons was 'ethnic minority'. Such is the hegemony of the term that its use continues, albeit in the altered and somewhat curious form of 'Black and Minority Ethnic' – or BME for short. 'Ethnic Minority' might no longer be in widespread use in the lingo of race relations and government bureaucracy, but its inversion, Minority Ethnic, is. The designation of Black people as an ethnic minority reflected an insistent strategy of *othering* Black-British people when to all intents and purposes they shared an almost infinite number of commonalities with their white neighbours. A sense of the partiality of the term 'ethnic minority' is reflected in the

rather conspicuous ways in which it is not applied to the whites of South Africa, even though, by almost any criterion, the term fits them particularly well. In reality, 'ethnic minority' was and remains a signifier of Black people, rather more than it might be an indication of a numeric proportion. Being compelled to come to terms with the blanket assignation of 'ethnic minority' was something of a jolt for Caribbean migrants who, despite the formidable economic and social difficulties they faced in the countries of their birth, grew up as part of an overwhelming ethnic majority. As Nancy Foner noted, 'While migrants and descendants of recent migrants made up the majority of the Jamaican population in the nineteenth century, Jamaicans and other newcomers are a very small minority in present-day England.'[19] Hence, Caribbean migrants went from being a majority to being a minority, and from being a minority, to being an ethnic minority.

Making mention of several studies into the difficulties that many Black children were having within the British school system, the *Observer* magazine feature noted,

> These studies highlight the difficulties faced by all West Indian children born or brought up in this country. Their parents found it difficult enough being both West Indian and British: the children have to learn a completely new identity, as 'black British'. They are not being integrated into British society, in the sense of becoming indistinguishable from all its members (a definition used by Enoch Powell).
>
> They cannot be 'assimilated', in the physical sense, and many of them do not want to be in the cultural sense. Unlike their parents, many of the second generation are turning away from British culture and are identifying with the militant American blacks, or with their own cultural roots in West Africa.[20]

Much has been written about the failures and inadequacies of British education's treatment of Black children. In the context of this book it is perhaps sufficient to note Nancy Foner's view that, 'Young blacks will probably be more disappointed with the English educational system than their parents have been.'[21] But it was her following sentence that identified the nub of what this book seeks to chronicle. Although Foner mentions the somewhat curious entity of 'British-born Jamaicans', her comments were, in all other respects, both prescient and apposite. 'British-born Jamaicans,

moreover, cannot look forward to a return home, because they *are* home. Neither Jamaican nor fully English, they often look to their blackness as a basis for identification.'[22] [Italicised emphasis in original text]. As mentioned in the Preface to this book, many Black Britons, finding the home or nation into which they were born not fit for purpose, imaginatively aspired to an altogether different Promised Land – the mythical Rastafarian homeland of Africa, and Ethiopia in particular.[23] Time and again, in texts produced in the mid to late 1970s, mention was made of the fascinating ways young Black Britons were turning to their Blackness as a means of making sense of their place in Britain and fashioning a collective sense of cultural identity. In this regard, Foner, in her text, quoted Gus John's comments.

> Certain characteristics and behaviour symbolise their identity as British-born blacks. Gus John (1972:82) writes, for example, that 'Black power [...] the growth of a distinctively black youth culture, all form the framework within which the black youth works out his stance to this society.'[24]

Surprisingly perhaps, in following the Garveyite admonition to look to Africa, young Black Britons were in some respects taking their cue from a strategy of reorienting notional citizenship, as developed and practiced by some of their parents' generation. By adopting the belief that a better existence, and a more settled and happy life, would not be forthcoming in Britain on account of the prevalence of discrimination (and that only through physical relocation to a better territory would people facilitate progress), both generations were to some extent enacting the same strategy, albeit with dramatically different spaces of *return* in mind.

> Because they are black, migrants and their children are often frustrated and disappointed by life in England. Some (especially men who have experienced a decline in their occupational status) react to their plight by defining their stay as a temporary one. The homeward orientation seems to shield migrants from some of the stings of racial prejudice: if England is not their real home, then they can more easily endure discrimination.[25]

The condition of Black Britain in the 1970s was sometimes caricatured as one that reflected some sort of 'identity crisis' brought about by the

peculiarities of their position within (yet simultaneously beyond) British society. Len Garrison was one of those who suggested that, *en masse*, Black youth in Britain were suffering from, or at least experiencing, a crisis of identity. Indeed, he centred his major research on this notion in the form of his book, *Black Youth, Rastafarianism, and the Identity Crisis in Britain*. In some ways, Black-British identity signified *non-whiteness* – a general state of exclusion, as much as it signified a positive clear alternative identity. It was, though, a perceived schism with the lifestyles, aspirations and sensibilities of the immigrant generation that, in part, informed this notion of an identity crisis. Others took the view that a straddling of two worlds informed the experiences of both generations.

> Born in Britain, young blacks have had, and will probably continue to have, very different life experiences than their parents. But they will not, however, become identical to Englishmen and women either. Like their parents, they straddle two worlds: the world of their parents, or first-generation migrants, and the world of English people.[26]

What made Black-British cultural expression such a unique and compelling component of the African Diaspora was the sense of *creolisation*, the process wherein distinct elements of white British culture made their way into a pronounced manifestation of Blackness, resulting in a new and distinct culture that owed its existence to a fascinating assortment of factors and considerations. Whilst Black youth have traditionally lacked structured spaces in which they could congregate, there were, in the mid 1970s, certain youth clubs that offered such a function. It was within such spaces, and other environments, that this creolisation, this hybridity, was able to germinate and flourish.

> Youth clubs have become important meeting places for blacks in their late teens, and a youth dialect has emerged, a kind of generalized West Indian English, which is not attributable to any single island but which has numerous Jamaican and Cockney elements.[27]

Though this was clearly something of a London-centric observation, it certainly held true that similar processes were taking place across Britain, in the major centres of Black settlement. Importantly, this was a process in

which both generations – immigrants and their offspring – played a variety of parts. 'The move to England has, for the first generation of Jamaican migrants, led to the emergence of new cultural and social patterns – a kind of creolisation process, as it were.'[28]

Although an inevitability of travel and a particular embrace of the international arena lay at the heart of many Caribbean people's view of themselves, they were perhaps ill prepared for the extent to which moving from their homes in countries such as Barbados, Jamaica and Trinidad to Britain was a fundamental act of displacement, even though many institutions in such countries were modelled on their British equivalents. There were particular certainties that characterised life and culture in the Caribbean, such as the importance of family ties, a sense of community, and a certainty of belonging. European industrial societies, in contrast, were characterised to a large extent by a somewhat atomised existence, in which family ties were being loosened and neighbourhoods were being transformed from settled, stable communities into spaces in which people might not even know their neighbours' names. In this regard, and in the light of other formidable challenges,[29] seamless assimilation into British culture was simply not a viable option. The aforementioned process of creolisation well and truly beckoned.

> Britain, like other industrial societies, is, moreover, quite heterogeneous, stratified, and pluralistic so that there is not always one set of institutions into which Jamaicans may assimilate. And even if we find similar behaviour patterns, for example, among Jamaican migrants and certain English people, this is not necessarily an indication of assimilation, in the sense of absorbing the new ways and values. Rather, these behaviour patterns may be independent responses to similar social and/or economic conditions which Jamaicans and English people face.[30]

Several sociologists, including Ken Pryce and Len Garrison, keenly observed the coming of age of the children of Caribbean migrants. In 1979, Garrison, a researcher into the impact of Rastafari on Black-British youth, wrote, 'a watershed has been reached in the process of self-discovery for the Black youths in Britain.'[31] Much of this 'process of self-discovery' was to manifest itself in the work of Black-British artists across a number of disciplines.

Pryce and Garrison were both Caribbean-born sociologists who wrote from positions of affinity, sympathy and respect. Within their respective research, they were by and large expressing the view that this new generation of Black people in Britain were very much at odds with the wider society around them. Garrison argued that these youths took refuge in Rastafari, a subject discussed in the following chapter. Pryce concurred, but supplemented Rastafari with delinquent lifestyles. The dominant framing of Black-British youngsters of the mid 1970s was as confused, conflicted individuals with, to varying degrees, an identity crisis, a propensity to delinquency, or a parlous state of occupying two worlds. Such generalisations persisted way beyond the shelf life of Pryce's and Garrison's research publications, and did little to aid the understanding of young Black people beyond the increasingly accepted wisdom that they had significant problems and *were* in turn significant problems. This issue of being framed as both reflecting and being problems was, as mentioned in Chapter 1, something the pioneering generation of Caribbean migrants had experienced.[32]

As disconcerting to the establishment as Pryce's and Garrison's views were, they were nonetheless sympathetically embraced by journalists, researchers, writers and others who saw such views as constituting a convincing template for understanding young Black Britain. Although Pryce and Garrison made many important and valid observations, their 'findings' took on an emphatic totality that quickly became the main terms of reference for young Black-British people. In so doing, a persistent stereotype (and an inflexible reading of Black-British identity) was born. Regarding the findings of sociologists such as Pryce and Garrison as so much guff, Rasheed Araeen commented, 'If there is no sense of belonging to Western/white culture among many black people, its main explanation will be found in the reality they face daily rather than in the pseudo-scientific uprootment and alienation.'[33] The lead article in the *Observer Review* of Sunday 5 September 1976, titled 'Young Bitter and Black', written by distinguished African-American journalist William Raspberry, sought to explore the position of alienation, anger and despair that the new generation of Black (male) youth was already said to embody. The piece was introduced as 'The *Observer* invited William Raspberry, the *Washington Post*'s black columnist, to investigate Britain's racial problems. In this first report he looks behind

the Notting Hill violence at the deeper causes of the hostility between the police and the West Indian community.' His fascinating feature concluded with the terse, pithy, and dispiriting sentiment: 'England isn't home.'[34] A distillation of Raspberry's feature appeared in a Black US college newsletter later that year and included such unvarnished sentiments as

> Most alienated of all within The 'colored' population are the youth. Unlike their parents who revel in a relatively comfortable nest inside the 'Mother Country,' the youth feel what Michael King, a West Indian, feels. Too much racialism, too little opportunity for Black people, too little chance to be a self-respecting person with ones racial and cultural ties intact.[35]

There were several other such mainstream newspaper and magazine features during the 1970s, including a major *Sunday Times magazine* feature from 30 September 1973, 'On the Edge of the Ghetto: The Way They See It'. Written by Peter Gillman, and illustrated with the striking photographs of Colin Jones, the two-part article was trailed on the magazine's Contents page as '"I Blame England": the plight of alienated Black teenagers in London, and their attitude to their environment' and '"I don't want to go back": the other side of the coin – young blacks talk of their attempts to make a living in Britain.'[36] The piece included choice quotes such as one offered by a young man named Beckford: 'I never used to hate white people. I still don't hate all of them. But it's them who teach me how to hate.'[37]

The process and experience of immigration as it affected the immigrants themselves, and subsequently their children, is central to understanding why a distinctly 'Black' identity (based largely on the notion and the experience of alienation) was such an important ingredient in the Black-British creativity that emerged in the early 1980s. The idea that Black people were aliens in this country became the ideological cornerstone of young Black-British cultural identity and expression in the late 1970s and early 1980s. The palpable sense of differentness in which Black Britain was being inculcated was being matched by an equally formidable pressure and pathology: pretty much all aspects of British cultural industries regarded the creative contributions of Black Britons as having little or no place in mainstream cultural expressions. From the fine arts to literature and poetry, from radio and television to theatre, the attitude of the

art establishment towards Black people and Black artists had come to be one of indifference and dismissal, punctuated by occasional limited interest centred on questionable and tokenistic offerings.

A measure of mainstream cultural industries' scorn and indifference to Britain's Black people was the perennial presence, on the BBC, of *The Black and White Minstrel Show*, a supposedly light entertainment show that ran on BBC television from 1958, by which time Britain's Caribbean population was growing significantly, to 1978, by which time the children of these immigrants had started to come of age. It is difficult to imagine anything more racially offensive than blackface, with its history that stretches back to the days of the lynching of Black men, women and children in the USA, Jim Crow segregation, and racist caricaturing. And yet the BBC, the self-regarding, national barometer of liberalism, resisted all protestations against *The Black and White Minstrel Show* and continued with this offensive and humiliating parody of Black people and African-American culture for two decades.[38]

At no time in the history of television had there ever been an appropriate time to broadcast such a show, in Britain or anywhere else in the world. Yet, as Stephen Bourne noted,

> Blackface minstrels looked old-fashioned and outdated, especially with the rise in popularity in Britain of glamorous black entertainers like Trinidad's Winifred Atwell and America's Harry Belafonte. By the late 1950s it should have been impossible for a blackface minstrel show to find an audience on national television, but nothing could be further from the truth, for that is exactly what happened… *The Black and White Minstrel Show* was an instant hit, and ran for twenty years.[39]

Regarding the aforementioned protestations, Bourne commented, 'though popular with viewers, complaints about the new version of *The Black and White Minstrel Show* started almost as soon as it began.'[40] Continued Bourne,

> [T]he black British magazine *Flamingo* responded by dismissing the series as 'a piece of outdated and degrading rubbish', The article also quoted several black commentators including the Trinidadian theatrical agent Pearl Connor. She complained,

'white performers with black faces look ridiculous and make me feel ashamed'. In the same article, Lloyd Squires, a black businessman from Brixton said, 'I feel ashamed and disgusted... Some friends have told me they switch off the moment the show starts.'[41]

The rarity with which Black people appeared on British television during the 1960s and 1970s was such that should a Black person be spotted on the television within a Black household, members of the household not in the room in which the television was located would be alerted and would make haste in hopes of catching sight of the novel spectacle. As Lloyd Bradley recalled, writing about London *circa* 1970: '[R]emember, at this point in time, if you saw a black face on television you'd shout for the rest of your family to rush to the living room.'[42] The presence in Britain of talented arts professionals with African backgrounds, in a range of fields, had a history stretching back several centuries. Furthermore, cultural activists in Britain had long since been agitating for greater and fairer representation on stage, on screen, on the radio, in print, and in galleries and museums. These initiatives met with little to no success, creating a *de facto* schism between British arts and culture and Black arts and culture. This schism led to a strengthening and further inculcating a distinct and separate Black-British cultural identity.

Though Black people watched as much television as anyone else, and though, by the later part of the twentieth century, it was a medium that dominated people's lives like no media before it, television played little to no part in Black people's sense of their own cultural identity. The only exception to this was the screening on British television, in the 1970s, of the US series *Roots*, in which the saga of slavery was presented as a critical component of the tracing by writer and journalist Alex Haley of his family tree. Caribbean migrants were, very simply, comprehensively excluded from television, apart from problematic news reports, bit parts, and that which framed them as entertainers and sportspeople.[43] Until the late 1970s, British television executives were excruciatingly timid about the prospect of Black people having anything other than an occasional and token presence. And when Black Britons were on television, it tended to be in roles and in programmes that were either ham-fisted or out and out embarrassing. Having been failed by television, Black Britons' cultural affirmation

was instead rooted in expressions such as poetry, music, the visual and performing arts and so on, though broadly speaking such expressions were grounded in structures of separate development.

Ultimately, establishment and societal racism prevented Black people, including artists and performers, from taking a central and continual place in the wider scheme of things. The 1970s, however, remained a critical decade in the mixed fortunes of Black Britons. While a number of immigrants decided (for various reasons) to return 'home' or move on to the United States or Canada,[44] the children of these immigrants were born into the highly charged situation in which they were, in many respects, emphatically 'British' (as opposed to their parents, whose identity never really ceased being 'West Indian', or even more specifically, Jamaican, Guyanese, Trinidadian, Bajan, and so on). But second-generation Caribbean youth were not 'British' in entirely the same ways that their white counterparts were. As mentioned, Black youth were British primarily insofar as they were technically born in Britain and therefore were given a British birth certificate and, in later years, had access to a British passport. They knew no other 'home' and therefore were (for the most part) unable to participate in the process of *onward/return migration* that their parents were able to undertake. Chapter 1 describes the degree to which, even before the mid 1960s, Caribbean migrants were said to be toing and froing across the Atlantic, seeking an elusive sense of settlement. By the late 1970s this process of continued migration had become a feature of Black life. It pointed, however, not only to the continued search for a zone of settlement and prosperity but, more importantly, to the development of a somewhat peripatetic existence for a number of Black people. This constant process of upheaval, relocation and movement became, for some people, a state of being with its own parameters and terms of existence.[45] Furthermore it was an accepted state of being that tended to discourage anything other than the most international and least parochial of world views or senses of identity.

The hindrance to British-born Black people to primarily identify themselves as 'British' has been a direct consequence of historical and contemporary experiences of racism, which permeated every facet of the existence of British-born Black people (as had frequently been the experience of their parents). The principal areas in which this discrimination

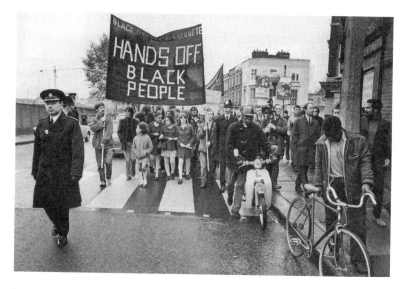

Figure 12: A demonstration in Notting Hill protesting against the harassment of Black people, organised by the Black Defence Committee, 31 October 1970.

operated were the school and education system, the police, the judiciary, healthcare, employment and housing. One particular sentence in a report by a mid 1970s researcher into Jamaicans in Britain stated, rather bluntly, 'Young blacks find it difficult to get the type of jobs they want and they are often victimised by the police.'[46] This relentless barrage of racism nurtured within many British-born Black youth a distinct and potent identity of being 'Black', much more so than being 'British'. Furthermore, this was a state of Blackness that required (and indeed generated) a range of nuanced and sophisticated cultural and other responses. In the mid to late 1970s, the first of this new generation of youth were finding themselves on the streets, having passed through an education system that had largely failed them. Marginalisation, alienation and violent confrontations with what was widely regarded as an increasingly oppressive police force[47] became the defining characteristics of this newly formed social grouping of Black-British youth.

And yet, verdicts such as Foner's may have been in need of both qualification and clarification. The comment that, 'Young blacks find

it difficult to get the type of jobs they want and they are often victimised by the police'[48] certainly had a pronounced gender application. It was young Black males, much more so than young Black females, who tended to find themselves in chronic unemployment and, partially as a result of their continued visibility on the streets of the towns and cities in which they lived, subject to unwarranted attention from the police. Similarly, it was Black boys in particular who tended to find their experiences of education ill preparing them for life beyond school. The other arguable failing of the pessimistic findings of sociologists and anthropologists was a perennial lack of wider context. Findings and reports on Black-British youth tended not to compare their experiences with those of their white and other peer groups, in which it was certainly the case that similar challenges such as inter-generational conflict, unemployment and brushes with the law were, for some, not unfamiliar experiences. When contrasts by commentators, sociologists, researchers and journalists, with other groups (most often, other immigrant groups) were inferred or implied, Asians were, more often than not, cast as altogether more industrious and serious about education and employment than their Caribbean counterparts.[49]

The ways in which young Black women contributed to Black cultural identity were, relatively speaking, very poorly attended to in scholarly literature on Black Britain produced during the 1970s and 1980s. More often than not, it was the experiences of Black males that tended to take centre stage in such literature, with women being somewhat relegated to the periphery of researchers' attentions, or ignored altogether. Ken Pryce's *Endless Pressure: A Study of West Indian Life-Styles in Bristol* was in some respects typical of this gendered imbalance. The cover of the first edition – from 1979 – featured a colour photograph of locksed-up young men, the sorts of young men on which the study was based. A subsequent edition featured a similar image, thereby pointing to a symbolic, as well as an actual, omission of women's voices and experiences.[50] Though several publications, such as Elyse Dodgson, *Motherland: West Indian Women to Britain in the 1950s*, and Beverley Bryan, Stella Dadzie and Suzanne Scafe, *Heart of the Race: Black Women's Lives in Britain*, presented themselves as corrective products (the cover of *Heart of the Race* even featuring a fetching rendering of

a Rasta-esque woman, set against an urban landscape), there could be no escaping the extent to which Black women's voices were, it seemed, systemically sidelined.[51] Both of those publications dated from the mid 1980s, which was also a time of renewed interest in important Black women who were to figure prominently in the revisionist narratives of Black history, British history, and Black-British history. Notable in this regard are Ziggy Alexander and Audrey Dewjee (eds), *Wonderful Adventures of Mrs Seacole in Many Lands*,[52] and Buzz Johnson (ed), *Claudia Jones: I Think of My Mother*.[53]

Precious few commentators paid heed to the gendered complexities of Black-British cultural identity, as it developed in the early 1970s and thereafter. Lloyd Bradley was a notable exception, and several passages of his book *Sounds Like London* pointed to the extent to which gender played its part in the transitional years of the 1970s. His narrative ran counter to dominant sociological and journalistic findings that tended to emphasise failings, disappointment and difficulties above all else.

> This was a time of strong family values. The original immigrants were largely establishment-sympathising churchgoers, who prided themselves on maintaining 'good homes', and most children were close enough to their parents to appreciate what they had gone through to get this far in a strange country. Despite Britain's niggling levels of residual racism, the overwhelming sense of alienation or frustration that became such a factor a decade or so later did not yet exist. There was a strong all-round sense of community. Of course there was inter-generational friction, and while this frequently resulted in young men 'locksing up'... there wasn't really any more rebellion than you'd expect in any other segment of society. By and large, the ideals that had made the crossing from the Caribbean were handed down mostly intact – especially to the girls.[54]

Bradley expressed the view that alongside Jamaican reggae, with its increasing emphasis on Rastafari, social comment and Blackness, there existed a concurrent embrace of other types of Black music by the upcoming generation of the children of migrants. Wrote Bradley, 'This separation between the sounds of sufferation that were coming out of Jamaica, and the lush love songs being listened to in London, makes a fitting metaphor for what

was going on in life in general.'[55] He then went on to make mention of 'the social evolution then taking place between the first and second generations in Britain, as the seeds of a black middle/professional class were beginning to germinate.'[56]

It has become somewhat traditional to regard unemployment and its corrosive effects as having a marked bearing on the sense of disaffection that, in part at least, characterised the emergence of Black Britain. In this regard for some amongst the second generation, unemployment was not simply a matter of having no job and as a consequence having no money. Instead, unemployment was a state of being that was either preferable to the low skill, low status work that might be available down at the Job Centre, or existed as some sort of continuum of the suffering and indignities heaped on enslaved Africans since the beginning of the seventeenth century. Unemployment equalled bondage, and freedom from Babylonian bondage and the reclamation of dignity were surely the most righteous of yearnings.

> The confiscation of freedom made a terrible impact on Afro-Caribbean people. The forced-labour experience they endured – that not belonging to yourself, that endless no-pay work, that being ineligible for common rights that uphold human dignity, that way of life called slavery – translated itself into a burdensome loss. Freedom became a haunting thought and prayer and dream of Afro-Caribbean people. It aroused resistance. It has come to arouse a dynamic desire for reclamation.[57]

But in contrast to the above sentiments, Bradley regarded the matter of (un)employment in markedly different terms.

> …for the sons and daughters of the first big wave of Caribbean immigration [the first half of the 1970s] was nonetheless shot through with a fair degree of optimism. True, Britain was never any sort of land of milk and honey – and police harassment was at a level best considered routine – but back then a British education was still worth something and, even if employment opportunities were far from equal, with so much yet to be computerised a wealth of clerical jobs were on offer. Most black teenagers seemed content to buy into the fundamental reason why so many of their parents had set sail from the Caribbean: for

their children to do better than they had themselves.[58]

While giving succour to those who were minded to caricature the older generation as conservative to the point of timidity, Barry Troyna cautioned against regarding young Black Britons as 'an homogenous and undifferentiated social category' with common impulses. Citing the 1980–81 riots that were to have such a profound bearing, Troyna noted,

> Though there is always a risk of oversimplifying the issue, the eruption of disorders in many multiracial areas in 1981 gives clues to the response of black youngsters to their situation. The recognition that their life chances are often determined not only by their possession of educational qualifications but by their skin colour has generated the adoption of a more militant posture than their parents were willing to assume. Of course, black youths do not constitute an homogenous or undifferentiated social category: many black youngsters openly reject the oppositional stance taken in 1981 as well as the ideology and practices of the Rastafarian movement. At the same time, many of the youths involved in the disorders and/or in the Rasta subculture retain a commitment to the work ethic and other features of UK society. To characterise black youth as an alienated social group is simplistic and misconceived. At the same time it is difficult to deny that they display a far greater and more overt resistance to racism and discrimination than their parents did.[59]

Further cautioning against oversimplification and the uninformed idea that black youths constituted any sort of homogenous or undifferentiated social category was provided by Lloyd Bradley, who wrote,

> Even if the UK at large tended to view its black population as a single homogenous group, several different black youth tribes were emerging in the 1970s, each under the radar but easily identifiable to anyone in the know. Just like white kids really. With black Britain undergoing the most significant shift in its demographics since the early days of mass immigration, the notion of a one-size-fits-all playlist was becoming less relevant than ever. A sizable wave of black teenagers, born in the UK, was coming of age. These were the first black Britons to approach their lives from a social perspective that related to the

Caribbean and Africa as well as Great Britain, and saw their blackness as being qualified by both. Exposed to cultural influences ranging across a broad cross-colonial spectrum, and of course to the US as well, via TV, this generation was characterised by a huge internal diversity. Jamaican music was especially prominent in the mix, and formed the basis of the first totally British black music.[60]

It was, though, within the realm of disaffection and marginalisation that a Black-British cultural identity saw its strongest germination. Whatever a 'black middle/professional class' might be, if such a thing really existed, its collective contributions – including within the realm of cultural identity – were difficult to discern. Those Black people desirous of social climbing or economic betterment tended to move away from recognisable Black communities – either by leaving home and going to polytechnic or university, or by seeking to move into more affluent neighbourhoods not blighted by the infrastructural neglect that so often characterised the hardscrabble spaces Black people occupied. This meant that Black neighbourhoods maintained an existence as spaces in which a certain fractiousness and defiance was the hallmark of the most explicit forms of Black cultural identity.

In this respect, the identity of being Black was both an imposed and a self-created one. It was imposed by the wider (white) society that refused to relinquish racism.[61] Concurrently, it was defiantly self-created by Black youth themselves, who countered their marginalisation and alienation by drawing heavily on a wide range of Black identities from elsewhere in the world, particularly the Black Power movement of the USA,[62] the increasingly popular movement of Rastafari, and its attendant 'Natty Dread' culture of Jamaica.[63] While London had its fair share of would-be, or in more modern parlance, wannabe, Black Power leaders, it was to their altogether more attractive and charismatic US equivalents that those Black Britons, so inclined, looked. London of the late 1960s and early 1970s gave rise to such Black Power figures as self-styled Michael X, born in 1933 in Trinidad as Michael de Freitas and Obi Egbuna, born in 1938 in Nigeria. Egbuna authored a book, *Destroy This Temple*, the cover of which hailed him as 'The voice of Black Power in Britain', but individuals such as these presented themselves as parodies of Black Power firebrands, trading off sometime reputations

as prominent polemicists for the British Black Power movement of the time. Few Black Britons took such characters seriously, and the writings of figures such as Michael X and Egbuna were in essence more heat than light. Black Britain tended to pay more respectful attention to legendary personalities such as Malcolm X, who visited Smethwick in the West Midlands in 1965, at a time of pronounced racial tension in the area, and Stokely Carmichael, who visited London in 1967 for the International Congress on the Dialectics of Liberation. Beyond the fleeting presence of such individuals, it was the mesmerising images, coming over from the USA, of the Black Panthers, together with the persuasive eloquence of figures such as the Reverend Dr Martin Luther King, which most gripped and inspired Black Britain. News footage of civil rights protestors being beaten, water-hosed, clubbed, attacked by police dogs and subject to no end of other vile abuses did much to remind Black people in Britain of their own struggles and challenges, and that there was perhaps a particularly global dimension to the Black people's quest for human dignity, equal rights and justice.

Britain in the 1970s was in many respects as ambivalent about its Black citizenry as distinct elements amongst its Black citizenry were ambivalent about its Britishness. Stuart Hall summarised this mid 1970s mood of ambivalence amongst Black-British: 'Fifteen years ago [*circa* 1973] we didn't care, or at least I didn't care, whether there was any black in the Union Jack...'[64] Notwithstanding the increasing societal and governmental traction of describing Black Britons as an ethnic minority, the 1970s gave rise to a pronounced and new tendency on the part of Black Britons to embrace the designation of *Afro-Caribbean*. And this distinct attempt at fashioning an Afro-centric identity was reflected in wider cultural manifestations. The 1970s was very much a decade of transition in the evolution of Black Britain. It marked the years in which Black youngsters came of age, and as the 1980s beckoned, they were poised to bring forth a most astonishing range of artistic practices, which sought to comment – with poise, certainty, and composure – on their newly developed state of being.

3

Rasta This and Dreadlocks That

All belief systems could be said to have strange origins. The things that ancient prophets were believed to have said and done, the incidences of supernatural occurrences, messianic visions, and visionary utterances – these are the sorts of foundations on which the world's faiths, religions and belief systems are built. As strange as any other belief system is Rastafari, founded in large part on a prophecy said to have been uttered by Marcus Garvey. Amongst the many activities that Garvey pursued was the work he undertook as a writer, journalist, and newspaper and magazine editor. In this regard, his prolific and now comprehensively documented writings began when he was in his early to mid 20s, and continued up until close to his death in 1940. Yet nowhere amongst his extensive writings – which included poetry – can be found evidence that he committed to print the sentiments attributed to him, that Black people of the world should 'Look to Africa for the crowning of a Black King, he shall be the Redeemer.'[1] Given the lack of definitive pointers as to exactly when, where, under what circumstances and in which context the prophetic words were uttered, it is perhaps not surprising that variations of the exact wording abound. Ernest Cashmore has the words as, 'Look to Africa when a black king shall be crowned, for the day of deliverance is near.'[2]

The opulence, splendour and majesty of Haile Selassie's 1930 coronation in Addis Ababa was taken by those so inclined as a fulfilment of Garvey's prophecy. Garvey's Africa-centred divination, his foretelling of the future, were taken as relating to the new crowned Emperor of Ethiopia in 1930, who took titles which included, His Imperial Majesty the King of Kings, Conquering Lion of the Tribe of Judah, Elect of God. Before his coronation, Haile Selassie was known as Ras Tafari, Ras meaning prince or monarch-in-waiting in the Ethiopian language of Amharic, and Tafari coming from the first of the names with which he had been christened, Tafari Makonnen Woldemikael. It was through such nomenclatural shifts and embraces that adherents of this strange new cult came to be known as Ras Tafarians, or more commonly by the conjoined version, Rastafarians. Simply put, Ras Tafari was nothing short of a fulfilment of prophecy, akin to any biblical prognostication. The evoking of biblical passages relating to Egypt and Ethiopia, by folk preachers in Jamaica and elsewhere, was a practice that stretched back over many decades, so it is perhaps not difficult to perceive the ways in which the coronation of Haile Selassie would strike such a chord with the scattered peoples of the African Diaspora. One writer summarised the significance of Haile Selassie's crowning, particularly to those who identified themselves as *Garveyites*, as follows:

> Haile Selassie was an embodiment of a Garvey prediction. For nearly two decades Marcus Garvey had steered his listeners towards the passage in the Bible which foretold that 'princes shall come out of Egypt'. In 1930, with Selassie's magnificent coronation, it had come to pass. A crop of international dignitaries had been treated to the splendour of an African coronation with ancient Abyssinian exoticism and first-world modernity [...] Emperor Haile Selassie had been the beneficiary of Garvey's advocacy, and was now even more so when in 1935 the 'Beast of Rome' Mussolini started assembling his troops on the edge of Ethiopia.[3]

But this, in many respects, makes the strange origins of Rastafari all the more strange, because, as Ellis Cashmore noted, 'in no way did Garvey endorse this new interpretation of his philosophy.'[4] Indeed, following Mussolini's assault on Ethiopia and Haile Selassie's departure into exile,

Garvey had no end of choice and decidedly critical words to say about the emperor. For example,

> Mussolini of Italy has conquered Haile Selassie of Abyssinia, but he has not conquered the Abyssinians nor Abyssinia. The Emperor of Abyssinia allowed himself to be conquered, by playing white, by trusting to white advisers and by relying on white governments, including the white League of Nations.[5]

Within this particular text, Garvey continued to wax lyrical, in similar vein: 'When Haile Selassie departed from the policy of the great Menelik and surrounded himself with European advisers, he had taken the first step to the destruction of the country.'[6] Ironically, this same text that reiterated its condemnation of Haile Selassie by claiming that, 'The Emperor's reliance on the League [of Nations] was unfortunate, but more so was his reliance on his white advisers' also ended with the sort of biblical reference that adherents of this strange new cult, emerging as it did in Jamaica in the 1930s, would take as *gospel*.

> The day will shortly come with the blessing of God, when [the Negro] will stretch forth his hands. Probably it is through Italy in Abyssinia that 'Ethiopia shall stretch forth her hands unto God and Princes shall come out of Egypt.[7]

In his comprehensive biography of Garvey, *Negro With a Hat: The Rise and Fall of Marcus Garvey*, Colin Grant made mention of other such pronounced criticisms of Haile Selassie by Garvey. Commented Grant, 'At a time when black activists around the world were galvanising support and funds for Selassie and his countrymen, Garvey's intervention and criticism made for uncomfortable reading.'[8] History would offer but one chance for Haile Selassie and Marcus Garvey to meet. This was when 'the exiled emperor made his way to England' and 'one of his advisers had arranged for him to meet a party of British officials and dignitaries [upon Haile Selassie's arrival at Waterloo station].' Grant recalled that, 'Also awaiting Selassie at Waterloo station was Marcus Garvey and a coalition of black delegates who had assembled to welcome the monarch. But when they tried to address him, Selassie ignored them and carried on walking.'[9] Such unvarnished ambivalence on the emperor's part towards

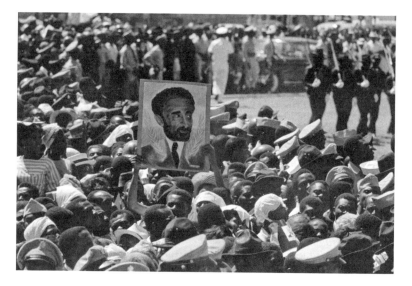

Figure 13: Portrait of Haile Selassie I held aloft in a crowd, Jamaica, 1966, on the occasion of Haile Selassie's visit to the country.

Garvey and his ilk would duly come to be reciprocated in the sorts of criticisms of Haile Selassie forthcoming from Garvey, himself in a sort of exile in London. Nothing, however, could uncouple the link, amongst the faithful, of Garvey's role as a prophet of Rastafari, and the embodiment of Haile Selassie as the fulfilment of that prophecy, not even such apparently trifling details as Garvey's Roman Catholicism[10] and Haile Selassie's dynastic linkages with the Ethiopian Orthodox Tewahedo Church. Believers in the divinity and greater significance of Haile Selassie were unswayed and indeed, uninterested in such matters. For them, 'what Garvey actually said [and did and wrote] was less important than what he was reputed to have said.'[11]

And yet, for all the arguable strangeness of Rastafari's origins, there was perhaps nothing at all strange about how strongly this intriguing belief system impacted Black Britain, leading one researcher to confidently state that the British manifestation of Rastafari represented 'a defiant protest against cultural denial and racial discrimination.'[12] Rastafari, so another writer, Leonard Barrett argued, could only be fully understood and appreciated

when set in the context of what he described as Ethiopianism in Jamaica. When seen as part of a continuum that spanned centuries of a particular *racialised* resistance in Jamaica, Rastafari was perhaps not the least bit strange. Indeed, there may well have been a certain logic about its emergence. And, given the extent to which Jamaican people established themselves, after a fashion, in Britain, there was, perhaps, a certain inevitability about its pronounced embrace by large swathes of Black Britain. Wrote Barrett,

> The emergence of the Rastafarians will remain a puzzle unless seen as a continuation of the concept of Ethiopianism which began in Jamaica as early as the eighteenth century. The enchantment with the land and people of Ethiopia has had a long and interesting history. From biblical writings [...] right down to our day, Ethiopia has had a hypnotic influence on history, which has been retained by the imagination of Blacks in Diaspora. In the nineteenth century when the defenders of slavery tried to divest Blacks of every dignity of humanity and civilisation, Blacks appealed to the fabled glory of Ethiopia. When confronted by stalwarts of religion, philosophy, and science who sought to falsify history in the service of Western slavery, Black preachers – though for the most part unlearned – discovered in the only book to which they had access (the Bible) that Egypt and Ethiopia were in Africa, and that these countries figured very importantly in the history of civilisation. They evidently read and pondered the meaning of Psalms 68:31 – 'Princes shall come out of Egypt; Ethiopia shall soon stretch out her hands unto God.[13]

Even without the beguiling emergence of Rastafari, it was perhaps unavoidable that Marcus Garvey would figure in the revisionist belief systems adopted by many young Black Britons. In establishing his Universal Negro Improvement Association and African Communities League, Garvey had settled on the dramatic motto, *One God! One Aim! One Destiny!* Thus Garvey, one of the greatest Pan-Africanists of the twentieth century, put God first in his audacious programme of nation-building. Furthermore, Garvey's assertions calling for a radical reformulation of who or what God was, and a concurrent *racialising* of God in the image of Black people, came to act as something of a blueprint for adherents of Rastafari.

Garvey's extreme racial nationalism demanded fulfilment in a truly Negro religion, for, as his widow explains, 'it is really logical that although we all know God is a spirit, yet all religions more or less visualise Him in a likeness akin to their own race [...] Hence it was most vital that pictures of God should be in the likeness of the [Negro] Race.[14]

The narrative continued,

From the first, however, Bishop McGuire [a prominent Episcopal clergyman who left his Boston pulpit in 1920 to become Chaplain General of the Universal Negro Improvement Association] urged the Garveyites to 'forget the white gods.' 'Erase the white gods from your hearts,' he told his congregation. 'We must go back to the native church, to our own true God.' The new Negro religion would seek to be true to the principles of Christianity without the shameful hypocrisy of the white churches. Garvey himself urged Negroes to adopt their own religion, with God as a Being, not as a Creature, a religion that would show Him made in our own image – black.[15]

In her 1977 text on Jamaicans living in Britain, Nancy Foner noted that 'many Jamaican migrants' thoughts of the future are dominated by the desire to return home.'[16] Had she also more substantially turned her attention to the children of these migrants, Foner could similarly have noticed the extent to which many amongst the second generation of Caribbean immigrants were likewise harbouring, and indeed manifesting, a similar desire to *return* home, though in their case, home was envisaged as the motherland of Africa, and the seat of the emperor himself, Ethiopia. Thus, both generations – parents and children – could be said to be displaying mindsets that pointed towards a disinvestment from, rather than an apparently futile, overly challenging and unrealistic investment in, Britishness and British culture.

The process of significant numbers of Black Britons looking beyond the boundaries of their relatively isolated geographic location, on an island between the North Sea and the Atlantic Ocean, had, after all, its precedents. For several generations people growing up in a number of the islands of the Caribbean had to contend with certain realities of the relatively small land masses on which they were born and raised. The relative smallness of the *small islands* called in many instances for constantly evolving strategies of

looking beyond one's geographical location, not only with the occasional view to travel, not only with a view to what might be brought in from overseas – people, produce, goods, music, and so on – but also, most importantly perhaps, with a view to making sense of one's existence in the here and now. Barbados is a land mass of some 166 square miles, Grenada, 133 square miles, Saint Vincent and the Grenadines 150 square miles, and biggest of this particular list of small islands is Antigua and Barbuda, covering significantly less than 200 square miles. Though Britain is a relatively larger land mass, its residents of Caribbean birth or heritage enacted strategies similar to those mentioned above, particularly with regards to understanding one's situation and one's identity. In the early to mid-twentieth century, Panama, other countries in Central America, and the USA itself, beckoned. A short time later, Britain beckoned. But within a generation, certain notions of Ethiopia and Africa beckoned.

There was one other fundamental way in which one of Garvey's key assertions would be embraced by young Black Britain of the mid to late 1970s, and within that particular demographic, those inclined towards Rastafari in particular. That is (as referenced in Chapter 1) the ways in which it would fall to the children of Caribbean migrants to fashion a political and cultural identity that would both undermine the West Indian designation that was so often foisted onto them, and pretty much render as irrelevant the delineation of identity along the lines of the specific and individual countries of birth of their parents; delineations of identity to which (with the possible exception of rallying around the pan-Caribbean West Indies cricket team) the pioneering generation of migrants tended to cling.[17] In this endeavour, one of Marcus Garvey's early writings, 'The British West Indies in the Mirror of Civilization' witnessed Garvey *prophesying*, as he himself put it, to the power of those from the Caribbean portion of the African Diaspora to be the means through which Pan-Africanism would be advanced, and the project of Black nation-building undertaken in earnest. As prophetic as Garvey was in so many ways, he perhaps did not imagine, when he wrote this text in 1913, the extent to which, many decades later, the British-born children of Caribbean migrants would be in the forefront of the grand project he envisaged. Like assorted notions of Pan-Africanism before it, Rastafari offered its own means by which a scattered race could be united.

As one who knows the people well, I make no apology for prophesying that there will soon be a turning point in the history of the West Indies; and that the people who inhabit that portion of the Western Hemisphere will be the instruments of uniting a scattered race who, before the close of many centuries, will found an Empire on which the sun shall shine as ceaselessly as it does on the Empire of the North today.[18]

As mentioned in the Introduction, the embrace of Rastafari is of critical importance in these narratives, primarily because Rastafari provided a compelling and indeed, mesmerising template for those Black youth for whom Britishness, much as their parents had found, was an ill-fitting garment. In so many respects, as a belief system Rastafari was near-perfect for many young Black Britons. Caribbean migrants were on the whole deeply religious, and remained, to varying degrees, steadfast in their Christian faith, across a range of denominations, many of them Pentecostal in orientation. An indication of the pronounced hold that Christianity had on Caribbean peoples can be seen reflected in a country such as Jamaica, which 'professes to have the greatest number of churches per square kilometre in the world, with virtually every imaginable denomination represented. Although most foreigners associate the island with Rastafarianism, more than 80 percent of Jamaicans identify themselves as Christian.'[19]

Black Britons often grew up in households in which adherence to the Christian faith was at its most stringent, determined and fervent, compared to the comparatively lacklustre ways in which white Britons demonstrated their Christianity. In a process of great audacity, Black youngsters were able to creatively tweak Christianity, with its language of exile, Babylon, the promised land, redemption, and so on, and apply its template to Rastafari, making the belief system from Jamaica easily understood and easily embraced by those who, in other respects, had drifted away from, or rejected outright, the organised religion of their parents' generation. With its appeal to Blackness, the centrality of a mythical African homeland, and the persuasive language of righteousness, sufferation and downpression, Rastafari gripped the imagination of young Black Britain in ways, and to an extent, never known before or since.

Furthermore, Rastafari's multiple messages, alternating between affirmation and condemnation, were primarily delivered through perfectly

crafted reggae music, which in so many ways was at a particular peak of musicianship, innovation, creativity and assertiveness. As Ken Pryce noted 'Reggae... is information-oriented and contains a high degree of reportage.'[20] British reggae took its cue from Jamaican music, and there was scarcely an experience such as alienation, police harassment, discrimination in the job market, racism, or the scorn of society that was not memorably expressed in Black-British reggae. In the mid 1970s it was noted that 'reggae, the latest Jamaican popular music, has become "THE urban black sound in England ..."'.[21] With 'Reggae music ... banned on many radio stations',[22] devotees of the music had to create for themselves spaces in which they could avail themselves of this Dread reportage, and it was in these spaces – neighbourhood record shops, blues dances, and various community centres – that a certain Black cultural identity germinated and flourished. Simultaneously, the influence of reggae music extended to other disciplines within the arts, notably the visual arts. In the early 1980s one young Black artist was quoted as saying, 'Reggae serves to reinforce Black cultural identity, and this is how we would like to see Black art.'[23] In this way, and others, from the mid 1970s onwards, for a period of about a decade, Rastafari and the attendant Dread culture carried the swing.[24]

Within the culture and consciousness of Rastafari, *culture* was not something that Black people simply embodied or carried with them, irrespective of time, place, circumstance, conditioning, etc. Instead, *culture* was what Black people had to *reclaim*, if they were to achieve true enlightenment as exiled children of Africa. Within this mindset, this consciousness, Rastafari was there to guide the latter day Children of Israel back to a blessed state of cultural fulfilment. Inevitably perhaps, Afrocentric consciousness emerged as the most apparently plausible route to this. As with so many other instances, African-American cultural activists had rehearsed these politics of identity. During a period of time from the late 1960s to the early or mid 1970s, 'natural' Afro hair, the wearing of *dashikis* and the adopting of African-sounding names became the norm for significant numbers of African-American people,[25] convinced that such gestures amounted to an important manifestation of both consciousness and resistance. These things had their place among Black Britons also, though in some instances 'natural' hair was manifest as *dreadlocks*, *locks*, or *dreads*; thus it was the influence of reggae and Rastafari that most enabled Black

Britons to echo reggae group Black Uhuru's triumphant sentiment of resistance and resilience, 'my culture is growing stronger and I hope I never surrender.'[26] Meanwhile, pretty much all cultural expression by Black people in Britain was, by the mid 1970s, being steered down paths of separate development, further ensuring both the cultural distinctness and the cultural separateness of Black Britain.

Chapter 1 discussed the ways in which Caribbean migrants, upon their arrival in Britain, promptly found themselves perpetually disconnected from rural spaces, the British countryside very much becoming a forbidden, off-limits, out-of-bounds environment. But Rastafari presented itself as personifying an imagined return to the land, with its pronounced agrarian overtones. The fluidity of Rastafari, and its extraordinary ability to embody and reflect no end of identities, was further evidenced by an implicit anti-capitalist sensibility. Though Rastas held no candle for either organised religion nor organised politics[27], such things as consumerism, nine-to-five jobs, and the acquisition of property were roundly condemned as being nothing more than manifestations of the system, (or as more graphically expressed, the *shitstem*.) Keith Piper summarised the appeal of Rastafari (to Black Britain) as follows:

> The image of the 'Dread' replete with the markers of a particular type of rebellion has always exercised a particular type of attraction. The essentially anti-materialistic, and therefore by implication anti-capitalistic, afrocentric and agrarian (even in urban setting) elements of the aesthetics of the Dread...[28]

There was an unmistakeable sense that Rastafari was, above all else, a means of fashioning an identity that would be fit for purpose, as far as the aspirations of young Black Britain (during the 1970s) were concerned. John Plummer, writing in 1978, remarked,

> the Rastafarian movement and some of its... ideas and adherents have had a profound impact upon the black community and its interactions with white society over the past ten years than any other ideology.
>
> There are of course many other black projects, churches and political groups all over the country...Yet none has reached so deep into the hearts and minds of a substantial section of the

younger generation. No other programme or concept has ena-
bled so many to find a truly positive sense of their own black
identity.[29]

Emphasising the nationwide appeal of this relatively new Black ideology,
an article written by Richard Woolveridge for the *South London Press* in
1976 stated that the popularity of Rastafari was 'not simply confined to the
notable black areas of London like Brixton and Notting Hill, but [was] in
every major town in the country.'[30]

Several books have been written that reference the ways in which
the emergence of Black-British youth as a recognisable and highly vis-
ible demographic entity coincided with, and was chaperoned by, distinct
influences of Rastafari, an ideology that enthralled many of these Black
youth. The appeal and influence of Rastafari was said by sociologists to
have marked a decisive shift in the political sensibilities of the 'younger
generation' of Black people, away from what was generally deemed to
be the subservient mannerisms of the 'older generation'. Len Garrison
wrote that,

> It is clear…that although many of the black children and teen-
> age youths were born in Britain and have known no other cul-
> ture, they have come to feel like outsiders. They are as a result
> embracing the contra culture of the Ras Tafari with which they
> feel more secure.
>
> Against this background we find the black youth in the
> inner urban areas demoralised by their experience and fate.
> In their new and growing stand, they reject their parents'
> ashamed and defensive attitude towards their blackness, they
> reject the subservient status and role their parents have had to
> play, they resent being treated as second class citizens … and
> finally they reject the idea that they should apologise for their
> colour. Increasing rejection of the assimilationist framework
> and values demonstrates that its demeaning status has become
> meaningless.[31]

Garrison (like a number of other commentators) was perhaps guilty of
perpetuating a problematic generalisation when he portrayed the genera-
tion of pioneering Caribbean migrants as being racially subservient, void
of any traces of the racial pride and rebelliousness that their offspring so

apparently and liberally demonstrated. Rather than accepting the familiar notion of a generational schism, *Roots & Culture* instead argues that, largely born of the wider society's prejudice, racism and ignorance, there is an unmistakeable continuum of Black-British cultural distinctiveness, beginning in the late 1940s and running through several decades. In this regard, the experiences and responses of these pioneering immigrants were an essential foundation on which the children of these immigrants selectively built.

The *Windrush* generation came to be regarded in certain circles as an embodiment of conformist and socially conservative behaviour. Such a caricature fitted neatly into sociologists' and researchers' narratives about inter-generational conflict, but beyond that the caricature often served no purpose. It might more reasonably and accurately be suggested that the older generation of Caribbean immigrants were the ones who – in the face of relentless, dispiriting and dehumanising prejudice and racism – nevertheless used all manner of creative strategies to carve out for themselves a place in British society. Home ownership was something that many of these migrants embraced as an important cornerstone of familial stability. When traditional access to capital – banks, mortgages, loans and so on – was withheld from migrants, they enacted what Sivanandan described as 'a sort of primitive banking system engendered by tradition and enforced by racial discrimination.'[32] Such schemes evolved whereby a group of people (in some instances linked through such institutions as their church or cricket club), provided they could find x amount of money each week or each month, could each receive on a rotating basis a sizeable amount of cash to put towards purchases, expenses, deposits *etc.* that might otherwise not be available. Large numbers of migrants were involved in *pardner* schemes (as they were known in Jamaican circles), or sou-sou schemes (as they were known in Trinidadian circles) in which money was equitably rotated, thereby attempting to circumvent the racism of the banking sector.[33]

The *Windrush* generation was also responsible for preserving Caribbean cuisine, language, cultural traits and other evidence of cultural resilience, such as the kissing of one's teeth, as an audible sign of displeasure. Another signifier of cultural resilience was the practice of Nine Night, a tradition that embraced both funereal and celebratory aspects of commemorating

the life of a recently departed person.[34] Nine Night, something akin to a wake taking place for nine nights after a loved one has died, is a Jamaican ritual to which the artist Donald Rodney paid tribute in his majestic solo show at South London Gallery in 1997, in what would prove to be his last exhibition before he died of complications relating to the sickle-cell anaemia from which he suffered. Rodney's exhibition took place in memory of his father, Harold George Rodney, who had passed away some time previously.[35] Rodney was not the only one to find himself responding to this fascinating tradition. Nearly a decade and a half earlier, Montserrat-born, US-raised playwright Edgar Nkosi White's play 'Nine Night' was staged in London by the Black Theatre Co-operative.[36] According to his biographer, comedian Lenny Henry, in the aftermath of his father's passing, was made aware of the tradition of Nine Night by his mother. 'It was only his mother explaining that the tradition of having an open house for nine nights went back to the West Indies, and previously to Africa, that calmed him down.'[37]

Other important aspects of cultural retentions passed from one generation to another include such things as baptism by total immersion and graveside mourners (often the men) taking it in turns to shovel soil on to the lowered coffin or casket until the soil reaches ground level.[38] Caribbean-born immigrants to Britain also contributed to the establishment and sustaining of what now, in hindsight, can be regarded as a strong press, oriented to the needs and interests of Black Britain. From the anti-imperialist, anti-racist paper, *The West Indian Gazette and Afro-Asian Caribbean News*, founded and thereafter edited by Claudia Jones, to papers such as *Caribbean Times*, *West Indian World* and the *Weekly Journal*, this press helped to define and shore up immigrant communities. Migrants sustained, for many years, a weekly British print edition of Jamaica's *Gleaner* newspaper. One other important contribution by the immigrant generation was the setting up of the Notting Hill Carnival in the wake of the racial violence they encountered in cities such as London and Nottingham. Mention should also be made of the ways in which those Caribbean migrants who were knowledgeable and passionate about the game of cricket were able to pass down to those children who were interested in learning what often seemed to be the arcane rules of the game. In similar regard, many amongst the children of Caribbean migrants availed themselves of their parents' love of the sport.[39]

Members of the *Windrush* generation were particularly resourceful and adept at seeking to circumvent the widespread prejudice they encountered. Recalling immigrants' attempts to subvert the prejudice of being regularly denied entry to night clubs and dance halls, Lloyd Bradley noted, 'For most ordinary black Londoners, routinely refused entrance to just about all the capital's regular dancehalls, the only options were unlicensed, pay-on-the-door dances in basements, empty houses, and school halls, where West Indian caretakers would make premises available after hours.'[40] In response to the reluctance of white barbers to cut Black people's hair (and a corresponding lack of faith, by immigrants, in the services offered by white hairdressers), Black hair salons and barbershops were established, sometimes as cottage industries, at other times in premises more publicly located.[41] And in response to the palpably poor education many Black youngsters were receiving, Caribbean migrants set up their own Saturday schools in an attempt to give their children the sorts of education they themselves received or wished their children to receive. More formally, some migrants established the Black Parents Movement,[42] having earlier in the twentieth century (1931) set up The League of Coloured Peoples, a British civil rights organisation that was founded with the goal of racial equality around the world. Jamaican-born Harold Moody, related to the sculptor Ronald Moody, was a leading figure in the establishment of this pioneering body. Its inaugural executive committee included people from Barbados, Trinidad, Grenada and British Guiana.

Despite this formidable range of responses to a somewhat racial adversity, the migrant generation were, as mentioned, caricatured in a number of quarters as being inherently conservative and manifesting a pronounced conformity. Keith Piper proposed the argument that, with their embrace of Rastafari and their supposed propensity to confrontational skirmishes with the police, the younger generation was a personification of rebelliousness, which came about as a reaction to their parents' embodiment of conformity. Paraphrasing Darcus Howe, Piper proffered the view that 'However, the flip side of this extreme conformity... is extreme rebellion: an attraction on the part of young people towards views and attitudes which represent the antithesis of those of their parents' generation.'[43] Piper argued that those he termed 'products of a Black Christian background' were present 'within the arena of contemporary Black art [and that this] represented an uneasy

alliance between conflicting tendencies towards conformity and rebellion.'[44] Hence Piper was suggesting that one of the clearest influences on (and factors that contributed to) the politicisation of a generation of Black youth (and those amongst them who became visual artists) was the influence of what he termed a 'Fundamentalist Christian' background.

By the late 1970s, therefore, the terms of reference for the newly created Black-British identity were firmly in place, and adherents of Rastafari found their understandings of these terms enhanced by the belief system they adopted. Unemployment, educational under-achievement (or *miseducation*), police brutality, an oppressive and unfair judiciary, poor housing conditions: these became defining experiences of those drawn to Rastafari, which simultaneously offered routes to salvation that were discernibly biblical in appearance. Few young Black people of the time failed to be influenced, to some degree, by the idea that these negative experiences were *their* legacy, *their British birthright*. Many young Black Britons, whether self-identifying as Rasta or not, respected much of what the Rastaman had to say about the condition of exile in Babylon. The ancient city in Mesopotamia, on the Euphrates, the capital of Babylonia in the second millennium BC, became, through a biblical prism, synonymous with sinful indulgence, fornication and idolatry. It was a near-perfect metaphor for the latter-day, morally bankrupt state in which adherents of Rastafari felt themselves to be living.

As mentioned earlier in this chapter, many Black Britons grew up in religious households in which the fire and brimstone language of fundamentalist manifestations of the Christian faith was fervently used. The Book of Revelation was replete with graphic and apocalyptic symbolism that referenced the most cataclysmic of events. The Bible was in any event an amalgamation of texts that – passage by passage, verse by verse – were open to all manner of interpretations. From stories easily understood by small children to passages that challenged and flummoxed seasoned biblical scholars, there was a remarkable degree of open-endedness and ambiguity in certain passages of scripture. In this regard, Rastafari put its own particular take on the graphic symbolism inherent in Revelation, particularly in chapters such as the 17th. As mentioned, Rastafari seized on texts such as 'And upon her forehead was a name written, MYSTERY, BABYLON THE GREAT, THE MOTHER OF HARLOTS AND ABOMINATIONS OF

THE EARTH'[45] as an unvarnished reference to several principle detestations, chief amongst them the society itself, wherever that earthly society might be. Thus, Rastas designated the whole of the society around them, particularly the twin pillars of church and state, as Babylon, the biblical overtones giving the description a particularly forceful validity. But, befitting its fluidity, Babylon also functioned as a reference to the police, who were by far the most visible (and indeed, the most intrusive) symbol of the corrupt, unjust, and oppressive order that Rastafari sought to resist, condemn, and flee from. It was in part this process in which Black youngsters, and the Dreads among them, were able to use Christianity, with its language of exile, Babylon, the promised land, redemption, and so on, that led Ernest Cashmore to note the extent to which, 'the majority of Rastas came from devoutly religious backgrounds.'[46]

The same could be said of any given number of other Black youngsters who, although not identifying as Rasta, nevertheless took to heart this founding tenet of Rastafari that the unjust world around them was Babylon[47] and that it would one day suffer a day of reckoning unlike any other in history. An indication of the interplay between religious upbringing and the forceful expression of a Black-British identity can be seen in the extent to which influential figures such as Black artist Keith Piper, and Dub Master Dennis Bovell[48] grew up as Seventh Day Adventists, one of a number of no-nonsense expressions of Christianity around which so many Caribbean migrants were wont to cluster. The culture that grew out of this Black-British identity was buoyed up to a massive degree by reggae music, both imported and home grown. British groups like Aswad, Black Slate, Steel Pulse, Merger, Cimarons, Misty in Roots, Capital Letters, and Dennis Bovell's Matumbi (later joined by 'Dub Poets' such as Linton Kwesi Johnson) were collectively responsible for a major body of music, songs and poetry that articulated and reaffirmed the Black-British experience. This experience, centred in large part on the notion that Black people in this particular corner of Europe were victims – of circumstance, of history, and of society. This sentiment was crystallised by one such British reggae group, the Regulars, in a song that pointed to a cross-generational understanding. 'My mama used to tell me/My papa used to show me/And I'm teaching my little sister/And I'm telling my little brother/They are a victim, a victim of life.'[49] The reference here to reggae music is important

because a number of young Black-British artists of the second generation, for a while at least, regarded themselves as producing a visual equivalent of reggae music, which from the mid 1970s through to the early 1980s was characterised by the strident social, spiritual and political narratives it communicated.[50]

Reggae groups formed all across the country, though London was a particularly fertile place for emerging reggae musicians and singers. Birmingham, the largest provincial city in the country, was home to many people from the Commonwealth countries, and to their British-born/raised children. And it was that particular city that gave rise to Steel Pulse, in 1975. The title track of their debut album, 'Handsworth Revolution' was a paean to the much-maligned people of Handsworth, the inner-city neighbourhood in which significant numbers of the city's immigrant population and their children lived. Not only was the song a paean, it was simultaneously a manifesto of resistance, an affirmation of consciousness and a determination to battle the forces that kept Black people down. Birmingham was in some respects typical of many such cities and represented fascinating and heady contrasts and contradictions, which in turn represented the all too perceptible processes of demographic changes and deindustrialisation. Well into the mid 1980s, in districts such as Lozells and Handsworth, milkmen still delivered milk in hand-drawn carts, yet the deconsecrated churches in such areas were now likely to be Muslim mosques, Hindu temples or Sikh Gurdwaras. Many people still lived in the sort of modest, working-class terraced housing of which whole neighbourhoods had been built, yet the traditional chip shop at the end of the street was now likely to be a Chinese takeaway, a Caribbean dumpling shop or an Indian restaurant. Many people still shopped locally, yet the high streets of these districts were becoming reflective of the tastes and requirements of the new residents of cities such as Birmingham. In the *Picture Post* article from 1952 quoted in Chapter 1, the writer referred to Caribbean migrants' eating habits, though one such reference was particularly disparaging. Wrote Hilde Marchant, 'They like rice, but have difficulty in getting it... they like oils, spices and an appalling dried salt codfish... the local tradespeople had tried to cater for these tastes: tried to reserve rice and bananas for their coloured customers.'[51] Between them, the various immigrant groups to Britain were, over a period of several

decades, able to make such comments largely redundant by finding ways to satisfy their own various culinary requirements. Not only that, but these groups also managed, in time, to transform the often bland and uninspiring eating habits of white Britons.[52]

Together with Brixton, Handsworth had, during the course of the 1970s, come to symbolise territory that represented the unmistakable emergence and presence of Black Britain. Towards the end of Chapter 1, mention was made of the ways in which, in time, in a profound and audacious manner, second generation Black youngsters would seek to reimagine these economically and socially disadvantaged ghetto spaces (which tended to be under-resourced and over-policed) as counter-cultural zones of resistance and positive affirmation of identity. In the words of Trevor Carter, 'Communities which had been grim ghettoes in the fifties grew into powerful political and cultural symbols for the black population.'[53] To be sure, Handsworth was such a zone of cultural transformation. Following the release of 'Handsworth Revolution', both this community and neighbourhood gained a special and particular place in the affections and empathies of younger Black-British people.

Steel Pulse had the measure of it when they sang (on the track 'Handsworth Revolution') that 'Handsworth means us, the Black people, Handsworth means us, the Black people'. It might not be difficult to imagine the Birmingham of the early to mid 1980s as being a doomed landscape of hopeless contradictions and difficulties. Affluence seemed to be reserved for only parts of the city, while post-industrial unemployment had, since the late 1970s, become an almost inescapable fact of life for many younger people of other areas such as Handsworth. Furthermore, as mentioned in this book's Preface, finding themselves particularly and disproportionately vulnerable to unemployment, Black youth often found that their visibility on the streets for extended periods of time meant they were subject to greater attention from the police. Referring to this conspicuous presence, Bristol reggae band Black Roots mentioned the manifestation of youth unemployment. 'Every day they are walking, walking the streets to kill time.'[54] In this regard, unemployment amongst Black youth had the consequence of bringing with it increased aggravation in the form of police harassment, as a partial consequence of public visibility. While these experiences were a common feature of the Black presence across the country, certain urban concentrations were

Figure 14: English reggae band Steel Pulse in Birmingham, April 1982. Left to right are Basil Gabbidon, David Hinds, Selwyn Brown, Ronnie McQueen, Colin Gabbidon and Steve Nisbett.

able to designate themselves, or be designated, as inspirational zones of Black resistance and fortitude. In the parlance of the time, areas such as Ladbroke Grove, West London, Brixton, South London, St Paul's, Bristol, Moss Side, Manchester and Toxteth, Liverpool achieved a somewhat privileged 'front-line' status.

Steel Pulse's first release had been a 45, titled *Kibudu -Mansatta – Abuku*.[55] It was a song that called for consciousness about African culture and Black history, just as much as it expressed solidarity with sufferers and reminded them of the healing embrace of Jah.[56] Wisdom was again evoked in the opening line of 'Handsworth Revolution', when a centuries old proverb was quoted – 'I say the people of Handsworth, knows that/One hand wash the other, so they say.'[57] As mentioned earlier in this chapter, Rastas designated the whole of the society around them, particularly the twin pillars of church and state, as Babylon, the biblical overtones giving the description a particularly forceful validity. In 'Handsworth Revolution', Steel Pulse evoked the parable of the wise and foolish men, who built their houses on rock and sand respectively.[58] Thus Handsworth was cast as the

rock on which the wise man built his house, even as the wider society was cast as Babylon. 'Babylon is falling / Babylon is falling / It was foolish to build it on the sand / Handsworth shall stand, firm – like Jah rock / fighting back...' If ever there was a single song that contained a wide-ranging manifesto of Black-British resistance and affirmation, this was it. There was even a reference to the place of armed struggle in the Black youth's attempts to confront their oppressors. 'Striving forward with ambition, And if it takes ammunition...' In its declared Pan-Africanist orientation, the song declared 'One Black represents all, all over the world', and to this end, the anti-apartheid struggle in South Africa was evoked as being part and parcel of Handsworth's revolution.

Reggae was the principal means by which the detail of Rastafari spread from Jamaica to Britain and indeed across the world. And once Rastafari had crossed the Atlantic, reggae continued to be the principal and dominant means by which adherents availed themselves of no end of nuanced messages. Furthermore, such messages were simultaneously constructed so as to bring understanding to wider African diasporic peoples about their history and the true nature of their existence. In this regard, the average roots and culture reggae record was a veritable treasure trove of ideas and information. Merger was a London reggae group whose first album, *Exiles in a Babylon*, contained much in the way of clear, succinct and coherent summary on the conditions under which Black people, including Black Britons lived, as well as pointers to the appeal of Rastafari. The track 'Understanding' told of the extent to which exiled Africans were a truly global presence, and in turn, how critically important it was for Black people to 'take a stand' and halt the disempowering feeling of having been scattered to the four winds. The song firmly located London as a space that linked with the African presence in the USA, as much as it linked with the African presence elsewhere in the Americas.

> We are scattered all over the world, from America to London to Jamaica,
> We are scattered all over the world, from Africa to Russia down to Asia,
> For 400 years we've been on the run, on the run, on the run, Now it's time for us to stop and take a stand.[59]

Exploring the greater significance of records such as Merger's *Exiles in a Babylon*, Christopher Partridge, writing in *The Lyre of Orpheus: Popular Music, the Sacred, and the Profane*, noted that,

> Rastas thought of themselves, their roots and their culture, in terms of captivity within an unrighteous system... Indeed, organizing its various millenarian doctrines was an underlying biblically informed exilic discourse. Like the Israelites, with whom they strongly identified, Africans were forcibly transported from the 'Promised Land' to 'Babylon.' It is this narrative that informs an apocalyptic discourse that looks forward to the end of the current exilic period. The time of mental and physical slavery will be terminated, the current world order will end, and a happier existence for black people will dawn. However, again, such theologies were not lifted wholesale from traditional Christian eschatology. As Ennis Edmonds comments, even when African slaves converted to Christianity, the beliefs 'to which they showed the greatest affinity were those that reinforced their Afrocentric worldview, informed their struggle for liberation, and promised them eventual freedom from and redress of the evil perpetuated against them by the colonial system.'[60]

This quote from Ennis Edmonds chimes with Leonard E. Barrett's assertion, quoted earlier, about the potency and primacy of Ethiopia in the religious and other types of consciousness of New World Africans, from the days of slavery right through to more recent times.

In the urban areas of mid 1970s Britain, this enduring appeal of the symbolism of Africa was reflected in the songs of reggae groups such as Merger and Aswad, the young lions of West London. Rastafari regarded itself as having an urgent and important mission of urging and revealing a Black consciousness that made explicit the links between fathoming the reasons for the abuses daily heaped on Black people, an alluring Black homeland, and personal redemption. Hence the need for, and value of understanding, a blessed and enlightened state of being, as well as a mass noun, based on the verb, to understand, proposed in Merger's *Exiles in a Babylon*. Rastafari was here to tell the people that without understanding, they would remain in darkness, without consciousness. The followers of Ras Tafari in 1930s Jamaica were drawn from the most impoverished, darkest skinned, and

most socially marginalised people. Rastafari was a compelling and convincing way of making sense of their condition and circumstance, and the persecution they endured, on account of the outward sign of their beliefs, their dreadlocks, which emphasised the righteousness of their new-found identity. In part, the appeal of this singular and decidedly counter-cultural approach to the growing of hair was based on biblical ordinances such as Numbers 6:5:

> All the days of the vow of his separation there shall no razor come upon his head: until the days be fulfilled, in the which he separateth *himself* unto the LORD, he shall be holy, *and* shall let the locks of the hair of his head grow.

The endemic colour consciousness of Jamaica society, referenced in Chapter 1, was accompanied by an equally pernicious approach to the growing and grooming of hair. Straight hair, almost more so than lightness of skin colour, was taken as evidence of good breeding. Conversely, *nappy* hair, or *kinky* hair, was widely understood to be *bad* hair, which required an almost inordinate amount of treating, straightening and grooming, in order to make it supposedly more attractive and supposedly more manageable. Rastafari rejected what they saw as an imposed manifestation of self-hatred, and unashamedly sought to carry their hair in a *natural* state, that appeared to be near-unkempt, if not wholly unkempt.[61]

Nearly half a century later, in another place and time, the logic of Rastafari again presented itself, but this time to sections of Black Britain, who felt just as put upon as the Jamaican sufferers with whom they now shared a belief system. Young Black Britain's widespread alienation from the land of its birth might well be understandable, given the range of factors discussed thus far in this book, but the embrace of Rastafari was something of an altogether different order, particularly when a fascinating and spellbinding manifestation of Zionism lay at the core of this belief system, born of the African Diaspora. Just as the Jewish people comprised the first diaspora, the state of being scattered as if to the four winds was an identity subsequently embraced with some enthusiasm by the African Diaspora. Likewise, Zionism, the Jewish response to the troubling existence of anti-Semitism throughout the world, gave rise to an Afrocentric version of Zionism, as declared in Rastafari and its antecedents. Though

the precise portion of land to be occupied by the Jewish state proposed by the founder of Zionism, Theodor Herzl, in 1895, was in some doubt, the principle was decidedly clear: Jewish people, should they so desire, ought to have access to a homeland, a safe haven, in which they could avoid anti-Semitism and freely practice their religion and the cultural manifestations of their identity. The biblical story of the Children of Israel's flight from bondage, their extended state of being *lost*, and their subsequent period of triumph in the Promised Land was a narrative much loved by Christians of a fundamentalist persuasion, who viewed it as one of the most gripping and inspirational stories of the Old Testament. It was therefore not surprising that England's Rastas, many of whom had been raised in such Christian households, would gravitate towards their own manifestations of an Afrocentric Zionism. After all, weren't Black people in similar captivity in Babylon? Weren't some Black people similarly burdened with disbelief, obstinacy and stiff neckedness? And hadn't Jah Rastafari provided a Promised Land?[62]

The primacy of understanding and consciousness was evoked, time and again, in reggae music heavily influenced by Rastafari. Aswad's song of 1975, 'Back to Africa'[63] began with an invocation, a plea, to 'Open your eyes, and you will see, a far-off land, for you and for me.' This was a doleful, almost mournful song that encouraged its listeners to 'move yah, back to Africa'. The plaintive sentiments were emphasised by the song's dispiriting realisation that to be born and brought up in Britain afforded no protection from racist abuse and that only fleeing the country, to safer environs, would bring happiness, contentment and growth. With its longing for an idyllic mother land, 'Back to Africa' was a convincing rebuttal of any hope of unfettered and nurturing Britishness. But this was not, of course, repatriation. To be repatriated required someone to have a home to which they could be sent or returned. The National Front, a far right party running rampant through Britain of the late 1970s and early 1980s, may have demanded 'If They're Black, Send Them Back!' but the reality was that few young Black Britons had uncomplicated access to other countries. These youngsters found that their relationship to Britain was similarly complicated and though their passports, birth certificates and accents might all be British, they were in effect strangers in a strange land. This state of being obliged Black youngsters to continue, and in some instances accelerate, the

pace of fashioning a distinct and separate cultural identity, begun by their parents' generation.

While, as noted by Ernest Cashmore in Chapter 1, 'mere blackness was insufficient to bring together the fragmented groups of West Indian [migrants] in England',[64] it fell to the children of this generation to fashion a group identity that paid no heed whatsoever to such markers as Caribbean country of origin, much beloved by their parents. The music groups mentioned in this chapter were products of a multicultural immigrant environment that generated radically different markers of identity. One of the defining elements that made British reggae so unique was the extent to which band members were either born in Britain, or came over as children. They came from countries such as Guyana, Barbados and Jamaica, but in London, or Birmingham, such things simply had no relevance, and they became, above all else, Black. Not even Jamaican reggae had that powerful sense of Blackness born of diversity, though of course an embrace of Rastafari was what many of the country's musicians, singers and groups shared.

Rastafari was, from the mid 1970s to the early 1980s, one of the largest and most important contributory factors in the cultural making of Black Britain. It seemed to its adherents to be tailor-made for the plight, conditions and history of Black people in Britain. Laden as it was with key sophisticated readings of the processes and experiences of dispersal, scattering, racism and discrimination, Rastafari similarly gloried in messages of redemption. Furthermore, its readings and messages were delivered through a range of persuasive counter-cultural sensibilities, and some of the greatest music to come out of the African Diaspora.

In the same way it was reported in the in mid 1970s that, 'reggae, the latest Jamaican popular music, has become 'THE urban black sound in England...'"[65] by the end of the 1980s it could be said that hip hop, the latest American popular music, had supplanted reggae and become THE urban black sound in England, as indeed, hip hop enjoyed similar affection across much of the African Diaspora, and other communities around the world.

4

Leggo de Pen[1]

As mentioned in the Introduction to this book, the *Windrush* generation had been brought up to embrace the finer points of elocution and took it for granted that distinct pronunciation and articulation in the King's or the Queen's English was the hallmark of culture, respectability and ambition. In the 1960s and 1970s, the children of these immigrants were discouraged, in the strongest terms, from speaking in, or mimicking, Jamaican *patois* (sometimes referred to as *patwa* or *patwah*). It was often felt by horrified and disconcerted parents who might hear their children mimicking patwa that speaking in anything other than 'good' English would deny their children professional and societal advancement, patwa being regarded as the language of the lower social orders in the Caribbean. And yet, though many of these immigrants often spoke with a far higher standard of English than many white, British-born people, the dynamic, expressive language of patwa was nevertheless preserved and indeed flourished, having travelled in much the same way as languages have throughout history. This chapter deals with the ways in which, by the end of the 1970s, patwa had become an important signifier and conveyor of Black-British identity.

There were clear and to a certain extent rational reasons, stretching back into history, why many migrants wished to discourage their children from speaking patwa. One of the ways in which enslaved Africans

were broken and then seasoned was through a form of cultural terrorism visited upon them by systems of slavery. Captured Africans, on the slave ship, were in any case purposefully drawn from different language groups, and even those who might have been from the same language group were deliberately kept apart from each other when slaves were shackled. The slavers feared that if enough captured Africans were of the same tongue and within reach or earshot of each other, some sort of coordinated insurrection was much more likely. This strategic undermining (and indeed, recognition) of the power of mother tongues and shared language was the first phase of the slavers' cultural terrorism. The second stage occurred not long before or after the auction block, when captured Africans were stripped of their names and allocated European names chosen by their new owners and brutally enforced by overseers. The stripping away of enslaved Africans' identity began with a denial of their language, and then a removal of their names. Thereafter, slave masters attempted to remove as many vestiges of African cultural identity as they could identify. It was then that the tyranny of the slave master's language came into its own. A common vocabulary of words were *taught* to the enslaved Africans, in an attempt to both eradicate the potency of African cultural identity and to create a universally understood and used series of words with which slaves could be commanded, called, instructed and so on. Enslaved Africans and their children caught speaking their native tongue, or demonstrating any other trait of cultural or tribal retentions, were severely punished.

> [Underneath] this language aspect of slavery… existed a system of brutal force, which made it possible for the Europeans to rob the slaves not only of their liberty but also of the African consciousness. If the slaves were to avoid punishment they had no choice but to understand the orders of their 'masters'. In order to survive it was a must to be able to understand certain necessary parts of this strange foreign language of the whites. Moreover, communication among the slaves themselves was often impossible for, originating from different regions of the African continent, they very often spoke different languages. So, a community, which draws its common strength from the exchange of information, from verbal communication, couldn't come into being. Something which, once realised by

the slave-masters, was used by them to break the spirit of resistance among the Africans by separating families as well as fellow members of one tribe (if that had not 'automatically' happened before, through death or sale).[2]

Nevertheless, the centuries of slavery gave birth to a distinct body of cultural retentions – words, foods and so forth – perceivable amongst communities of new world Africans themselves, though for the most part, slavers saw to it that enslaved Africans knew, understood and communicated in whichever European language was that of the slave master. Mervyn Morris and other researchers have given us reasons to view Caribbean language patterns as displaying evidence of African retentions, rather than African erasure. Wrote Morris, 'Yet in analysing Caribbean creoles, linguists now often show that some of the forms once deemed "corrupt" or "bad" or "broken" English may be better or more fully understood in relation to one or other of the West African languages.'[3]

Over time, in the English-speaking Caribbean, particular types of English came to be spoken by the slave-owning elite, the *plantocracy*, while the slaves themselves used their own versions of the language that had been imposed upon them. This was, though, never a simple matter of the plantocracy speaking one version of English and the enslaved African speaking another. Patwa has its roots in the ways in which enslaved Africans adapted the master's language in order to effectively communicate amongst themselves. This creative approach to language continued after abolition, and indeed continued well beyond the nineteenth century and can be perceived as continuing, in constantly mutating forms, up to the present day. Slaves in the English-speaking Caribbean and their descendants knew or realised that if or when they needed to communicate with the slave master, and in time, the colonial elite, they would need to speak a version of English that most closely approximated that which could most easily be understood by the people to whom they were speaking or responding when commands had been issued. Similarly, the slave master, and in time, the colonial elite of the Caribbean knew or realised that if or when they needed to communicate with their slaves, and in time, with those they perceived to be of a lower social order, that they too would need to speak a version of English that most approximated that which could most easily be understood by the people

to whom they were, again, extending commands, speaking or responding. In this way, peoples of the Caribbean (across the colour-coded, or shade-coded bands mentioned in Chapter 1) came to practice, and to a certain extent took for granted, a complex manifestation of multilingualism. This was, however, a particularly tiered multilingualism which had a distinct pronunciation and articulation of the King's or the Queen's English at the top, and an equally distinct pronunciation and articulation in the people's English, or folk English, located significantly below the King's or the Queen's English.

Frederic G. Cassidy, however, cautioned against too simplistic a reading of these matters, and to this end introduced the notion of a varying bilingualism with distinct speech patterns at opposite ends of a spectrum.

> Jamaica Talk… exists in two main forms, which may be imagined as lying at opposite ends of a scale, with every sort of variation between, but with each variant inclining in some degree toward the right or the left. At one end is the type of Jamaica Talk that aims toward the London 'standard' or educated model, and, in many Jamaicans; usage, reaches it extremely well…
>
> At the other of the scale is the inherited talk of peasant and labourer, largely unaffected by education and its standards… Moving toward the middle from the educated end, one finds an increasing inclusion of local elements – of Jamaican rhythm and intonation, of words that the Londoner would have no reason or need to know, of turns of phrase that have grown up in the island – what may be called 'Jamaicanisms'.[4]

It was in these ways that the most pronounced and least adulterated form of patwa became, in effect, 'a replacement for the real African tongue that had been lost,' and along the way, 'from the time of the planter's society to the present [becoming], a social and cultural force.'[5] By and large, Caribbean-based intellectuals, writers and novelists had always had a pronounced respect for folk culture, including the different forms of patwa spoken across the Caribbean. But this tended to set them apart from much of the rest of polite Caribbean society, which in the mid-twentieth century was scornful of patwa. And it was this attempt at distancing themselves from patwa that was reflected in the attempts by certain immigrants to dissuade their children from using it.

Consequently, patwa could not help but signify rebelliousness, subversion and a powerful expression of an African identity complicated and muddied by slavery. To speak patwa as a matter of course was to identify with the darkest skinned, most marginalised and disadvantaged people in Caribbean society. Those who used patwa as their default language were not only signifying an apparent lack of ambition and inclination to social betterment, they were simultaneously, pouring scorn on the sensibilities and supposed cultural superiority of whites and their fairer-skinned allies. And those who used the King's or the Queen's English as their language of choice were not only signifying ambition and an inclination to social betterment, they were simultaneously pouring scorn on the darker-skinned and supposed rougher elements with whom they came into contact. But as disrespected and scorned as it was, patwa travelled across the ocean, from the countries of the Caribbean, continuing its fascinating mutation that had begun centuries earlier, in events and circumstances leading up to, and following, the auction block. Patwa, or more specifically, its British manifestation, became for many Black youngsters an important and vital lexicon of coded vernacular expression, the use of which signified resistance and defiance, and striving for cultural autonomy, just as much as it had for their ancestors who had so creatively developed it.

The dominant culture has always responded to what it perceived as Black cultural expressions in set and predictable ways, particularly when those cultural expressions had a clearly discernible vernacular or folk dimension. The stock response was to dismiss, ridicule or marginalise such expressions. Speech patterns developed by the people of the African Diaspora have been consistently subject to such treatment. Even within the African continent itself, there exists an extensive history of colonial authorities seeking to discourage African peoples from speaking in their native tongues, with the colonial language being enforced as the preferred or acceptable form of communication. Schools, universities and many other institutions established or run by colonial authorities enforced clear and explicitly *raced* diktats that either forbade native languages or regarded them as inherently inferior to the European languages of the colonisers.

In this regard, there was, and not for the first time, a particular correlation between the treatment of African peoples within the African continent and the treatment of peoples of African origin elsewhere in the world.

Like the slavers before them, colonisers feared that if Africans were freely allowed to communicate in native languages, some sort of insurrection, insolence or resisting of the imposed order was much more likely. As a direct consequence of this, a coded but nevertheless explicit manifestation of linguistic supremacy was established across colonial Africa. This saw those native peoples who became fluent in the master's language as occupying a somewhat elevated social tier, compared to those natives who appeared to understand, or use, little beyond their own languages. These matters, in the Caribbean and in Africa itself, were fiendishly complicated. Not only were enslaved peoples discouraged from becoming too fluent in their master's language, they were similarly discouraged from learning to read and write. Those discovered to be engaged in literacy activities were often severely punished, and those enslaved peoples who indicated an aptitude for the grammatical mannerisms of their masters were regarded with suspicion, and branded *uppity*.

The derision and scorn with which Africans of the colonial era were treated when they demonstrated proficiency in the master's language is revealed in the emergence of the contemptuous term *trousered niggers*, used to describe Africans who had availed themselves of education.[6] The sense that education was not appropriate for Africans and might precipitate disastrous consequences was given unvarnished expression in *Impressions: Nigeria 1925*, written by Douglas Fraser and published in London in 1926. Wrote Fraser,

> We have introduced a form of education to this primitive man, forgetting that he is primitive, and are endeavouring to transform his nature in a decade, to something approaching our own, which is the outcome of centuries.
> The result is that we are producing a type, puffed up with conceit and ridiculous imitation, which considers himself already the equal of the white man.[7]

Fraser would certainly have considered himself a friend of Nigerian people, making his comments all the more troubling, though somewhat typical of the times in which they were written. 'Never fond of manual labour, the native of Nigeria, once he possesses a smattering of education, will sooner starve than do a day's work with his hands.'[8]

The hegemonic response to what were perceived as *Black* cultural expressions was to dismiss, ridicule or marginalise such articulations, as reflected in the range of terminology that came into being to deride such vernacular or folk idioms. Broken English and Pidgin English,[9] were the sorts of terms that were created to categorise Black English as sub par. The specific notion came into being that the mass of Black people of the Caribbean, or of Africa, were communicating in speech patterns regarded as fragmented and incomplete. Furthermore, such speech patterns were characterised or marked by supposedly faulty syntax and inappropriate diction. It was in large measure an acute awareness of the pejorative ways in which patwa was regarded in the Caribbean as well as in Britain that led migrants to discourage their children from acknowledging and seeking to use the language even though, like other forms of English throughout the African Diaspora, it was extraordinarily creative, nuanced, and rich.

Robbie Earle pointed to the sophistication of patwa, noting its ability to 'change from sleepy drawl to violent bark in the space of a sentence.'[10] James Berry for one was near incredulous as to why patwa in its various manifestations could not be both respected and celebrated.

> Who anyway, except the narrow minded, would want a language as rich as Creole to become defunct? 'He bring basketful a mango laas night', 'She come si we tomorrow', 'Man, he mash up!' – Caribbean Creole has a flight of directness, a rhythm and clear imagery that readily leads to poetry.[11]

Berry could well have added that patwa, or what he preferred to called Creole, *was* itself poetry, as well as being tailor-made *for* poetry. The use and elevating of patwa was an act that did much to strengthen, and carry forward, Black-British cultural identity of the mid to late 1970s onwards. This audacious response was all the more remarkable because the pejorative terms for those whose speech patterns supposedly pointed to a limited register of English were applied to British-born and British-raised Black people. In effect, attitudes of linguistic derision (that had been applied on the plantation, in post-slavery Caribbean society and in colonial Africa) were reflected in dominant attitudes towards Black speech patterns in Britain, if such speech and language strayed from that which the society demanded or expected. British society had always held in bemusement,

ridicule and contempt English as spoken by a non-native speaker.[12] Now it extended that same bemusement, ridicule and contempt to Black Britons' use of patwa,[13] even though, as Mervyn Morris so memorably declared, *Is English We Speaking*.[14]

As mentioned earlier, Caribbean intellectuals, writers, novelists and poets demonstrated a pronounced respect for folk culture, including the different forms of patwa spoken across the Caribbean. To this end, the work of poets such as Linton Kwesi Johnson and others were lauded by important figures such as James Berry.

> Dialect – 'Patois', 'West Indies Talk', 'Bad Talk' – has come to be defined and clarified by the term 'Creole'. Use of this language figures largely now in the poetry, drama and general literature of the Caribbean. In Britain, like the West Indies, Caribbean Creole is naturally bound up with the identity of its speakers. An acceptance and recognition of the roots language declares an acceptance of 'black'. Unfortunately it is common among West Indian parents in Britain to regard Creole language as having no educational or advancement value. They apply pre-Independence values to the Creole and will insist on standard English only for their children. Of course standard English is neglected at a great price. At the same time, acceptance of the roots language works as a release.[15]

The above quote comes from a 1981 reprint of a collection of poetry edited by Berry. The first edition, published five years previously, had made mention of the ways in which patwa, being particularly suited to poetry, had also secured for itself, improbably perhaps, an intellectual embrace.

> Westindies Talk, Westindian dialect or Westindian English, which had been the shame of village people suddenly became the pride of university students and city intellectuals. And it is now largely accepted that Westindian English did not develop out of a failure to learn correct English but was a successful response to the need to communicate naturally and well in a new tongue, without formal instruction.[16]

The perception that many West Indian parents in Britain regarded Creole language as having no educational or advancement value was reiterated in

a study titled 'London Jamaican and Black London English', by Mark Sebba. Under a section called 'London Jamaican', Sebba wrote,

> The degree of acquaintance that young London-born blacks have with their parents' native language varieties varies greatly. It is often the case that the parents themselves (some of whom have been in Britain for thirty years) considerably modify their language in the direction of London English, so that their children do not hear Creole spoken at home except in a rather anglicised form.[17]

Sebba then proceeded to make mention of several possible contributory factors, the most important of which he identified as 'the low esteem in which Creole languages are held by the parents themselves (an attitude they would most likely have brought with them from the West Indies) and negative attitude to, and misunderstanding of, non-standard varieties of language that still prevails in many schools'.[18] Despite the apparently widespread attempts by Caribbean migrants to distance their children from patwa, for the most part, the attempts ultimately proved futile and the expressions of the Dub Poets, both written and aural, were an intoxicating revelation about the power of patwa, not only in and of itself but also, and importantly, as a vehicle for communicating the clearest of sentiments regarding Black-British experience and identity. Patwa was after all 'primarily the language of the youth culture associated with reggae, Rastafari and "sounds"'.[19] From the late 1970s onwards, emerging oral cultural expressions of Black Britain, including those that utilised patwa, were of increasing appeal to other communities and identities. As Sebba noted, 'this culture has itself spread outward and attracted many people from outside the black community, so the language, London Jamaican, has been acquired by white as well as black adolescents.'[20]

In his study, *Dub Poetry*, Christian Habekost mentioned the work of a pioneering linguist on Caribbean language, Frederic G. Cassidy[21] and his description of folk language as a 'hot pepper pot'. Wrote Habekost,

> 'White' English is quantitatively the strongest ingredient in this pepperpot, contributing the basic structures, the bulk of vocabulary and certainly grammatical features. But it is the African words, syntactical features and almighty intonation, its

rhythm, that gives 'Patwa' the distinctive and hot flavour Cassidy is talking of. Moreover, there are other elements that had, and still have, their influence on Jamaican language: the Spanish of the very first occupants of Jamaica, some Indian and Chinese, brought to the island by the 'Coolie' and 'Chineyman' immigrants, not forgetting the ever growing invasion of American styles and idioms.[22]

Though Habekost displayed a profound ignorance as to the first occupants of Jamaica, and issue could be taken with both the status and place he allocated 'White' English and the terms he used to describe immigrants from different parts of Asia, his comments nevertheless spoke to the mutation that was and remains a characteristic feature of patwa. This mutation continued when the language arrived in Britain, and a variety of British influences became discernible in the work of Linton Kwesi Johnson et al. These poets unflinchingly took a variety of the experiences and thinking of Black Britons and in ways that were both exquisite and profound fashioned an art form that propelled and expressed new or evolving forms of identity.

No one knows precisely when the term dub poetry first started to be used, though Linton Kwesi Johnson made mention of it in an important text of his from the mid 1970s, to 'Dread dub-poetry'. Even so, leading exponents of the art either disavowed knowledge of the origins of the term, or else they claimed the term to have only a partial relation to what they did. Yet,

> In spite of all these difficulties with the term when it is used to define the individually very different works of the poets, Dub Poetry has established itself as a general label to describe not only an art but a movement, one of the most important militant voices of the Africans/Blacks in the Western world.[23]

Dub (which had existed as a casual metaphoric verb in reggae lyrics for quite some time)[24], was a brilliant word to link to this bold new form of poetry. It was a type of reggae-based music that developed its own cult following in its halcyon days of the late 1970s to mid 1980s. An extraordinarily creative genre of music that grew out of reggae music in the 1960s and 1970s, dub consisted, for the greater part, of instrumental remixes of existing recordings. Dub first emerged within the context of the flip side

Figure 15: 27 April, 2008; Indio, CA, USA; Poet Linton Kwesi Johnson reads during the 2008 Coachella Valley Music and Arts Festival, at the Empire Polo Club.

of more conventional or traditional vocal-based songs and became much more than the instrumental B-sides to which they owed their origins. Though Christian Habekost dramatically conflated the time between the convention of a reggae single having an instrumental version on its B-side, and the distinct emergence, in its own right, of dub music, his summary in *Dub Poetry* was nevertheless useful.

> On the A-side of a single the original or title song is to be found, the B-side consists of the 'dub' or 'instrumental version'. This is 'dub': an instrumental, a remixed version of the A-side of the single very often with technical effects. Bass and drum are even more upfront and this rhythmic frame becomes a veritable playground for producers and mixers behind their studio desks.[25]

Dub music was characterised by its bold manipulation and reshaping of recordings, almost to the point of abstraction, or the point to which the dub version was an entirely different product when set alongside its erstwhile original. A dominant trait of dub music was its notable editing or removal of vocals from an original recording, and its emphasis on an often booming bass, which carried the music, and enabled listeners to greater appreciate the stripped-down 'riddim' of the track. There was no one single type of dub, and its creators ensured that a range of products were available, from the decidedly mellow to the much more aurally strident. Techniques for its creation included for some dub masters a reliance on such things as echo, reverb, panoramic delay, while other exponents of the craft used the occasional dubbing of vocals or instrumental extracts, all potentially from either the original or other recordings.

Dub was, above all else, a decidedly counter-cultural type of music. It was, it seemed, deliberately challenging of the commercial ways in which music was often listened to. Dub music defied radio airplay and the only record shops that respected it enough to play tracks in full were the reggae shops that sprung up in and characterised Black neighbourhoods. Dub tracks were not often of the usual three-minute duration of the traditional pop song, and a recording could last any number of minutes. In that sense, and perhaps others, dub music was more akin to an orchestral score or movement. It was not danceable in the same ways that more commercial music aimed to be, and it resisted the cult of the star singer that was a feature of all sorts of popular music, including reggae. Often played in nocturnal, near-subterranean spaces – some filled with ganja smoke – dub music, in its glorious abstraction and simultaneous near militaristic precision of the beat of the drum, was perfect for communicating all manner of sentiments that the music implied and its listeners inferred.

Also remarkable about dub were the ways in which it pointed to another profound interplay between the music of Jamaica and the Black music coming out of London. Though there was a culture of treasured dub plates coming in from Jamaica, for sound system operators London-based groups such as Aswad proved that meticulously crafted dub music could be produced on British soil. What dub music evoked, just as much as what dub music was, was near perfect for the sensibilities of the work of poets who, like dub music itself, represented an equitable exchange between Jamaica

and Britain. Dub poets of Jamaica took their place alongside equivalent practitioners emerging from English cities such as London and Liverpool. Dub music, much like more dominant forms of reggae, provided great solace and enjoyment to its listeners. As Michael Smith referenced in his poem 'Long Time', 'Dancin to de sounds of de dub, we find dat dis was we only fun'.[26]

From the mid to late 1970s to the mid to late 1980s, dub poets carried the swing, performing regularly in a wide range of venues. And despite its association with a particular form of amplified music, poets often needed little or no accompaniment to perform. Many performances of dub poetry featured only the poet him- or herself or, on frequent occasion, just the accompaniment of a drummer. With the drum being 'the original expression of Africa's presence in the 'New World',[27] it was a particularly gripping, evocative and bold sound to accompany this new form of message-laden poetry. The combination of the righteous spoken word, delivered over, or in line with, an equally righteous drum beat, created a profound equation. Word, sound 'ave power,[28] or, word and sound equals power.

Schoolchildren from all sorts of backgrounds had been introduced to the work of poets such as Browning of the Victorian era, or the later Romantics, Byron, Keats and Shelley, but dub poetry was something of an altogether different order. Poetry was generally regarded as a rarefied interest of a cultured elite, but the dub poets put paid to that mindset and made poetry real, immediate and relevant to all sorts of new audiences. When Black Uhuru toured Britain in the early 1980s, the Jamaican poet Michael Smith opened for them, indicating the extent to which poetry had become, for some, unashamedly enjoyable and socially relevant. Rooted in diasporan sensibilities, poetry became an important dimension of wider cultural expression, reflected in such things as the regular performances of Black poets at all manner of events, including the legendary poetry showcase that took place at the first International Book Fair of Radical, Black and Third World Books in March 1982.

> The most important medium for a Dub Poet to spread his word is the live performance. Whether in small clubs, youth centres, community halls, schools, universities or large concert venues, whether accompanied by a band, drumming or just a voice on

its own – seeing a Dub Poet live one realizes that there is more to it than a simple poetry reading.[29]

As indicated in Chapter 2, young Black Britons were developing a range of identities, which were cohering around different musical tastes. Pointing to the broad range of musical styles that Black Britain gravitated to, Dennis Bovell recalled,

> If you look back to the sixties and early seventies, black kids in London just liked black music – it could be James Brown or Otis Redding or Nicky Thomas or the Pioneers or Kool & The Gang or Betty Wright or the Equals.[30]

But as the 1970s wore on, particular musical expressions began to dominate, even as popular Black music, including that from the USA, continued to be enjoyed. 'Once roots and culture took over... this new reggae was all about Jamaica, indeed all about one aspect of being Jamaican – sufferation.'[31] This locating of sufferation at the heart of constructions of Black-British identity was something earnestly appropriated and extended by the dub poets. Music such as Lovers' Rock was all well and good, but the coming of the dub poets signalled the extent to which *reality* was central and could not, would not and should not be avoided. 'The famous "message" is there straightaway: direct, simple and without superfluous linguistic ornament. "Reality" is at the centre of all poetic creation.'[32]

The US Black Arts Movement, which took place approximately a decade or so before its British equivalent, had seen an enormous growth of the numbers of young African-American people regarding poetry as a legitimate and important vehicle through which to articulate their feelings, experiences, frustrations and aspirations. Perhaps, had the times in the USA (the mid 1960s through to the mid 1970s) been less fractious, fewer African-Americans might have turned to the arts to express themselves. For Black Americans, however, the arts had always been a vehicle for self-expression of matters in the social, political and racial realm, so perhaps in some respects the Black Arts Movement simply reflected a greater appreciation of this. Whatever the reasons, the USA witnessed an extraordinary growth in numbers of Black poets and also a growth in numbers of those who appreciated their work. The popularity of new African

American poets such as Gil Scott Heron and the Last Poets (much like the subsequent popularity of the dub poets), owed much to them taking the day-to-day challenges of Black people's existence as compelling subject matter for their poetry. Some of these poets, and their advocates, believed that such arts activity was subservient to a greater social and political struggle and was, or ought to be regarded as, a tool, a means towards an end. One such advocate, Sherry Turner, in a text that reflected the then emerging US Black Arts Movement, cited the Last Poets as an example of arts-as-activism. Turner let it be known that 'The name of the group ... comes from a poem... which says after *this*, there will be no more poetry, no more poets, only the sound of the spear turning in the marrow of the oppressor.'[33]

Pretty much the same sorts of growth in a noticeably politicised expression of the arts occurred in Britain in the late 1970s, again for approximately the greater part of a decade. While of course certain poets have continued to develop and practice their craft in the decades beyond the 1980s, Black Britain gave rise to a significant number of people who felt able, or compelled, during the heady days of the late 1970s and 1980s, to commit their feelings, experiences, frustrations and aspirations to verse and rhyme. Benjamin Zephaniah spoke of the process of using mundane or everyday experiences of racism as a basis for poetry. 'Poetry for me was walking down the road getting beaten up by some pigs, coming home and writing down the anger. Poetry for me was walking down the road, getting stopped and searched, not knowing why, coming home and then writing down why.'[34]

In dub poetry, Black Britain had finally found a way of committing to verse and rhyme its experiences and challenges. Similarly, in dub poetry, young Black Britain saw a range of telling, expressive and articulate reflections of itself, unlike any other. In the history of British poetry recorded onto cassette or vinyl, such products had rarely been best sellers,[35] yet for a while, the dub poetry of Linton Kwesi Johnson and several others were best-selling records and tapes, in which the bold use of patwa added a powerful frisson of excitement. Though the brightest and best of the dub poets had brilliant, disciplined minds, there were ways in which the genre had a particular appeal to would-be practitioners and exponents. There were, in simple terms, 'no common rules of spelling.'[36] The written word

was based solely on a written phonetic understanding of the spoken word. For some, this presented particular challenges in reading dub poetry, but the abandonment of what were widely perceived as dictatorial and discriminatory rules of English grammar, spelling and syntax gave succour to the notion that patwa was a vibrant language, every bit as important as any other.

> In England Linton Kwesi Johnson and Shakka Dedi especially have thought hard about how to abandon antique English spelling conventions to find an adequate way of writing their own Nation Language. They simply follow phonetic rules writing exactly what they hear. Examples for this are Shakka Dedi's 'Wan Struggul' or Linton's ...'Klassikal Dub'... Music becomes words and words become music and the rhythm is omnipresent.[37]

In some respects, the loosening of linguistic shackles that freed up the most astonishing creativity of dub poetry had been reflected in the embrace, by some young Black Britons, of Rastafari. Rastafari eschewed hierarchy, organisational structure and extensive dogma. At its simplest, adherents were required to do nothing other than 'knot up your hair, and lead a righteous life.'[38] This simple, unrestrained admonition enabled adherents to interact with Rastafari in markedly expansive and individual ways.

There are several other senses in which dub poetry was foundational to the strengthening of a distinct Black-British culture of the mid to late 1970s. Quite apart from their identities as latter day *griots* – those West African folk historians, storytellers, praise singers, poets and repositories of a tribe's oral histories – dub poets were also compelling communicators of Caribbean oral histories. The children of Caribbean migrants had often grown up in households in which folk proverbs, sayings, expressions and utterances were frequent linguistic and conversational currency.[39] Sometimes, sayings such as 'Who can't hear must feel', or 'Who won't hear must feel' were evoked as a threat or warning of a beating to be administered, by an exasperated parent, on a supposedly unruly child, or such sayings accompanied said beatings. Thus, the richness of Caribbean language was gratefully used by dub poets. 'Language-wise everything which the rich word-power and the multi-layered culture of Jamaica can offer is used: "street talk"... proverbs, nursery rhymes, riddles, folk songs.'[40] Furthermore, certain dub poetry was

resplendent with the sorts of near-archaic, old-time language and terminology that had either travelled from the Caribbean, or was used by an older generation of Caribbean migrants, thereby demonstrating another instance of dub poetry as cultural retention, alongside its other attributes. In Linton Kwesi Johnson's 'Want Fi Goh Rave', one of the poem's protagonists declares, "Mi naw wok fi noh pittance, Mi naw draw dem assistance." Pittance, meaning a very small or inadequate amount of money, was a well-understood word, though not exactly a word otherwise in everyday usage by younger generations. Similarly, the act of 'drawing assistance', meaning to sign on for unemployment benefit, was a term that had tended to be used by migrants of an older generation.[41]

The cover of *sounds*, a British music magazine, of 2 September 1978 carried a full-page photograph of Linton Kwesi Johnson, which appeared to show Johnson looking out from behind two vertical bars, giving the appearance of a prison cell. The photograph, and its messages, could not have been clearer or more explicit. Not only was Johnson (or 'LKJ' as he came to be known) communicating his own experiences and opinions, he was, simultaneously, expressing the sentiments of a much wider body of people – Black like him, British like him. To this end, the magazine cover declared Johnson to be 'The Voice of Black Britain'. Within the text itself, this sentiment was reiterated, with Johnson being introduced as 'The first artist to deal with the reality of the Black experience in Britain.' By the end of the decade, Johnson had been the subject of a number of such features, attesting to the ways in which this intriguing new form of poetry, and indeed, his own contributions to its development, were of singular interest to journalists and filmmakers. Two years after the *sounds* piece, the *Sunday Times magazine* of 3 August 1980 carried a feature on Johnson which introduced him as 'poet-in-residence to the streets of Brixton, and his LPs are best sellers.'[42] The piece went on to state,

> Transplanted from rural Jamaica to Brixton 17 years ago, aged 11, Johnson has become the voice of that generation of young blacks who were born in or have grown up in this country.
>
> Which means his work necessarily addresses itself to the everyday humiliations of discrimination and harassment, enforced idleness and poverty, and predicts relentlessly but

quite matter-of-factly the inevitable consequence: How can
there be calm when the storm is yet to come?'[43]

Johnson proved himself to be a particularly vociferous, trenchant and ener-
getic critic of the existing order, in his poetry, in his interviews and in his
activism around the Race Today Collective. When interviewed, he missed
no opportunity to table the most withering of criticisms. Since the 1960s,
Britain had been developing what became known, in some circles, as the
race relations industry – heavily bureaucratic initiatives, generated and
endorsed at local or national governmental levels, that seemed to produce
not much more than jobs for a few and masses of paperwork. Similarly,
going back as far as the mid to late 1940s, beginning with K. L. Little's book,
Negroes in Britain: A Study of Racial Relations in English Society (1947),
there had come into being a sizeable corpus of literature on the experi-
ences of Caribbean immigrants to Britain, most of it of an anthropological,
sociological, ethnographic or journalistic bent.[44] These books, which by
the early 1980s were significant in number, existed in their own marginal
world – of sectional interest to some academics, but irrelevant to the lives
of the ordinary Black people purportedly or ostensibly the focus of such
studies. Johnson's commentaries, his books of poetry, his recordings, were
of an altogether different order. Frank, prescient, empathetic, Johnson's
opinions, and those of other dub poets, were hardly found elsewhere.

> Alienation, though, is not a word that finds a place in Linton
> Kwesi Johnson's vocabulary. 'The newspapers talk about "alien-
> ated young blacks",' he has said, 'but they've made a clear
> choice: young blacks are saying that we are not prepared to live
> under the demoralised immigrant status that our parents lived
> under; we're not going to do the same shit work they did – still
> do: and we're not going to go through the demoralisation of the
> social security system. So we will survive by any means neces-
> sary, even if it means crime.'[45]

Learned, cultured, educated, Johnson had a brilliant mind and his com-
ments in interviews casually betrayed these aspects of his identity. The
sentiment 'So we will survive by any means necessary' evoked not only
the legendary pronouncement of Malcolm X, but also the celebrated and

respected French intellectual Jean-Paul Sartre, who first used the phrase in his 1963 play *Dirty Hands*. It was, though, through the militant assertion of Malcolm X that the phrase gained Afrocentric familiarity and affirmation. Addressing audiences through the platform of his new organisation (formed after he split from the Nation of Islam, the organisation for which Malcolm X had been an energetic minister), he proclaimed in 1964:

> We declare our right on this earth to be a man, to be a human being, to be respected as a human being, to be given the rights of a human being in this society, on this earth, in this day, which we intend to bring into existence *by any means necessary*.[46]

This electrifying declaration spread through the printed word, but also through the recorded word, as vinyl recordings of Malcolm X's speeches became popular. This legendary utterance clearly left open the possibility, or the option, of armed resistance as a legitimate tactic in defence of human rights. In the face of aggression and terror, Malcolm X tabled the view that Black people should use whatever means it might take to counter the abuse of Black life – a sentiment with which Johnson very much seemed to concur. Citing several reggae songs in one particular passage of a foundational text written by Johnson in 1976, he stated, 'We get the feeling from these songs that the oppressed Jamaican has decided that it is only a matter of time before armed struggle shall be launched and that they are prepared for it.'[47] Indeed, a number of Johnson's poems appeared to allude to the credibility of violence, when turned against the oppressor. In 'Reggae Sounds', Johnson intoned,

> Ridim of a tropical, electrical storm
> Cool doun to de base of struggle
> Flame ridim of historical yearnin'
> Flame ridim of de time of turnin'
> Measurin' de time for bombs and for burnin'
> Slo' drop, make stop, move forward
> Dig doun to de root of pain
> Shape it into violence for de people
> They will know what to do, they will do it[48]

As referenced in the previous chapter, Birmingham's Steel Pulse had also unapologetically made mention of what the group saw as the credibility of armed struggle, in their seminal track, 'Handsworth Revolution': 'Striving forward with ambition, And if it takes ammunition...'[49]

Johnson appended his evocation of Malcolm X's quote with 'even if it means crime', which pretty much steered the sentiment in a particular direction. This frank declaration was echoed in the type of reggae music to which dub poetry paid homage. Chapter 3 quoted a line from a song by Bristol roots reggae band Black Roots about Black youth's experience of unemployment: 'Every day they are walking, walking the streets to kill time.'[50] However, the next line of the song is: 'No money in their pocket, so now they must commit crime.' With such lyrics, attempts were made to forge a causal link between economic conditions and criminality, though the wider society, and its institutions of law and order – particularly the police and criminal justice system – needed no encouragement in its pathology of equating Black youth, *en masse*, with criminality, and consequently the need for that alleged or apparent criminality to be met with draconian policing and incarceration. Aswad, too, had advanced a causal link between economic conditions and criminality, in their track of the early 1980s, 'Not Satisfied'. In the wake of the riots of St Paul's Bristol, 1980, and Brixton, 1981, followed by unrest elsewhere in the country, 'Not Satisfied' emerged as a cogent document of both Black youth disaffection and dissatisfaction. 'Problem time like this, I've seen youth who've turn to crime. They, looking a way to keep their head above the water...'[51]

To be sure, Johnson's comment 'So we will survive by any means necessary, even if it means crime'[52] (a reflection of sentiments on tracks of his such as 'Want Fi Goh Rave')[53] would have appalled God-fearing, church-attending, Caribbean migrants and their children who aspired to be law-abiding citizens. Even Black people who held no candle for organised religion would have been discomfited, particularly by the knowledge that such opinions had a wider circulation and would be read by white people, many of whom needed no encouragement to regard Black people as having some sort of propensity to criminality. But Johnson had deliberately oriented his poetry towards the notion that he was the voice of the voiceless, and as such wrote poetry and made comments with particular constituencies in mind. Chapter 2 of

this book alluded to the pathology of regarding Black people as 'problems', a mindset established in tandem with the first batch of post-war Caribbean migrants.[54] In 1957, Joyce Eggington published *They Seek a Living*, which was trailed as:

> In the summer of 1948 there steamed into Tilbury a dirty white troopship with a number of refugees abroad. With them were more than four hundred Jamaicans who had made the journey because they saw no future in their own land. These were the first of thousands – scarcely noticed at the beginning, so infrequently did they arrive. But soon the trickle became a flood, and the flood became a problem which has yet to be solved.[55]

But in an act that was both audacious and defiant, Johnson declared that marginalised and disenfranchised Black Britons had no end of problems with the society around them.

Echoing the attention to London paid by Jamaican reggae artists of the 1970s and beyond, Britain of the early 1980s became a favoured destination for Jamaica's accomplished and stellar practitioners of dub poetry, such as Jean Binta Breeze,[56] Mutabaruka, Michael Smith[57] and Oku Onoura. Many of these poets performed regularly and extensively in the sorts of venues mentioned earlier – small clubs, youth centres, community halls, schools, universities or large concert venues. And with their British equivalents such as Shakka Dedi,[58] Anum Iyapo, Benjamin Zephaniah, Levi Tafari, Frederick Williams and Amon Saba Saakana[59] being similarly active, such poetry became a vital means of expression and communication, and was appreciated by significant numbers of Black Britons. Furthermore, cassettes or records of poetry, as well as books of poetry, were often available for sale at performances, thereby ensuring that no end of strident reflections on Black-British or African diasporic experiences and identities had a greater dissemination.

It was in many respects no surprise that dub poetry should be so comprehensively linked to Linton Kwesi Johnson. After all, in the mid 1970s Johnson had penned, a text that became something of a manifesto for the genre, with its emergence still some way off into the future. Paying due deference to the influence and some of the ideas of Rastafari, particularly around such things as the belief system's construct of Babylon,

Johnson's text was in some respects linked to Jamaican music's pronounced articulation of *sufferation*. Though there was a solitary reference to 'Dread dub-poetry', Johnson's text, 'Jamaican Rebel Music', which appeared in *Race and Class*, XVII, 4, 1976, introduced its readers to the term dub-lyricist, used repeatedly throughout the text. The 'dub-lyricist' was

> the DJ turned poet. He intones his lyrics rather than sings them. Dub-lyricism is a new form of (oral) music poetry, wherein the lyricist overdubs rhythmic phrases on to the rhythm background of a popular song. Dub-lyricists include poets like Big Youth, I Roy, Dillinger, Shorty the President, Prince Jazzbo and others.[60]

'Jamaican Rebel Music' was a text that both pointed to Johnson's influences, and to the characteristics that would come to inform his own work and could in large part be used to describe the work of other dub poets. For example, referring to a song by Toots and the Maytals, Johnson observed, 'Here the lyrics are sung in the first person, so that it is the individual experience, the personal situation, that informs the song. But the individual experience is the experience of all.'[61] Much of the power of dub poetry, and its attraction to young Black Britain, came from its insistent use of the first person. 'Want fi Goh Rave', referenced earlier, was a perfect example of the power of the first person narrative, and its ability to create empathy. The poem begins with:

> I woz
> Waakin doun di road road
> Di addah day
> When a hear a lickle yout-man say

This was a recollection of something that might otherwise have been a pretty mundane experience – that of someone walking along the road. This person, however, is attuned to the speech and language of the Black youngsters with whom he casually comes into contact as he passes them by. And it is this demonstration of empathetic hearing/listening that opens up the multiple declarations of resistance and defiance that give the poem its content and its power.

Johnson read Jamaican reggae in much the same terms in which his own dub music would come to be read.

> I say it again: the popular music of Jamaica, the music of the people, is an essentially experiential music, not merely in the sense that the people *experience* the music, but also in the sense that the music is true to the historical experience of the people, that the music reflects the historical experience. It is the *spiritual expression* of the *historical experience* of the Afro-Jamaican.[62]

Johnson was by no means the only person to pick up on this fascinating, foundational aspect of Jamaican reggae. At the time Johnson penned his text, a notable cluster of British reggae bands was taking centre stage in Black-British music, taking their cue, to a large extent, from the preoccupations of their musical mentors. It was this that informed Lloyd Bradley's comment that new British reggae was 'all about Jamaica, indeed, all about one aspect of being Jamaican – sufferation.'[63] Though Johnson discussed reggae and its assorted social and cultural significances in particularly rapturous terms, there were those who suspected that the rise of *roots reggae* and *roots and culture*, in part at least, was due to other factors. Bradley, in his study of the history of Black music in London, saw the genre of lovers' rock, a popular socially light form of British reggae that invariably focussed on romance and affairs of the heart, as effectively being muscled out by its altogether more socially boisterous and explicit rival. Wrote Bradley,

> Lovers' rock may have struck a resonant chord with young black Londoners, but it found itself at odds with the roots reggae that was then enjoying such a high profile. In Bob Marley's slipstream, record labels like Island and Virgin were marketing acts like Burning Spear, Max Romeo, Lee Perry, Big Youth and Culture to rock fans, and shifting serious amounts of albums. The music media gave unprecedented space to reggae, as large sections paired it up with punk to promote an apparent alliance of the oppressed.[64]

In this regard, dub poetry may have been the net beneficiary of a fortuitous confluence of factors, in which its messages of reality, sufferation and resistance found ready audiences, already attuned to the social vibrancy of reggae, and a music industry minded, in Bradley's view, to promote these

messages. Bradley identified what he regarded as 'the changing perception of black music within the British music media.'[65]

> Post-Motown, black music wasn't supposed to be frivolous. To be taken seriously in the 1970s, it needed to have a purpose, which usually meant being an expression of pain and suffering or a protest against injustice.[66]

Given that Jamaica was the largest of the Caribbean's English-speaking islands, it was perhaps not surprising that the factors and ideas Johnson identified in his 'Jamaican Rebel Music' text would come to such have a marked influence on Britain's aspiring Black poets. But there were other ways in which Jamaica and its cultures dominated the construction of Black-British cultural identity from the 1960s onwards. Though it had both a smaller land mass and population than Jamaica, Trinidad and Tobago had given rise to important and loved musical genres such as calypso, which had developed during the early to mid-twentieth century. Even so, Jamaican reggae was the music of choice when many Caribbean migrants socialised, leading to manifestations of Jamaicanness among the children of these migrants that may well have been reflected in the ascendancy of Britain's dub poetry. What might be regarded as a diasporic pan-Caribbean gravitation towards Jamaican music and cultural mannerism was echoed in comments by Victor Romero Evans, himself a 'lovers' rock icon.'[67] According to Evans, 'Even though my parents are from St Lucia, when they had a party the music would be reggae.'[68] Janet Kay, who could similarly be described as a 'lovers' rock icon,'[69] made mention of Jamaican identity as, in some instances, either an assumed or a feigned one:

> We all assumed we were all Jamaicans and nobody bothered to correct anybody. You'd never have known Dennis [Bovell] was Barbadian by the way he spoke, you'd naturally think he was Jamaican. You'd never have known that Drummie or Brinsley from Aswad weren't Jamaican by the way they spoke. But they're Grenadian and Guyanese.[70]

In 1978, while simply going by the street name 'Poet' and working with his band, known as 'the Roots', Johnson released his first album of poetry, *Dread Beat an' Blood*. A year previously he had released his

first recording, a 12-inch single, with 'All Wi Doin Is Defendin' and 'Five Nights of Bleeding' on the A-side, and dub versions on the reverse. Typical of the profound multi layering and open-endedness of patwa (despite its frequent strident and assertive tone), 'All Wi Doin Is Defendin' could be taken as meaning either that Black people should go on the attack, as all they were doing was reasonably defending themselves rather than taking the fight to the aggressor, or that what might look like aggression on the part of Black people was in actuality no more than defending themselves, which was all they were doing. Released on the Virgin label, the press release accompanying the release of 'All Wi Doin Is Defendin' and 'Five Nights of Bleeding' was simply titled 'POET'. It offered a substantial introduction to Johnson, both his biography and the significance of his poetry. After stating that Johnson 'grew up in Brixton, one of London's largest black communities, and his experiences there became the basis of the raw material of his poetry'[71] and that he was 'a sociology graduate',[72] the press release continued ' "Poet", as he is known locally in Brixton, began writing poetry around 1971, as a direct result of his involvement in the struggles of the black working class in Britain'[73] and went on to state,

> His poetry has been widely read in Britain to large audiences, as well as on radio in the Caribbean and on BBC television. *Dread Beat and Blood* has proved to be one of the most popular books of poetry to be published by a black writer in Britain in the black communities up and down the country. The book is being used in some secondary schools (perhaps as a means of capturing the interest of black youths who are becoming increasingly indifferent to what the British school system has to offer) and is already having a marked influence on a new generation of emerging British black poets.[74]

Subsequently, the press release continues,

> His poetry deals with the concrete social realities of life for blacks in Britain in general, and black youths in particular. He works within the Jamaican oral tradition, employing the rhythms and nuances of the Jamaican creole language and his poetry belongs to the same oral tradition of dee-jay dub-lyricists like U Roy,

Big Youth, Dr. Alimantado, Dillinger and others.

But unlike the dub-lyricist who improvises words to fit a pre-recorded rhythm, the music in 'Poet's' poetry comes out of the poetry itself. With his first record, 'Poet' has introduced a new dimension to both oral Jamaican poetry and music by means of a synthesis of both, creating 'reggae-poetry'. The marriage of his words to reggae rhythms is a natural progression of 'Poet's' art since he has always worked within a musical mode.[75]

It was clear, through Johnson's poetry, that he regarded the dub-lyricist as being uniquely gifted and uniquely placed to undertake a number of socially informed roles, as a commentator and a conduit of the hopes, aspirations, frustrations and grievances of the people. After all, Johnson had, in his 'Jamaican Rebel Music' text, identified some of the ways in which the Jamaican DJ had not only to develop gladiator-like linguistic skills with which to fire up fiercely partisan sound system devotees, but also had to develop verbal skills with which he could pacify audiences that were susceptible to outbreaks of violence in the dance hall. 'Whenever two rival sound systems meet, violence often erupts between the rival supporters, so the DJ is often both the musical pace setter and the musical peace keeper.'[76] But while Johnson's beloved dub-lyricists often spoke of a tortured history that stretched far back into the days of slavery, Johnson himself addressed altogether more recent episodes in history – specifically Black-British history, not only in London, but also in towns and cities such as Bradford.

Virgin information's press release ended with references to the sorts of histories Johnson was particularly interested in articulating and commenting on.

Both 'All Wi Doin Is Defendin' and 'Five Nights of Bleeding' are taken from the book, *Dread Beat and Blood*. The first poem is a poem of defiance, written in 1974 at the height of the police's anti-sus[77] campaign against black youth and, in a sense, predicted the violent confrontation which later occurred between black youth and the police. 'Five Nights of Bleeding' was written in 1973 and deals with a number of violent incidents involving black youth that year. This poem, like some of the others in 'Dread Beat and Blood', addresses the ambivalent nature of the violence experienced by young blacks in Britain – the violence

that is inflicted upon them by oppressive agencies and the violence they inflict upon themselves.

'Command Counsel Dub' and 'Defence Dub' [on the reverse side of the recording] are riotous rhythms which depict, in their dramatic urgency, the rhythms of violent confrontations like the events of the now infamous Carnival '76.[78]

For all its newness and its explicit focus on articulating and reflecting the disappointments and challenges of aspects of Black-British experiences, dub poetry could be linked to other important influences. Pioneering Jamaican poet James Berry was a key figure in the development of distinctly Black, or distinctly Caribbean, forms of British poetry. Like so many other Caribbean people, he undertook to travel beyond his native Jamaica at an early age, in search of employment. Berry worked, as did so many others, as a farm labourer in the USA, in the early to mid 1940s. As discussed in Chapter 1, many of the early post-war migrants to Britain had experience of travelling beyond the Caribbean, for either military service, for King and Country or in search of work in Central America or the USA. Linton Kwesi Johnson was himself acutely aware of these histories of migration, and in his text he had linked the yearnings of Rastafari for a better life, in a better place, with the early to mid-twentieth century patterns of movement in which James Berry and others were involved. Wrote Johnson,

> The rastafarian's demand of repatriation back to Africa then is not unreasonable or unrealistic but quite legitimate. And it is the historical experience which legitimizes this demand. In fact it was the same hopelessness and despair which substantiates the rastafarians' demand that led to mass emigration since the turn of the century to places like Cuba, Panama, North America and the UK.[79]

While the *Empire Windrush* has achieved near-legendary status, in certain quarters, for the part it played in the making of Black Britain, the vessels laden with Caribbean people that arrived in the aftermath of the *Windrush* are relatively unknown. It was on one of these vessels, the SS *Orbita*, that a young James Berry, then approaching his mid twenties, arrived in 1948, settling in London. Over the course of the decades since his arrival, Berry's poetry

has distinguished itself for its bold and distinctive mixture of what might be termed *standard* English and Jamaican patwa. This respect for, and access to, very different but in many ways complementary linguistic traditions made Berry perfectly placed to edit anthologies of the work of Caribbean poets based in Britain. The first of these anthologies was *Bluefoot Traveller*, from which Berry's Introductions in both editions were quoted earlier in this chapter. Ian Dieffenthaller was one of several writers to mention the significance of the anthology. In 'News for Babylon and the Role of the Anthology in the Nineteen Seventies and Eighties', Dieffenthaller wrote,

> In the two decades following the demise of CAM [Caribbean Artists Movement], poets from both the 'oral' and 'scribal' traditions were able to build upon the cross-cultural accommodations described in the work of [Linton Kwesi] Johnson and [Jean Binta] Breeze...[80]

Dieffenthaller went on to describe *Bluefoot Traveller* as 'the first nationwide anthology to really set the scene for West Indian British poets.'[81]

Other commentators were similarly keen to stress that Linton Kwesi Johnson's singular poetry could be seen as evolving from earlier poetic traditions.

> This increase in creole or nation language writing in the 1980s can be linked partly to literary developments in the late 1970s. The emergence of the first dub and other young poets during this period marked not only a newly confident poetic use of creole but also the start of a new receptiveness to literature in a creole idiom. This was largely, but by no means exclusively, facilitate by the new wave of performance poetry being utilized by poets such as Linton Kwesi Johnson, Michael Smith and Oku Onoura who attracted worldwide audiences...[82]

The first edition of *Bluefoot Traveller: An Anthology of Westindian Poets in Britain* had been published by Limestone Publications, London, in 1976; the second edition, some five years later, by Harrap, in 1981. There were marked differences in the tone and content of each edition's respective Introduction by Berry, and in their own ways these introductions tell us much about the evolution of Black Britain between 1976 and 1981, even though both

of these years reflected similar aspects of the somewhat fractious young Black-British presence. (1976 had seen disturbances that pitched young Black males in direct confrontation with the police, around events at the Notting Hill Carnival. This was one of the earliest occasions in which this new Black presence turned on its uniformed, truncheon-carrying nemesis, which had long since declared itself, by its actions, as a tormentor of Black youth. And 1981 had witnessed epoch-making 'riots' that erupted, in the first instance in Brixton, leading Linton Kwesi Johnson to describe them as 'Di Great Insohreckshan'.) Berry's 1976 Introduction was in many respects a dispiriting summary which evoked loss, lack and alienation. By 1981, however, an entirely different sensibility characterised Berry's text, which by now evoked a determined sense of a Black-British *presence*.

Taking issue with what he regarded as 'unduly pessimistic' comments, David Sutcliffe, in his book *British Black English* introduced *Bluefoot Traveller* as containing,

> poetry that is striking in its immediacy, its dialect range and its technically successful handling of this range. James Berry (editor and contributor) is being unduly pessimistic when he writes in the introduction: 'West Indians here are a long way from the dynamic cultural activities of American blacks or their fellow West Indians at home. They are grossly under-explored, under-expressed, under-produced, and under-contributing.' While it is obvious what he means, this volume of poems itself is indicative of a potential that is at least *beginning* to be realized. Linton Kwesi Johnson is one of the most widely known of the poets. He frequently takes on 'the voice of the people', but in this case it is the angry voice of London Black youth. In poems such as 'Reggae Sounds' and 'Dread Beat and Blood' the poet uses a Black English in a way that grows out of the dynamic aspects of the Caribbean voice, where the voice and the movement merge.[83]

By the second edition of *Bluefoot Traveller*, Berry was decidedly more upbeat.

> Since the first *Bluefoot Traveller* appeared in 1976, new developments have called for a fresh selection of poems. Britain's Caribbean community has sharpened its pride in showing its ethnic arts. It involves itself much more intensely with

expressing its cultural background. It has become more active in writing and publishing and in the opening of local bookshops. It is also active in the visual and performing arts and in self-help education.[84]

Reiterating developments in the aftermath of the Caribbean Artists Movement, (as mentioned previously, by Ian Dieffenthaller), James Proctor put the significance of Berry's and Johnson's work into another context – that of 'the racial tensions that had emerged during the time of the Brixton riots of 1981.' Wrote Proctor,

> Linton Kwesi Johnson, who would emerge as one of the key poets of the next generation, has subsequently spoken of the formative influence the [Caribbean Artists] Movement had on his own artistic career. Johnson himself came to embody the new wave of black British writing during the late 1970s and early 1980s, which was largely poetry-based, vernacular, and often overtly political. The work of this [earlier] generation was gathered in anthologies such as James Berry's *Bluefoot Traveller*... Much of it was indebted to [Edward Kamau] Brathwaite's [one of the founders of CAM and a major voice in the Caribbean literary canon] influential call for a new aesthetics of poetry that abandoned the rigidity of the iambic pentameter in favour of 'nation language'. (This at a time when black Britons were being encouraged to speak 'standard' English in order to resolve the racial tensions that had emerged during the time of the Brixton riots of 1981.)[85]

As the originator and the leading exponent of dub poetry, Linton Kwesi Johnson cast an unforgiving and probing light on the Black-British social, cultural and political condition. His poetry was born of a consciousness that extended deep into all manner of histories, cultural and otherwise. The profile on him that appeared in *The Sunday Times* magazine in 1980 mentioned a number of these factors, including old Jamaican work songs.

> Although his early poems were, as he puts it, 'in English', it was under the influence of reggae, as the extract from 'Bass Culture' below suggests, that he started using patois and Brixton street slang in his work. In the tradition of the work-songs

he remembers from his grandmother's small-holdings in Clarendon Parish [Jamaica], it is meant to be spoken rather than read:

muzik of blood
black reared
heart geared;
all tensed up
in the bubble and the bounce
an the leap an the weight-drop
it is the beat of the heart
this pulsing of blood
that is a bubblin bass
a bad bad beat
pushin gainst the wall
whey bar black blood
an is a whole heappa
passion a gather
like a frightful form
like a righteous harm
giving off wild like is madness[86]

The dub poets were not the only ones to embrace patwa. When a new body of Black artists emerged in the early 1980s, they embraced the speech pattern not only in the titling of the first exhibition, *Black Art an' done*, but also within works such as 'who nuh Black no nah guh Black agen', its text screenprinted in black, onto a black background.[87] As referenced earlier in this chapter, there existed a veritable corpus of books that purported to study, research and report on the often disheartening experiences of Caribbean migrants in Britain.[88] It took a new generation of dub poets to get straight to the heart of the matter and offer the frankest, most succinct of commentaries. Jamaican-born Frederick Williams came to the UK as a young man in his late teens in 1965. Who else but a dub poet could articulate several decades of disappointment in lines of poetry such as,

De street weh dem seh pave wid gold
Pave wid sou-soh daag shit[89]

5

Africa: The Call of the Continent

From the earliest incidences of enslaved Africans being removed by force from their homelands – Africa (or the specific regions of the continent from which they were taken) has occupied a variety of positions in African diasporic thinking. Reflective of no end of fiendish complications born of diaspora, diasporic attitudes to Africa have ranged, at various times, from alienation and indifference to a romanticised but nevertheless powerful embrace of the continent by followers of Rastafari, who see Africa as a symbol, a place, of Black redemption and liberation. And from the seventeenth century onwards, multiple schemes and notions of repatriation took their places alongside cultural manifestations through which links to Africa were maintained and nurtured. The diasporic embrace of Africa took what was perhaps its most dramatic form in the activities and writings of Marcus Garvey, Garveyism, and its antecedents, though before the Jamaican-born Garvey's years of triumph and tragedy there existed the towering personality of Edward Wilmot Blyden, rightly described as the father of Pan-Africanism.[1]

For a variety of reasons and in a multiplicity of ways, Africa came to figure prominently in the crystallising of a young Black-British cultural identity in the mid to late 1970s. This was a time when Rastafari and its attendant Dread culture cast a particular influence over young Black Britain.

The colours of Rastafari – red, gold and green – were a familiar sight in the urban spaces Black people occupied. The colours were, first and foremost, those of the Ethiopian flag, but many other African countries also had the dynamic tricolour as their flag, in horizontal or vertical bands of equal width or depth. In this regard, it was very much a combination of colours that demarcated African diasporic territory, as much as pointing to the particular embrace of Rastafari. From badges, belts, scarves and crocheted tams, to painted street signs, lamp posts, and the décor of community centres, red, gold and green seemed to be everywhere, reflecting an embrace of, a consciousness of Africa never before and never since seen in Black Britain. This chapter seeks to examine some of the ways in which Africa came to figure so prominently in Black Britons' cultural identity as these youngsters came of age. Racial pride, the defence of Africa (or more specifically, solidarity with the suffering peoples of South Africa and Rhodesia and the Frontline states brutalised by the apartheid regime), the embrace of heritage – such things were unquestionably the order of the day for much of Black Britain.

As referenced in Chapter 2, virtually the only way in which television distinguished itself as having any particular relevance to Black people (beyond Black acts on *Top of the Pops* and sporadic, brief appearances of the odd Black person) was through the screening on national television (in the mid 1970s) of the American television dramatisation of Alex Haley's book *Roots*.[2] Through the experiences of a captured young African man, and the subsequent barbarity of his passage into slavery, *Roots* told the African-American story of the brutality of slavery and its place within American history. *Roots* was a family history as traced and embellished by writer and journalist Alex Haley. Through the recollections of his older relatives and other areas of research, Haley was able to create an American history, a family tree, with the brutal experience of slavery and the slave trade as one of its foundational aspects. In so doing, Haley demonstrated and reaffirmed that the experience of slavery was not just historical; it was very much an animated and consistent ingredient in the identity of Black people, both in the United States and elsewhere.

There had of course been a number of earlier scholarly investigations into slavery and the slave trade. Pioneering works such as Eric Williams' *Capitalism and Slavery* (1944), James Pope-Hennessy's *Sins of the Fathers: A Study of the Atlantic Slave Traders, 1441–1807* (1967) and later, Oliver Ransford's *The Slave Trade: The Story of Transatlantic Slavery*

(1971) could be found in libraries, but for the most part, such books existed in a somewhat quarantined space, not necessarily easily accessible. School history books carried the occasional, near furtive, reference to slavery and the slave trade, but for the most part a graphic but vague *sense* of slavery, unadorned by specifics and detail, tended to characterise most people's consciousness of this aspect of African and African diasporic history. That vagueness, or more acutely, a profound ignorance of an episode that spanned several centuries and led to the creation of the African Diaspora, reflected most people's understandings (or lack of awareness) of slavery during the 1960s and up to the mid 1970s. The screening of *Roots* changed all that.

In her text 'Everybody's Search for Roots: Alex Haley and the Black and White Atlantic', Helen Taylor offered a clear reading of the ways in which *Roots* was a television event of phenomenal proportions. '*Roots*... was filmed immediately for television, brought to audiences on both sides of the Atlantic a new awareness of black heritage, genealogy, and pride.'[3] Taylor continued:

> *Roots* begins in the year 1750 and records the story of the original ancestor of former Coast Guard journalist Alex Haley. Kunta Kinte, a Gambian Mandinka warrior, is captured into slavery and taken to the American South, where he becomes the first of a long line culminating in Alex, his brothers, and his sister. The book records the horrors of the Middle Passage, the cruelties and deprivations of slavery, the separation of families, economic and sexual exploitation, the rise of abolitionist fervour, secession, the Civil War, the emancipation of slaves, and gradually a new prosperity for what became the Haley family[4]

Astonishingly perhaps, *Roots*, in printed as well as in televised form, became a worldwide, *trans-racial* phenomena that reached out to and touched audiences across the globe. Taylor pointed to its multiple successes: '*Roots* was an instant success. Its advance print run of 200,000 sold out at once; 1.5 million hardback copies were sold in the first eighteen months, and millions have sold since.'[5] *Roots* has been described as a 'ground-breaking melodramatic mini-series... one man's search for his ancestors portrayed black history and resistance on prime-time television.

In America the series reached an audience of 130 million.'[6] And among the large numbers of Britons watching on the other side of the Atlantic were the families of Caribbean migrants. *Roots* proved to be a watershed moment which, though sanitised and playing fast and loose with historical accuracy, nevertheless made flesh Burning Spear's provocative and evocative question, 'Do you remember the days of slavery?' *Roots*, as a compelling example of creative non-fiction, enabled Black Britons, for the first time ever, to visualise slavery and learn about the trauma of being brutally stripped of one's dignity, one's humanity, name, culture, identity and so on. *Roots* was near-perfect for the mid 1970s moment. Rastafari had urged Black people to know themselves and their history, to 'remember the days of slavery' and to embrace the African continent. For Black Britons, *Roots* enabled all those things, and much more besides.

At a time when newly emerging Black Britain was asking questions of itself as to its identity, *Roots* enabled the most dramatic of cultural foregrounding. Though it was in essence Alex Haley's story, one of the great strengths of the book and the television series was the way in which they became not just Haley's story, but also the stories of communities of people who felt that he was telling their story. Kunta Kinte was a relative with whom Black Britons could empathise, even as he existed as a figure with whom the non-Black readership and television audiences could sympathise. Here, at last, was evidence of where Black people had come from, and evidence of an extraordinary ability to *survive*. This led, directly and with surety, to the vivid construction of the notion of a point of destiny for Black Britons after their travails over centuries, and the ensuing legion of uncertainties born of that history. As Taylor summarised,

> *Roots*, the post-war, postcolonial text that most successfully foregrounded the historical struggles and present dilemmas of African-Americans and – by analogy – displaced and rootless blacks everywhere. Roots took the ship's voyage as one of its central themes and metaphors, not of hybrid exchanges but of diasporic people's loss of, and need for, origins. This work, about the routes of one family and indeed one man, Haley himself, argues passionately for the need to discover roots, to locate and celebrate origins, to find the single identifying moment for black identity. It is an unashamedly Afrocentric vision, leading

American blacks back to a Rousseauesque vision of original purity and innocence, to the Paradise lost of one of their earliest societies. Luckily for Haley, its somewhat lukewarm working title, *Before This Anger*, was changed by shrewd editors to the more resonant and mythic final name.[7]

The poet Linton Kwesi Johnson and the critic Kobena Mercer both articulated the appeal and the significance of *Roots* on a BBC TV documentary screened in 1992:

Johnson: It made a lot of people angry and resentful about what whites had done to Blacks.

Mercer: It wasn't so much a series of programmes, as [it was] an event. In the sense that that was what people were arguing about, and even fighting about, in the school playground.

Johnson: It enabled us to locate ourselves, to answer the question 'who am I and how did I get to be where I am today?' *Roots* did that, and it made us realise that we had a past, we weren't just wild savages running around in the jungle.

Mercer: It had an important influence on me in terms of opening my eyes and raising my awareness about the historical experience of slavery, as there'd been very few representations of slavery and colonialism on British television.[8]

Roots was extraordinarily malleable in its readings and interpretations. Whatever Haley's own political persuasion or orientation may have been, his story was taken by many Black Britons as evidence of the difficult societal position they occupied. Slavery became a means by which Black Britain could make sense of its ongoing contemporary challenges. The saga of slavery and its bittersweet aftermath, as graphically told in *Roots*, further heightened the sense of alienation and marginalisation felt by many Black-British people, aided by an almost infinite number of reggae songs, many touching on or dealing with the experience of slavery and sufferation, as well as the memory of Africa. *Roots* stoked the memory of slavery in the collective and individual psyche of New World Africans and their descendants. Furthermore, *Roots* became a graphic signifier for the myriad ways in which the history of the transatlantic slave trade

spawned a thousand Black liberation struggles, not least right here in Britain, in Babylon. The signifiers of enslavement, exploitation, bondage, torture and death were clearly near-universally central to the reading of *Roots* and the watching of its television adaptation. And though *Roots* went through the celebratory motions of a distinctly American tale of personal triumph over adversity and the affirmation of the importance of the family unit, many Black Britons were inclined to read into *Roots* wider redemptive signifiers of survival, perseverance and a deeply personal struggle for Black humanity. Perhaps most affirming of all was the notion that Haley's *Roots* was in essence an encapsulation of what the Rastaman had been preaching all along, and that Rastafari represented the purest manifestation of the quest for, or embodiment of *Roots*. This was expressed, succinctly as ever, by Bob Marley, in the year Haley's *Roots* took the world by storm: 'Some are leaves, some are branches, I and I a' de roots.'[9]

While Alex Haley and Bob Marley were affirming their beloved *Roots*, albeit in markedly different ways that converged and overlapped in the consciousness advocated by Rastafari, Black Britain was also embracing other manifestations of the centrality and importance of Africa. The mid to late 1970s was a period of intense political and cultural activity for young Black Britain; much of this activity found its form in Afrika/Africa Liberation Day, an annual political/cultural gathering that took place in May, largely taking its cue from the internationally established African Liberation Day. Africa Liberation Day (ALD) was convened at venues within urban centres having a close proximity to the Black community – towns and cities such as London, Birmingham, Manchester and Wolverhampton. Large numbers of Black youth attended these conventions and rallies – a reflection of the growing sense of Pan-Africanism that Rastafari brought with it. Black Britons and Caribbean migrants had long since participated in demonstrations and marches, albeit in fairly limited numbers. ALD gatherings, though, were highly-charged events in which large numbers of militants, activists and supporters of Black struggle communed with each other, to air grievances, to formulate strategies and to learn – often directly from international speakers – about the realities of struggle in different parts of the world.

Since the early 1960s, the African continent had witnessed a number of coups and civil wars. They were horrible, gut-wrenching affairs that looked for all the world as if Africans were being pitted against Africans, with consequences and effects that were every bit as brutal as many other historical episodes of violence. Some of these episodes had shadowy orchestrators based in cities such as Washington DC or Brussels; and civil wars, a new feature of postcolonial Africa, were bankrolled from capitals such as Havana, Moscow, or (again) Washington DC. Furthermore, the world's arms manufacturers appeared to have formed unholy alliances that saw weapons and military hardware liberally supplied to seemingly maintain, stoke and prosecute these sometimes complex internecine wars, with roots that sometimes stretched back to all sorts of colonial machinations. While there were those who clearly identified heroes and villains in such conflicts, episodes such as Patrice Lumumba's violent overthrow, and attempts by the east of Nigeria to secede, under the leadership of Chukwuemeka Ojukwu, a military officer and politician who led the breakaway Republic of Biafra, appeared as hostilities that in some ways resisted simplistic interpretations and responses. The situation in Southern Africa was, howver, perceived by Black Britain as something of an entirely different order. Like the struggles of African-American people for justice and equality, the anti-apartheid struggle and the sweeping aside of the settler regime of Rhodesia were righteous campaigns that resonated with decent people everywhere, but had a particular resonance with Black Britain. It was these Southern Africa campaigns, which took in the defence of the Frontline states, that most exercised those who attended ALD.

> The annual commemoration of African Liberation Day (ALD) became an opportunity to inform and encourage black communities supporting black struggles around the globe. Black activist groups used the day to focus attention on the liberation struggles in southern Africa. Activities involved panel discussions and debates among invited speakers, question and answer sessions, the dissemination of literature, and cultural and social activities celebrating aspects of black culture. In the city of Birmingham, the Afro-Caribbean Self-Help Group organised marches, and its members usually paraded with banners to Handsworth Park where speakers criticised the government

and local authorities who had failed to address the grievances of the black community. Activists also talked with bystanders en route and recruited as many as possible to join the crowd.[10]

Birmingham-based photographer Vanley Burke documented much of this fervent activity: the city of his residence was an important epicentre of Black-British anti-apartheid and anti-colonial protest, as well as having been a setting for Africa Liberation Day, and its very sizeable Black presence assured the event dedicated audiences and participants. No single image of the 1970s summed up the Africa-centred cultural spaces to which young Black Britain was gravitating more than Burke's majestic, panoramic photograph, taken in Handsworth Park, Birmingham, at an ALD rally in the late 1970s. Perhaps counter-intuitively, Burke made the focus of the photograph not the people addressing the multitude, but the multitude itself. In this sense, though the focus of the gathered throng's attention is located somewhere beyond, or outside of, the right side of the image, Burke chose to make the attentive crowd the subject of his picture. To successfully photograph large numbers of people gathered together in one place is one of the most difficult of tasks for a photographer. And yet, within this image, Burke produced a compelling and remarkably cogent document of a particularly culturally and politically charged moment in the history of Black Britain.

The large number of people in the magnificent, commanding photograph nearly all – to a man, to a woman – betrayed about them or their person some evidence of the influence of Rastafari, the hugely empowering and counter-cultural movement that had emerged amongst Black people in Jamaica earlier on in the twentieth century. In Burke's photograph, dreadlocks abound, as do tams, wraps and numerous other signs of Rasta. As with all great photographs of crowd scenes, we see not so much a crowd, or a multitude, but a sizeable group of individuals. And in beholding or appraising individual people *en masse*, Burke in effect created a singular study of such things as the facial expressions, body language, and clothing that make each of the photographed people distinctive, particular, and in one or two instances, idiosyncratic or eccentric.

In the far reaches of the photograph, at the edge of the crowd, can be seen the massive speaker boxes of the sound system there to entertain

Figure 16: March Against Apartheid in Trafalgar Square, 2 November 1986.

and uplift the crowd. The speakers have fallen silent while speechmakers address the gathering; but within time, the speaker boxes would again be pumping out the sort of reggae music that was popular at the time, a music that did much to shore up the identities of emerging Black Britain whilst chanting down Babylon and those who would heap misery on African people throughout the world. This was a time during which British reggae groups such as Birmingham's Steel Pulse were involved in assorted anti-racism campaigns in the late 1970s and early 1980s, such as the Anti-Nazi League and *Rock Against Racism*. The track 'Jah Pickney R A R [Rock Against Racism]' witnessed Steel Pulse nailing their colours firmly to the mast of these two campaigns with lyrics such as

> Rock against racism, smash it.
> Rock against fascism, smash it.
> Rock against nazism, me say smash it,
> I've come to conclusion that,
> We're gonna hunt, yeh, yeh, yeh.
> The National Front – yes we are.
> We're gonna hunt, yeh, yeh, yeh.

140

Figure 17: Schoolchildren protesting during the Soweto uprisings in South Africa 1976.

The National Front!
'Cause they believe in apartheid,
For that we gonna whoop their hides...[11]

And this a year after Steel Pulse had railed against the Ku Klux Klan in a track taken from their *Handsworth Revolution* album.[12] Jamaican reggae tended to eschew explicit links to formal campaigns but in Britain, John Plummer perceived such contributions by British reggae acts as 'an indication of a growing involvement in contemporary issues'.[13]

As mentioned earlier, a highly significant component of Black Britain towards a Pan-Africanist sentiment in the 1970s was the ongoing bloody

and highly emotive struggle against apartheid in South Africa. Two events in particular had profound effects on the political awareness of Black Britain. On 16 June 1976, police opened fire on unarmed schoolchildren who were staging a peaceful demonstration against the Bantu Education system in Soweto. Large numbers were killed, leading many, perhaps for the first time, to begin to appreciate the South African state's vicious attempts to suppress Black South Africans' demonstrations and protestations against apartheid, in this instance schoolchildren protesting against being taught in Afrikaans, a language they perceived to be that of their oppressors.

Out of these awful events there came the iconic photograph by South African photographer, Sam Nzima, of the slain body of schoolboy Hector Pieterson, the first casualty of the Soweto uprising. The solitary frame of this celebrated photograph quickly came to symbolise the barbarity of the apartheid system and its wilful predilection for destroying Black lives, including those of schoolchildren. At the time, the Soweto uprising represented the latest bloody and violent episode in the anti-apartheid struggle. Those above a certain age could remember the Sharpeville Massacre of 1960,[14] but for those not yet born in 1960, or those who were small children at the time, the Soweto uprising represented their first comprehension, as teenagers or young adults, of the barbarity of the apartheid regime.

Over a period of some several months in the Soweto uprising, many persons lost their lives, including schoolchildren, though it was the killing of Hector Pieterson on the first day of the uprising that eclipsed all others in the imagination of the sympathetic public, including many Black-British people, beyond that fractured and tormented country. Nzima's photograph showed the fatally wounded Pieterson, who was no more than twelve years old, being carried by an older boy, with Pieterson's distressed sister running alongside. The image was in many ways somewhat surreal, indicating as it did the ways in which the full force of one of Africa's most sophisticated and well-equipped militaries was unleashed, with extreme prejudice, on protesting schoolchildren. No other single image provoked outrage and garnered sympathy as much as Nzima's iconic picture.

In the same ways that Sam Nzima's photograph helped to draw the world's attention to the barbarity of apartheid, so too did the death, in the following year, on 12 September 1977, of Steve Biko, a Black

Consciousness leader in South Africa, who died of injuries sustained during a prolonged and extremely abusive period in police custody. Biko was a brilliant young anti-apartheid activist in South Africa in the 1960s and 1970s, who was first a student leader before founding his Black Consciousness Movement which was based on principles of Black pride, political mobilisation, and resistance to apartheid and the ways in which it had the effect of denigrating Black life. Biko's militant positions put him directly at odds with the South African authorities, leading, ultimately, to his horrific, tragic and untimely death. Biko had sought to empower and mobilise the Black population of South Africa's cities, people who were at the time largely corralled into townships, their movements, as well as their aspirations, curtailed by the apartheid system. Many young Black people in Britain saw in Biko a charismatic, handsome, intelligent and compelling leader in the Black struggle – a figure with whom they could strongly empathise. In the year following his death, a powerful collection of his writings was published. The title alone – *I Write What I Like* – pointed to the ways in which Biko was a man for his time, with an uncommon intellect and energy.[15]

Biko's writings had the bravery and the fearless intellectualism of writers such as Frantz Fanon, James Baldwin, and Eldridge Cleaver, making him a firebrand, respected by many, and feared by others. One of his early texts, 'I Write What I Like: Black Souls in White Skins' indicated Biko's extraordinarily ability to wield a pen.

> Basically the South African white community is a homogeneous community. It is a community of people who sit to enjoy a privileged position that they do not deserve, are aware of this, and therefore spend their time trying to justify why they are doing so. Where differences in political opinion exist, they are in the process of trying to justify their position of privilege and their usurpation of power.
>
> …But these are not the people we are concerned with. We are concerned with that curious bunch of nonconformists who explain their participation in negative terms: that bunch of do-gooders that goes under all sorts of names – liberals, leftists etc. These are the people who argue that they are not responsible for white racism and the country's 'inhumanity to the

143

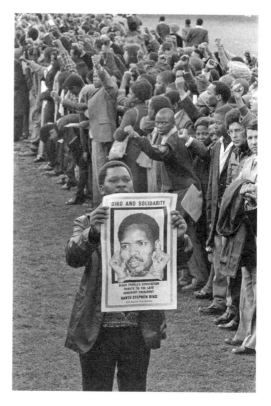

Figure 18: October 1977 in King William's Town, South Africans attending the burial ceremony of Steve Biko.

black man'. These are the people who claim that they too feel the oppression just as acutely as the blacks and therefore should be jointly involved in the black man's struggle for a place under the sun. In short, these are the people who say they have black souls wrapped up in white skins.

The role of the white liberal in the black man's history in South Africa is a curious one. Very few black organisations are not under white direction. True to their image, the white liberals always knew what was good for the blacks and told them so. The wonder of it all is that the black people have believed them for so long. It was only at the end of the 50s that the blacks started demanding to be their own guardians...[16]

Passages in David Harrison's book *The White Tribe of Africa: South Africa in Perspective* indicate the extent to which Biko was revered by those familiar with him, and the ways in which news of his death acted as a fillip to the anti-apartheid struggle.

> The death of Steve Biko provoked much hostile comment abroad and outrage at home from the liberal establishment and its English language Press. Twenty thousand mourners attended the funeral... Many [white] South Africans may not have known who Steve Biko was but within days his name had gone round the world. The calls for boycotts and sanctions echoed once more from Washington to Westminster and round the United Nations Plaza. A South African Foreign Minister had once reported that his country was generally regarded as 'the polecat' of the world. It was never more so than in September 1977.[17]

Upon his death, Biko rapidly attained the status of a martyr of the anti-apartheid movement as his killing shocked, stunned and galvanised many within the Black community in much the same way that the deaths, four years later, of thirteen young Black people in a house fire in London would.[18] Alongside the mainstream media's reporting of the killing of Steve Biko there existed the highly effective reportage of reggae music. Several highly charged and emotive songs were recorded in the wake of Biko's death, one of which was Tapper Zukie's 'Tribute to Steve Biko', a militant and plaintive ballad that weaved its way in and out of sentiments that graphically extended Jesus Christ's teachings: 'Blessed is the man who will get up and fight, blessed is the man who will fight for him rights.'[19] In this track Tapper Zukie ensured that Biko's memory was kept alive with a compelling example of late 1970s Jamaican reggae, a medium preferred above all others, by its adherents, for its ability to communicate Afrocentric sentiments of affirmation and resistance. This was also a track in which Biko was reverentially included in a pantheon of martyred greats, stretching back into history. 'Same way them kill Marcus Garvey, same way them kill Martin Luther King, same way them kill Paul Bogle, and same way them gwine kill

ev'ry greater one whe' come.'[20] The mid 1970s witnessed Jamaican reggae finding common cause with the anti-apartheid struggle, and the plight of apartheid's sufferers. To this end, record sleeves visualised this common cause, on occasion making use of powerful reportage photographs, such as those taken by South African photographer Peter Magubane.[21]

It was the Birmingham reggae group Steel Pulse that offered a particularly empathetic response, reflective of the ways in which of Biko's death touched Black Britain. Inevitably perhaps, the song figured on their *Tribute to the Martyrs* album. 'The night Steve Biko died I cried and I cried/The night Steve Biko died I cried and I cried.'[22]

The apartheid state's response to the Soweto uprising, the killing and maiming of defenceless juvenile protestors, followed by the killing of Steve Biko were two atrocities, two outrages against humanity, and two murderous acts of depravity. In much the same sorts of ways as the memory of slavery became a means by which Black Britain could make sense of its ongoing contemporary challenges, the sufferings and killings of Black people in South Africa were taken by many young Black Britons as horrible confirmation of the universality of their sufferation, and the righteousness of attempts to resist or overcome it.

Within wider Black-British cultural circles, the mid 1970s presented an opportunity of massive proportions to embellish and make real the notional as well as actual links with Pan-Africanism. This opportunity was the hosting by Nigeria, in 1977, of the World Black and African Festival of Arts and Culture *(Festac'77)*.[23] By hosting the festival, Nigeria demonstrated its credentials as the emerging intellectual, artistic, cultural and political giant of the African continent – this at a time in which South Africa remained firmly entrenched as the pariah state of the continent, wedded to the systemic dehumanising of Black life. Nigeria aspired to be the international focus of the African Diaspora, and *Festac'77*, a veritable extravaganza, declared this intent, bringing together cultural activists, writers, artists, performers and other people to showcase and celebrate the cultural manifestations and practices of Black/African people throughout the continent of Africa and the wider diaspora. This was a deliberately African-centred programme of events, performances, activities and exhibitions, for the most part taking place in the then Nigerian capital of Lagos.

Nigeria spent massive sums of money on *Festac'77*, including the building of a National Theatre and Festac Village, a housing development in which to accommodate many of the invited performers and artists. Other key infrastructure, costing tens of millions of dollars, was also built for the festival.[24] Taking place in Lagos and Kaduna between 15 January and 12 February 1977, the Second World Black and African Festival of Arts and Culture was attended by large numbers of participants from many countries, making it one of the largest cultural events ever held on the African continent. The British delegation or contingent affirmed the ways in which London had established itself as an important hub for Black arts activity, somewhat separate and distinct from the main currents of British arts activity.[25]

The head of the Nigerian government, Lt-General Olusegun Obasanjo, writing a foreword for the official *Festac'77* publication, highlighted the significance of this festival.

> Nothing is more appropriate at this time in Black and African history than a re-discovery of those cultural and spiritual ties which bind all Black and African peoples the world over... The Festival will provide an unusual forum to bring to light the diverse contributions of Black and African peoples to the universal currents of thought and arts.'[26]

Obasanjo used the terminology 'Black and African', though the use of the term becomes clearer when one considers the involvement in *Festac'77* of groups such as Aboriginal Australians, who lay beyond the scope of the African Diaspora. Obasanjo went on to stress that 'the Festival will help to obliterate erroneous ideas regarding the cultural values of the Black and African race.'[27]

For a great many of the invited participants (a number of whom were themselves Nigerian by birth, upbringing or nationality) this was a *return* to the motherland like no other. Nigeria, the giant of West Africa, was home to awesome cultural histories of peoples, such as the Yoruba, the Ibo and the Hausa, who now lived within its borders. Interwoven with direct exposure to the rich heritage of the country, participants also had access to each other, making the event an African-based, Pan-Africanist, or African Diasporan interplay not seen since President Leopold Senghor convened

the First World Festival of Black Arts or (sometimes referred to as the World Festival of Negro Arts) in Dakar, Senegal, in April 1966. Before these colossal cultural events of the mid 1960s and mid 1970s, previous grand comings-together of African diasporic peoples had taken place under the auspices of Marcus Garvey's Universal Negro Improvement Association conventions, such as those held in New York earlier on in the twentieth century, during the heyday of Garvey's organisation.

Given that the First World Festival of Black Arts had taken place just over a decade earlier, it might not be a surprise that Senghor's influence could clearly be detected in *Festac'77*:

> On the question of unity, contemporary Négritudinists gener-
> ally feel that one of the major prerequisites for unification of
> black people towards a federation is knowledge of 'who we
> are.' It is necessary to know each other on a personalized basis
> in order to develop as a people. Part of this knowledge is an
> awareness of the past, of our heritage, our history; and thus an
> understanding and appreciation for our cultural achievement,
> for example, religion, philosophy and art.[28]

The stated aims of the *Festac'77* were:

(i) to ensure the revival, resurgence, propagation and promotion of black and African cultural values and civilisation;

(ii) to present black and African culture in its highest and widest conception;

(iii) to bring to light the diverse contributions of black and African peoples to the universal currents of thought and arts;

(iv) to promote black and African artists, performers and writers and facilitate their world acceptance and their access to world outlets;

(v) to promote better international and interracial understanding;

(vi) to facilitate a periodic 'return to origin' in Africa by black artists, writers and performers uprooted to other continents.[29]

It was this last aim of *Festac'77* which gave the clearest acknowledgement of the Pan-Africanist dimension of the festival, and how that dimension drew in Black communities from Britain and elsewhere. According to Michael McMillan, some 250 or so British-based writers, artists, photographers,

academics, performers and others visited *Festac'77*, heightening the extent to which Black people in Britain saw themselves as part of a larger, international, Africa-centred, Black community.[30] The intensity of this impulse echoed sentiments such as those offered by Dr. M. Ron Karenga, who at the Colloquium accompanying *Festac'77*, 'called for the world's African masses to coalesce into a common cultural and political front.'[31] Thus, individuals returned to London with an enhanced understanding of the African Diaspora, having seen, and indeed been a part of, its manifestation in all its glory, and been party to discussions of the declared importance of a progressive diasporic cultural identity. For Black-British artists and performers, this Africa-focus compensated for, or countered, the marginalisation of them and their practices within the UK. Britain might have been ambivalent about what its Black artists and performers had to offer, but within Pan-Africanism, these artists and performers fashioned for themselves no end of dynamic, nuanced and relevant contexts in which to locate and further their respective practices.

The contributions to *Festac'77* from many of the countries of the African Diaspora differed markedly in some respects from the contributions to the festival from within the continent. There was significant state involvement in the contributions made by those African countries, whose governments were often keen to ensure that an *acceptable* national image was presented at the festivities in Lagos. Furthermore, the state bureaucracies of many African countries were at the time heavily controlled by the government or ruling elite, a control that manifested itself in such matters as the issuing of passports and exit permits, or the issuing of visas to nationals of other countries, often making the acquisition of such things no easy or straightforward matter. Ethiopia had, in 1974, witnessed the deposing of Haile Selassie and the installing of the Derg, (sometimes written as Dergue, and meaning council or committee). The Derg, or Coordinating Committee of the Armed Forces, Police, and Territorial Army prosecuted its revolution and ruled Ethiopia for a number of years following the overthrow of the monarch. To this end, Ethiopia's contribution to *Festac'77* faithfully reflected the wishes of the Derg. 'On Saturday, January 29 [1977] Ethiopia presented 'Our Struggle' – an epic story of their revolution.'[32]

The delegation to *Festac'77* from Britain had no such state constraints, simply because the country declared itself indifferent to *Festac'77*, thereby

leaving it up to individuals themselves to fashion organising committees, formulate programmes, and so on. Yet again, Britain took little or no notice of what its Black citizens were doing, thereby furthering a sense of difference amongst Black Britons. This indifference of the state went hand in hand with a particular British slap in the face to *Festac'77*: the pointed refusal of the British Museum in London to lend to Nigeria the fabulous Benin ivory mask, the image of which was used extensively as the *Festac'77* logo and official symbol. Wrote Alex Poinsett,

> Like those millions of blacks, uprooted from Mother Africa and enslaved on foreign shores, the original mask had been stolen during England's 1897 conquest of Benin and shipped to the British Museum in London. Recently British authorities refused to lend the ivory original to Nigeria for display at *Festac'77*. It was too fragile for shipment, they claimed.[33]

As mentioned in the Introduction to this book, the birth of Black Britain was given a major and most singular fillip, by its recognition/creation at *Festac'77*. Pointedly, the Black Britons in attendance had no credible flag behind which they could march and parade at the extravaganza's ceremonies. To this end, the conspicuous and very loaded absence of the Union Flag spoke volumes and was a gesture akin to the Black Power salutes given, nearly a decade earlier, by gold medallist Tommie Smith and bronze medallist John Carlos on the podium after the 200 metres race at the 1968 Summer Olympics held in Mexico City.

Fashioning a supposedly representative UK contingent for *Festac'77* was no mean feat, but the task was made considerably more doable by the tangible sense of distinct, Afrocentric cultural surety, engendered by the formidable network of Black arts centres across London and indeed, across the country. London played host to pioneering ventures such as the Factory, in West London (which subsequently changed its name to Yaa Asantewaa Arts Centre, in honour of the Gold Coast warrior queen, who led an Ashanti rebellion again British colonial forces). Across the city, in North London, Oscar Abrams directed the Keskidee Centre, near Kings Cross, an innovative, trailblazing venture characterised by its commitment to the visual arts as an integral aspect of its work. Equivalent centres existed across the country, from Handsworth, Birmingham, to Moss Side,

Manchester, to St. Paul's Bristol. These grassroots community centres were important foci for Britain's Black communities and were seldom without murals depicting heroes from Black history. Art exhibitions, community newsletters, residences, performances, lectures, workshops, all these activities and more took place venues such as these. Another important means by which word of *Festac'77* was spread was through Black newspapers such as *West Indian World*.

An exhibition purportedly representing 'The work of the artists from the United Kingdom and Ireland' was sent to *Festac'77*. In reality, all of the artists were London-based, and the list now provides us with a fascinating snapshot of the Black artists and photographers, drawn from different parts of the world, such as Nigeria itself, the USA, Jamaica, and other parts of the Caribbean, who had, by the mid 1970s, made London their temporary or permanent home. These artists were Winston Branch, Mercian Carrena, Uzo Egonu, Armet Francis, Emmanuel Taiwo Jegede, Neil Kenlock, Donald Locke, Cyprian Mandala, Ronald Moody, Ossie Murray, Sue Smock, Lance Watson and Aubrey Williams. The artists each represented different types of art practice, from the demonstrations of abstraction that lay at the heart of the paintings of Branch and Williams, to the pronounced manifestations of African cultural identity in the work of Nigerian artists Egonu and Jegede, to the ecological and environmental concerns frequently manifest in the work of Ronald Moody. The group of artists, with a comprehensive range of formal concerns and subject matter, came together as British-based practitioners of the Black, African and Pan-African worlds.

Mindful of the Pan-Africanist sentiments of *Festac'77*, Yinka Odunlami, Exhibition Officer of United Kingdom African Festival Trust (UKAFT), London, writing in the catalogue produced to accompany the exhibition, characterised the practices of Black artists in London in 1977 as 'Black Art'. And this was several years before the term gained a certain traction, as a reference to a bold new type of art by a younger generation of artists, characterised by its bold embrace of social narratives.[34] Wrote Odunlami,

> And in fact, other aspiring black artists (whose works are not represented in this exhibition) have shown great imagination and contributed to the general cultural scene of the Black

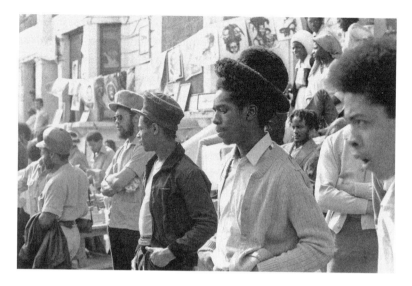

Figure 19: Rastafarians and Dreads, with prints of drawings by Ras Daniel Heartman, Notting Hill Gate, London in the 1970s.

community in the UK and Ireland. In this respect we can mention the paintings of Caboo, Errol Lloyd, Ralph Webster, Lena Charles and other aspiring artists. It is hoped that something of the new spirit of 'Black Art' as amongst artists working in the UK can be detected.[35]

For those Black people living in Britain privileged enough to participate in *Festac'77*, this was quite literally a once-in-a-lifetime opportunity in which an extraordinary confluence of factors enabled Black Britons to see their Afro-centric identity affirmed and reflected on as big a stage as could be imagined – right there on the African continent. One of the most fascinating attenders from London was a young Michael McMillan, then a schoolboy in his mid teens. McMillan attended *Festac'77* by way of winning an essay competition, details of which were circulated in *West Indian World*. His essay 'Power to the Black Youth' spoke to the powerful emergence of a bold new demographic of which he and his peers were very much a part.[36]

While the British mainstream press and media followed the 1977 celebrations of the Queen's Silver Jubilee in excruciating detail, they ignored

Festac'77, leaving it to the Black publishing world to reflect on the powerful cultural events that took place in Nigeria in early 1977. Amongst the texts that celebrated *Festac'77* was one written by artist Arthur Monroe, in which he waxed lyrical about *Festac'77* and its multiple dimensions:

> Better than 17,000 artists from some 57 countries took part in what the world has come to know as FESTAC'77… Held in Lagos, Nigeria, a teeming energetic city of 3 million people, earlier this year, the long awaited festival attracted nearly 500,000 spectators who attended the rounds of non-stop activities and special events.[37]

Towards the end of his decidedly celebratory text, Monroe expressed the view that

> FESTAC'77 was the culmination of many inventions, diversity of expression and the myriad ways black people are identifiable with African heritage, whether we speak in terms of a diaspora or the continent itself; and contained in that testament of talent was a moving reaffirmation of an inspired humanity, despite slavery, colonialism, discrimination, apartheid, atomic bombs and genocide.[38]

Thus, throughout the 1970s, young Black Britain was seeing its aspirations and its self-image reflected on a number of fronts, within the country and internationally. 'Black' identity was being both validated and celebrated. From the mid to late 1970s, large numbers of Black people, born and/or raised in this country emerged from their teens having mapped out their social, political and cultural presence and identity, influenced to a significant extent by the disparate Africa-centred factors outlined in this chapter, together with the colossal Africa-centric insistencies of Rastafari. In turn, it was this identity that chiefly influenced the generation of (as Keith Piper put it) the 'young Black politicised practitioners who were to become visible in the early eighties and beyond.[39]

For the first time since the mid-twentieth century immigration from the Caribbean, Africa was being framed, within the bedrooms, living spaces and homes of the children of these migrants, as a positive, affirmative *place*, aiding many of them in their sense of self and their place in the world. There was, in the late 1970s and early 1980s, scarcely a home

of *conscious* young Black Britons that did not contain posters and prints, often framed, of drawings of heroes such as Malcolm X and Steve Biko, alongside the wonderful drawings of locksmen, dreadlocked children and righteous dignified mothers created by Ras Daniel Heartman. The country's Black bookshops, in London, Birmingham and elsewhere were essential outlets for such visuals. White Britons' homes were, in the 1970s, frequently adorned with era-defining framed reproductions such as 'Wings of Love' by Stephen Pearson. In marked contrast, the homes of many young Black Britons were, during the same years, frequently adorned with equally era-defining prints, brimming with racial pride, by Ras Daniel Heartman.

6

Fyah!

This chapter looks at the ways in which riots in 1980 and 1981 both reflected and contributed to an evolving sense of Black Britain's cultural identity. For much of the past several decades, the inner city districts of English cities with a pronounced Black presence have seen the fermenting of a potent cocktail of factors that might spark any given riot with a conspicuous racial dimension. Nevertheless, pronounced episodes of rioting have been rare, rather than regular events. One of Linton Kwesi Johnson's early poems had made mention of Black youth as biding their time, and 'Measurin' de time for bombs and for burnin'.'[1] In this respect, Johnson saw the supposedly peaceful and sedentary months, years, decades even, between bouts of rioting as tactical periods of revolutionary ferment and preparedness. To this end, one of numerous journalistic features on Johnson quoted the questioning line from one of his poems: 'How can there be calm when the storm is yet to come?'[2] By the late 1970s. Johnson was regularly cast as 'the voice of that generation of young blacks who were born or have grown up in this country',[3] so the violent eruptions of 1980 and 1981 lent Johnson's poetry a persuasive and compelling prophetic element. Johnson was perhaps caught unawares by the cataclysmic rioting that took place on his turf, in Brixton, in April 1981. The journalistic feature on Johnson mentioned above, published in August of 1980, a few months after Bristol's rioting, continued as follows:

'Bristol yesterday: Brixton today!' the writing on a wall close to Johnson's home says, an empty boast that he dismisses as the work of young whites; 'anarchists.' But of course the events of last April in Bristol, he says, came as no surprise to him or to anyone else of his acquaintance.[4]

Within about four months of the feature being published, an unimaginable event would add another element to the combustible cocktail of factors mentioned above.

White Britain saw itself – indeed, sees itself – reflected a near-infinite amount of times each day, in the media. Some of this media reflection was parody, caricature, or otherwise problematic, but on balance, white Britain relied, or could count on, seeing its multiple identities, its histories, its experiences, continually affirmed by the media. Not so Black Britain. Within the context of the evolution of Black-British cultural identity, the 'riots' of the early 1980s were significant for two reasons. Firstly, the cataclysmic events of 1980 and 1981 were the first time Black Britons saw an aspect of themselves and their fractious presence burst upon the television screen and occupy significant column inches in the nation's newspapers. It perhaps goes without saying that much of this media attention oscillated between caricature and slander, but beyond such problematics, the riots affirmed the presence, the existence of young Black Britain in ways and to extents previously not seen, notwithstanding the skirmishes that took place between Black youth and the police in the mid 1970s.[5] The riots were also a culminating expression of recent counter-cultural declarations, as much as an articulation of animated protest.

St Paul's, an area of Bristol with a relatively high proportion of Black residents, erupted for a brief though intense period of anti-police 'rioting' by Black youth in 1980. In 1976, during the course of the annual Notting Hill Carnival, violent street battles erupted between Black youth and the police in the vicinity of the Carnival. It was this rioting, and that which took place in St Paul's, Bristol, in 1980 that emphatically declared the arrival of the dissatisfied urban-dwelling ghetto *yout*. Possibly the most significant thing about the 1980 riot was that it happened where it did. Notting Hill had, as mentioned, erupted some years earlier, but Notting Hill had a history of race-related street violence, stretching back to the late 1950s. Rioting might also have been expected in supposedly notorious inner-city areas such as

Moss Side, Brixton, Handsworth or Toxteth. Indeed, in due course, the ghetto defenders of these areas did indeed join battle with the police. But (notwithstanding Ken Pryce's bleak assessment of St Paul's, *Endless Pressure*, which had been published the previous year)[6] the riot in Bristol surprised many. In the absence of violent disturbances, Black people were perceived by the wider society to be ultimately contented with their lot. In addition, many within the wider society adopted a comforting though delusional out-of-sight-out-of-mind attitude to the Black districts of the towns and cities in which they lived. Though no one ever knows or can predict the precise confluence of variable factors that might spark a riot at any given moment, St Paul's was perhaps the last place that many people expected a riot.

As Martin Kettle and Lucy Hodges reported:

> When the leader of Bristol city council, Claude Draper, was telephoned on the night of 2 April 1980 and told there was a riot taking place in the St Paul's district of Bristol, he thought it was a joke. 'Quite frankly I would never have expected a riot in St Paul's,' he said.[7]

For many within Black Britain, these riots put St Paul's and Bristol firmly on the map. Notwithstanding the West Country city's extended history of a Black presence stretching back centuries, many people beyond the city had not even realised that there were Black people in Bristol. That Bristol could and did erupt into a certain visibility as a consequence of its 1980 riots had a profound impact on the level of awareness that Black people lived, in significant numbers, in many different parts of the country, beyond those areas in which they were imagined to live. Furthermore, many young Black people, on hearing of the eruption in St Paul's, formed the view that there were certain commonalities of experience characterising their lives, from one part of the country to another. This awareness of a nationwide or across the country presence, sharing certain commonalities did an immense amount to create, enhance and cement a distinct Black-British cultural identity. For tens of thousands of Black people, as Peter Fryer stated, 'Bristol became a symbol of resistance.'[8]

Suddenly everyone, including Black Britons, knew where Bristol was. Everyone knew that there were Black people in the city. Margaret Thatcher, the Prime Minister of the day, heading a government only recently elected,

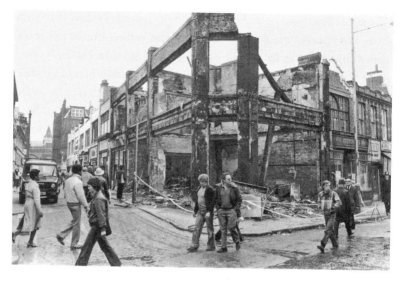

FIgure 20: Locals walk past a building destroyed during the second night of rioting in Brixton, 13 April 1981.

was inclined to view the rioting as a demonstration of criminality. More liberal establishment figures sought *answers* as to the causes of the riots, though many Black Britons were of the view that the unrest represented youthful resistance to intrusive and abrasive policing. These ghetto sufferers emboldened and heartened a generation, as events throughout 1981 testified. But, in the weeks and months after the St Paul's riots, it was Bristol that carried the swing. Not many months after the Bristol riots, a stark horizontal poster commemorating – indeed, celebrating – the riots was produced and sold in left-wing bookshops. It showed, in dramatic black and white tones, the apocalyptic inferno that was, for a few hours, the St Paul's riot. In the image, fire burned uncontrollably from a Lloyds Bank, in front of which was a gutted, upturned police car. This photograph, more than any other single visual, vividly symbolised Rastafari's call for the fire of judgment and purification to reach every appropriate quarter, being taken to heart. Across the top of the poster were the words ST PAULS BRISTOL 1980. The message was clear: two of the major tormentors of young Black Britain – capitalism and an oppressive police force – brought to book in a perhaps unexpected day of reckoning. It was not just Peter

Fryer, who as mentioned previously, suggested that, 'Bristol became a symbol of resistance.'[9] St Paul's, as another commentator had previously noted, 'became a symbol of resistance – black youths chanted "Bristol, Bristol, Bristol" at police defending a National Front march in Lewisham, South London, later the same month [April 1980]'.[10]

In April of the following year, Brixton, a similar though much larger inner-city area of South London, also saw intense 'rioting' in the form of destruction of property, including police vehicles, and pitched street battles between Black youth and the police. Brixton seemed to light some sort of fuse because similar activity spread throughout the country over the following days and weeks (in what elements of the press and media dubbed 'copycat riots'). What characterised these clashes was a widely felt and largely mutual hostility and antagonism between youth in the Black community and the uniformed agents of the law whose policing of these youth was openly unfair, aggressive and deeply racist. The police embodied and represented much of the grievance that Black youth had against the treatment handed out to them by 'society'. The police used brutal devices such as the notorious 'sus' laws to harass, intimidate and interfere with Black youth, while being widely seen as ignoring the real and terrifying problem of racial violence against Black people, and the ways in which Black people were also, frequently, themselves victims of crime. Black people were suffering appalling injuries and casualties at the hands of racist thugs, and yet the police refused to acknowledge the problem of racist violence, both from within their own ranks and within the white community at large. Rather uneasily perhaps, Evan Smith suggested that, 'a consensus seemed to have been reached concerning the causes, motives and actions of the 1981 riots, particularly, that the 1981 events were a "legitimate" form of protest against police harassment and institutional racism.'[11] In this regard, Smith was likely cognisant of one of the salient conclusions of the Scarman Report, commissioned in the wake of the Brixton riots.

> The disorders were communal disturbances arising from a complex political, social and economic situation, which is not special to Brixton. There was a strong racial element in the disorders; but they were not a race riot. The riots were essentially an outburst of anger and resentment by young black people against the police.[12]

Reflective of the ways in which particular areas of public space had become highly contested territory, and certain cultural expressions such as carnival and the sound system had attracted a distinct suppressive element of policing, a number of young Black people had throughout the mid to late 1970s been involved in sporadic confrontations and street battles with the police (1976 being a particularly violent year).[13] In addition, 1980 and 1981 can (on account of the unrest in St Paul's Bristol, and Brixton, South London, respectively) be singled out as important years during which Black youth achieved a high degree of media visibility, in regard to these ongoing and increasingly bloody street confrontations. Commenting on this defiant new Black-British presence, Keith Piper noted that,

> It was a presence which was at times to express itself in the most dramatic of terms. All too often during this [mid 1970s] period, it appeared to take the flight of petrol bombs to place any reference to these new constituencies of 'Black Britishness' onto the local and national political agenda.[14]

While riots have taken place for centuries in a great many different countries, settings and circumstances, and with radically differing constituencies of participants, within the riots of the early 1980s could be perceived the influence of Rastafari and the exigencies of its messages, as communicated through reggae music. (And in turn, the ways in which such cultural resonances arguably made their way into the psyche of rioters in England.) Though the episodes of unrest in 1980 and 1981 were sometimes dubbed 'racial' in their construction and manifestation, on account of some proportion or other of African-Caribbean males being seen as active participants, both the proportion and numbers of African-Caribbean youth caught up in rioting were in all instances relatively small. It bears stating that the vast majority of young Black Britons, for a variety of reasons, had no involvement in the riots whatsoever. But given the factor of conspicuousness, the darker skins of Black-British youngsters meant that they were collectively and invariably the ones identified by the police and the media as being key participants in the riots.[15] As already mentioned, the proportion and numbers of Black youth engaged in this rioting were small, though as an absolute certainty it is literally impossible to properly

ascertain credible figures. The most stable criterion that might be employed is that of police and criminal justice records for the charging and conviction of those arrested for riot-related charges. But such records are by definition unreliable and problematic. Where records or journalistic notations of those arrested, charged and convicted mention perceived or apparent ethnicity or skin colour, such references are, again, unreliable, particularly given the unstable journalistic or judicial identification of people as 'black', 'white', 'mixed race' or 'Asian'.[16] Furthermore, as referenced in a footnote in Chapter 2, in the wake of a violent episode such as the riots in Birmingham in 1985, the person arrested for the some of the deaths that occurred was white. Even so, these cautionary notes notwithstanding, it was as if the rioting of the mid 1970s and early 1980s was the fire that forged the concerns, grievances, identity and agendas of young Black Britain, crucially at the precise moment in time that the wider and greater body of young Black Britons began the process of emergence into visibility.

That the riots were for the most part constructed and presented (by the media) as having young Black males as their chief protagonists led to use of the term 'race riot' to describe the unrest. The designation had several effects. Firstly, it contributed to a pre-existing pathology that linked (young) Black males to an inclination to deviance and criminality, which could only be kept in check by the energetic policing of these people and the communities with which they were associated.[17] Secondly, the term 'race riot' functioned as a readymade understanding of these cataclysmic events, by elements of the mainstream media, and those in power in government, at both local and national levels. It was an understanding that brought forth the Scarman Report, quoted above, and no end of initiatives aimed at addressing what were viewed, in certain circles, as the causes of the riots: poor relationships between the police and Black people, and systemic disadvantage of Black people in housing, employment, social amenities and so on. Thirdly, the term 'race riot' ensured that the complexities of its participants were obscured, and reduced to the aforementioned simplification of raced participants.

> The typification of these incidents as 'race riots' not only helped to shape ensuing political debate on the matter but

also helped to determine the nature of subsequent political interventions.

In fact, careful scrutiny of what took place at Brixton, Southall, Toxteth, Moss Side, and elsewhere in 1981 reveals that 'race riot' is a wholly inappropriate mode of classification: not only is it a factually incorrect description, it also denudes the incidences of any political complexion and the participants of any political edge to their protest.[18]

The other term beloved of the media to describe the disturbances that spread across the country in 1981 was, as mentioned, 'copycat riots'. This reflected the belief that it was images of rioting, broadcast on television, that inspired or contributed to imitative behaviour. But Black Britain was for the most part more inclined to see the spreading of riots as confirmation of shared experiences and shared grievances. According to Peter Fryer, rioters in Liverpool were responsible for 'burning down 150 buildings, including some of symbolic significance, putting 781 policemen out of action, and holding the area until the police returned with CS gas, which they fired at people with cartridges intended for use against walls'.[19] His narrative continued,

> Within hours, the rebellion had spread to Manchester, where 1,000 youths... besieged Moss Side police station. Then it hit Handsworth in Birmingham, Chapeltown in Leeds, Bolton, Luton, Leicester, Nottingham, Birkenhead, Hackney, Wood Green, Walthamstow, Hull, High Wycombe, Southampton, Halifax, Bedford, Gloucester, Sheffield, Coventry...[20]

Fryer then goes on to name a further eighteen town and cities 'and dozens of other places'[21] in which riots occurred. Barry Troyna assessed that rather than being any form of imitative behaviour, the riots were born of shared grievances, primarily the police's harsh and abusive treatment of Black youngsters:

> If the disturbances were neither 'race riots' nor 'copycat riots' but forms of protest against specific conditions, one has to establish what these conditions actually were. Clearly, the dramatic rise in unemployment, especially among the young, locally and nationally constituted one of the most significant of the underlying

causes. Though as the studies of the 'burn baby, burn' incidents in the USA revealed, unemployment does not directly and inevitably provoke social unrest. What is more, unemployment levels in parts of Scotland and the northeast of England exceeded those in Brixton, Toxteth and Moss Side but were not scenes of disorder.

When they took to the streets, the youths made it clear that their hostility was directed towards the police: in all the major districts affected in 1981, relations between the police and the local community had reached a low ebb.[22]

Writing with Ellis Cashmore, Troyna subsequently embellished this by asserting that the earliest riots

were not just blacks rioting against police malpractice, the refusal to protect blacks from racial attacks and the propensity to subject blacks to harassment. In both episodes, [Bristol and Brixton] conflicts with the police provided catalysts setting in motion the larger affairs… But the black anger was not so much directed at police officers, but at the system they personified.[23]

These riots occurred at key historical points that have served to benchmark the birth and testy growth of Black Britain. As such, the 'rioter' has on occasion been framed as occupying a certain blessed position in the vanguard of struggle, even as the dominant society has sought to position the Black rioter as the undiluted manifestation of supposedly innate deviance and criminality. Sivanandan assessed that

By the middle of the 1970s, the youth had begun to emerge into the vanguard of black struggle. And they brought to it not only the traditions of their elders but an experience of their own, which was implacable of racism and impervious to the blandishments of the state.[24]

He went on to state,

And they [the youth] were now beginning to carve out a politics from the experiences of their own existence. Already by 1973, 'marginalised' young West Indians in the ghettos of Britain were being attracted to the popular politics of Rastafari. Bred in the 'gullies' of Jamaica, the Rastas were mortally opposed to

consumer-capitalist society and saw in their own predicament the results of neo-colonial and imperialist intervention. And in their locks and dress and music they signified their deadly opposition. They were the 'burning spear' of the new resistance. The police took note, the state also.[25]

What Sivanandan described frequently and most clearly took the form of an occasionally explosive resistance to police 'downpression', and it was this resistance that was frequently dubbed 'rioting'. In the eyes of a great many Black-British people, the police came to symbolise and embody the forces, the institutions and the various forms of endless pressure that tormented so much of young black Britain. Though riots against Caribbean migrants had occurred in late 1950s England, the 'inner-city' riot was, for some within young black Britain, a new voice, a new form of expression. Armed with the weapons of the weapon-less, 'bakkles an bricks an sticks',[26] some young black males availed themselves of sporadic opportunities to join battle with their tormentors, in actions that frequently engaged the attentions of visual artists, dub poets, and reggae singers.

Fire, that most primeval of elements, has a place of great significance in New World African Diaspora culture. Fire is a longstanding metaphor for light and assorted manifestations of illumination. But it is also a symbol of judgment, destruction and God's day of reckoning. In the words of the Negro spiritual, 'God gave Noah the rainbow sign, no more water, the fire next time'. Chapter 3, which looked at the influence of Rastafari, made mention of the extent to which biblical injunctions born of a particularly fervent embrace of Christianity were very much an important and fundamental aspect of the lives of many within the Caribbean, and subsequently, the lives of many Caribbean migrants. When, in the case of the Brixton riots, unlucky buildings were raised to the ground through conflagration, and in other riots in which police cars suffered the same fate, we see not so much a manifestation of the fire next time, as the fire *this* time. This notion of willing the fire to do as much damage as it can has an absorbing and compelling antecedent in the legendary phrase 'Burn, Baby, Burn'.[27] What some might regard as a satisfying spectacle, of the justifiable conflagration of the aforementioned buildings and police vehicles, is indelibly linked to

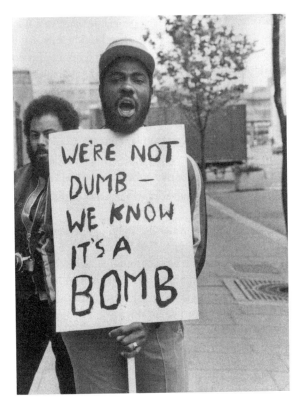

Figure 21: 21 April 1981: Protesters outside County Hall as the inquest opens into the 13 Black people killed in the January 1981 fire in Deptford, South London. The fire aroused anger within the local community and beyond, with allegations of a police cover-up of a racial attack.

the notion of payback for seemingly systemic and ongoing tormenting of large numbers of young Black Britons. In this context, destruction by fire carried with it a distinct resonance of righteousness.

Fire, of an altogether different manifestation, plays a particular part in these narratives. The cataclysmic events of Brixton 1981 have in some respects to be seen within the context of a tragedy a few months earlier, which galvanised the Black community, acutely increasing its sense of purpose and cultural identity. Peter Fryer outlined the incident and the bold, confident response from a traumatised Black community:

In January 1981, 13 young black people perished in a fire at a house in Deptford, an area where other black homes had been attacked and a black community centre had been burnt down. As usual, police discounted the possibility of a racial motive; but the entire community, not just the anguished parents, were convinced that the fire had been started by fascists.[28]

Some three years after the tragic events, Stephen Cook, in a publication that sought to 'reconstruct the events of that night and set out the [apparently] conflicting evidence' penned a brief introduction that pointed to battle lines and tensions that surfaced in the wake of the seismic events.

In the early hours of a winter morning, in a terraced house in South London, a boisterous all-night party was coming to an end when fire broke out on the ground floor. Within minutes, the whole three-storey house was in flames; thirteen young black people died, most of them only in their teens. The inquests three months later returned an open verdict – and despite a lengthy police inquiry the cause of the fire has never been ascertained. Was it a tragic accident or was it arson? Members of the black community have accused the police of ignoring evidence that the fire was started deliberately by a white racialist attacker; the police in turn have accused black organisations of making political capital out of the tragedy.[29]

From the start, mystery seemed to surround the cause of the fire and speculation was rife, though circumstantial evidence suggested that the fire might well have been the work of violent racists. The cause of the tragedy was either arson or an accident; many Black people opted for the former and discounted the latter. Amongst the particularly unpalatable and to some, offensive, scenarios said to have been favoured by the police was that one of the victims, Owen Thompson, was involved in setting a fire that rapidly engulfed the house. Such were the apparent depths, in the minds of some, to which the police were prepared to stoop. Significant numbers of Black people were convinced that, in the longstanding tradition of police denial of racist motives when Black people were attacked, the police did little more than designate the fire an accident. Protestors against perceived police indifference carried placards stating, 'We're not dumb – We know it's

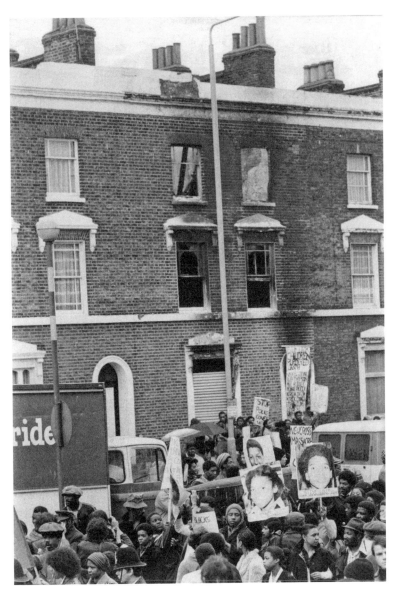

Figure 22: Black People's Day of Action, March 1981, passing the site of the gutted house in which a fire claimed 13 young Black lives.

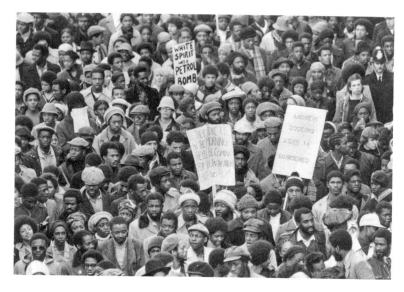

Figure 23: Black People's Day of Action, March 1981, protesting against the house fire in Deptford that claimed 13 young Black lives.

a bomb'. Protestors also rallied around in defence of Thompson, who they felt had been horribly slandered, even in death. 'Thompson Murdered Not Murderer' and 'Thompson Murdered – No Black Scapegoat'.[30]

The Deptford fire threw up an uncomfortable realisation of the widespread indifference shown to the deaths by royalty, the news media, senior politicians and the police themselves. In the immediate aftermath of the tragedy, the Establishment failed to extend condolences to the families of the victims. This indifference, coupled with what were regarded as lacklustre efforts made by the police to establish the cause of the fire, or to investigate possible suspects, enraged many Black Britons, giving rise to the cry 'Thirteen Dead, Nothing Said'. It appeared as if Black lives didn't matter.[31]

The journalistic investigation, mentioned earlier, into the fire and its aftermath reported that, in the wake of the tragedy,

> Relations between the black community and the establishment rapidly began to go very sour. The bereaved families felt that the newspapers were giving far less coverage to the case than they would have done if the youngsters killed had been white.

There was no message of sympathy from the Queen, and a letter from the Prime Minister arrived only five weeks later and then seemed concerned mainly with defending the police investigation. The families in mourning began to feel that no one cared for their distress.[32]

'The New Cross Massacre' (named as such by activists within the Black community) gave rise to a massive act of protest by Black Britons.

> Three months later some 15,000 black people, in the most remarkable demonstration ever mounted by Britain's black communities, marched the ten miles from Deptford to central London. They demanded justice for Black people and an end to racist murders. They protested against police conduct of the Deptford inquiry. And, as they marched through Fleet Street, they protested against media indifference to the mass murder.[33]

Though Fryer plumped for 15,000, some put the number of demonstrators in the region of 20,000. As was typical with certain demonstrations, the police were wont to play down estimated numbers, and suggested the somewhat paltry and arguably offensive figure of 4,000. It is difficult to overestimate the significance of the march (which took place on 1 March and was dubbed the Black People's Day of Action). Never before (and indeed, never since) had London played host to Black people gathering in such numbers.[34] The march offered an electrifying sense of self-affirmation for young Black Britain. Seeing itself present in such a multitudinous throng did much to strengthen a sense of raced solidarity reflected in this coming together of many children of the *Windrush* generation.

These were indeed heady days for Black Britain, in which mournful feelings existed alongside a newly-defined sense of solidarity and purpose. Many felt that racism lay at the cause of the fire, and in its aftermath, grieving parents found that they were not immune to vile racist sentiments directed straight at them.

> The Deptford fire tragedy provided a focus and an emotional outlet for some of the deep-seated feelings of bitterness and

injustice that had accumulated in the community. Such feelings were intensified when Mrs Ruddock [mother of Yvonne Ruddock, the young woman whose party it was, who, along with her brother, perished in the inferno] began receiving letters whose writers gloated over the fire and said it had made a start in getting rid of black people.

When a crowd of youths in the demonstration in March 1981 ran down Fleet Street shouting 'Freedom!' Justice!', and when one parent, Nerissa Campbell, stood on the steps of the High Court after the request for a new inquest was refused and said: 'It's just because we're black – no-one gives a damn,' they were articulating the pressures and feelings of persecution experienced by many black people in a white dominated society.[35]

Like the rioting that was to follow, this terrible act of carnage was one of the factors that forged the identity and agenda of young Black Britain.

Although Lord Scarman demurred from this view, the influence of Rastafari, touched on earlier, had its part to play in considerations of the riots of 1980 and 1981.[36] Indeed, the cries of 'Freedom!' Justice!' were, together with 'Equal Rights!' very much a part of the lexicon of Rastafari. Furthermore,

The kind of consciousness informing [the riots of 1981] was greatly stimulated by the growth in popularity of the Rastafarian movement amongst young blacks... During the mid-1970s, the Rastafarian movement surfaced, as first, in London and Birmingham and, later, in all the major UK cities. Black youths adorned themselves with the national colours of Ethiopia, coiled their hair into long dreadlocks, cultivated an esoteric language and, generally attempted to detach themselves from the society they regarded as inherently evil and exploitative of black peoples. The system that had ensured the early enslavement of Africans and cemented the continued oppression of blacks Rastas called Babylon and only when this system was obliterated would black people achieve total emancipation of the mind as well as the body. They would realise themselves as Africans.[37]

This fascinating and important consideration was embellished as follows:

The blossoming of the Rastafarian movement in the 1970s had a strong bearing on the outbreaks of 1981. Rastas brought a fresh

and critical consciousness, theirs was an acerbic, anti-colonialist ideology. Their ultimate aim was the dissolution of the total system of control, Babylon. But this concept of Babylon had relevance not only for Rastas but for all black youth and, indeed many whites in the early 1980s. Young people, black and white, grew up in a world in which their prospects were limited by circumstances external to them. Their understanding of the world was wrought out of everyday material existences. In particular, blacks felt their chances of improvement restricted by, amongst other things, their blackness, so shared a conception of common destiny.

These views were cemented with every successive round of school-leavers armed with ideas about unemployment and the double disadvantage of being black and working class. Hence the upsurge in Rasta ideas; specifically the concept of a system geared to suppress black peoples gained enormous credibility. Babylon for many black youths was not a bizarre way of describing the world: it was their world. The attraction of Rasta ideas to white as well as black youths suggested that, in the early 1980s, the movement began to speak to a general condition, the most important feature of which was a widespread loss of confidence in the future.[38]

Consequently, the manifestation of the riots of 1980 and 1981, indeed of previous and subsequent riots, is one that takes as its blueprint the seminal and influential track by the Wailers, 'Burnin' and Lootin'', taken from their 1973 album, *Burnin'*.[39] In 'Burnin' and Lootin'', Marley named and identified the riot as a positive act of purification, redemption and political integrity. This audacious and profoundly empathetic act struck an international chord with fractious Black-British youngsters and Jamaican ghetto sufferers alike. Thereafter, rioting would never be considered by many of its perpetrators as being the negative, destructive and anarchic act that others, particularly the mainstream media and the forces of 'law and order' took it to be. When the Wailers sang: 'That's why we're gonna be burnin' and a-lootin' tonight … burnin' all illusions tonight, burnin' all pollution tonight' rioting was, for some people at least, forevermore transformed from merely or simply a violent expression of protest against perceived injustices into an almost sacred act of righteousness, of purification, of judgement. Four years later, British reggae group Merger again celebrated the 'riot' in a song called '77'.

Offering a transgressive alternative to the Queen's Silver Jubilee celebrations of 1977, they sang about the year being 'a festival of destruction time'.[40] Though 'Burnin' and Lootin'' bridled at Jamaican oppression, it appeared to have proposed a type of release for those young Black Britons who could stand it no longer.[41] The song's blending and articulation of frustration, disaffection, political consciousness and rioting was but one manifestation of the socially charged nature of reggae music. The music has always been extraordinarily diverse in its rhythms, lyrics and messages, though the pronounced influence of Rastafari presented itself as a hugely important strand of reggae. As noted in Chapter 3, reggae music spawned no end of British manifestations, from the music of groups such as Merger, Capital Letters, Black Slate, Aswad, Cimarons and Steel Pulse to later British developments such as jungle, hip hop, electronic, ragga, drum 'n' bass, dancehall, garage, grime and dubstep. This astonishing diversity reflected reggae's importance to ongoing generations of Black-British (and indeed other) 'subcultures'. While more recent generations of subcultures might view roots reggae and Bob Marley as near-ancient historical antecedents, it was unquestionably music such as 'Burnin' and Lootin'' and other such songs that created for young Black Britain an enduring template that is to this day a discernible and recognisable characteristic of the narratives of more contemporary manifestations of reggae.[42] Reggae music across the decades was replete with references to fire and burning, endlessly evocative of righteous destruction, purification, and the lighting of the sacred herb.[43]

A number of Black-British artists found themselves charmed by Marley's reference to the burning of illusions and pollution. In 1981, filmmaker Menelik Shabazz made a landmark feature-length film that he titled *Burning an Illusion*. Its publicity described it as being 'the story of a Black woman's awakening'. Years later, in conversation with Lubaina Himid, the artist Donald Rodney referred to some of the influences that lay behind the making of one of his pieces: *The Lords of Humankind* (1986). This work, dealing with slavery and the political and psychological consequences of its aftermath, relied heavily on written text, surrounding central images of a shackled slave and plans of slave ships crammed with human cargo. The images and text were executed on cotton sheets that were then extensively burned around parts of their

edges. The sheets, when suspended from the gallery ceiling, came to resemble a grouping of flags, displaying a terrible assortment of exigent messages. Himid noted the burned and conspicuously damaged nature of the work. Rodney responded 'I burnt the flags, that's what that's about. Burning that type of history ... I love that phrase – "burning an illusion" – that's probably why I use burning a lot.'[44] Such was the unbridled influence of the simplest, yet most defiant of song titles, behind which lay no end of complex narratives taken to heart by much of Black Britain.

The immediate visualisation of reggae music – the reggae record cover – is replete with the images and symbolism of destruction and consumption by fire, with all its biblical resonances. One need look no further than the record covers produced to house recordings by first the Wailers, then by Bob Marley and the Wailers, during the groups' years with Island Records. The first Island Records release was *Catch a Fire*. Characteristic of the flexibility of Jamaican patois, the title was both descriptive and imploring. The original 1973 vinyl record sleeve was one of the most singular in the history of album-cover graphic design, and was the work of graphic artists Rod Dyer and Bob Weiner.

The 12-inch record was encased in a cardboard sleeve depicting that most iconic of American lighters, the Zippo. The sleeve functioned like the casing of a real Zippo lighter, opening at a side hinge to reveal the record within. When the upper 'lid' of the Zippo sleeve was opened, there appeared a giant flame, printed on the previously concealed part of the sleeve. In effect, each time the record sleeve was opened, as a prelude to the record itself being played, the holder of the sleeve was sparking a near literal but primarily metaphorical flame, to light a marijuana cigarette, to illuminate a path through life (the playing of the record itself, with its multiple, timely and prophetic messages)[45] or to 'bun dung Babylon'.[46] The sleeves of reggae records such as these were important sources of messages of affirmation and positive action aimed squarely at the music's listeners and adherents. In this regard, the reggae record, in multiple dimensions, became a hugely important aspect of Black Britain's counter-cultural identity. Record sleeves – particularly the *gatefold* version – served other important functions as well. During the 1970s and 1980s, it was common for the sleeve itself (once the record was removed from its sleeve and placed on the turntable) to assume the practical function

of being a handy surface on which marijuana cigarettes could be ritualisti-cally prepared and made, by those so inclined.

Though the smoking of marijuana was truly international in scope, reached far back into history, and was practised by people from all sorts of ethnicities and backgrounds, Rastafari brought with it a particular injunc-tion – at least as far as some Rastas were concerned – to imbibe the holy weed. In this regard, the police and the judiciary came to single out certain people for harsh punishment for the possession of marijuana, even in the smallest of quantities. Police roughly searched no end of Black youth and those found to be in possession of weed were severely dealt with, often attracting criminal sentences. In this respect, the smoking of weed and the harsh sentences the 'crime' attracted meant that many Black youth found common cause with the put-upon Rastas of Jamaica, as no end of reggae music let it be known that such severe punishment was being meted out to dreadlocked herb smokers across the island. Reggae music mounted a long-running and quite formidable campaign to end such harassment and to see marijuana decriminalised or legalised. Such earnest sentiments also found expression in Black-British reggae.[47]

While the conclusions as to the causes of the Brixton riots were fairly clear-cut and unequivocal, a complex array of factors, beyond those cited in the Scarman Report, could be said to be contributory factors in the epoch-making events. Alongside factors such as police harassment and other grievances, there was the boil of the Deptford fire, a boil that could, seemingly, only be lanced by the Brixton riot and the disturbances that occurred thereafter. But it was, in so many ways, the trajectory of an evolv-ing Black-British cultural identity that played a particular part in the trig-gering of the riots. Likewise, the riots in turn contributed to Black-British cultural identity of the early 1980s and immediately thereafter. It was the near-tactile sense of the Black-British community having emerged that led, in part at least, to the establishing of the *Voice* newspaper in 1982 – a new kind of newspaper, aimed not so much at Caribbean migrants, but aimed instead at *Black Britons*. Significantly, the aftermath of the riots also produced a highly fertile environment in which Black-British practition-ers within the arts flourished and produced highly charged, nuanced and expressive art, literature, theatre, and poetry.

7

Picture on the Wall

As outlined in Chapter 4, it was Britain's dub poets who first articulated, in strident tones, the fractious elements of Black-British identity and experience. Indeed, aspects of the poetry of Linton Kwesi Johnson and others could be said, in some ways, to have offered a blueprint for a younger generation of visual artists, keen to make contributions that similarly spoke of Black people's struggles and aspirations. But until the emergence of a bold new body of artists who gravitated towards 'Black Art', Black artists who had migrated to Britain from the Caribbean were disinclined to regard their work, or to create their work, in any sort of explicitly *raced* manifestation. Instead, artists such as Ronald Moody, who came to Britain from Jamaica in the early 1920s, Frank Bowling and Aubrey Williams, both of whom came to Britain from British Guiana at the beginning of the 1950s, tended to presuppose that they were finding spaces for themselves in an art world for which modernism was the order of the day, and adverse racial considerations had no place.

In some respects, all of the major strands of the arts in Britain occupied default spaces that were intrinsically conservative and, by and large, not minded towards the sorts of explicit social narratives beloved of the dub poets. There was during the 1950s, 1960s, and 1970s a determined sense of the arts as an entity more often than not distancing itself from the political

Figure 24: Guyana-born British artist Frank Bowling in a studio, London, 1962. Elements of his art theory are painted on the wall behind him.

realities of people's lives, and concerning itself with supposedly loftier pre-occupations. Furthermore, the arts were one of a number of sectors that demonstrated not only a resistance to acknowledging or incorporating Black Britons' contributions, but which also constantly reflected elitist or discriminatory practices, in audience preference, employment preference, and practitioner preference. Consequently, Black artists in Britain found themselves engaged in struggles for visibility that predated the early 1980s' emergence of a new generation of Black artists, wedded to a belief in the importance of explicit social narratives in their work.

One of the most energetic of British artists of Caribbean background active in the early 1960s was Frank Bowling. Demonstrable ambition and

relative success notwithstanding, Bowling found his career hitting something of a roadblock, typifying perhaps a chronic, systemic and historic reluctance on the part of art establishment to unreservedly embrace artists from a plurality of backgrounds. Evoking Charles Dickens, Mel Gooding chronicled this dispiriting period of Bowling's life.

> For Bowling, the mid-1960s were the best of times and the worst of times. His confidence in the kind of painterly expression that had brought him to critical notice and afforded him some degree of professional success had faltered, and he had embarked on work that in its disconcerting combination of different styles and manners seemed to signal private, political and artistic dilemmas. In the spring of 1964 he had been excluded from two important and critically significant exhibitions: the Gulbenkian-promoted exhibition *54 64 Painting and Sculpture of the Decade* at the Tate, and the Stuyvesant-sponsored *The New Generation: 1964*, selected by Bryan Robertson and put on at the Whitechapel Art Gallery. The latter was the more hurtful omission in that Bowling had been treated with great kindness, and as a kind of protégé, by the brilliantly ebullient and influential Robertson. Bowling's work was also omitted from the rapidly expanding Peter Stuyvesant Foundation Collection, put together by a team of influential selectors over two to three years to form what, in the catalogue to an exhibition mounted at the Tate, they described as 'a general picture of recent British painting.'[1]

Commenting on this difficult period, one art critic, Colin Gleadell, tabled the rather blunt sentiment that for Bowling and his work, 'Being West Indian did not help.'[2] It was when Bowling was seeking to ascertain why he had been overlooked for *The New Generation* that he was apparently told, 'England is not yet ready for a gifted artist of colour.'[3]

Perhaps as a consequence of being kept at a distance from Britain's infrastructure of art galleries, Black artists eventually found themselves firmly within the designated category of ethnic arts. This would in time become something of a subaltern pigeonhole that was to assume, and be informed by, state-mandated dimensions. It was certainly not incidental that, as mentioned towards the end of Chapter 4, James Berry wrote that 'Britain's Caribbean community has sharpened its pride in showing

its ethnic arts.'[4] After all, ethnic arts had by the early 1980s emerged as the dominant framework with which to view the art of migrant communities. Most worryingly, this designation of ethnic arts excluded white Britons and artists from Europe and was applied to Black-British-born practitioners as much as to migrants born in the Caribbean or elsewhere in the world.

One of several important factors that distinguished a new body of Black artists in early 1980s Britain was the determined ways in which they either challenged or circumvented this designation of ethnic arts. The exhibition that marked the beginning of a relatively brief period of visibility and activity for Black artists in Britain clustered around 'Black Art' was *Black Art an' done*, which took place at Wolverhampton Art Gallery in the spring of 1981. The latter part of the exhibition title was a popular Jamaican expression of the time. As with many other Jamaican expressions and phrases, 'an' done' did not translate neatly into what might be termed 'standard' English. It was a term that approximately translated to 'that's that' or 'let that be the end of it' or 'and leave it at that'. To those with African Caribbean backgrounds who could understand the exhibition title, it read something like: 'This is Black Art, and that's the end of the matter.' Determined yet playful, playful yet determined, the exhibition title settled on by the artists was near perfect. In the first instance, it was, as Rasheed Araeen suggested 'perhaps the first time the term 'Black art' has been used in Britain in relation to a contemporary art practice'.[5] Secondly, the use of a Jamaican colloquialism in the titling of an exhibition was unprecedented and served to intrigue a number of people, not least a number of the exhibition's reviewers who mentioned the unusual title in the reviews they filed. Typical in this regard was the *Guardian's* Irene McManus, who opened her review with the admission, 'I'm still thinking about that title.'[6]

Given London's formidable status as the cultural centre of gravity of Black Britain, there may perhaps have been a reasonable expectation that should a socially explicit type of Black artists' practice ever emerge, London would be the city giving birth to it. The group of young Black artists and art students who contributed work to *Black Art an' done* were all from the West Midlands, four from Wolverhampton itself and one from the Sparkbrook area of relatively nearby Birmingham. Most came from the sorts of fundamentalist Christian backgrounds mentioned in Chapter 3 – the sorts of backgrounds from which so many of the Rastas and Dreads of the country

Figure 25: 9 June 1970: Anti-racism demonstrators gather in Wolverhampton in protest against Enoch Powell's controversial immigration policy with anti-Powell banners. Mr Enoch Powell was in Wolverhampton as part of his campaign for the forthcoming election.

had similarly come. From the late 1940s onwards, the West Midlands had been an important destination for tens of thousands of migrants, and had been referenced as such in articles and books. In the mid–twentieth century, the West Midlands was home to significant amounts of manufacturing, mining and other industries, and consequently it was a region to which migrants in search of work gravitated.

Consequently, perhaps, it was a region that had also experienced racial tension and Malcolm X had visited one particular locale, Smethwick, in 1964, the year in which a distinctly febrile atmosphere had developed. The racial tensions of 1964 were typified by the infamous slogan adopted by Peter Griffiths, a prospective parliamentary candidate for the Conservative Party, 'If you want a nigger for a neighbour, vote Labour.'[7] Griffiths gained the Smethwick seat by defeating the Shadow Foreign Secretary Patrick Gordon Walker in the general election of that year. The sentiment with which Griffiths became forevermore associated could in some respects be set alongside equally notorious comments by another

West Midlands Conservative politician, Enoch Powell, who as MP for Wolverhampton South West (a constituency which included leafier suburbs as well as areas with relatively high concentrations of immigrants, particularly from the Caribbean and South Asia) made notorious comments that nearly half a century on have lost little of their calculated bile and venom. Powell's disquisition, dubbed his 'Rivers of Blood' speech, was delivered to a Conservative Association meeting in Birmingham on 20 April 1968, barely two weeks after the assassination of the Reverend Dr Martin Luther King.

The opening passages of Powell's speech included extracts from a conversation Powell claimed to have had with 'a constituent, a middle-aged, quite ordinary working man'[8] who apparently feared that 'In this country in 15 or 20 years' time the black man will have the whip hand over the white man.'[9] The speech contained many of the anti-immigrant sentiments that, nearly half a century later, continue to find shrill expression and popular appeal within British politics. Powell reiterated the not uncommon view that immigrants are a sinister, uncivilised menace, who have no end of adverse effects on school places, hospital services, housing infrastructure, and the order of society. Speaking of what he claimed to be his upstanding though beleaguered white constituents, Powell claimed,

> They found their wives unable to obtain hospital beds in childbirth, their children unable to obtain school places, their homes and neighbourhoods changed beyond recognition, their plans and prospects for the future defeated; at work they found that employers hesitated to apply to the immigrant worker the standards of discipline and competence required of the native-born worker.[10]

It was, though, the following passage, prophesying bloodshed of apocalyptic proportions, which gave the diatribe its nickname.

> Here is the means of showing that the immigrant communities can organise to consolidate their members, to agitate and campaign against their fellow citizens, and to overawe and dominate the rest with the legal weapons which the ignorant and the ill-informed have provided. As I look ahead, I am filled

with foreboding; like the Roman, I seem to see 'the River Tiber foaming with much blood.'[11]

Given the extent to which Wolverhampton had figured in Powell's 'Rivers of Blood' speech, the town's art gallery might perhaps have been a perfect setting for an exhibition such as *Black Art an' done*. This was perhaps a confirmation, or maybe a rebuttal, of Powell's dire predictions for the town's future, as a consequence of its immigrant population. In Powell's view, 'The cloud no bigger than a man's hand, that can so rapidly overcast the sky, has been visible recently in Wolverhampton and has shown signs of spreading quickly.'[12]

By the late 1970s, the former industrial heartland of the West Midlands had been laid waste by factory closures, industrial retrenching, and rampant unemployment. It was, both simultaneously and consequently, a region undergoing seismic social and cultural change. This was a time of social fracture, and the realignment of cultural tectonic plates. Previous certainties of community, of state, of Britain's place in the world, were all challenged and put under stress by a range of factors, including immigration. But by the mid to late 1970s, all manner of British-born people, across ethnicities, were seeking to figure out where they existed in the uncertainty and vulnerability of the times. Times in which technological advances took place alongside an escalating unemployment that seemed to hark back to the 1930s. Some people continued to cling to longstanding notions of identity, even as the world around them changed. And some people took refuge and found solace in new-found belief systems such as Rastafari, which harked back to developments in colonial Jamaica and elsewhere in the world, during the 1920s and 1930s, as much as it looked forward to a far-off promised land. Riots, declaring a new dimension to the Black-British presence, had erupted in the Notting Hill Carnival of 1976, and, several years later, in St Paul's Bristol. This unrest seemed to exist as cataclysmic events which disturbed and consternated some even as they thrilled, excited and fired the imagination of others. This was something of the wider context in which these earliest manifestations of Black Art came to exist.

In time, the socially, politically and culturally charged entity and designation of Black Art would not only lose its appeal, but the term would come to refer to almost anything and everything produced by artists perceived or regarded as not being white. Rasheed Araeen sought to unpick this muddle.

181

However, the allusion to 'race' in this specificity indicates an experience of a particular group of people or a community, which has resulted not necessarily from its own perception of itself but the way white society defines it by invoking its difference. This difference is of course there and is part of the community's identity, but it is not fundamental to what it aspires to in the modern world. What therefore concerns Black Art is not so much this difference as how this difference is defined and experienced in a society that has not yet fully come to terms with its colonial past and its racial violence. It seems that the intensity of this experience among some black art students was so great that they were unable to share it with their white teachers and class fellows, producing a frustration and an anger that led to a denunciation of the whole system. It was this denunciation that underlies the emergence of Black Art in the early 1980s. It should not therefore be confused with the work of every black artist before and after this emergence.[13]

The exhibitors in *Black Art an' done* had come together through an informal network linked by church (a majority of them having grown up as Seventh Day Adventists) or by college. The latter factor pointed to the growing, though still marginal, ways in which higher education in general, and art school in particular, was an option that numbers of Britons of Caribbean background were availing themselves of. The exhibition had been in preparation since late 1979 and had come about at the instigation and encouragement of Eric Pemberton, a Black teacher at a Wolverhampton school. Years later, Keith Piper offered up a wide-ranging set of factors and influences that contributed to or were responsible for the working positions of this group of young artists. One of the influences flagged up by Piper was what he regarded as a generational polarity that was said to bring with it attitudes of 'extreme rebellion' as a partial consequence of a background of 'extreme conformity'.[14] But Piper had a number of other contributory factors to add, including 'a sense of aesthetic bleakness derived from growing up in the West Midlands during the industrial recession of the late seventies and early eighties, which was able to match well a fashionably anti-crafts value, anti bourgeoisie art establishment posture…'[15]

The artists collectively adopted the essential elements of the Black Power/Black Art manifesto propagated by African-American poets and

prophets a decade earlier across the USA. The resounding electoral victory of Margaret Thatcher's Conservative Party, indicated the extent to which these were heady days for Black Britain and the unequivocal certainties espoused by these five artists were typical of the times. In part, the press release for the exhibition read;

> The exhibitors all share a common preoccupation with the culture and civil rights of Black people in this country and abroad... they are concerned with the propagation of... Black Art within the wider sphere of modern Black culture. The group believes that Black Art – which is what they call their art – must respond to the realities of the local, national and international Black communities. It must focus its attention on the elements which characterise... the existence of Black people. In so doing, they believe that Black art can make a vital contribution to a unifying Black culture which, in turn, develops the political thinking of Black people.'[16]

Such were the influences on these West Midlands born and raised young Black artists. In pinning their colours so firmly to the mast of racial resistance and empowerment, Piper et al. were as mentioned, reprising the shift in African-American cultural politics that had taken place in the USA a decade earlier. Given the culturally powerful ways in which Rastafari entered the Black-British frame from the mid 1970s to the mid 1980s, perhaps it ought to be of no surprise that Piper would also cite, as an influence on his own distinctive practice, 'the work of a Rasta artist named Ras Lucas at a show in Birmingham. The brother was using a combination of image and text to make direct and powerful statements.'[17] Consequently, the work of a Rasta artist from Piper's home city of Birmingham took its place alongside other influences such as 'the writings of black American militants, particularly Eldridge Cleaver and Huey Newton.'[18]

The Other Story was a landmark exhibition which sought to outline a history of 'Afro-Asian artists in post-war Britain'. The exhibition was curated by Rasheed Araeen and organised by Hayward Gallery and the South Bank Centre, London, in 1989.[19] In one of his essays for *The Other Story* catalogue, Rasheed Araeen described the work of Piper et al. as expressing 'intense anger and frustration in their work [that] can only be understood in light of the fact that they grew up in Britain'.[20] Referring to Powell's speech of 1968, Araeen continued,

The event is a symbol of the social reality faced by black children every day in British society. If there is no sense of belonging to western/white culture among many black people, its main explanation will be found in the reality they face daily rather than in the pseudo-scientific uprootment and alienation.'[21]

Quoting from the catalogue for *Black Art an' done*, Araeen's essay went on,

The work of the black artist should be seen as having specific positive functions: a tool to assist us in our struggle for liberation, both at home and abroad, as opposed to simply reflecting the moral bankruptcy of our modern times... Black Art, at the very least, should indicate and/or document change. It should seek to effect such change by aiming to help create an alternative set of values necessary to better living. Otherwise it fails to be legitimate art.[22]

Press responses to 'Black Art' exhibitions of the early 1980s tended not to discuss the aesthetics of the practice – the use of assemblage sculpture, Pop Art mechanisms and techniques, the artists' use of image and text, the relationship to photomontage, the artists' use of everyday technology such as the photocopier, the influence of the art school environment – none of these factors were given much consideration, if any, by press reviewers, who were more minded to view the work through the lens of its explicit messages and the wider context of the racial fractiousness of the times. But this, as far as the artists were concerned, was all well and good, as they themselves tended to downplay the significance or importance of aesthetics in their work, derisively dismissing what they termed 'art for art's sake'. As with several other aspects of British 'Black Art' of the early 1980s, this posture had precedents in the African-American Black Arts Movement that had taken place a decade or so earlier. In 1971 Samella Lewis opened a pictorial directory of African-American artists' work with the statement,

No longer satisfied with having their work viewed as an extension of Western esthetics, Black artists throughout the world are striving to make artistic contributions on their own terms. In other words, they are insisting that their views in relationship to their art be expressive of their experiences... For centuries

Black people have been identified on a racial basis rather than on a nation basis. Because this kind of identification occurs frequently, efforts are being made to use it in an advantageous manner in the struggle towards the idea of Nation Building.[23]

Since the decades of the mid twentieth century, artists such as Ronald Moody, and later Frank Bowling and Aubrey Williams, had sought to practice firmly within a non-racial environment characterised by an appreciation and an embrace of the main currents of modernism. Though these artists and others from elsewhere in the world who came to London in the 1950s and 1960s might have bridled against the idea that their work was simply or merely 'an extension of Western esthetics' there could be no doubting the extent to which they employed a strategy of either seeking inclusion or presuming art world inclusion. Though young Black artists of the early 1980s may have been every bit as serious about their practices, there could be no doubting the extent to which some of them were, as mentioned, scornful of 'art for art's sake' and its apparent centrality within the art school environment – even as they sought access to gallery spaces around them. Though Lewis had applied an arguably ill-fitting international template to the artists about whom she was enthusing, there could be no doubting the degree to which, in the early 1980s, a small number of young Black-British artists were 'striving to make artistic contributions on their own terms'.

The willingness of some Black-British artists to define themselves, their practice and their contributions along race lines was a strategy developed within African America a decade earlier. As mentioned, some of the more vociferous advocates of Black Art implied or demanded that Black Art should exclusively reference the Black community, and it was this call for an explicitly Black-centred art practice that distinguished much of the work, and many of the catalogue statements of Piper et al. The American term 'Black Art' had irreversibly found its way into these artists' individual and collective vocabulary. In 1981, with the St. Paul's district of Bristol already having witnessed direct confrontations between the police and Black youth, resulting in the destruction of property, including police cars, the term 'Black Art' adequately and fittingly embodied the militant aspirations and posturing of certain Black youth at that time.

The press response to the *Black Art an' done* exhibition set the tone for the type of coverage that such Black artists' exhibitions would receive throughout the forthcoming decade. Primarily, the exhibition's reviewers employed adjectives – for both art and artists – such as 'angry', 'impassioned', 'crude', and 'furious'. While such descriptions were not necessarily negative or uncomplimentary, reviewers' pathology of gravitating towards such language became a pronounced aspect of the ways in which these artists were framed. Again, the US Black Arts Movement had given rise to an equivalent pathology. The equating of the explicitly presented *Black* image or subject matter tended to be read in particular ways, though few, if any, of the artists of the time took issue with this. With the word 'angry' being by far the most frequently used description to appear in mainstream press articles about exhibitions such as *Black Art an' done*, pretty much the only comment that took issue with this came from the artist, poet and cultural activist Shakka Dedi. Writing in 1984, the then Director of The Black-Art Gallery observed that,

> in many cases the realities being dealt with by artists... [are] often misinterpreted by white/European viewers who see the work as being 'angry' and 'aggressive', when in reality there is little or no anger expressed – but simply the visually stunning and dynamic presentation of hard, cold facts.[24]

The position adopted by the *Black Art an' done* artists reflected an insistence that their art be unreservedly aligned to the struggles of Black people. These artists implied, and in some instances declared or advocated, that 'artistic' considerations had no part to play in the work of the Black artist. After all, so Piper et al. reasoned, Ron Karenga (referenced in relation to *Festac'77* in the previous chapter) had instructed as much when he wrote '[Black Art] must be functional, that is *useful*, as we cannot accept the false doctrine of "art for art's sake"'.[25] The rejection of 'art for art's sake' by the *Black Art an' done* artists contrasted sharply with the aspirations and the aesthetics embraced by some of the older generation of Black artists. The previous generation of Britain's Black artists, including the likes of painters such as Frank Bowling and St Lucian-born Winston Branch, sought to paint in a world in which race was irrelevant, and artists were simply artists. Pioneering practitioners such as Bowling and Branch were arguing for the right to

embrace modernist forms of art practice, without hindrance from any quarter. Reacting against such strategies were fiery Black Art advocates of the early 1980s who preached that Black artists should have nothing to do with art movements perceived as being 'white', self-indulgent and existing for their own sake – a clear reference to the abstract forms of expression typical of modernist art practice and its resonances with aesthetic individualism.

But in the Black 1970s, and the early 1980s, the idea of embracing modernism carried no resonance or appeal for emerging, alienated Black Britain, and the young artists who so dramatically identified with this put-upon demographic. Instead, it was the Black Power influence that carried the swing, certainly as far as a vocal minority of young Black-British artists were concerned. They rejected what they considered to be the mould and the model of 'Western' art and its associated art history. Young Black-British artists sought instead the Black mould of the *ghetto defender*, the *exile inna Babylon*, the *rebel with a cause*, the *sufferer*, and so on. White reviewers of exhibitions by these new, younger artists obliged, and reviewed their work along these self-designated lines of identity. This framing was indeed the most dramatic of shifts. A 1978 review[26] of an exhibition of work by painter Errol Lloyd (who was born in Jamaica in 1943 and subsequently migrated to London) was critiqued in reference to the European artists Henri Matisse, Salvador Dali and Paul Gauguin. By contrast, *Black Art an' done* was linked by several reviewers to concerns and references such as 'race relations', 'unemployment' and 'South Africa'.

Deliberately and determinedly going against the grain of the dominant perception of the artist as occupying a rarefied space of privilege that set him or her apart from perhaps less favoured or privileged elements of society, these artists were happy to regard themselves as emerging from, as well as addressing, the 'inner-city' Black experience, as it was constructed by strands of Black popular culture and liberal sociologists alike. 'The inner-city' had long since come to be depicted as the *natural* habitat of the most *authentic* Black experience and was synonymous with educational under-achievement, rampant unemployment, poverty, alienation, etc. Though these young artists had, as mentioned earlier, tended to come from somewhat different backgrounds, at the beginning of the 1980s a number of these Black artists were happy to

assume a 'Black' identity that located itself in or identified itself with an inner-city sensibility, and white reviewers were equally happy to use such heavily constructed terms of reference in their coverage of exhibitions such as *Black Art an' done*. In this regard, these young Black artists were by and large taking their cues from the strands of reggae music that by the mid to late 1970s had come to dominate. As referenced in a previous chapter, 'Once roots and culture took over... this new reggae was all about Jamaica, indeed all about one aspect of being Jamaican – sufferation.'[27] This locating of *sufferation* at the heart of constructions of Black-British identity was something earnestly appropriated and extended by Britain's dub poets and some amongst a new generation of Black artists alike. Consequently, Black-British cultural expression of the early 1980s both propagated and reflected the view that the inner city experience is the only *real* Black experience and those who aspirationally placed themselves beyond 'the ghetto' – literally or otherwise – were racially suspect. Particular strands of Black music of the 1960s, 1970s and 1980s carried with them the message that there was righteousness, authenticity of experience and racial integrity in 'the ghetto', or, as it later came to be referred to in the USA, in vernacular terms, 'the hood'. The genres that preceded reggae, such as ska and bluebeat, were typified by a range of lyrical content – affairs of the heart, rivalries between popular singers, exuberance over Jamaica's independence, and so on. But by the late 1970s Jamaican reggae group the Twinkle Brothers was singing, 'I was born in the ghetto / the ghetto is where I'm from / I was born in the ghetto / the ghetto is where I belong...'[28] This somewhat mannered embrace of sufferation, and a pronounced declaration of solidarity with sufferers throughout the African Diaspora, was reflected in British 'Black Art' of the early 1980s. In sum, *Black Art an' done* marked the first attempts by a new generation of Black artists to decisively and boldly align their artistic practice to the struggles of Black people.

These young Black artists boldly reflected a cultural strategy that characterised the emergence of a distinct Black-British cultural identity. In order to make sense of their identities as Black-British youngsters, coming of age in a racially fractious, post-industrial (and by now Thatcherite) environment, these artists reached out and found common cause with the struggles of Black people in different parts of the world, thus rallying

around Burning Spear's plaintive and mournful insistence that 'di whole a we suffa'.[29] Simultaneously, these artists reached back into history, identifying and celebrating individuals who had made important contributions to Black struggle. In his text widely regarded as introducing the term and the concept of dub poetry, Linton Kwesi Johnson described history as being, for the oppressed Jamaican, 'not a fleeting memory of the distant past, but the unbearable weight of the present'.[30] Much of the work of this cluster of artists reflected this bold and provocative reinscribing of *history*. As noted in Chapter 2, Black youth themselves countered their marginalisation and alienation by drawing heavily on a wide range of Black identities from elsewhere in the world, particularly the Black Power movement of the USA, the increasingly popular movement of Rastafari, and the attendant 'Natty Dread' culture of Jamaica. Reflective of these strategies, when this new grouping of Black artists emerged in Britain in the early 1980s, they took as their heroes, and visualised accordingly, such African-American figures as George Jackson, Huey Newton, Martin Luther King, Sojourner Truth, Malcolm X, and so on. It was iconic figures such as these who loomed large in the consciousness of artists such as Marlene Smith, Donald Rodney, and Keith Piper. In a great many instances, the artistic embrace of these recognisable individuals reflected the Pan-African sensibilities of the Black Arts Movement, with its dynamic agenda of celebrating struggle and memorialising resistance. Much of the early 1980s' work by Keith Piper and others bore witness to these artists' strategies of reaching into history and reaching into the international arena for subject matter.

With his compelling and influential book, *Revolutionary Suicide*, Huey P. Newton had emerged as a charming, charismatic, tragic hero/antihero of the Black Power era. Newton's writings had a significant influence on Piper, who sought to memorialise Newton in an astonishing work of 1982. Within the work, Piper stretched untreated canvas over a fairly large frame. He then took a piece of cardboard of stencilled lettering with the words 'Black Panther Party for Self Defence'[31] and, using an aerosol can of red paint, repeatedly stencilled the words across the canvas in dramatic fashion. In the middle of the canvas, Piper adhered a photocopy of Newton, behind prison bars, flicking a V sign. Not the inwardly turned V sign historically beloved of peace activists, but the altogether different, more

assertive, more uncompromising outwardly turned V sign, with its decidedly different readings, more akin to today's gesture of a single, raised, middle finger. Across one of Newton's eyes and part of his forehead and hair, Piper painted, in translucent red ink, a single five-pointed star, symbolising Newton's socialist credentials and the ways in which socialist thought was such a dramatic underpinning of Black Panther activism. Approximately A4 in dimension, the photocopy of Newton's portrait was completed with a salvaged thin picture frame, thereby emphasising the status of this troubled Black Power revolutionary.

Though Newton was still alive at the time that Piper made the work, it nevertheless functioned as a memorial to both a fallen revolutionary and a fallen revolutionary movement. Piper had layered the mixed media work with a particularly pithy, succinct encapsulation of the rise and fall of one of America's most intriguing revolutionary movements of modern times: 'A BROTHER ONCE DECLARED WAR ON A CORRUPT SOCIETY. THE CORRUPT SOCIETY WON BECAUSE NO-ONE BELIEVED IT WOULDN'T.' Thus Piper not only alluded, in typically dramatic fashion, to the rise and fall of the Black Panther Party, but also gave his audiences a compelling narrative with which to understand the reasons for the group's existence, and a tragic yet powerful summary of the reasons for its failure, which devastatingly included societal complicity.

Here, writ large within this piece, was the manifestation of Ron Karenga's diktat that 'Black art must expose the enemy, praise the people and support the revolution'.[32] In memorialising Newton, Piper was not only drawing renewed attention to a rapidly fading movement, but was simultaneously urging remembrance of one of its original thinkers and activists. But what made Piper's Huey P. Newton piece all the more astonishing was the anti-art school thesis embedded within it. At the time of the work's making, Piper was a fine art student at Trent Polytechnic, Nottingham. Like other art schools across the country, the dominant ethos at the time was the teaching of formal aspects of fine art – technical abilities of painting and drawing, the rules of perspective, form, line, colour, still life, and model drawing, and so on.

This approach was deemed to be most appropriate to equip students for the tasks of being artists and going on to make work, having mastered

the necessary and prerequisite skills. Furthermore, this was an approach that ensured that work with pronounced social and political agendas was kept far from the art school studio. Students were taught how to stretch canvases, prepare the canvases for painting, mix paints, and so on. No consideration was given to the best ways in which exigent societal messages might be communicated within a work. In effect, Piper drove a coach and horses through this dominant ethos, breezily disregarding it in a declared preference for making work that dynamically challenged the prescribed role of the art student as socially disengaged individual. In making this work, Piper headed to the art school store for his canvas and nothing more. His lettering stencils he created himself, and instead of oils or acrylics, he utilised a can of aerosol paint, as used by motor garages and graffiti artists alike. Aerosol can, stencil, and photocopy – these were the tools Piper used to create his singular homage to Huey P. Newton. Piper's determined and studious challenge to the dominant art school ethos and all it represented also manifested itself in other important work of his of this period. His sophisticated, informed, critical monument to Huey P. Newton reflected a profound and formidable anti-art-school ethos, with its salvaged aesthetics, its frugality of cost and manufacture, and its sparse but emotive messages.

Though barely out of his teens, Piper was, by 1981, a highly skilled and effective user of archival material. An artist with a particularly keen eye, he sourced an astonishingly broad range of material for the making of his art. The range of imagery and paraphernalia Piper sourced for his work included many images from the ongoing history of the fight against apartheid. Throughout the 1980s and well into the 1990s, the struggle against the racist system of apartheid consumed the creative and political energies of many people. Within this context, Piper produced numerous works that sought not only to expose the barbarity and criminality of apartheid, but also the hypocrisy of apartheid's friends in the upper echelons of British society. To this end, Piper made good use of the hugely important archive of images chronicling the victims of – and resistance to – apartheid. Similarly, Piper sourced a number of images from documentation of the years of the transatlantic slave trade, which occurred between the seventeenth and nineteenth centuries. But Piper was also interested in decidedly local concerns and to this end also sourced his

imagery from British contexts. Indeed, one of his collaborations with another young Black artist, Donald Rodney, was a 1987 exhibition called *Adventures Close To Home*,[33] about the regular incidences of great violence meted out to Black people, by the police, both on the streets and within domestic environments.

As mentioned earlier, the exhibitors in exhibitions such as *Black Art an' done* had come together through an informal network linked by church or by college. This latter network was to become a particularly important one. Donald Rodney, like Keith Piper, was a native of Birmingham. His Jamaican parents had settled in Smethwick, and following his schooling he had opted for art college. Arriving at Trent Polytechnic in 1981 to study Fine Art, Rodney met, in the year above him, Keith Piper. Embracing both the aesthetics of pop art and the ideology of 'Black Art' (that is, a socially dynamic visual art practice, closely aligned to militant political and cultural agendas of progress for Black people), Piper's practice even as a student was sharp, caustic, powerful and engaging. Piper had argued that the work of Black artist/art student should speak to 'the Black experience'. To this end, Piper's work, as referenced in this chapter, cogently touched on the experiences of Black people in the United States, Africa, and elsewhere in the world. Rodney later recounted the extent to which he found himself charmed and persuaded by Piper's position and practice.

> When I went to Trent [Polytechnic], I'd been brought up in the tradition of painting. I knew how to paint. I knew the history of painting. I knew my Picassos, my everything. I wanted to be a Black Picasso. Not because I thought being Black was important. It's just that I wanted to be famous. When I got to Trent I met Keith and he introduced me to Eddie [Chambers] and their work was about the experience of being Black. And up until that time at Trent I'd been painting flowers – really pretty flower painting. I thought they were dead-on! And then I just stopped. I thought this should be about... I should start doing things about me. The actual jump from doing flower-painting to this might seem like a huge one to anybody else, but to me it was just logical because it was a radicalisation process. I suddenly became aware of what I wanted to say and who I wanted to say it to.[34]

With a certain audacity, purpose and singular sense of resolve, art students such as Piper, Rodney and Marlene Smith made the art school a site of struggle. For them, as art students, this improbable or unlikely site of struggle witnessed culture wars every bit as important as those taking place in other arenas. In the early to mid 1980s Britain, students such as these missed few opportunities to pursue an art practice that was rooted in their own identities, biographies and aspirations. Relatively few Black youngsters were going to art school, but amongst those who were, Piper, Rodney, and several others (who were often the only students of colour in otherwise all-white student bodies, and all-white faculties) waged war against a cultural hegemony, thereby declaring their solidarity with the struggles to which they related and empathised. Though Rasheed Araeen, in his evaluation of Black Art of the early 1980s, had imagined the art school as an alienating environment which precluded understanding of the stressed and fractious nature of Black people's experiences, histories and identities; and though they were for the most part at art schools around the country, geographically distanced from each other, these students created for themselves a network of mutual support through which they were able to create exhibitions and bring to the attention of different constituencies an important dimension of Black-British cultural identity.

Upon meeting Keith Piper, a particularly influential figure of the 'Black Art' movement of the early 1980s, Rodney found himself being readily persuaded of the importance and validity of Black Art. From 1982 onwards Rodney started exhibiting alongside Keith Piper and the other art students who formed a series of ever-changing line-ups for exhibitions that tended to be called *The Pan-Afrikan Connection*[35], the group itself eventually coming to be known as the Blk Art Group.[36] These exhibitions took place between 1982 and 1984 at a range of galleries throughout the country. The statements that Rodney submitted to exhibition catalogues during this period indicated his new found commitment to Black Art.

> The work you shall see is fresh and cutting and black. The colour of our skin is the reason you are here; the colour of our skin is the reason that keeps us together and it is the colour of our skin that has made us produce this work.[37]

By the early 1980s the history of Black artists in Britain was substantial, taking in many different types of artists, and a diverse range of art practices. But never before had such forthright sentiments been expressed. That they should come from art students, located in England's provinces, made these statements all the more remarkable.

In the early 1980s, there was pretty much only one proactive course of action open to arts student who aspired to have their work seen in contexts beyond the art school, and that was submitting work to *New Contemporaries*. These young Black artists boldly announced an alternative strategy, which met with approval in certain journalistic quarters. One admiring reviewer of one of the group's London exhibitions noted, 'Like New Contemporaries (ICA) this is an exhibition organised by art students. But instead of hopefully submitting a piece to be accepted into an atmosphere of vague pluralism, these artists have constructed a show with a powerful identity and purpose.'[38] In the late 1970s, this 'atmosphere of vague pluralism' had seen an artist such as Eugene Palmer twice included in *New Contemporaries*, but the strategy of Piper et al. of virtually breaking out of the art school was something of an altogether different order.

Beyond 1984 and beyond the Blk Art Group, Piper and Rodney went on to collaborate on a number of occasions, the work and the exhibitions they produced together representing a decisive meeting of minds. One of Piper and Rodney's most compelling and successful collaborations was *The Next Turn of the Screw*, which was in effect an homage to Black lives lost or damaged in acts of great violence by the police. The work took the form of an installation, painted and built in the gallery area of Chelsea School of Art. This work was part of a larger group show, titled *The Devil's Feast* that featured work by Zarina Bhimji, Chila Burman, Jennifer Comrie, Allan de Souza, Keith Piper and Donald Rodney, the exhibition taking place 27 April – 8 May 1987.[39] In some ways the catalyst for the piece was yet another suspicious or questionable death in police custody of a young Black man, named Clinton McCurbin. He died while being restrained and arrested by the police, in a clothes shop in Wolverhampton town centre, in February 1987. McCurbin's violent death was one of a number of similar tragedies to take place in the mid 1980s.

Piper and Rodney were determined that these deaths would not go unremarked. To this end, they set about creating a work of profound

empathy. *The Next Turn of the Screw* featured, in part, painted sparse, impressionistic portraits of six unfortunate people, each of whom was a victim of alleged police brutality. The unhappy roll call featured, chronologically, Colin Roach, Jackie Beverley, Cherry Groce and Cynthia Jarrett, Trevor Monerville and finally, the aforementioned Clinton McCurbin. What was remarkable about *The Next Turn of the Screw* was that the artists had to collect and rely on decidedly partial, fragmentary source material. The nature of these archival images threw into sharp relief the violence that blighted the lives of these sorry individuals. Colin Roach (who was said by police to have shot himself in Stoke Newington police station in January 1983) is shown smiling, the portraits of Jackie Beverley (alleged to have been raped whilst in police custody) and Trevor Monerville (who sustained brain damage, allegedly after a police beating, around New Year, 1987) are incomplete – evidence of the ways in which their likenesses were sourced from what were often other people's photographs. By far the most poignant image was that of Cherry Groce (shot and paralysed by armed police, in her Brixton home). The only image of her that was circulated within the press and media in the aftermath of her injuries was lifted from a wedding photograph. The cropped photograph – taken several decades earlier – showed her as a bride, wearing her wedding-day finery. Similarly poignant was the image of Cynthia Jarrett (who died of a heart attack during the course of a police raid on her Tottenham home), taken at a social function.[40] No other pictures of the hapless victims recent – or otherwise – were available. Beneath each portrait the artists had, almost by way of an epitaph, written a brief description of the violence that befell the six.

The Next Turn of the Screw was in effect history as cultural memory, history as remembrance and memorial. To profound and deeply sobering effect, the artists used archival images to create something that was in itself an archival document. The piece was only ever shown as part of *The Devil's Feast* and, upon the close of the exhibition, was dismantled and the six portraits executed directly on to the gallery wall were painted over.

Such was the importance of this manifestation of Black Art in a British context, wholly in keeping with, and reflecting a new generation of Black Britons and some of the identities and challenges they were coming to terms with, that Stuart Hall identified it as one of his Three 'Moments'

in Post-war Black Diaspora Artists in Britain History.⁴¹ Hall's article had
offered,

> a conjunctural analysis of three 'moments' in the post-war
> black visual arts in the UK. The main contrast identified is
> between the 'problem space' of the artists – the last 'coloni-
> als' – who came to London after World War Two to join the
> modern avant-garde and who were anti-colonial, cosmopoli-
> tan and modernist in outlook, and that of the second gen-
> eration – the first 'post-colonials' – who were born in Britain,
> pioneered the Black Art Movement and the creative explosion
> of the 1980s, and who were anti-racist, culturally relativist and
> identity-driven. In the work of the former, abstraction pre-
> dominated; the work of the latter was politically polemical and
> collage-based, subsequently embracing the figural and the more
> subjective strategy of 'putting the self in the frame'. This genera-
> tional shift is mapped here in relation to wider socio-political
> and cultural developments, including the growth of indig-
> enous racism, the new social movements, especially anti-racist,
> feminist and identity politics, and the theoretical 'revolu-
> tions' associated with them. The contemporary moment – less
> politicized, and artistically neo-conceptual, multi-media and
> installation-based – is discussed more briefly.⁴²

Hall argued that 'To speak metaphorically, between the work of [Francis
Newton] Souza or Aubrey Williams and that of Eddie Chambers, Keith
Piper and the Pan-Afrikan Connection falls the shadow of *race*.'⁴³ Hall had
suggested earlier in his text that an embrace of modernism was one of the
main characteristics distinguishing the pioneering generation of migrant
artists from the generation to come thereafter. Further, that abusive and
challenging events and experiences within the arena of race (and indeed,
some of the challenges of responses these events and experiences pro-
voked) cast a shadow over, or left a mark on, the several decades that sepa-
rated these two groups of artists. Hall cited,

> the Notting Hill Race riots of 1958 followed by the mur-
> der of Kelso Cochrane; the Smethwick election; the visits to
> Britain of Martin Luther King and Malcolm X; the formation
> of the Campaign Against Racial Discrimination (CARD); the

196

passing of the Immigration Acts, with their 'second-class' and 'patrial' categories; the appearance of Stokely Carmichael at the Dialectics of Liberation Conference in 1968; the sound of Bob Marley and the sight of locksmen on the streets; the new sport of 'Paki-bashing'; the campaign against the 'sus' laws, and Enoch Powell's 'Rivers of Blood' speech.[44]

Given events, over time, that took place following the arrival of Caribbean migrants to Britain, it was perhaps inevitable that, from those on the receiving end, the

> result was a full-blown anti-racist politics, a powerful grass-roots and community mobilisation against racism and racial disadvantage and a fully-formed black consciousness, fed by Civil Rights, anti-apartheid and other global struggles. By the mid 1970s race had finally 'come home' to Britain. It had been fully indigenised.[45]

Having arrived with the mid-twentieth century movement of Caribbean migrants, albeit as a Rhodes Scholar, Hall was perfectly placed, as were others of his generation, to comment on, first hand, the events he had seen and indeed was very much a part of. As noted throughout this book, the cluster of 'Black Art' practitioners to emerge in the early 1980s were similarly well placed to comment on, first hand, the events they had grown up with, and had very much contributed to the complexity of their identities. As Hall continued,

> This is the world into which the second 'wave' emerged. In the place of anti-colonialism, *race* had become the determining category. This changed conjuncture reshaped the experience, the political outlook and the visual imaginary of the first black generation to be born *in* the diaspora. There was nothing in the experience of the first 'wave' – who had certainly experienced racial discrimination – to match the speed and depth of this racializing process. The anger it provoked exploded across Britain's black communities. It literally scars, fractures, invades, scribbles and squiggles, graffiti-like, across – batters the surfaces of – works like Eddie Chambers's *Destruction of the NF* (1979–80) and *I Was Taught To* Believe (1982–93), Keith Piper's *Reactionary Suicide: Black Boys Keep Swinging (Another Nigger Died Today)*

(1982) and *Arm in Arm They Enter The Gallery (This Nigger Is
Sure As Hell Stretching My Liberalistic Tendencies)* (1982–83) or
Donald Rodney's *The Lexicon Of Liberation* (1984).[46]

Hall carefully constructed the particularly animated congregation of Black
artists to emerge in the early 1980s as contrasting with the previous genera-
tion, but being, simultaneously, a continuum.

The point of Piper, Rodney et al. being part of a trajectory had previ-
ously been made by Rasheed Araeen, who wrote about this 'Black Art' as
having a 'specificity and its social significance – which expresses not only
a critical moment in the history of postwar British society but also a black
experience and its articulation within the trajectory of postwar modern-
ism.'[47] Araeen was minded to assign substantial strategies of resistance to
the initiatives undertaken by this handful of young Black artists.

> What was particularly significant about Black Art was its ability
> to respond critically to the social and political forces of the time,
> and to set up an ideological framework for a militantly radical
> art movement. Its aim was to confront and change the system
> that, though centred in the West, encapsulated and dominated
> the whole world. It was the time when in Britain, as well as in
> the US in particular, the political leadership turned to the right
> in order to explicitly re-establish its anti-socialist and imperial-
> ist agendas, with dire consequences for the world at large but
> also for the liberalism of the mainstream art world. It was in
> this sociopolitical milieu, when many 'avant-garde' white art-
> ists – as they were thus deprived of their historical roles as the
> progressive conscience of Western liberalism – began to turn to
> their inner selves, cynicism and language-games, that Black Art
> in Britain came up with a voice of humanity, as I wrote in 1982,
> that refuses to be brutalised and insensitised.[48]

Footnote 59 to Chapter 1 of this book quotes what stands as being by far
the most notorious sentiment, post Powell, in respect of the demonisation
of immigrants and the framing of them as chronic problems. It was made
by Margaret Thatcher, the then Leader of the Conservative Party, then in
Opposition, in a 1978 television interview. Piper et al. were all in their
mid teens when Thatcher expressed a view that was widely interpreted, by

anti-racists, as giving succour to those who would seek to inflict violence on Black people in Britain – immigrant or otherwise: '... if there is any fear that [this country] might be swamped people are going to react and be rather hostile to those coming in.'[49] As referenced earlier in this chapter, Enoch Powell had, a decade earlier, established the template with which immigrants and immigration would be problematised. Supposedly speaking on behalf of his white British constituents, Powell claimed, 'They found their wives unable to obtain hospital beds in childbirth, their children unable to obtain school places, their homes and neighbourhoods changed beyond recognition, their plans and prospects for the future defeated.'[50] These young artists had grown up in an environment in which their parents had either heard such comments first hand, or had been made aware of them in the workplace, on the streets, in town and city centres, and so on. By the time of Thatcher's comments, the children of Caribbean migrants were likewise aware, or were made aware, of this framing. It was into this context of racist political utterances that Rasheed Araeen sought to locate the work of the Black Art cluster. Focusing on one piece of work in particular (made as an emphatic rebuttal of far-right violence that was, during the late 1970s and beyond, plaguing the lives and aspirations of Black people), Araeen advanced the view that such work provoked the question, 'How do we re-define Britain as a multiracial society before it fragments into ethnic categories under the weight of its old order?'[51]

> It all began in 1979, not long after Mrs Thatcher had come to power as a result of her racist anti-immigrant speeches, when a young black art student of Afro-Caribbean parents, who was doing his foundation course at the Lanchester Polytechnic in Coventry, altered an image of the Union Jack in such a way that it appeared to contain a Swastika. ...What he then proceeded to do further was remarkable. Although this allusion within the Union Jack has significance he did not stop there, turning the whole thing into an art object. This would have foreclosed the possibility of a further transformation. Although this Union Jack-fascism nexus was a cliché, even at that particular moment at the end of 1970s when British society was in a grip of right-wing xenophobia, its implication pointed to a reality. It seems [the artist] wanted to warn us about the danger

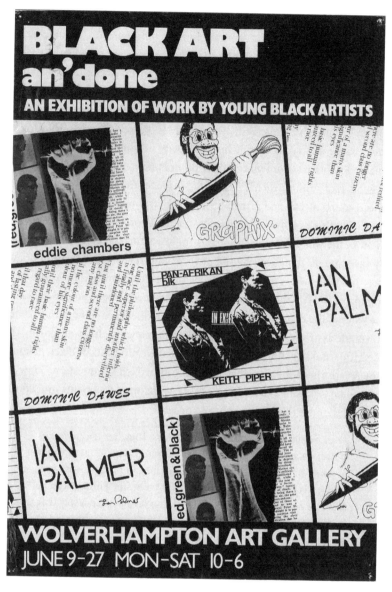

Figure 26: *Black Art an' done* exhibition poster.

of fascism within the growing nationalist identity of a Britain based exclusively on its indigenous white population; and what he also did was to suggest a radical process by which to deal with this danger. He in fact then proceeded to tear up the combined image of the Union Jack and a Swastika, resulting in small shreds so that the whole thing was no longer recognisable either as an image of the Union Jack or of a Swastika. Although the work does not resolve into anything definable, it does raise an important question. How do we re-define Britain as a multiracial society before it fragments into ethnic categories under the weight of its old order?[52]

Araeen then went to argue that the 'work suggests a process with a potential for further and continual transformations. Another extremely important aspect of the work is its apparent lack of racial references and the absence of the artist' s own ethnic identity in it.'[53] The 'cut-out and collage' aspect of the above work, *Destruction of the National Front*, was referred to by Hall, who suggested that

This new 'horizon' produced a polemical and politicized art: a highly graphic, iconographic art of line and montage, cut-out and collage, image and slogan; the 'message' often appearing too pressing, too immediate, too literal, to brook formal delay and, instead, breaking insistently into 'writing'. The black body – stretched, threatened, distorted, degraded, imprisoned, beaten, and resisting – became an iconic recurring motif. Keith Piper's and Donald Rodney's work of this period is exemplary – a magisterial rebuttal of the cliché that art and politics cannot creatively coexist. It was of a piece with Eddie Chambers's statement in *Black Art an' Done* (1981) that Black Art 'is a tool to assist us in our struggle for liberation both at home and abroad.'[54]

The observation that most of the grouping of young Black artists and art students who contributed work to *Black Art an' done* came from fundamentalist Christian backgrounds bears stressing, because there was, within such exhibitions, something of the urgency and fervency of the fundamentalist church service, or camp meeting. Within such exhibitions, exigent social and political messages took the place of less earthly sentiments,

communicated with no less passion or conviction within the sanctuary or from the pulpit. Consequently, exhibitions such as *Black Art an' done* and the ones that were to follow resonated with church-like messages of righteous condemnation of evil-doers and wrongdoers, alongside a yearning for manumission, redemption and salvation. The artists cast themselves as preachers, and yearned for audiences that, depending on their demographic, would feel a righteous wrath, or succumb to plaintive pleading, or enjoy moments of sublime vindication, or be *baptised*. It was perhaps with good reason that Linton Kwesi Johnson had evoked a reference of the embrace of the church, by poorer, darker Jamaican people, in his foundational text on dub poetry:

> In the Afro-Jamaican churches, men, women and children gather together to rid themselves of their pain and their agony in a remorseful outpouring of the souls as they sing those mournful songs, bleeding on the cross, stretching forth their cupped hands, reaching, reaching out for the new Jerusalem.[55]

Though Black Art, as a specific artistic response to prevailing circumstances, was to last for only a few short years, early exhibitions such as the one at Wolverhampton Art Gallery were to act as a catalysts for all manner of practice and exhibition activity by Black-British artists throughout the rest of the 1980s and beyond. And while Black-British artists' work had always been, from Ronald Moody onwards, particularly diverse and resistant to commodification, there could be no doubting the extent to which a relatively small number of younger artists sought to make work that reflected not only Black-British cultural identity during a particularly politically charged period of time, but also the experiences and aspirations of a section of the African Diaspora that was growing ever more significant. In his succinct retelling of the story of Black artists in Britain, Hall briefly alluded to the ways which 'Black Art' gave way to 'a second set of impulses, less overtly political, though no less 'engaged' with wider issues.'[56] Wrote Hall,

> The moment of the late 1970s/early 1980s was however divided at its heart. Right alongside this politicized work, we can identify a second set of impulses, less overtly political, though no

less 'engaged' with wider issues: concerned with exploring the experience of, and resistance to, racism, but in a more subjective idiom. At first these tendencies overlapped. A critical factor here was the Civil Rights struggle. It was here that Eddie Chambers, Keith Piper, Marlene Smith and others picked up the idea of a Black Arts movement grounded in an anti-racist politics, an Afro-centred black identity and a 'Black Aesthetic'. But more significant perhaps in the long run was the path that the Civil Rights movement took, from the integrated 'black-and-white-unite-and-fight' desegregation struggles of the mid 1960s to the Black Power, black consciousness, 'black-is-beautiful' phase, with its greater focus on 'race' as a positive, but exclusive, identity category, and its more separatist, cultural-nationalist, Afro-centric and essentialist emphases. Exhibitions like the *Black Art An' Done* show, organized by Chambers and Piper, at the Wolverhampton Art Gallery and the *Five Black Women* show organized by Lubaina Himid, Claudette Johnson, Sonia Boyce, Houria Niati and Veronica Ryan at the Africa Centre, translated those vibrations on to the British scene – though the decision of five black women to exhibit separately may have been a harbinger of trouble to come. These and similar initiatives opened the floodgates to a veritable deluge of independent shows and exhibitions in photography and the visual arts, the prelude to that extraordinary explosion of creative production which staked out the terrain of the autonomous 'Black Arts' movement of the 1980s and 1990s.[57]

The responses to exhibitions of work by Black artists of the early 1980s – from critics, the Black press, and audiences – were varied, but for the most part articulated and referenced the ways in which pronounced social dimensions of diasporic African existence lay at the heart of much of this work. Relatively little has been written about the 1980s emergence of a new generation of Black artists in England. And, beyond the nuanced readings offered by the likes of Araeen and Hall, much of what has else been written has tended to be shallow and reductive. Historians and researchers have yet to substantially undertake the process of critically examining artists of the period and according their work individual and focussed attention. A great many works themselves (reflective of the sometimes difficult circumstances in which individual artists functioned, such as a lack of regular

access to studio space and storage) have been lost, or lost to history, so the task of researching Black artists' practice of the recent past is an urgent and important one. Paradoxically, given the sophistication with which a number of artists have sourced and used archival material, documentation of the work of these artists remains patchy. There is still much to be done in fashioning a substantial and tangible history of the emergence of artists such as Piper, Rodney, Claudette Johnson and Marlene Smith and the singular contributions they made to the visual arts and Black-British cultural identity in the early 1980s.

8

Failing the Cricket Test

Reflective of a somewhat pathological distrust of those regarded as foreigners were those white Britons sceptical of the Britishness of their Black and Brown citizens. The fact that many of these citizens, like their parents, were British by birth, together with the ways in which many of these citizens born in the countries of South Asia and the Caribbean had long histories of being British, and/or had always regarded themselves as British, was of no consequence to the aforementioned sceptics. As the 1980s gave way to the 1990s, senior Conservative politician Norman Tebbitt, who had developed something of a reputation as a combative, no-nonsense type of politico, devised his own litmus test for Black and Brown loyalty to Britain. Intriguingly, Tebbitt's decisively indicative test took a most original form and centred on the supposed allegiances of cricket fans with backgrounds in those Commonwealth countries of South Asia in which cricket was an esteemed sport. Tebbitt's cricket test has, over the decades since it was first proposed, been referenced ad infinitum, taking on an almost mythic quality. Despite London and other parts of the UK being home – short or longer-term – to significant numbers of Aussies and Kiwis (informal terms for people from Australia and New Zealand respectively), Tebbitt's cricket test excluded such people, even though cricket fans from these Commonwealth countries were often fiercely partisan, and even though

cricketing rivalries, between England and Australia in particular, were the stuff of legends.

Tebbitt opined that true and convincing demonstrations of loyalty to Britain could only be ascertained when Black and Brown British people could be seen to be cheering on, rooting for, English cricket teams rather than the teams they faced, such as those representing Pakistan, India, Sri Lanka and the West Indies. One writer, evoking another sporting metaphor – that of goalposts being moved – reported the infamous test as follows:

> In social life, it is never clear what counts as complete integration nor who can be said to be fully integrated. Goalposts can be moved at will. In the 1980s in Britain, the Conservative politician Norman Tebbitt devised the cricket test: minorities could not claim to be integrated until they supported England rather than India, Pakistan, or the West Indies in England's cricket matches with these countries.[1]

In formulating his indicator of sporting allegiance, Tebbitt may well have been taken aback by the exuberance with which Black Britons greeted the often-crushing defeats of the England cricket team when playing the West Indies side. Going back to the mid-twentieth century, Caribbean migrants and Black Britons had proved themselves to be earnest and enthusiastic fans of the visiting West Indies team, turning out in significant numbers to watch them play at cricket stadia around the country, particularly those within relatively close proximity to significant communities of Black people. Tebbitt's cricket test was as ridiculous as it was pernicious, because even the most superficial examination of Black-British identity vis-à-vis West Indies cricket would reveal that, until their current demise as one of the world's most feared and respected international cricket sides, West Indies cricket had a profound part to play in the formation of identity in a racist, postcolonial society such as Britain. Only someone in absolute denial about the widespread, pathological discrimination, prejudice and racism heaped on Black people over time, and in the present age, could come up with this sort of test.

Cricket, even more so than rugby, football, or any other game exported to the colonies by the British Empire, became a sport that bristled with tensions of race, nationalism, social stratification, and supremacy, alongside the somewhat fractional factor of sporting prowess. As with other

factors discussed in this book, behind the tensions referred to above there lay an assortment of complications. Cricket tended to be an *English*, rather than a *British* game. Rugby tended to be the revered game in Scotland and Wales, and football, by the decades of the mid-twentieth century, existed as very much the game of the working classes, throughout parts of Britain, but particularly within England, especially following England's World Cup victory of 1966. (Cricket, on the other hand, had very much grown out of the middle classes). Further complications were reflected in the ways in which the West Indies cricket team was drawn from different nations of the Caribbean, making it a manifestation of pan-Caribbean collaboration, in which no one single Caribbean nation was seen to dominate. Furthermore, the earliest West Indies cricket sides were dominated by expats and cricket in the Caribbean was, in the earlier decades of the twentieth century riven by all manner of racial hierarchies and class tensions. Another complicating factor to be mindful of in the consideration of cricket is the way in which the West Indies team frequently comprised players from South Asian backgrounds, playing alongside cricketers from African backgrounds. This of course reflected two of the dominant *racial* groups in parts of the Caribbean such as Guyana and Trinidad, but it is nevertheless a complication that should have pointed Tebbitt away from the homogenised, crude, and to a large extent clumsily raced perception of certain cricket sides, as reflected in his test.

Pretty much everything exported to the colonies from Britain had a warped application and manifestation, and in this regard, cricket was no exception.

> The game of cricket in the British-ruled Caribbean emerged and began to develop in the early nineteenth century. For the ruling white colonial planter class, there was a continual desire to reinforce social and cultural barriers between themselves and the majority black African population. The introduction of cricket was a welcome additional pastime for the colonial elite and British army soldiers stationed in the Caribbean. Through its assumed associated high values as a social activity, cricket began to be utilised as an additional tool to culturally and socially distinguish the planter class from the rest of Caribbean colonial society.[2]

Furthermore, while 'for the ruling elite in the British-ruled Caribbean, the importation of cricket maintained identifiable cultural ties with the imperial centre of British colonial rule,'[3] the manifestation of the sport gave rise to numerous opportunities to apply the master – servant hegemony:

> As Professor Clem Seecharan outlines, cricket in the Caribbean was reserved for the colonial ruling class and became an epitome of Englishness. The rest of the population was deliberately excluded, which served to encapsulate the virtues of what was perceived to be a higher form of civilisation. While the colonial elite played the game, blacks were usually required to undertake peripheral tasks. This included the preparation of the playing area, the weeding or scything of the ground, retrieving the ball from the ubiquitous cane field, and performing a range of chores connected with the entertainment of guests.[4]

With similar racial hierarchies being manifest in the structural implementation of the game in India, South Africa, and elsewhere in the British Empire, even before the players arrived at the cricket ground, and at all moments thereafter, cricket embodied no end of signifiers of a blunt pecking order. Even so, as Robert Lipsyte observed (writing of C. L. R. James and his seminal book on cricket, *Beyond a Boundary*) James 'has no doubt', he writes, that the 'clash of race, cast and class did not retard but stimulated West Indian cricket.'[5] Lipsyte further opined that the introduction of cricket by the colonial masters

> seemed like a classic ploy by the conquerors: games, particularly so restrained and ritualistic a game as cricket, could be imposed on the colonisers to tame them, to herd them into psychic boundaries where they would learn the values and ethics of the colonist.
>
> But once given the opportunity to play the master's game, to excel at it, the colonials gained a self-esteem that would eventually free them.[6]

The earliest West Indies cricket sides contained few Black players, and the captains of such teams were invariably white. But this apparent racial schism masked no end of further complexities between a variety of class and other cleavages, amongst the cricket clubs and teams gradually established

throughout the Caribbean, many attached to schools serving the children of the colonial elite, or those located in any one of the society's tiers.

By the mid-twentieth century, shortly after the beginnings of a pronounced Caribbean migration, the West Indies team contained a number of Black players, including the likes of Hines Johnson, Prior James, Lance Pierce, Sonny Ramadhin and Clyde Walcott. Thereafter, the team comprehensively took on the Black and Brown appearance with which the world of cricket is now familiar. In 1950, the West Indies cricket team beat England for the first time on English soil, thereby continuing the establishment of the game as a sort of proxy war of competing colonial and postcolonial identities. As Colin Babb noted, 'The 1950 Lord's victory provided Caribbean migrants in Britain, including the small group of West Indian supporters at Lord's, with a definitive symbol of West Indian arrival and an early opportunity to express a collective migrant identity.'[7]

However, considerations of the part cricket played in the evolution of Black-British cultural identity must out of necessity go beyond the imagined spectacle of teams of Black and Brown cricketers doing battle with, and often beating, teams of white cricketers (a scenario tabled by Tebbitt). The England cricket team became, in time, a side that included talented and proficient Black, Caribbean-born batsmen and bowlers such as Devon Malcolm and Gladstone Small, born in Jamaica and Barbados respectively. Malcolm was a revered fast bowler (meaning that he was able to bowl the cricket ball at extraordinarily high speed, thereby manipulating or inducing it to bounce in ways the batsman often found intimidating, unnerving, disconcerting, and above all, unpredictable). The other pronounced skill of fast bowlers such as Malcolm is to manipulate the ball to swerve in flight, which often dramatically lessens the batsman's chances of either hitting the oncoming ball cleanly, or of not being bowled out.[8] Small was a similar talent. It was the presence of such Black players in the England cricket team that lead a somewhat exasperated Macka B to sing, in 1990, 'Dih West Indies a dih cricketing champion/Inglan' ongle beat dem sake a two Black man'.[9]

The 1950 victory established the cricket pitch as a battleground as viable for political and social tussles between colonial masters and colonial subjects as any other, particularly given that anti-colonial/pro-independence struggles across the Caribbean and elsewhere were

gathering momentum. Sporting rivalries between certain countries had long elicited what seemed to be more than simple and healthy sporting rivalry. It seemed for all the world that when England and South Africa faced each other on the cricket pitch, the unfinished business of the Boer War hovered over the field of play. And when England and Australia met, there seemed to be a near tactile English yearning to box the ears, rein in, or bring down a peg or two, the precocious dominion upstart. The yearning for sporting mastery seemed to mask, or be a flimsy stand-in for, a greater mastery born of numerous tension and violence-filled histories.

Within the mindset of culturally supremacist white Britain, it was the natural and correct order of things for the father to always discipline, and always be better than the offspring. This mentality existed as much more than a metaphor in mid-twentieth-century Britain, as the Black and Brown peoples of the world who were subject to British Empire rule were, as a matter of course, widely regarded as children. These children were not yet in a position to stand on their own two feet, move out from the care and control of the father of the household, and through their behaviour, they constantly declared that they themselves, as juveniles, had much to learn before they too reached adulthood. Such were the insistent and pernicious father/child metaphors that were, as a matter of course, used to frame the supposedly naïve or precocious impulses and sentiments of independence expressed by Black and Brown peoples. Indeed, the construction of the peoples of Africa, Asia and the Caribbean as pitiful, immature, child-like peoples in need of firm and paternalistic governance had existed for centuries. There were of course gradations of tension when strong international cricket teams faced each other, though perhaps the biggest cricketing rivalry of all existed between India and Pakistan, the two South Asian countries literally coming to blows at several moments during post-independence decades marked by a certain antagonism, antipathy and hostility stemming in large measure from the bloody ways in which India was partitioned by the British. The intensity of the fireworks when these two cricket teams met was rivalled only by the intensity of the desire of each set of fans to see their team victorious, and the other team vanquished.

There were less than ten great cricketing nations or teams in the world, each jockeying for position within rankings established by the

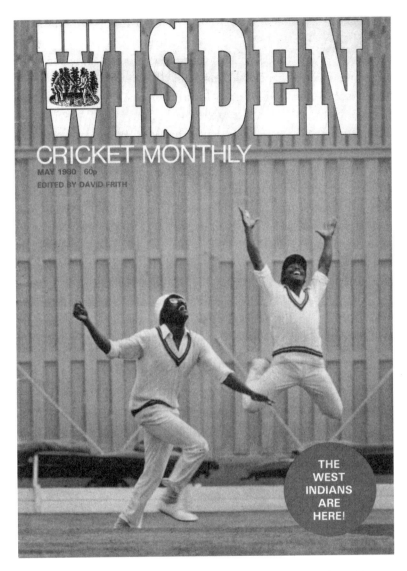

Figure 27: 'The West Indians Are Here!', *Wisden* magazine cover, May 1980.

Imperial Cricket Conference, a body established at Lord's, the home of English cricket, in 1909, which subsequently changed its name, in the mid 1960s, to the International Cricket Council. England aside, the great cricketing nations all existed in parts of the world touched by the British Empire. Thus, teams such as Australia, India, New Zealand, Pakistan, South Africa, and the West Indies embodied, and could not escape the most dramatic and awful of histories. When the West Indies team inflicted its defeats on England, Caribbean peoples the world over were wont to celebrate what seemed to be much more than sporting prowess. Throughout much of the 1970s and 1980s, the successes of a resurgent West Indies cricket continued to be an unstoppable and substantial source of pride and identity for Black people throughout the Caribbean, and, crucially, their families and descendants in Britain. Though Tebbitt's cricket test was dreamed up on the eve of the demise of West Indian cricketing dominance, had the test been tabled earlier, tens of thousands of Black Britons would have declared themselves more than happy to fail it. Babb spoke for a sizeable demographic when, as a British-born person, he wrote,

> when it came to watching international cricket, it never occurred to me to support the England cricket team. I supported West Indian cricket because I felt my personal and cultural identity was intimately tied to the Caribbean. I was presented with an opportunity to support a group of players who came from the countries my family came from. As a metaphor for Caribbean representation in Britain, cricket was an activity that 'we' (as West Indians living in Britain) had a strong tradition in and could beat England at.[10]

Tebbitt would indeed have had few takers for his test, and those who might take it – Babb et al. – would, as mentioned, have delighted in failing it. Tellingly, the extent to which many among the second generation of Caribbean people in Britain were familiar with what often appeared to cricket outsiders as the arcane rules of the game, mattered little. Equally of little to no consequence was the frequent lack of a wider sporting interest in the fortunes of other nations' cricketing. It was when the West Indies played England, and when the West Indies played South Africa,[11] that the interest of Black-British sometime cricket

Figure 28: Brazilian footballer Pelé holds up the Jules Rimet trophy after Brazil's 4–1 World Cup Final victory over Italy at the Estadio Azteca, Mexico City, 21 June 1970. Pelé scored the first of his team's goals in the match.

aficionados was piqued. In effect, the extent to which many among the Black-British populace were true cricket fans was pretty much a lesser concern. What was significant was that the success of the West Indies cricket team offered Black-British people, from youngsters through to elders, an opportunity to express an unapologetic, proud and above all collective sense of identity. In this regard, the social impact of cricket on Black-British communities of Caribbean descent is an important component of this *Roots and Culture* narrative, particularly relating to developing identities during the 1970s and beyond.

Black Britons' pride in the achievements of West Indies cricket needs to be set into the context of a substantial and corresponding ambivalence around football. This despite football being the nation's game, the followed sport of the common people, and the near infinite ways in which the British media and popular culture were football crazy, football mad. The travails of Britain's Black footballers have been fairly well documented, but within the context of this book, Black-British footballers' painful and laborious efforts to counter racism and win respect tell us much about why

cricket, and not football, achieved particular Black affection in the 1970s and 1980s. The *Sunday Times Magazine* of 21 March 1976 featured on its front cover a portrait of a young, pensive-looking Laurie Cunningham. Reflecting nomenclatural terminology of the time, the cover asked, 'Will Laurie Cunningham be the first coloured footballer to play for England?' Given that this was the second half of the 1970s, one might reasonably have expected such a question to have been asked 30, 40, 50, 60 or however many years earlier. The ways in which British football, and its national teams, has had to be dragged, kicking and screaming, towards more inclusive manifestations of the game has left a marked legacy of alienation and indifference among Black Britons.[12]

Recent manifestations of confirmed racism from Premiership footballers, and a perceived reluctance of the sport to give Black ex-footballers opportunities that went beyond punditry, underline the extent to which Black Britain has never truly taken football to its bosom. Indeed, it's arguable that the closest Black Britain ever came to being football crazy was when the Jamaican national team, nicknamed the Reggae Boyz, made it to its first ever World Cup finals, held in France in 1998. Given the relative size of Jamaica, and given that, like national teams such as Ireland, Jamaica had to crib players from its diaspora, making it to a World Cup was no mean achievement.[13] Though the team's results in France were mixed, and it failed to make it beyond the group stages, there was no doubting the affectionate and excited ways in which Black Britain followed the Reggae Boyz' fortunes and adventures. Macka B didn't miss an opportunity to reflect on the achievements of the Reggae Boyz and to this end, within months of the Reggae Boyz astonishing achievement, he had recorded and released on his *Roots & Culture* album of early 1999 a track in honour of the Jamaican football team. 'Allez the Reggae Boyz'[14] was in significant part sung in French, in deference to the country which had played host to the World Cup of 1998.

Earlier manifestations of Black Britain's enthusiastic embrace of soccer teams included the Brazilian team at the 1970 World Cup, which went on to win the tournament that year. With players such as Jairzinho, and of course Pelé, watching Brazil ease through the tournament, (beating World Cup holders England along the way) was the first time many young Black people in Britain came to learn something of Brazil's primacy within the

African Diaspora. Whenever teams from African countries qualified for the World Cup, Black Britain followed closely the progress of such teams, rooting for them against European or white opposition, particularly so when facing England as opponents. Macka B's *Pam Pam Cameroun* not only celebrated the progress of the West African nation's football team during the World Cup of 1990, but also rejoiced in the ways in which Africa had well and truly become a continent synonymous with footballing talent. In the manner of the most seasoned and proficient wordsmiths, Macka B described in telling and reliable detail the progress of Cameroun through the 1990 World Cup; the ways in which they beat Argentina (a shock result for which Macka B reported had odds of '5000 to 1 inna di bookmaker'), then Romania, qualifying for the next round, the quarter finals, but causing heartache for Black-British fans such as Macka B when they narrowly lost to England, thus ending their involvement in the 1990 tournament. In sentiments that would have appalled Tebbitt, Macka B recalled that facing England, the West Africans carried the hopes of Black Britain, hopes that were dashed when penalties were awarded, and settled, in England's favour. 'Everyone a pray fi Inglan get dust/Dem get two penalty, man it sick mi stumuch'. Earlier in the song, the Wolverhampton-born reggae artist had declared, 'I wanted Cameroun to win the World Cup/But they put Africa on the football map.'[15]

Trailed on the magazine cover as 'The Black Goal', the *Sunday Times Magazine* feature was titled 'The Great Black Hope' and opened as follows:

> Black soccer players still have a hard time in England. Natural talent and flair receives only luke-warm appreciation from many managers: colour prejudice manifests itself in verbal taunts from the terraces and harsh physical contact on the field. Integration can only be complete when England awards a soccer cap to a black player. Brian Glanville discusses the chances of this happening in the foreseeable future, and talks to one of the prime contenders.[16]

Thus, the feature reflected something of the threadbare and near-bankrupt mindset of believing that single, near-tokenistic appointments can somehow make everything all right. The capping of one solitary black player, whenever it happened, was unlikely to signal 'complete integration', and four decades later, the goal seems as unattainable as it ever did. In 2015

British Prime Minister David Cameron was rebuked by some when he described migrants and refugees determined, it would seem, on gaining entry to the UK, as a 'swarm'.[17] Glanville's piece, unconsciously perhaps, evoked similar language that equated Blackness with some sort of pestilence, when he wrote 'A few years ago, when a club like London's West Ham United seemed to swarm with exotic names and black faces...'[18] Elsewhere in the text, Clyde Best is said to 'brush off tackles as a horse might switch off flies'.[19] In almost every sentence, the text reflected the pernicious ways in which Black Britons were framed and constrained. Youngsters British by birth were described as 'West Indian children [,] here in large numbers', for whom football might be a way out of 'the black ghettoes', such children 'peer[ing] out in droves' from school photographs.

> West Indian children were here in large numbers. Growing up, would they not find football a way out of the black ghettoes, as surely as Brazilian Negroes found it a way out of the *favelhas*? They had the movement, the rhythm, the reflexes. They seemed to peer out in droves from photographs of junior school teams all over the country. It was surely no more than a matter of time.[20]

Though Britain's first professional Black footballer, Arthur Wharton, signed for Rotherham in 1889, nearly a century later the conspicuous absence of Black players from the England squad was, in 1976, still being explained in terms of mental fragility and an imagined brevity of the presence of Black people in Britain. Wrote Glanville, (about the supposed reasons for the lack of Black players in the England football squad): 'I suggest it is that the West Indians have not been here for very long, that they are more easily deterred and discouraged than their equivalents in Brazil or the USA.'[21] Other sentiments within what was, ostensibly, a liberal-minded, progressive, feature offered substantial pointers as to why Black Britain of the 1970s and beyond looked askance at English football's ability to respect and embrace it. One sentiment related to the preponderance of insulting and deeply offensive 'banter' aimed at Black football players. Incredulously, given the palpable yearning for respect that characterised the Black presence going back decades and centuries, racist 'humour' was accepted in certain circles as normal, acceptable and worthy of repetition. Amongst

Glanville's conversations, recalled and quoted in his feature, was a supposedly jocular comment by one Harry Haslam, manager of Luton Town, described as 'a cheerful Mancunian'. Haslam described himself as having been 'a bit broad-minded', a view of himself which reflected the yawning gulf between Black-British hopes for advancement based on individual merit, and a self-delusion amongst white Britons that masked, or reflected, no end of troubling pathologies. The supposed jocular comment in question, aimed at a Black player was:

> It is different for a coloured kid. They've got to accept 11 [team mates], we've only got to accept one [Black player]. So I've been a bit broad-minded to break this down. Like the other night I said, "Don't get into any dark corners where I can't see you!"[22]

Another disturbing sentiment related to the deluded, ignorant, naïve and politically bankrupt attitude of football managers towards racist name-calling aimed at Black players. Then, as now, white managers reacted to racist name-calling by either pretending it did not exist, or thinking that somehow those on the receiving end of such abuse actually thrived on such adversity. George Petchey, the manager of Leyton Orient (Cunningham's team, at the time the piece was written) was said to be,

> forever telling Cunningham to ignore any racial insults, not to descend to the level of the insulter, but to 'just laugh and say, "Next time, boyo, it's going in the back of the net." If anyone called [Cunningham] a black bastard we'd be all right. The spark comes into his eyes and it makes him play.[23]

And so it was that a yawning gap opened up between young Black Britain and all possible notions of football (particularly at the level of support for the England team) having a positive impact on its cultural evolution. There were, very simply, far too many obstacles (reflected in the mindset that brought forth the sorts of appalling comments quoted above) to Black youngsters forging a collective identity around whatever team might represent England in international tournaments. Alongside its lingering disrespect for both the sensitivities of Black footballers on the pitch and training ground, and the managerial aspirations of Black footballers beyond their playing years, football in Britain had far too tainted a history

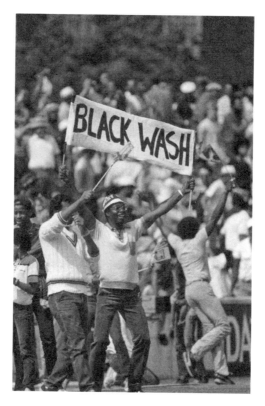

Figure 29: Jubilant West Indies supporters holding up a 'Black Wash' banner during the Fifth Test Match between England and the West Indies at the Oval, London, 1984.

of anti-Black hooliganism and thuggery to be taken to the bosom of Black Britain in the 1970s and 1980s.

Returning to the matter of West Indies cricket and the blessed regard in which it was held by many Black Britons, no one single image captured the extent to which the game had been brought within the fold of a dynamic manifestation of diasporic identity than that taken by a photographer at the end of the fifth and final test match between England and the West Indies in 1984. The test match was played at the Oval, the legendary cricket ground just a short distance away from Brixton, the district of South London that had long since become synonymous with Black Britain. Given that the Oval had been home to many exciting and dramatic showdowns

between England and the West Indies (including the visitors' victory over England in the final test match of the 1963 series), it seemed fitting that the venerable cricket ground should once more play host to another extraordinary spectacle.

In sporting parlance, the West Indies had inflicted a 5 to 0 defeat, a *whitewash*, on their hapless opponents. Whilst whitewash existed as a universally understood, informal sporting term which described a game or series of games in which the losing team fails to score, a Black man, with an acerbic wit to match that of Noël Coward, produced a makeshift banner that read, simply, BLACK WASH. With the English language's substantial preponderance of words that equated black with bad things, it was Rastafari and the attendant culture of Dread that engendered a telling response to this palpably racist language in which not only did black tend to mean bad, but for good measure, white, with few exceptions if any, tended to equate with good, clean, pure things. Rastas had a thing or two to say about that, and in so doing, created a dynamic lexicon of words that not only laid down a formidable linguistic challenge but also, simultaneously, enhanced the meanings and understandings of no end of words. Understand became overstand, or ovastan'. After all, to overstand something was surely to gain a sort of mastery over the thing in question. Oppression became downpression, the easily imagined downward trajectory inherent in the new word effortlessly emphasising the subaltern space occupied by those who were downpressed. Similarly, when affection existed between two people, they ought really to be said to apprecilove (rather than appreci-hate) each other. Such were the playful, yet nuanced and dynamic ways in which Rastafari boldly reinscribed a language that had done much to torment and let down Black people. What else could the West Indies have inflicted on the England cricket team other than a Blackwash? The sign delighted many within the ground, already ecstatic about their team's comprehensive victory.

Such was the extent of both West Indies cricket itself, and the corresponding exuberance of its supporters in Britain, that by the mid to late 1970s cricket had achieved a certain and singular synonymity with Black Caribbean people. Indeed, beyond this, Rastafari, or at least the growing of dreadlocks, had become synonymous with an international diasporic presence, not least in Jamaica from where the movement originated. This much

was reflected in the song 'Dreadlock Holiday' by white British group 10cc.[24] The reggae-esque song was one of 10cc's big hits, making its way to the top of the charts in the autumn of 1978. The song's lead vocalist assumed the voice of a white tourist visiting Jamaica, who has a series of encounters, one of which is particularly unpleasant, with local Black people. The first verse recounts a would-be mugging, during which the hapless white man seeks to talk himself out of being relieved of his silver chain by declaring his love for cricket, in the hopes that such a declaration will diffuse the situation, and identify him as a soul brother.

It was perhaps inevitable that the exuberance of Black-British fans of the West Indies cricket team would leave its mark, long after the demise in the early to mid 1990s, of the team's dominance. Recalling the height of West Indies cricket dominance, Babb noted the ways in which

> West Indians used cricket grounds in England as a site to re-create a Caribbean match-day setting. In areas of the ground where West Indians congregated, whistles were blown, a bell was being rung, and empty beer and soft drinks cans… were bashed together to create a rhythmic sound.[25]

Another writer, Jack Williams, made mention of this:

> The black West Indian style of watching cricket was far different from the English tradition with its emphasis on reserve, polite-ness, passivity and the avoidance of displays of undue passion… For African Caribbean spectators, watching cricket has been a means of participating in the match.[26]

And so it was that the mid 1990s gave rise to the 'Barmy Army', a motley assortment of white English cricket fans who, travelling the world to watch and support the English team, use flags, banners, songs, chanting and boisterous exuberance to encourage the team and engender partisan crowd participation. Thus, the culture of English cricket fans' reserve, characterised (or caricatured) by polite applause, hushed watching of the game, during which breaks were taken for the consumption of tea and cucumber sandwiches, gave way to altogether louder, brasher, displays of support that owed much to the ways in which Black Britons had occupied cricket stands and supported their team. Forty years ago, it was unthinkable that English

cricket fans would have a trumpet player accompanying their singing and chanting from the cricket terraces. But such near-tactical approaches to the supporting of national cricket sides by Black-British cricket fans in effect created a blueprint conspicuously and willingly adopted by white English supporters. Not for the first time, distinct aspects of Black-British cultural identity left their mark on the wider society.

Conclusion: (Dawning of a) New Era

This book has sought to examine the ways in which the pioneering genera-
tion of Caribbean migrants, while in many respects arriving as British, gave
birth to a generation of people who expressed a decidedly different manifes-
tation of British cultural identity, not only to that of their parents, but that of
the wider society. Simultaneously, there was much in the way of commonal-
ity between young Black Britain and its parental generation, less so, perhaps,
with the wider, white cultural identity. The time period during which this
evolution of cultural identity was at its most racially pronounced and con-
scious lasted approximately a decade, from the mid 1970s to the mid 1980s.
It is fascinating that the way in which Black Britain rallied around the West
Indies cricket team was very much a cross-generational, if overwhelmingly
male, occurrence. Photographs and sports footage of the African-Caribbeans
who made their way to grounds such as the Oval, Lords, Headingly, Trent
Bridge and Edgbaston to watch their beloved West Indies cricket team in
action show older men alongside youngsters and children, thereby reflecting
a unique environment of shared cross-generational bonding and expression.

Whilst some historians have done hugely significant work in increasing
our knowledge about the histories of Black people in Britain during centuries
past, there is still much to be done in historicizing cultural formations among
Black people in Britain in the centuries before the coming of the Windrush
generation. The cultural identity of the Black presence in Britain during for

example, the eighteenth or nineteenth centuries, was likely every bit as fascinating as the stories told in *Roots & Culture*. As and when historians attend to such questions, our understanding of these matters will increase.

During the decades referenced in this study, the 1950s through to the 1980s, Black-British people were failed on a number of fronts by manifestations of Britishness that really ought to have been more inclusive and more reflective of the diversity in its midst that was, year on year, becoming ever more apparent. In this regard, British television failed, with too few exceptions; until the screening of *Roots*, it was the *Black and White Minstrel Show* that pointed to the characteristic contempt and indifference with which British television treated Black people. Elsewhere, the English language, the means by which British people communicated with each other – verbally and through the printed word – also failed. It took the coming of the dub poets to take something that again, ought really to have been a wider, cohering cultural element for Britons, and make the English language fit for purpose. In these remarkable efforts to lively up the English language, patwa co-opted no end of unsuspecting words from the English language and press-ganged them into much more dynamic use. As Paul Gilroy observed,

> 'Massive', 'Safe', 'Settle' and 'Worries' are all words which were playfully endowed with meanings unrelated to those invested in them within the dominant discourse. In this context, the subversive potential in the ability to switch between the languages of oppressor and oppressed was already appreciated.[1]

Needless to say, it was in the decidedly blunt experiences of wider British society – housing, employment, education and so on – in which the greatest and most sorrowful failings occurred. As has been mentioned, William Raspberry, a distinguished African-American *Washington Post* journalist, was commissioned by the *Observer* to reflect on the dispiriting experiences of Black-British youngsters in the mid 1970s. Raspberry reported 'large numbers of Blacks in prisons and mental asylums' and that [Black] 'youngsters feel such overwhelming rejection that they come to hate the country of their birth.'[2] In effect it was, perhaps, the sum of these failings that propelled Black cultural identity in the directions chronicled in *Roots & Culture*.

Certain chapters and passages in this book have sought to demonstrate the ways in which particular types of reggae music had a profound effect on

the cultural shaping of Black Britain. There comes a time in a person's life – most often some point between their early teens to early twenties – when the brain is particularly susceptible to receiving favoured music, its rhythms and its messages in pure, almost concentrated forms. Forms which see the lyrics, sentiments and content of the music to which said person gravitates make particular impressions that remain intense, unrivalled and easily recalled during the rest of that person's life. For young Black Britain, reggae music, with its insistent themes of sufferation and racial uplift, came along at a time when this new demographic was coming of age, and willingly susceptible to its messages. Reggae music seared itself into the consciousness of large sections of young Black Britain. To this end, the lyrics, sentiments, and content of reggae music made profound and lasting impressions on Black Britain that remain (despite the subsequent ascendant hegemony of hip hop and other American forms of music) key aspects of Black Britain's collective emergent identity.

While this book's narratives cite the mid 1970s to mid 1980s as having a particular importance, it is of course the case that Black cultural identity, beyond the 1980s, continued to mutate, giving rise to no end of further and fascinating manifestations that lie beyond the scope of this study. No belief system, save perhaps Christianity, influenced Black Britain to the same extent as Rastafari. This powerful, compelling, challenging counter-cultural way of living had a particular part to play in this book's narratives. But with Rastafari in Britain now having had its day (though leaving behind a cultural footprint of great importance), the most distinct manifestations of a strong defiant Black identity have given way to other influences. Even during the period of this study, Black cultural identity in Britain had, at its core, an interplay with the wider society that was never really was clear-cut or easily understood and defined in neat terms. Instead, a variety of factors gave rise to cultural manifestations that were decidedly and singularly hybrid. Cultural manifestations of Blackness in Britain were *always* complicated, not least by varying cultural commonalities with the wider society. What might at first, to the casual observer, appear to be determined and unequivocal was often, in actuality, something that bore distinctive clues in which could be discerned an inevitable amalgamation of factors, some of which were very much British.

Coventry band the Specials reflected something of that cultural fusion and hybridity, as they blended local Coventry and West Midlands musicians and singers from different racial backgrounds, as much as they blended

musical influences, including those from Jamaica, alongside forms of music that had emerged in Britain and elsewhere in the world. Thus, though paying distinct homage to ska, a music genre that had originated in Jamaica in the late 1950s and was the forerunner of rocksteady and reggae, the Specials embodied a uniquely British form of musical expression. As such, the Specials were a fitting symbol of some of the ways in which the new Black presence, while still evolving, even so existed in a noticeably energetic, probing, though nevertheless quite settled state of being, unashamedly characterised by pronounced notions of cultural and racial hybridity. Social mobility and political advancements might, for Black Britons, have remained as elusive as ever, but in other respects, they were, during the 1970s and on into the 1980s, able to forge an identity every bit as important as those forged by African descendants in countries such as Brazil and the United States. One of the Specials' hit songs was '(Dawning of a) New Era' – something which the band itself represented, as did the second generation of Black youngsters, such as those included in the group's line-up.

On many different fronts, it seemed a certainty that as much as Black cultural identity had mutated into something dispersed or hybrid, so too many of the factors discussed in this book had likewise changed. Cricket, for example, had by the mid 1990s ceased to be the cohering mechanism of identity it had been in the 1970s and 1980s. As Colin Babb noted, 'Evidence of the slowly deteriorating relationship between the diaspora and West Indian cricket can be observed by the decreasing number of West Indians attending West Indies matches in England.'[3]

It was Smiley Culture who pointed to some of the ways in which Black-British cultural identity would come to manifest itself beyond the period looked at in this book. His record *Cockney Translation* created a witty linguistic interplay between that which had previously been considered *white* speech and that which had previously been considered *Black* speech. In bringing these two contrasting speech patterns together, Smiley Culture performed an impressive balancing act, out of which grew distinct pointers to the ways in which Black (and indeed British) cultural identity would come to manifest itself. Until *Cockney Translation*, Cockney and patwa were considered by many to be mutually and racially exclusive forms of communication, though those whose daily speech effortlessly moved from one to the other and back again, knew different. In the words of Gilroy, 'The

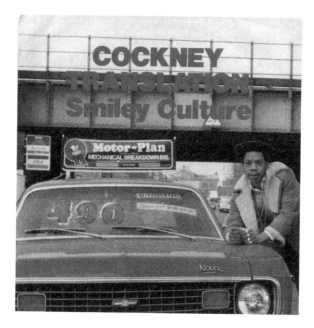

Figure 30: Smiley Culture 'Cockney Translation', (Fashion Records, 1985), record sleeve.

languages [*Cockney Translation*] introduced – Cockney rhyming slang and London's black patois – connote fixed positions of class and "race".[4] Smiley Culture drove a coach and horses through that view, thereby uncovering an interplay that had not only existed for many a year, but one that by the mid 1980s, was a firm indicator of a mutating demographic.

> The implicit joke beneath the surface of the record was that though many of London's working class blacks were Cockney by birth and experience (technical Cockneys) their 'race' denied them access to the social category established by the language which real (i.e. white) Cockneys spoke. Cockney Translation... suggested that these elements could be reconciled without jeopardising affiliation to the history of the black diaspora.[5]

Later on in his passages referencing *Cockney Translation*, Gilroy argued,

> The record contains a veiled but none the less visible statement that the rising generation of blacks, gathering in the darkened dance-halls, were gradually finding a means to acknowledge

their relationship to England and Englishness. They were beginning to discover a means to position themselves relative to this society and to create a sense of belonging which could transcend 'racial', ethnic, local and class-based particularities and redefine England/Britain as a truly plural community.[6]

As noted in Chapter 2, this intriguing new hybridised speech pattern had earlier, in the mid 1970s, been identified as emerging from spaces such as youth clubs and other environments that seemed to create a fascinating creolisation or hybridity. It was within such fertile spaces that an extraordinary cultural interplay was able to germinate and flourish.

> Youth clubs have become important meeting places for blacks in their late teens, and a youth dialect has emerged, a kind of generalized West Indian English, which is not attributable to any single island but which has numerous Jamaican and Cockney elements.[7]

Gilroy's quote above references a hugely important factor in this book's narratives – that of class. It was, after all, within the solidly working class communities of Black-British people that Black cultural identity was at its most pronounced and distinguished. Inevitably perhaps, as numbers of Black Britons gained university education, going on to buy homes in unfamiliar places,[8] it was among those Black people who remained in particularly close proximity to each other that the strongest manifestations of Black cultural identity continued to exist. This point is important because Black-British cultural identity varies from one environment to another, and from one part of the country to another. The cultural identity of a Black Briton in say, Hartlepool, Stourbridge or St Leonards is going to be markedly different from that of Black Britons in Greater London or other cities with a sizeable Black presence. In this regard, London has given rise to a particularly settled, dynamic and fertile state of Black-Britishness, existing alongside or within a wider urban diversity,[9] despite perennial problems such as disproportionate unemployment and fractious relations with the police.

Though their black skins rendered them unassimilable in comparison to successive groups of white immigrants, it was nonetheless the case that Black Britons' presence reflected dominant trends in the ages old process of migration. Those coming as immigrants harboured, or retained, the strongest sense of having come from somewhere else, regardless of the extent to which that

'somewhere else' might have been a socially or economically challenging environment. Their children were born and grew up knowing – through visits, through home cooking, through language and through many other factors – something of the cultures and countries from which their parents came. But by the late 1970s and thereafter, a third generation of Black Britons was being created. For these grandchildren (and in some instances, great-grandchildren) of the pioneering generation of Caribbean migrants, manifestations of their British cultural identity became ever more mixed, and had a pronounced commonality with that of white Britain. For many of these twenty-first-century Black Britons, the Caribbean often presented itself as primarily being a region on a map, rather than a space and place with which they shared a pronounced affinity. Furthermore, large numbers of white British youngsters were adopting no end of Black cultural mannerisms, thereby decisively complicating any continued notion of a unique and distinct Black-British cultural identity.

> As the 1980s rolled into the 1990s, the notion of black Britishness became more delicately balanced. A large proportion of those coming of age had parents who were born here, and multi-national backgrounds that could include two or three Caribbean islands and more than one continent. Add to that African/Caribbean-Caucasian mixed race as London's fastest growing ethnic group, and for many youngsters 'back home' was what they saw out of the window; anything else was just an interesting holiday. The capital's constantly evolving street slang provides the best illustration: Jamaican patois remained its foundation, but it included at least as many hip-hop reference points and a grab bag of longstanding Londonisms – you could visit three different time zones within the space of a sentence. That this vernacular was in use by kids of all races further muddied the cultural waters.[10]

Within this passage, Lloyd Bradley pointed to the manifestations of the seismic shifts and changes that served to undermine the certainty of a distinct, Black-British cultural identity. Similarly, he also pointed to one of the ways in which the construct of Black-British cultural identity was not, or was no longer, a self-referencing entity. Interestingly, the hybridised speech pattern mentioned earlier is even reflected, on occasion, in the verbal communication of white Britons, including the middle classes, who were traditionally somewhat reluctant to practice any English they considered broken. It now

seems, at times, that one is more much likely to hear expressions such as back in the day, bigging up or big you/me/it/myself up, on Radio 4 than among the circles of Black people among whom the expressions originated in the 1980s and 1990s. An aspect of Black-British culture's ever mutating dimensions was a particular linguistic agility that saw novel but highly apt and original expressions such as big up pass from a common Black usage, to be replaced by other, more contemporary but equally pithy, expressions. Such gravitation or co-opting of language is further reflected in the noun or mass noun bling. Having originated in hip hop culture, the word, meaning expensive, ostentatious clothing and jewellery, has now entered mainstream usage.

By the late 1980s, many of the apparent certainties that had governed the world's view of itself were being challenged, eroded and dismantled. The 1990s became characterised by new ways of looking at society and the world around us, and in this regard postmodernism carried the swing. Postmodernism posited that society and the world were in a state of perennial unresolve and never-ending incompleteness and that furthermore, rather than generating insecurities, the consciousness of this state of being enabled new, often shifting identities (including cultural) to emerge and thrive, as much as it compelled old certainties to abate. Black-British culture found itself caught up in, and reflecting, these profound changes, and by the 1990s, though many Black people's experiences in the social, political and economic arenas might have remained the same, the sorts of certainties that had characterised Black cultural identity of the 1970s were rapidly evaporating. In a key text from 1988,[11] Stuart Hall decisively pointed to the ways in which Black-British cultural identity could be, and indeed was being, recast with altogether different terms of reference that decisively gravitated away from the presumed historical certainties of Black identity. In so doing, Hall's lively and compelling reformulating of Black cultural identity made previous apparent certainties appear anachronistic.

Elsewhere, though television is and remains a particularly infantile or regressive medium, the sight of a Black person on television has long since ceased to elicit animated responses in Black households. The mutation of Black-British cultural expressions and identity beyond the mid to late 1980s falls largely beyond the scope of this book, but it will be a fascinating task for cultural historians of the future to reflect on the ways in which the dominant culture has absorbed aspects of Black culture, even as it continues to demonise those it deems immigrants, refugees or asylum seekers.

229

Notes

Preface

1 Lord Scarman's report, written in the wake of the Brixton riots, expressed the view that 'The street corners become the social centres of people, young and old, good and bad, with time on their hands and a continued opportunity, which, doubtless, they use, to engage in endless discussion of their grievances.' (Lord Scarman, the *Scarman Report: The Brixton Disorders, 10–12 April 1981*, (London: Penguin Books, 1982), p. 22.)

2 For recollections of these tensions, listen to 'Blues Dance Raid' by Steel Pulse, *True Democracy* album, Elektra label, 1982 or 'Complain Neighbour' by Tippa Irie, Greensleeves UK Bubblers label, 1985.

3 Aswad, 'African Children', from the album *New Chapter*, CBS, 1981.

4 Such demographics were not always the case. In the late 1940s, for the greater part, an altogether different manifestation of the Black presence existed across the country. As noted in an edition of *Picture Post* magazine from 1949,

> [a]lthough there are no official figures, the coloured population of Great Britain is estimated by both the Colonial Office and the League of Coloured Peoples at about 25,000, including students. This total is distributed over the whole of Britain, but there are two large concentrated communities: one of about 7,000 in the dock area of Cardiff, popularly known as 'Tiger Bay', and the other of about 8,000 in the shabby mid-nineteenth century residential South End of Liverpool.

The feature went on to report that 'Smaller coloured communities are found in all the main ports including London, (there is one of about 2,000 in North and South Shields), in Manchester and the industrial areas of the Midlands. (Robert Kee, 'Is There a British Colour Bar?', *Picture Post: Hulton's National Weekly*, 44, No. 1, 2 July 1949, 23.)

5 The immigrants who came in the late 1950s and thereafter sought employment significantly different to that in which Britain's Black population had been thus far engaged. The *Picture Post* feature (see note 4) made it known that in the early 1950s the major pockets of Britain's Black population, in Cardiff and Liverpool, 'came into existence largely as a result of the immigration of colonial coloured people to work as seamen, soldiers and factory hands in World War I. They were supplemented during the Second.' (Kee, 'Is There a British Colour Bar?' *Picture Post*, p. 23.)

6 According to the Office of National Statistics' *Ethnicity and National Identity in England and Wales 2011*, Wales remains the least ethnically diverse area of England and Wales.

7 Poet and the Roots, 'It Dread Inna Inglan (for George Lindo)', written and produced by Linton Kwesi Johnson, Virgin label, 1978.

8 'Inglan is a Bitch', written and produced by Linton Kwesi Johnson, *Bass Culture*, Island Records label, 1980.

9 Doscarla Publications, London, 1977.

10 As no credible, authoritative or comprehensive research has been undertaken regarding these matters, they remain subject to a certain speculation on my part.

11 Chris Abbott, 'Rivers of Blood', Enoch Powell (1968)', *21 Speeches That Shaped Our World*, 'Part 1: All the World is Human', (London: Rider, 2012), p. 44.

12 Hilde Marchant. 'Breeding a Colour Bar?', *Picture Post, Hulton's National Weekly*, 56, No. 10, 6 September 1952, p. 31.

13 Dennis Brown/Aswad, 'Promised Land', Simba Records, *circa* 1982.

14 Throughout this book (except when quoting directly from other texts) I choose to refer to *Rastafari* rather than *Rastafarianism*. The difference might seem slight, but given the Rastafarian dislike of *ism-skism*, the appending of an *ism* to denote Rastafari might be regarded as insensitive. In *Natural Wild*, a reggae album released in 1980 by Prince Lincoln & the Rasses (United Artists Records), the track 'Mechanical Devices' rails against 'Babylon system, pure ism and skism… Socialism, Communism, Protestantism, Liberalism, Capitalism, Catholicism, too much ism and skism'. As Christian Habekost writes, 'It is impossible to define Rastafari as one of the numerous "-isms"'. (Christian Habekost, *Dub Poetry*, Michael Schwinn, 1986, p. 17.)

Introduction

1 This was the concluding sentence in a major feature in the *Observer Review* (William Raspberry, 'Young Bitter and Black', 5 September 1976), that looked into the fractious existence of the newly emerging demographic of Black Britain, particularly young Black males.

2 The first sizeable group of Caribbean immigrants to arrive in Britain following World War II came on the MV *Empire Windrush*, docking at the port of Tilbury, Essex in June of 1948, carrying nearly 500 passengers looking to either start new lives for themselves, or earn money with which to return to their respective countries and prosper.

3 In recent years much important research and scholarship has appeared in print regarding the contributions to the war effort by Black people of the Empire. Stephen Bourne's book, *The Motherland Calls: Britain's Black Servicemen & Women* (Stroud: The History Press, 2012), is one such source of information. In one of the opening sections of the book, 'Statistics', Bourne recollects that,

> Juliet Gardiner, author of *Wartime Britain 1939–1945* (2004), claims that on the day war broke out, 3 September 1939, there were no more than 8,000 black people living in Britain. However, some historians of black Britain have suggested a much higher figure, including Dr Hakim Adi (around 15,000). The recruitment of black people from the colonies into the war effort changed this situation but, without official figures, estimates vary.
>
> In 1995, using a variety of Colonial Office sources, Ian Spencer estimated in his contribution to *War Culture* that, of British Caribbeans in military service during the war, 10,270 were from Jamaica, 800 from Trinidad, 417 from British Guiana, and a smaller number, not exceeding 1,000, came from other Caribbean colonies. The majority served in the RAF.

The history of Black fighting men in the service of the British goes back several centuries and includes those African-Americans who fought during the American War of Independence in the eighteenth century. One of the most iconic examples of eighteenth-century British history painting is *The Death of Major Peirson, 6 January*

1781, a large oil painting of 1783 by John Singleton Copley. The painting depicts the death of Major Francis Peirson at the Battle of Jersey, which took place early in 1781. Prominently located to the left of the fallen hero is a Black marksman engaging the enemy and seeking to avenge the death of Major Peirson.

4 Marcus Garvey was arguably the most important international figure in twentieth century Black political and cultural thinking and activity. He lived a fascinating, extraordinary life. He was born in a small town in rural Jamaica in 1887 and died in London at the relatively young age of 53.

At the time of Garvey's birth, Black people throughout the colonial world had yet to experience any sort of 'independence'. Jamaica for example, together with numerous other countries in Africa, Asia and the Caribbean region were run as outposts of the British Empire. Economic and social conditions were wretched for the mass of dark-skinned people in these countries. One of Garvey's enduring legacies and achievements was to encourage Black people of the world to see themselves and their struggles as being interlinked, via the common denominator of African ancestry. This philosophy, in a variety of forms, came to be known as Pan-Africanism. Garvey first travelled outside of Jamaica when he was twenty-two years old, visiting and working in Costa Rica. Within a few years he familiarised himself with the economic and social conditions of Black people in many parts of the Central America region, including Honduras, Colombia, Venezuela, Panama and Nicaragua. Shocked and affected by the conditions he witnessed, Garvey resolved to dedicate his life to improving the conditions of Black people throughout the world. Garvey's life was full of dramatic twists and turns. In 1927 he was deported from the USA, having served prison time for mail fraud. In the years following Garvey's death, he came to be embraced as a prophet of Black redemption and the voice of the sufferer. Rastafarians and reggae singers in particular claimed him as one of their central icons. In this regard, Winston Rodney, aka Burning Spear, has done more than any other single individual to keep the memory of Marcus Garvey alive and resonating with a variety of contemporary applications.

5 During the years of the mid-twentieth century there was a tradition amongst Caribbean parents of naming their children after prominent British politicians and statesmen. For example, Winston, after Winston Churchill was common. Other quite remarkable examples exist, such as the artist Clement Bedeau, one of the artists included in the important 1984 exhibition of Black-British artists' work, held at the Mappin Art Gallery in Sheffield, *Into the Open*. Shortly after his birth in 1950, Bedeau was given the name Clement Atlee Bedeau, in honour of Clement Attlee, the prominent mid-twentieth-century Labour Party leader who led the party to a landslide election victory in 1945 and a subsequent victory in 1950. Some years later, in 1962, Donald Gladstone Rodney was christened, his middle name that of the great nineteenth-century Liberal politician. Rodney grew up to be one of the most important artists of his generation, though he was to die prematurely in 1998. Such deference for Britain amongst Caribbean people and migrants, extending as it did to the naming of their children, was not uncommon. One of comedian Lenny Henry's earliest characters had names that poked fun at this habit, which pointed to a particular embrace of Empire. The character in question (supposedly 'A Rastafarian, whose catchphrase was a vast, croaked, 'Oooookaaaay") went by the name of Algernon Winston Spencer Churchill Gladstone Disraeli Palmerston Pitt the Younger Pitt the Elder Razzmatazz. (Jonathan Margolis 'Falling Over Blackwards', *Lenny Henry: A Biography*, (London: Orion 1995), p. 87.)

6 'London is the Place for Me', written and performed by Lord Kitchener, *London is the Place for Me: Trinidadian Calypso in London, 1950–1956*, Honest Jon's Records, 2002.

7 'I was there (at the coronation)…', written and performed by Young Tiger, *London is the Place for Me: Trinidadian Calypso in London, 1950–1956*, Honest Jon's Records, 2002.

8 Matumbi, 'Go Back Home', Trojan Records, 1978.

9 Chris Mullard, 'The Numbers Game', *Black Britain*, London: George Allen & Unwin Ltd, 1973, p. 53. There has been little in the way of published research into the voting habits and patterns of Britain's post-war Caribbean migrants. With specific regard to Jamaican migrants, there may possibly have been a notional conflating of Britain's Labour Party with the Jamaican Labour Party, the JLP. The JLP was one of the two main parties that have dominated Jamaican politics from Independence in 1962 onwards. The JLP was, however, the approximate equivalent of Britain's Conservative Party, while the People's National Party, the PNP, was the approximate equivalent of Britain's Labour Party.

10 The title comes from lines in a poem by Jamaican-born British poet, Frederick Williams, *De street weh dem seh pave wid gold/Pave wid sou-soh daag shit* (Frederick Williams, 'A Pressure Reach Dem', *Leggo De Pen*, (London: Akira Press, 1985), p.14). The lines translate into Caribbean immigrants' despondent realisation that 'The streets they told us were paved with gold were actually paved with dried out dog shit', or 'only paved with dog shit'.

11 It was this that lead Tabby Cat Kelly to protest, in his British reggae release of 1979, 'Don't Call Us Immigrants' (Arawak Records, produced by Dennis Bovell).

12 Mullard, 'Black Consciousness', *Black Britain*, p. 30.

13 Stuart Baker, 'Rastafari: The Dreads Enter Babylon 1955–83', booklet essay, Soul Jazz Records, 2015, p. 17.

14 Black Uhuru, 'Leaving to Zion', from the album *Showcase*, Taxi label, 1979.

15 This paraphrased quote appeared in Nubia Kai, 'Africobra Universal Aesthetics', *Africobra: The First Twenty Years*, Nexus Contemporary Art Center, Atlanta, Georgia, 1990, p. 5.

16 Patrick Chabal, *Amilcar Cabral: Revolutionary Leadership and People's War*, Cambridge University Press, 1983, p. 183. For more on Cabral and culture, see the section 'Culture and National Liberation', in turn, part of the chapter 'Amilcar Cabral: Social and Political Thought', in. Patrick Chabal, *Amilcar Cabral: Revolutionary Leadership and People's War*, (Cambridge: Cambridge University Press, 1983), p. 183.

17 James Smethurst, 'Malcolm X and the Black Arts Movement', in Robert E. Terrill (ed.), *The Cambridge Companion to Malcolm X*, (Cambridge: Cambridge University Press, 2010), p. 85.

18 Steel Pulse, 'Prodigal Son', *Handsworth Revolution*, Island Records, 1978.

19 Vivien Goldman, 'Linton Kwesi Johnson, Poet of the Roots', *sounds*, 2 September 1978, pp. 23–5.

20 Burning Spear, 'Slavery Days', from the album *Marcus Garvey*, Island Records, 1975.

21 Osei Yaw-Akoto, 'Racism Reigns in England', *The Heritage*, University of Michigan-Dearborn, 1, No. 1, November 1976, 4.

22 Notting Hill Carnival has a hugely important part to play in the cultural evolution of Black Britain, though it is perhaps something of a go-to reference point for the ways in which Black-British arts and culture are perceived and framed by the wider society. Nevertheless, its story is much more complex and nuanced than the ways in which the dominant society both caricatures and (in the case of some senior politicians) seeks to appropriate it. For reflections on the importance of Notting Hill Carnival, see publications such as Kwesi Owusu and Jacob Ross, *Behind the Masquerade: Story of Notting Hill Carnival*, (London: Arts Media Group, 1988) and Michael La Rose (ed.), *Mas in Notting Hill: Documents in the Struggle for a Representative and Democratic Carnival, 1989–90*, (London: New Beacon Books Ltd, 1990).

23 *Caribbean Artists in England*, Commonwealth Art Gallery, Kensington High Street, London, 22 January–14 February 1971. The exhibition featured some seventeen practitioners, showing fabrics, paintings, sculpture and ceramics.

24 John Lyons, 'Denzil Forrester's Art in Context', catalogue essay in *Denzil Forrester: Dub Transition, A Decade of Paintings 1980–1990* (the exhibition first shown at Harris Museum & Art Gallery, Preston, 22 September–3 November 1990), p. 17.

25 Colin Babb, 'The Rise of West Indian Cricket: An England Captain is Made to Grovel, Cricket's Link to Diaspora Self-Esteem and the Emergence of the Caribbean-born English Cricketer', *They Gave the Crowd Plenty Fun: West Indian Cricket and Its Relationship with the British-Resident Caribbean Diaspora*, London and Hertfordshire: Hansib, 2012, p. 43.

26 Babb, 'Introduction', *They Gave the Crowd Plenty Fun*, p. xiv.

27 Ibid.

Chapter 1: De street weh dem seh pave wid gold

1 *Race Relations in Britain*, by Anthony Chater, part of the *Socialism Today Series* published by Lawrence and Wishart, London 1966, (p.33) provides the following information about net immigration from the 'West Indies' between 1955 and 1964:

1955	27,550
1956	29,800
1957	23,000
1958	15,000
1959	16,400
1960	49,650
1961	66,300
1962	34,041
1963	7,928
1964	14,848

Sources: Hansard, 18 March 1965; Home Office Statistics, Cmnd. 2379 and 2658; White Paper on Immigration, Cmnd. 2739.

2 A number of books on Britain's history of immigration exist. See for example Robert Winder, *Bloody Foreigners: The Story of Immigration to Britain*, (London: Little Brown, 2004).

3 The majority of mid-twentieth century Black immigrants came from either countries of the British Empire or countries of the Commonwealth. As such, both these migrants and their offspring seemed to have a certain proximity to notions of the Commonwealth. 'A black teacher in the early sixties was talking to his class about the Commonwealth. He asked the children to put up their hand if they thought they were in the Commonwealth. The hands that shot up belonged to every one of the handful of black kids in the class. None of the white kids identified with the Commonwealth. (Trevor Carter, 'Integration: A Hopeless Pursuit', *Shattering Illusions: West Indians in British Politics*, (London: Lawrence & Wishart, 1986), p. 72).

4 Claudia Jones, 'The Caribbean Community in Britain', *Freedomways: A Quarterly Review of the Negro Freedom Movement, The People of the Caribbean Area*, 4, No. 3 Summer, 1964, p. 341.

5 Winder, 'The Empire Comes Home', *Bloody Foreigners*, p. 256.

6 Ernest Cashmore 'The Journey to Jah', *Rastaman: The Rastafarian Movement in England*, (London: George Allen & Unwin, 1979), p. 50.

7 Robert Kee, 'Is There a British Colour Bar?' *Picture Post: Hulton's National Weekly*, 44, No. 1, 2 July 1949, 24.

8 Winder, 'The Empire Comes Home', *Bloody Foreigners*, p. 256.

9 Kee, 'Is There a British Colour Bar?', *Picture Post*, p. 26.

10 Ibid.

11 Frederic J. Haskin, 'The Negro Workers', *The Panama Canal*, (New York: Doubleday, Page & Company, 1913), p. 154.

12 Ibid, p. 156.

13 Ibid.

14 Ibid, p. 154.

15 Trevor Carter, 'Different but Still Unequal', *Shattering Illusions: West Indians in British Politics*, (London: Lawrence & Wishart, 1986), p. 77.

16 Chris Mullard, 'Black Settlement', *Black Britain*, (London: George Allen & Unwin Ltd, 1973), p. 41. The figure of 100 Caribbean immigrants a year being allowed into the USA on account of the McCarran-Walter act is often cited. In this regard, one particularly authoritative source was Claudia Jones, 'The Caribbean Community in Britain', *Freedomways: A Quarterly Review of the Negro Freedom Movement, The People of the Caribbean Area*, 4, No. 3 Summer, 1964, p. 341. Jones' comment added the not insignificant detail that the figure of 100 per year related to each individual Caribbean territory:

> the United States Federal Government enacted the racially-based McCarran-Walter Immigration Law, which unequivocally was designed to protect the white 'races' purity, and to ensure the supremacy of Anglo-Saxon stock; limited to 100 per year, persons allowed to emigrate to the United States from each individual Caribbean territory.

17 E. David Cronon, 'A Son is Given', *Black Moses: The Story of Marcus Garvey and the Universal Negro Improvement Association*, (Madison, WI: University of Wisconsin Press, 2nd edition, 1972), p. 14.

18 Ibid, p. 15.

19 Barbara Bair, 'Amy Ashwood Garvey', *Dictionary of African Biography*, Vol. 2 Emmanuel K. Akyeampong and Henry Louis Gates, Jr. (editors in chief), (New York: Oxford University Press, 2012), p. 428.

20 Haskin, 'The Negro Workers', *The Panama Canal*, p. 163.

21 Winder, 'The Empire Comes Home', *Bloody Foreigners*, p. 257.

22 Carter, 'Mixed Feelings', *Shattering Illusions*, p. 29.

23 Ibid.

24 Robin Cohen, 'Cultural Diaspora: The Caribbean Case', *Caribbean Migration: Globalised Identities*, Mary Chamberlain (ed.), (London: Routledge/Taylor & Francis, 2002), p. 26.

25 Two of the texts referred to throughout this chapter came from the politically liberal *Picture Post*, a popular culture and lifestyle magazine. The first such piece was Robert Kee, 'Is There a British Colour Bar?' *Picture Post: Hulton's National Weekly*, 44, No. 1, 2 July 1949. Hedging its bets, it had opted for the established journalistic device of framing its title around a question, rather than around a definitive statement. Three years later, it again opted for this strategy, with its feature, Hilde Marchant, 'Breeding a Colour Bar?' *Picture Post, Hulton's National Weekly*, 6 September 1952. By the mid 1950s, however, the posing of such questions had been dispensed with, and now a *Picture Post* feature on Caribbean migrants took the form of an unvarnished assertion that posited the firm view that such

people were synonymous *with* problems and indeed, *were* problems. (Hilde Marchant, 'Thirty-Thousand Colour Problems', *Picture Post, Hulton's National Weekly*, 9 June 1956, 28, 29, 38).

26 Carter, 'Mixed Feelings', *Shattering Illusions*, p. 64.

27 Ibid, p. 71.

28 Mullard, 'The Numbers Game', *Black Britain*, p. 47.

29 Ibid.

30 Ibid, p. 48.

31 'The Half-Open Door', *The British Empire, The Loose Ends of Empire*, BBC TV Time-Life Books, No. 95, 1973, p. 2656.

32 Marchant, 'Breeding a Colour Bar?', *Picture Post*, p. 31.

33 Kee, 'Is There a British Colour Bar?', *Picture Post*, p. 25.

34 Ibid.

35 Quoted in Mullard, 'Black Britons' Dilemma', *Black Britain*, p. 145.

36 Carter, 'Mixed Feelings', *Shattering Illusions*, p. 41.

37 'Immigration', from the Basement 5 Album, *1965–1980*, Island Records, 1980.

> Partly formed out of the Art Department of London's Island Records HQ in 1978, Basement 5 were an innovative and highly original black Post-Punk group who created a kind of politically charged, futurist Dub. Their lyrics were an attempt to reflect the situation of young people in Britain in the era of Thatcherism, high unemployment, strikes, racism, and working class poverty.' (http://www.discogs.com/artist/119558-Basement-5, accessed 16 April 2015.)

38 Robert Moore, 'Labour and Colour 1965–1968', *Venture*, September 1968. Quoted in Mullard, 'The Numbers Game', *Black Britain*, pp. 60–61.

39 Nancy Foner, 'The Jamaicans: Cultural and Social Change among Migrants in Britain', *Between Two Cultures: Migrants and Minorities in Britain*, James L. Watson (ed.), (Oxford: Basil Blackwell, 1977), p. 146.

40 Ernest Cashmore 'From Evasion to Truculence', *Rastaman: The Rastafarian Movement in England*, (London: George Allen & Unwin, 1979), p. 39.

41 Haskin, 'The Negro Workers' *The Panama Canal*, p. 157.

42 Ibid. One of the meanings of *nabob* relates to it being a person of conspicuous wealth or high status, and historically one who returned from India to Europe with a fortune.

43 Carter, 'Different but Still Unequal', *Shattering Illusions*, p. 87.

44 Marchant, 'Breeding a Colour Bar?', *Picture Post*, p. 30.

45 In Crowd, 'Back a Yard', written by Fil Callender, Cactus label, 1978.

46 Cashmore, 'From Evasion to Truculence', *Rastaman*, p. 39.

47 Ernest Cashmore 'Rasta Renaissance', *Rastaman: The Rastafarian Movement in England*, (London: George Allen & Unwin, 1979), p. 50.

48 Carter, 'Integration: A Hopeless Pursuit', *Shattering Illusions*, p. 63.

49 Richard Hooper, 'Britain's Coloured Immigrants', *The Listener*, 25 February 1965, Vol. LXXIII, No. 1874, p. 283.

50 Even Ken Pryce, a sociologist and researcher, could not resist positing the Jamaican presence in Bristol as being weightier by far than the apparently lesser presence of people originally from other islands in the Caribbean. Wrote Pryce in the opening chapter of his study,

> I focus on Jamaica instead of on the West Indian region as a whole for two reasons. Firstly, the West Indian community in Bristol is a predominantly Jamaican one, as I have mentioned already. Of course, there are other

West Indians in Bristol, the so-called 'small-island' West Indians – from Trinidad, Barbados, Dominica, St Kitts, etc – but they are not many and the few who have settled in the city are completely overshadowed by the sheer numbers of Jamaicans and the overwhelming Jamaican-ness of the community. (Ken Pryce, *Endless Pressure: A Study of West Indian Life-Styles in Bristol*, Second Edition, (Bristol: Bristol Classical Press, 1986), p. 1.)

51　The West Indies Federation/Federation of the West Indies, was a short-lived, highly ambitious political union that existed from early 1958 to mid 1962, a period of little over four years. Various English-speaking islands of the Caribbean that were British colonies, including the larger such countries of Barbados, Jamaica, and Trinidad and Tobago, came together to form the West Indies Federation, with its capital that of Trinidad and Tobago, Port of Spain. The stated aim of the Federation was to create a pan-Caribbean political union, which would become independent from Britain. This was a somewhat revolutionary idea, however, and the Federation collapsed due to a number of factors such as the withdrawal of Jamaica and internal conflicts. Norman Manley, the Jamaican political stalwart and husband of celebrated sculptor Edna Manley, was leading Jamaica during the years in which the Federation existed. He called a referendum on the issue in 1961, in which the voters of Jamaica duly rejected continued membership. Independence for Jamaica was gained the following year. There was a pronounced sense of indifference to the prospect of Jamaica's continued involvement in a West Indies Federation – so much so that the Trinidadian-born calypsonian Lord Creator made a reference to its demise in his 1962 hit, celebrating Jamaican independence. Sang Lord Creator, 'Manley called up a referendum, for you make your decision, So the people voted wisely, now everyone is happy that there's no more federation.' ('Independent Jamaica', Lord Creator, Island Records, 1962).

52　Mullard, 'Black Settlement', *Black Britain*, p. 37.

53　Hooper, 'Britain's Coloured Immigrants', *The Listener*, p. 283.

54　Foner, 'The Jamaicans', *Between Two Cultures*, p. 131.

55　Hooper, 'Britain's Coloured Immigrants', *The Listener*, p. 283.

56　Cashmore, 'Rasta Renaissance', *Rastaman*, p. 68.

57　Kee, 'Is There a British Colour Bar?', *Picture Post*, p. 23.

58　Ibid.

59　By far the most notorious sentiment, post Powell, in this regard, came from Margaret Thatcher, the then Leader of the Conservative Opposition party in a 1978 television interview. Opined Thatcher,

> [T]here was a committee which looked at [immigration] and said that if we went on as we are then by the end of the century there would be four million people of the new Commonwealth or Pakistan here. Now, that is an awful lot and I think it means that people are really rather afraid that this country might be rather swamped by people with a different culture and, you know, the British character has done so much for democracy, for law and done so much throughout the world that if there is any fear that it might be swamped people are going to react and be rather hostile to those coming in. ('World in Action', 30 January, 1978, quoted in Trevor Russel, *The Tory Party: Its Policies, Divisions and Future*, (Harmondsworth, UK: Penguin, 1978), p. 115.)

60　Ibid.

61　Figures and percentages need always to be treated with caution, and this figure was offered as an 'estimate': 'Although there are no official figures, the coloured population of

Great Britain is estimated by both the Colonial Office and the League of Coloured Peoples at about 25,000, including students. This total is distributed across the whole of Britain.' The text continued to reference 'two larger concentrated communities: one of about 7,000 in the dock area of Cardiff... and the other of about 8,000 in... Liverpool.' (Kee, 'Is There a British Colour Bar?' *Picture Post*, p. 23).

62 Kee, 'Is There a British Colour Bar?', *Picture Post*, p. 24.

63 Ibid, p. 25.

64 Ibid, p. 25. Kee continued to outline a nomenclatural manifestation of this discrimination that remains a problem – particularly in the area of employment – up to the present time. Wrote Kee:

> The operation of this particular unofficial colour bar is always the same. A coloured man, perhaps with a name like Smith or Murdoch, will write or ring up in answer to an advertisement and be told to call to see the room at a certain time. The landlady, when she sees him, will usually say quite politely that the room has just been let. In many cases, a check carried out by a white friend immediately afterwards will prove that the room is still available.

Indicating the extent to which such discrimination was something of a perennial problem, Stevie Wonder, referencing another place and time, sang of similar experiences in his 1980 track, 'Cash in Your Face', on his *Hotter Than July* album, released on the Tamla label.

65 Kee, 'Is There a British Colour Bar?', *Picture Post*, p. 26.

66 Ibid, pp. 23–8.

67 Ibid, p. 23.

68 Marchant, 'Breeding a Colour Bar?', *Picture Post*, pp. 28–31.

69 Kee, 'Is There a British Colour Bar?', *Picture Post*, p. 27.

70 Hooper, 'Britain's Coloured Immigrants', *The Listener*, p. 285.

71 Mullard, 'Black Britons' Dilemma', *Black Britain*, p. 150.

72 Hooper, 'Britain's Coloured Immigrants', *The Listener*, p. 284.

73 Kee, 'Is There a British Colour Bar?', *Picture Post*, p. 27.

74 Hooper, 'Britain's coloured immigrants', *The Listener*, p. 284.

75 Ibid. Alongside the popular belief that the Black worker was unskilled existed the accompanying belief, held with equal certainty, that the Black worker was inclined to laziness. Though without foundation, the belief persisted throughout the twentieth century, and found an expression in the chapter on Black workers in the construction of the Panama Canal, referenced in this chapter: 'It was a common saying in the Zone that if the negro were paid twice as much he would work only half as long.' (Frederic J. Haskin, 'The Negro Workers', *The Panama Canal*, (New York: Doubleday, Page & Company, 1913), p. 155.) Towards the end of this chapter, Haskin claimed that Caribbean labourers had benefitted from their work on the canal on account of shedding the 'charge of inefficiency and laziness'. Wrote Haskin,

> Under the firm but gentle guidance of the master American hand, ['The Negro Worker'] did his work so well that he has forever erased from the record of his kind certain charges of inefficiency and laziness that had long stood as a black mark against him. (Haskin, *The Panama Canal*, 'The Negro Workers', p. 163).

76 Ibid.

77 Ibid.

78 Ibid.
79 Mullard, 'Black Settlement', *Black Britain*, p. 42.
80 Ibid, pp. 42–3.
81 Carter, 'Different but Still Unequal', *Shattering Illusions*, p. 82.
82 Mullard, 'Black Britons' Dilemma', *Black Britain*, p. 152.
83 Carter, 'Different but Still Unequal', *Shattering Illusions*, p. 113.
84 Quoted in Foner, 'The Jamaicans', *Between Two Cultures*, p. 125.

Chapter 2: Towards the Black 70s

1 K. L. Little, 'The Coloured Man's Reaction to the English', *Negroes in Britain: A Study of Racial Relations in English Society*, (London: Kegan Paul, Trench, Trubner & Co., Ltd, 1947), p. 247.
2 Ibid, p. 256.
3 Len Garrison, 'Cultural Pluralism and the Search for a New Identity', *Black Youth, Rastafarianism, and the Identity Crisis in Britain*, (London: Acer Project, 1979), p.1.
4 Nancy Foner, 'The Jamaicans: Cultural and Social Change among Migrants in Britain', *Between Two Cultures: Migrants and Minorities in Britain*, James L. Watson (ed.), (Oxford: Basil Blackwell, 1977), pp. 130–31.
5 Trevor Carter, 'Mixed Feelings', *Shattering Illusions: West Indians in British Politics*, (London: Lawrence & Wishart, 1986), p. 22.
6 Foner, 'The Jamaicans', *Between Two Cultures*, p. 134.
7 Ibid.
8 Carter, 'Mixed Feelings', *Shattering Illusions*, p. 29.
9 Christiane Schlote, 'Oil, Masquerades, and Memory: Sokari Douglas Camp's Memorial of Ken Saro-Wiwa', *Cross/Cultures No. 148: Engaging with Literature of Commitment. Volume 1: Africa in the World*, Gordon Collier, Marc Delrez, Anne Fuchs and Bénédicte Ledent (eds), 2012, p. 245.
10 A passage from Donald Hinds' book, *Journey to an Illusion*, London: Heinemann, 1966, quoted the disillusioning experiences of a returning Jamaican, arriving at Kingston airport. 'The dream of returning was not so romantic when I reached the airport. It is a fact that the place is very elegant. But returning migrants are considered tourists.' (Winston James, 'Migration, Racism and Identity Formation: The Caribbean Experience in Britain', *Inside Babylon: The Caribbean Diaspora in Britain*, Winston James and Clive Harris (eds), (London: Verso, 1993), p. 247).
11 Mike Phillips and Trevor Phillips, 'Vehicle to Progress: 1970–1975', *Windrush: The Irresistible Rise of Multi-Racial Britain*, (London: Harper Collins, 1998), p. 256.
12 It is to the years following the first of the voyages of Christopher Columbus to the Americas that began in the late fifteenth century that the terms *West Indies* and *West Indian* can be traced. In his ignorance, Christopher Columbus, upon his arrival in the Americas, believed himself to have navigated his way to India, or the *Indies*. Thereafter, Europeans used *West Indies* to distinguish the region from the *East Indies*, which was the term then in use given to what became commonly understood as being Asia. Out of this muddle, ignorance and confusion emerged the notion that the peoples of the Americas first encountered in the late fifteenth century were Indians. No amount of cartography has been able to comprehensively dislodge the monumental misnomer, even though the Caribbean region, and the Asian continent are literally an ocean apart. It was perhaps with good reason that reggae songs railed against Columbus – songs such as Burning Spear's 'Columbus', which states and restates the charge that, 'Christopher Columbus is a damn blasted liad.' ('Columbus', a track on Burning Spear, *Hail H. I. M.*, Rondor Music,

1980. In Jamaican patwa, a 'liad' is someone who has lied or who lies consistently.) While the term *West Indian* has largely been discarded and has in some senses assumed a somewhat archaic feel, its use nevertheless continues. In this regard, dominant examples are the University of the West Indies and the West Indies Cricket Team. One of the biggest airlines of the region went by the name of British West Indies Airways, or *Bee-Wee*. For some, however, the term Caribbean is hardly an improvement, signifying it as meaning its inhabitants were 'Carried Beyond' their homelands in Africa. (See Linton Kwesi Johnson, 'Jamaican Rebel Music', *Race and Class*, 27, No. 4 XVII, 4, 1976, 402.

13 *Observer* magazine, 28 November 1971. The feature was one of several such pieces, appearing weekly, which together comprised *The New Britons*. This particular feature, the first in the series, was on *Black Britons*. 'Prejudice aside, the facts on immigration are hard enough to come by. First part of a special inquiry.' Written by Jann Parry, with photographs by Romano Cagnoni, pp. 17–25.

14 Jann Parry, 'The New Britons', *Observer*, 28 November 1971, p. 24.

15 Ibid.

16 Ibid, p. 22.

17 Quoted in Foner, 'The Jamaicans', *Between Two Cultures*, p. 129.

18 Ibid.

19 Foner, 'The Jamaicans', *Between Two Cultures*, p. 121.

20 Parry, 'The New Britons', p. 25.

21 Foner, 'The Jamaicans', *Between Two Cultures', p. 145.

22 Ibid.

23 Dennis Brown/Aswad, 'Promised Land', Simba Records, *circa* 1982.

24 Foner, 'The Jamaicans', *Between Two Cultures*, p. 145.

25 Ibid, p. 138.

26 Ibid, p. 144.

27 Ibid, pp. 145–46 (Foner was quoting from Midgett, Douglas, 'West Indian Ethnicity in Britain', in *Migration and Development*, edited by Helen Safa and Brian duToit. (The Hague: Mouton Publishers, 1975), p. 75).

28 Ibid, p. 144.

29 Foner, 'The Jamaicans', *Between Two Cultures*, p. 145. These other formidable challenges were succinctly referenced, with a certain understatement, by Nancy Foner as follows:

> Used to being a majority back home, blacks are a very small minority in Britain. More important, English people are often racially prejudiced, and blacks are systematically exploited at every level in British society – in employment, housing, education, and the social services. Numerous studies have documented the widespread discrimination blacks in Britain experience in housing and employment... They occupy the worst-paid, the dirtiest, and the most boring jobs: jobs that English people usually do not want.

30 Ibid, p. 122.

31 Len Garrison, 'Cultural Reversal and Separation', *Black Youth, Rastafarianism, and the Identity Crisis in Britain*, (London: Acer Project, 1979), p. 17.

32 In its most unvarnished form, this pathology was reflected in the titling of Hilde Marchant's 'Thirty-Thousand Colour Problems' *Picture Post, Hulton's National Weekly*, 9 June 1956, 28, 29, 38. By the 1970s, Britain had long regarded itself as having exemplary 'race relations'. Apart from 'extreme' groups considered to be on the margins, major vestiges of racism were widely believed to have been eradicated from the society. Laws such as those aimed at outlawing racial discrimination in the workplace and recruitment were

seen as being sufficient to address the issue of racism. So for researchers and sociologists such as Pryce and Garrison to suggest that Britain was not yet 'home' for seemingly an entire generation of British-born children was damning indeed and flew in the face of the establishment's preferred thinking.

33 Rasheed Araeen, 'Confronting the System', *The Other Story*, (London: Hayward Gallery, South Bank Centre, 1989), p. 72.

34 William Raspberry, 'Young Bitter and Black', the *Observer Review*, 5 September 1976, p. 19.

35 Osei Yaw-Akoto, 'Racism Reigns in England', *The Heritage*, University of Michigan-Dearborn, 1. No. 1, November 1976, 4. This piece drew from the dispatches Raspberry filed for the *Observer* over several weeks in September 1976, plus other aspects of the newspaper's coverage of the disturbances that took place at the Notting Hill Carnival the previous month.

36 Peter Gillman, 'On the Edge of the Ghetto: The Way They See It', *Sunday Times Magazine*, 30 September 1973, pp. 28–44 and 47–9.

37 Ibid, p. 35.

38 Somewhat bizarrely, Lenny Henry became something of a staple on *The Black and White Minstrel Show*. Even his sympathetic biographer could scarcely conceal his incredulity at this turn of events, describing it as 'one very strange departure'. Jonathan Margolis, wrote, 'Robert Luff [Henry's agent in 1975] prevailed upon his new star to do something which, if it seems bizarre now, seemed, at the very least, downright eccentric then'. Going on to recall that 'Lenny Henry was the first real black man ever to appear on *The Black and White Minstrel Show*, [a programme which by then was] 'on its last legs'. (Jonathan Margolis, 'Conic Relief', *Lenny Henry: A Biography*, (London: Orion 1995), p. 58.)

39 Stephen Bourne, 'The Uncle Tom Show', *Black in the British Frame: The Black Experience in British Film and Television*, (London: Continuum, 2001), p. 4.

40 Ibid, p. 5.

41 Ibid.

42 Lloyd Bradley, 'The Whole World Loves a Lovers', *Sounds Like London: 100 Years of Black Music in the Capital*, (London: Serpent's Tail, 2013), p. 217.

43 The *allowing* on to television of Black people as entertainers and sportspeople does of course reflect a pathology of primeval dimensions. Robert Kee in 'Is There a British Colour Bar?' (*Picture Post: Hulton's National Weekly*, 44, No. 1, 2 July 1949, p. 28) referred to sport and entertainment as the two arenas in which British society suspends its colour prejudice.

44 As noted earlier in this chapter, by the late 1960s many Caribbean migrants went in search of greener pastures, and 'in 1968 and 1969 more than twice as many West Indians left Britain for Canada alone as were admitted to Britain for work'. (Jann Parry, 'The New Britons', *Observer Magazine*, 28 November 1971, p. 22.)

45 Within the wider African Diaspora, this peripatetic existence had begun as early as the early twentieth century, when large numbers of Caribbean peoples journeyed to countries such as the USA or Panama, where their labour was (for relatively short periods) required.

46 Foner, 'The Jamaicans', *Between Two Cultures*, p. 145.

47 There are a number of texts that deal with the relationship between Black youth and the police during the 1970s and early 1980s. These include Derek Humphry, *Police Power and Black People*, London: Panther, 1972, and Martin Kettle and Lucy Hodges, *UPRISING! The Police, the People and the Riots in Britain's Cities*, (London: Pan Books, 1982).

48 Foner, 'The Jamaicans', *Between Two Cultures*, p. 145.

49 Sections of the mainstream press were fond of emphasising the apparent contrast between industrious Asians and supposedly feckless, idle Caribbean youth, predisposed towards criminal damage, looting and mugging. Reporting on the riots that took place in Birmingham in the mid 1980s, in which several people lost their lives, the *Sun*

took particular license, claiming that, 'Two Asian brothers screamed in agony as West Indian rioters beat them – and then left them to burn alive in the petrol-bombed sub-post office [run by the Asian brothers].' (*Sun*, 11 September 1985, reported in John Solomos and Les Black, 'Parties, Black Participation and Political Change', *Race, Politics and Social Change*, (London: Routledge 1995), p. 82.) Solomos and Black continued,

> The dominant theme of the reporting of these events suggested that a 'race riot' had taken place and that the death of the Moledina brothers was the result of tension between the African-Caribbean and Asian communities. This was despite factual details such as the presence of large numbers of whites and Asians on the streets who were arrested during the incident, and the fact that the person charged for the Moledina murders was in fact white...
>
> This event marked a definite shift in the way in which black male youths were represented ... black criminality had been one of the key themes in the ways in which the black presence in Birmingham had been described. At one level the reporting of the events of September 1985 was merely an elaboration from one form of racialised criminality (mugging) to another (rioting). The 'black mugger' was surpassed by a new folk demon, the 'black bomber'. This shift not only associated black youth with crimes against the person but also with crimes against society.

50 One relatively brief chapter, 'The Women on the Receiving End', dealt with women's experiences in relationships with the sorts of men on whom the study was based. For the most part, these experiences largely consisted of women being either unlucky in love, or the victims of spousal abuse in a variety of forms.

51 As a pointer towards these histories and voices, the inaugural exhibition at Brixton's Black Cultural Archives in 2014 was *Re-imagine: Black Women in Britain* (24 July–30 November 2014).

52 *Wonderful Adventures* was an extraordinary work, even when it was originally published in 1857. It was an autobiography of Mary Seacole, who had been born in Jamaica in 1805, and went on to live a fascinating life, travelling widely and setting herself up as a businesswoman, hotelier and nurse, helping soldiers wounded during the Crimean War. Seacole was an intriguing figure, whose contributions and significance as an independent, self-possessed woman of the Victorian era were significantly overshadowed by the altogether better-known Florence Nightingale.

53 Claudia Jones, like Seacole, was an important historical figure, albeit from relatively more recent times. Jones was born in Trinidad in 1915, and, like Seacole, went on to live a fascinating life, her family moving to the USA when she was a child, although she was later deported on account of her political activism. In London, she continued her work as a campaigner for civil rights and justice, alongside her energetic activities as a journalist. One of her most enduring legacies is her contribution to establishing the Notting Hill Carnival, in the wake of racial tensions and violence encountered by Caribbean immigrants in cities such as Nottingham and London in the late 1950s. Jones died in 1964.

54 Bradley, 'The Whole World Loves a Lover', *Sounds Like London*, pp. 220–21.

55 Ibid, p. 220.

56 Ibid. Such was the all constraining, formidable and inescapable nature of poverty and hardship in Jamaica that vernacular culture, heavily influenced by Rastafari, produced

highly descriptive nouns with which to describe its state of being and those who endured it. These terms were, respectively, *sufferation* and *sufferer* (sometimes appearing as *sufferah*). Elsewhere in the English-speaking world, no less a figure than Fela Kuti, the Afrobeat musician and singer, coined his own, distinctly Nigerian version of the sufferer, becoming in the process, the 'Original Sufferhead.' (Felá Anikūlapo-Kuti, 'Original Sufferhead', Arista label, 1981.)

57 James Berry, 'The Literature of the Black Experience', David Sutcliffe and Ansel Wong (eds), *The Language of the Black Experience: Cultural Expressions through Word and Sound in the Caribbean and Black Britain*, (Oxford: Basil Blackwell, 1986), p. 69.

58 Ibid.

59 Barry Troyna, 'Afro-Caribbeans in the UK', *Dictionary of Race and Ethnic Relations*, E. Ellis Cashmore (ed.), (London: Routledge, 1988), p. 11.

60 Bradley, 'The Whole World Loves a Lover', *Sounds Like London*, p. 212.

61 Books, essays and articles have referred wholly or in part to the issue of racism and how it has affected Black youth in particular and Black people in general in Britain. These include Zig Layton-Henry, *The Politics of Race in Britain*, (London: Allen & Unwin, 1984); Trevor Carter, *Shattering Illusions: West Indians in British Politics*, (London: Lawrence and Wishart, 1986); Remi Kapo, *A Savage Culture: Racism – A Black-British View*, (London: Quartet Books, 1981); Paul Gilroy, *'There Ain't No Black in the Union Jack': The Cultural Politics of Race and nation*, (The University of Chicago Press, 1991).

62 Though the term *Black Power* had been in existence for some time, it was popularised by Stokely Carmichael in the mid 1960s, thereafter growing in traction and importance as an aspiration and a political ideology. Compelling definitions of *Black Power* include the one offered by Larry Neal, one of Black Power's staunchest poets and prophets, in an article entitled 'Black Art and Black Liberation.' Wrote Neal,

> Black Power, in its most fundamental sense, stands for the principle of Self-Definition and Self-Determination. Black Power teaches us that we must have ultimate control over our lives. It teaches us that we must make a place on this Earth for ourselves, and that we must construct, through struggle, a world that is compatible with our highest visions. (Larry Neal, 'Black Art and Black Liberation' (31–2), *The Black Revolution: An Ebony Special Issue*, (no editor given), (Chicago: Johnson Publishing Company Inc., 1970), pp. 31–53.

See also Floyd B. Barbour (ed.), *The Black Power Revolt*, (Boston MA: Extending Horizons Books/Porter Sargent, 1968).

63 A number of books have been written about the Rastafari movement. More so than the Black Power movement, books on Rastafari offer different though for the most part overlapping understandings of the movement, and because there is no single universally recognised body that represents those who call themselves Rastafarians (or Rastas), it becomes unwise to single out any one interpretation as having a wider application than another. Works on Rastafari include John Plummer, *Movement of Jah People: The Growth of the Rastafarians*, (Birmingham, UK: Press Gang, 1978); Leonard Barrett, *The Rastafarians*, (Boston: Beacon Press, 1977); Joseph Owens, *Dread: The Rastafarians of Jamaica*, (Kingston: Sangster's, 1976); Ernest Cashmore, *Rastaman: The Rastafarian Movement in England*, (London: George Allen & Unwin, 1979).

64 Stuart Hall, 'New Ethnicities', ICA Documents 7, *Black Film British Cinema*, (London: A BFI Production Special, 1988), p. 27.

243

Chapter 3: Rasta This and Dreadlocks That

1 Leonard E. Barrett, 'Domination and Resistance in Jamaican History', *The Rastafarians*, (Boston: Beacon Press, 1977), p. 67.

2 Ernest Cashmore, 'The Rastaman in Jamaica', *Rastaman: The Rastafarian Movement in England*, (London: George Allen & Unwin Ltd, 1979), p. 22.

3 Colin Grant, 'Gone to Foreign', *Negro with a Hat: The Rise and Fall of Marcus Garvey*, (Oxford: Oxford University Press, 2008), p. 439.

4 Ellis Cashmore (ed.), 'Rastafarian Movement', *Dictionary of Race and Ethnic Relations*, (London: Routledge, 1988), p. 254.

5 This text, *Italy's Conquest?*, originally appeared in one of Garvey's many publishing ventures, *The Blackman Magazine*, August 1936. It was reproduced in the section 'Marcus Garvey in His Own Words', in *Marcus Garvey and the Vision of Africa*, John Henrik Clarke (ed.), (New York: Vintage Books, 1974), p. 363.

6 Ibid.

7 Ibid, p. 365. The biblical verse that Garvey was referencing came from Psalms 68, verse 31 of the King James Bible – 'Princes shall come out of Egypt; Ethiopia shall soon stretch out her hands unto God.'

8 Grant, 'Gone to Foreign', *Negro with a Hat*, p. 440.

9 Ibid.

10 An earlier biographer of Garvey stated that he had been 'brought up a Roman Catholic' (E. David Cronon, 'One God! One Aim! One Destiny!', *Black Moses: The Story of Marcus Garvey and the Universal Negro Improvement Association*, University of Wisconsin Press, 2nd edition, 1972, p. 178). However, the most recent biography on Garvey claimed that, from the days of his youth, he 'would forge strong links with the Roman Catholic diocese of Jamaica, and would convert to Catholicism.' (Grant, 'Bury the Dead and Take Care of the Living', *Negro with a Hat*, p. 18).

11 Cashmore (ed.), 'Rastafarian Movement', *Dictionary of Race and Ethnic Relations*, p. 255.

12 Len Garrison, 'Ras Tafari and the Black Youth in Britain', *Black Youth, Rastafarianism, and the Identity Crisis in Britain*, (London: Acer Project, 1979), p. 24.

13 Barrett, 'Ethiopianism in Jamaica', *The Rastafarians*, p. 68.

14 Cronon, 'One God! One Aim! One Destiny!', *Black Moses*, p. 178.

15 Ibid.

16 Nancy Foner, 'The Jamaicans: Cultural and Social Change Among Migrants in Britain', *Between Two Cultures: Migrants and Minorities in Britain*, James L. Watson (ed.), (Oxford: Basil Blackwell, 1977), p. 137.

17 'Young West Indians saw themselves not as fractionated and culturally diverse but as one people, sharing similarities of backgrounds, of present circumstances and, more importantly, of future.' (Cashmore 'Rasta Renaissance', *Rastaman: The Rastafarian Movement in England*, p. 68).

18 Marcus Garvey, 'The British West Indies in the Mirror of Civilization', in John Henrik Clarke (ed.), *Marcus Garvey and the Vision of Africa*, (New York: Vintage, 1974), p. 82.

19 Richard Koss, *Jamaica*, Lonely Planet series, 2008, p. 36.

20 Ken Pryce, 'The Quest for Solutions: Black Identity and the Role of Reggae', *Endless Pressure: A Study of West Indian Life-Styles in Bristol*, (Bristol: Bristol Classical Press, 1986), p. 160.

21 Foner, 'The Jamaicans', *Between Two Cultures*, p. 145.

22 Osei Yaw-Akoto, 'Racism Reigns in England', *The Heritage*, University of Michigan-Dearborn, Vol 1, No. 1, November 1976, p. 4.

23 '"Black Art" Message Praised', *Jamaican Weekly Gleaner*, 2 June 1982, p. 5.

24 For an important and enduring discussion of Jamaican reggae and its contribution to, as well as reflection of, the identity of the sufferer, see Linton Kwesi Johnson's seminal text, 'Jamaican Rebel Music', *Race and Class*, Vol. 17, No. 4, 1976, pp. 397–412.

25 The graphic designer, artist, poet, and cultural activist Shakka Gyata Dedi, who was to become the director of The Black-Art Gallery in North London, was one of a number of people persuaded of the validity of adopting a more Afrocentric sounding name. Growing up with the name Melvyn Mykeal Wellington, he chose instead a name that, in part, paid homage to Shaka, one of the great monarchs of the Zulu kingdom, who grew into manhood in the early nineteenth century. The Dominican-born artist Tam Joseph, was widely known as Tom Joseph, before deciding to tweak his name from what he regarded as the Eurocentric sounding Tom, to the more Afrocentric sounding Tam. Nomenclatural rearrangements could, however, be something of a minefield. Tam was a historical abbreviation of tam o' shanter, a nineteenth-century traditional Scottish bonnet worn by men, supposedly named after Tam o' Shanter, the eponymous hero of the eighteenth-century poem by Robert Burns.

26 Black Uhuru, 'Leaving to Zion', from the album *Showcase*, Taxi label, 1979.

27 Reggae music continually expressed a marked ambivalence about what were scornfully regarded as the duplicitous antics of politicians. In his 1984 hit, 'Mi God, Mi King', Papa Levi asserted, 'Thru mi nuh check fi politician, nuh care who win di election.' (Papa Levi, 'Mi God Mi King', written by P. Levi, Level Vibes! Records, 1984.) In a similar regard, Papa Levi, on a different track, maintained, 'Levi nuh check political party', adding, for good measure, 'Mi woulda fool fi tink seh Inglan a fi mi country.' ('In-A-Mi-Yard', written by P. Levi, Level Vibes! Records, 1984.) Elsewhere, Benjamin Zephaniah opined, 'No politician can't come round here.' (Benjamin Zephaniah, 'No Politicians', *Rasta*, Uptight Records, 1983.) Many such sentiments were expressed in reggae music, including the more recent forcefully asked question, 'Why should we trust in politicians? Why should we vote in their election?' (Morgan Heritage, 'Politician', from the album *Mission in Progress*, VP Records, 2008.)

28 Keith Piper 'Step into the Arena: Black Art & Questions of Gender', in exhibition catalogue for *Step into the Arena: Notes on Black Masculinity & The Contest of Territory*, Rochdale Art Gallery, 3 May–1 June 1991, p. 6.

29 John Plummer, *Movement of Jah People: The Growth of the Rastafarians*, (Birmingham, UK: Press Gang, 1978), p. 4.

30 Quoted in Len Garrison, 'Image Building', *Black Youth, Rastafarianism, and the Identity Crisis in Britain*, (London: Acer Project, 1979), p. 18.

31 Ibid. p.15.

32 A. Sivanandan, 'From Resistance to Rebellion', *A Different Hunger: Writings on Black Resistance*, (London: Pluto Press, 1982), p. 6.

33 One description of the 'pardner' scheme can be found at http://www.blackeconomics. co.uk/partner.htm (accessed 10 May 2015):

> The 'pardner' has been popular among Caribbeans in the UK since they started arriving in England, and discovered credit services from banks were not easy to come by. It engendered a good savings discipline and allowed many to save to buy homes or cars.
> A group of people regularly deposit sums of money over a fixed interval with a principal individual, the 'banker', in a central fund. Each person in the group takes a turn in withdrawing their 'hand', usually the total amount collected for that week or month. It tends to operate amongst friends, families or close groups of other kinds. It is more

frequently used for saving for smaller purchases, usually in conjunction with other more formal borrowing or savings schemes.

34 'See Amber Wilson, 'Nine Night', *Jamaica: The People*, (New York: Crabtree Publishing, 2004), p. 23. for one description of Nine Night.

> 'Nine Night' is a Jamaican ceremony that takes place when someone dies. Different communities observe Nine Night in different ways. According to one tradition, eight nights after a loved one dies, friends and family gather in the deceased's home for a 'set up'. They sit up all night, playing a game called dominoes, singing songs, and drinking coffee, tea, and rum. On the ninth night, the group sings songs of farewell to the spirit, or 'duppy', of the person who died.

This summary of Nine Night, though betraying a notable degree of unfamiliarity, nevertheless pointed in large measure to aspects of the tradition.

35 Rodney's *Nine Night in Eldorado* exhibition at South London Gallery ran from 10 September to 12 October 1997. From the accompanying press release:

> The Jamaican tradition of the 'Nine Night' is one in which old memories and myths, corny jokes, dreams, hopes, fantasies and desires are revisited as relatives stay together for nine nights following the death of a loved one. Such a place for a nine night is Eldorado, that magical city of gold which no-one has ever found. Eldorado, 'the land of milk and honey' is evocative for generations of travellers from the sixteenth-century Spanish explorers to a generation of West Indians of the 1950s and 1960s who left their families to take up an extended offer to come to Britain. *9 Night in Eldorado* can be read as a narrative, a 'personal' history but its themes resonate for many.

36 The play's synopsis has been recorded as follows:

> Hamon Williams has lived in exile in England for twenty years. He calls a family gathering to propose that the family can regain its unity by travelling back to Jamaica. The nine night ritual for the dead is performed to help the troubled soul cross into Paradise and Hamon's nine night is a cathartic experience of challenge, self-examination and release, that allows him to travel back to Jamaica. (http://www.blackplaysarchive.org.uk/explore/productions/nine-night (accessed 10 May 2015).

37 Jonathan Margolis, '… And Lenny Henry', *Lenny Henry: A Biography*, (London: Orion 1995), p. 80.

38 Lenny Henry's biographer mentioned the practice, as Henry 'and the other male mourners followed the Jamaican tradition of each shovelling some earth on to the coffin.' (Margolis, '…And Lenny Henry', *Lenny Henry*, p. 79.)

39 The significance of cricket in the evolution of Black-British cultural identity is discussed in Chapter 8.

40 Lloyd Bradley, 'The Whole World Loves a Lover', *Sounds Like London: 100 Years of Black Music in the Capital*, (London: Serpent's Tail, 2013), p. 215.

41 In this regard, the Black barbershop represented far more than a much-needed amenity. It represented a space of comfort, affirmation of self, and a certain double consciousness. Within the Black barbershop, such things as current affairs, sport and music in the UK

could be passionately discussed and argued over, sometimes in the most animated of ways, alongside, or interwoven with, equally nuanced reflections on current affairs, sport, and music in the Caribbean. Many Black people in Britain found that a substantial sense of self could only be maintained if they continually availed themselves of understandings and familiarities with aspects of the country to which they had migrated, alongside corresponding understandings and familiarities with the major dimensions of the countries they had left. White British people were, by and large, under no such pressures. Consequently, the Black barbershop became, and indeed remains, a space for sharing news, opinions, and exchanging information about events and activities particularly pertinent to the Black communities.

42 See http://www.georgepadmoreinstitute.org/archive/collection/black-parents-movement (accessed 10 May 2015).

> The Black Parents Movement ran from 20 April 1975 and was most active until the mid 1980s. The Movement can be seen as an extension of the Black Education Movement and was formed after struggles by black people in Britain during the late 1960s up until 1974 over issues of education, police, housing and unemployment in which its founding members had participated. Such issues continued to be the focus of Black Parents Movement activity, with members participating in a large number of campaigns and legal cases, together with international political activity, especially in Grenada and Guyana.

43 Keith Piper, 'Black Art/Black Church', catalogue essay for *A Ship Called Jesus* exhibition at Ikon Gallery, Birmingham, 17 January–23 February 1991, unpaginated.

44 Ibid.

45 Revelation, 17:5 King James Version.

46 Cashmore, 'Creating Rastafarian Reality', *Rastaman*, p. 131.

47 A measure of the extent to which Babylon was understood as a perfect metaphor for Britain is reflected in the titles of books such as *News for Babylon: The Chatto Book of Westindian-British Poetry*, edited by James Berry, (London: Chatto & Windus, The Hogarth Press, 1984) and Winston James and Clive Harris (eds), *Inside Babylon: The Caribbean Diaspora in Britain*, (London: Verso, 1993).

48 Dennis Bovell was born in Barbados in 1953 and later moved to London. A reggae guitarist, bass player and record producer, Bovell was a member of the British reggae band Matumbi, one of a number of such groups formed in the mid 1970s, and is one of the leading figures in the history of Black-British reggae.

49 'Victim', written by George Clarke and performed by the Regulars, from the long-playing record of the same title, CBS Records, 1979.

50 Books on reggae music and its influences on Black-British youth and their cultural identity include Lloyd Bradley, *Bass Culture: When Reggae Was King*, (London: Penguin, 2000) and Lloyd Bradley, *Sounds Like London: 100 Years of Black Music in the Capital*, (London: Serpent's Tail, 2013).

51 Marchant. 'Breeding a Colour Bar?', *Picture Post*, p. 30. In time, ackee and saltfish, a much-loved meal in the Caribbean, would become the national dish of Jamaica.

52 As a signifier of this, not only did the local shopping districts referred to earlier, such as Handsworth's Soho Road, become spaces in which shopkeepers offered a wide range of fruit, vegetables and other foodstuffs that migrants wanted, but even large supermarkets such as Asda, Tesco and Sainsbury's each came to have their own world foods, or ethnic foods' aisles, selling similar products.

53 Trevor Carter, *Shattering Illusions: West Indians in British Politics*, 'Different but Still Unequal', (London: Lawrence & Wishart, 1986), p. 82.

54 Black Roots, 'Juvenile Delinquent', written by Black Roots, Kick Records, 1984.

55 Steel Pulse, *Kibudu – Mansatta – Abuku*, written by R. McQueen, Concrete Jungle label, 1976.

56 Jah is the word for God, the Creator, the Giver of life, the Redeemer, the Almighty. As a declaration of faith, or a greeting, or an utterance at the point of departure, the word Jah is often spoken or chanted as 'Jah Rastafari!'

57 The proverb had previously shown up in reggae records such as 'One Hand Washes the Other', Prince Buster, (written by Cecil Campbell, Blue Beat Melodisc Records, 1962) and 'Blazing Fire', by Derrick Morgan (written by Derrick Morgan, Island Records, 1963).

58 Matthew 7:24–27, King James Version.

> [24] Therefore whosoever heareth these sayings of mine, and doeth them, I will liken him unto a wise man, which built his house upon a rock:
>
> [25] And the rain descended, and the floods came, and the winds blew, and beat upon that house; and it fell not: for it was founded upon a rock.
>
> [26] And every one that heareth these sayings of mine, and doeth them not, shall be likened unto a foolish man, which built his house upon the sand:
>
> [27] And the rain descended, and the floods came, and the winds blew, and beat upon that house; and it fell: and great was the fall of it.

59 'Understanding', written by Barry Ford, from Merger, *Exiles in a Babylon*, Sun-star Muzik Co., 1977.

60 Christopher Partridge, 'Religion', *The Lyre of Orpheus: Popular Music, the Sacred, and the Profane*, (New York: Oxford University Press, 2014), p. 220.

61 Ennis B. Edmonds offered the following useful and enlightening comments on the significance of dreadlocks:

> As with other Rastafarian symbols, dreadlocks have multiple levels of significance. Aesthetically, dreadlocks indicate a rejection of Babylon's definition of beauty, especially as it relates to European features and hair quality. According to Rastas, hair straightening and skin bleaching by black people reflect a yearning for Whiteness and are therefore symptomatic of alienation from a sense of their African beauty. Against this background, dreadlocks signify the reconstitution of a sense of pride in one's African physical characteristics. As Ernest Cashmore explains, dreadlocks are 'used to marry blackness to positive attributes and so to upgrade the black man and align him with elite groups – and so render white stigmatic conceptions of blacks impotent.'
>
> Ideologically, dreadlocks express the Rastafarian belief in and commitment to naturalness. Since trimming, combing, and straightening one's hair change the natural looks, they are regarded as artificial and are proscribed by most Rastas. Dreadlocks thus bespeak Rastafari's uncompromising posture against the artificiality of Babylon. (Ennis B. Edmonds, 'I: Dread 'I' In-a-Babylon: Ideological Resistance and Cultural Revitalization', Nathaniel Samuel Murrell, William David Spencer, Adrian Anthony McFarlane (eds), *The Rastafari Reader: Chanting Down Babylon*, (Philadelphia: Temple University Press, 1998), p. 32.)

The above text goes on to state that '... the shaking of the locks is thought to unleash spiritual energy that will eventually bring about the destruction of Babylon.' Incidentally, the strangeness of Rastafari, alluded to in this chapter, was perhaps all the more strange as

the man widely regarded as the first Rasta, Leonard Howell, did not himself have dreadlocks, even though this distinctive way of maintaining one's hair has become, universally, a preeminent symbol of Rastafari. For a study of the origins of Rastafari, see Hélène Lee, *The First Rasta: Leonard Howell and the Rise of Rastafarianism*, (Chicago: Lawrence Hill Books, and imprint of Chicago Review Press, 2005).

62 The *Promised Land* of Rastafari was variously constructed as the continent of Africa, or more specifically, Ethiopia, the ancient country in which Haile Selassie had been born and had ruled. Further, many Rastas regarded Shashamane, lying about 150 miles to the south of the Ethiopian capital of Addis Ababa, as the land to which they wished to migrate. The emperor Haile Selassie was said to have donated some 500 acres of Shashamane to be occupied by those throughout the African Diaspora, in gratitude for the support he and his beleaguered country received during the time of the Italian invasion.

63 Aswad, 'Back to Africa', written by Courtney Hemmings, Island Records, 1976.

64 Cashmore 'Rasta Renaissance', *Rastaman*, p. 50.

65 Foner, 'The Jamaicans', *Between Two Cultures*, p. 145.

Chapter 4: Leggo de Pen

1 'Leggo de Pen' (which translated to *Let the Pen Loose*, or *Set the Pen Free*) is the title of a collection of poems by Frederick Williams, (London: Akira Press, 1985).

2 Christian Habekost, *Dub Poetry*, Michael Schwinn, 1986, pp. 19–20.

3 Mervyn Morris, 'Is English We Speaking', *English Today*, 36, Vol. 9, No. 4, (October 1993), p. 20.

4 Quoted in Morris, Ibid., p. 19.

5 Habekost, *Dub Poetry*, pp. 19–20.

6 See http://www.fsmitha.com/h2/ch14-africa2.htm (accessed 27 May 2015) for a description of this term:

> In Nigeria, Ghana, Gambia and Sierra Leone, Britain's colonial rule included efforts in education. Clerical skills were taught, and people with these skills found employment in local government, in the churches, in commerce and in industry. The two hundred or so graduating every year from secondary schools were doing their work with skill and responsibility. And there were those who went to Europe for training as doctors, veterinary surgeons, agricultural and forest officers and in other fields. They returned to work in their professions or in positions such as managers in retail stores, as schoolmasters, or as officials in tribal government. A new category of African was being created, called by Europeans the 'trousered niggers'.

Revisionist histories sometimes sought to clean up the vile expression by referring to this category of Africans as 'trousered blacks', though historians have by and large remained true to the original expression, which could be contextualised in other ways. For example:

> Their unique status as a Westernised elite-class, however, brought them face to face with the problem of the class and mass divide exploited by British colonial authorities who feared competition from the 'trousered niggers', the demeaning term they reserved for the European-educated Africans.' ('Casely Hayford, Joseph Ephraim', F. Abiola Irele and Biodun Jeyifo (eds), *The Oxford Encyclopedia of African Thought*, (NY: Oxford University Press, 2010), pp. 213–14.)

7 Douglas Fraser, 'Missionary Work', *Impressions: Nigeria 1925*, (London: Herbert Jenkins Ltd., 1926), pp. 84–5.

8 Ibid, p. 85.

9 Various attempts to counter the prevalent corrosiveness of terms such as *broken English* were proposed by Caribbean intellectuals and writers, who sometimes sought to advance terminology of their own, for the people's language. Chief amongst these counter terms was Creole, followed by assorted references to roots language.

10 Robbie Earle, 'Many Rivers to Cross', *One Love: The Story of Jamaica's Reggae Boyz and the 1998 World Cup*, (London: Andre Deutsch, 1998), p. 32.

11 James Berry, 'Introduction', *Bluefoot Traveller*, (London: Harrap, 1981), p. 8.

12 This was typified by a British television comedy series of the 1970s about a fresh and eager young English teacher, named Jeremy Brown, who takes a job teaching a group of immigrants whose English was, in varying degrees, limited. The comedy, *Mind Your Language*, was made by London Weekend Television (LWT) between 1977–81 and pandered to British caricatures and stereotypes of foreigners.

13 The pathology (discussed earlier in this chapter) that came into being, suggesting that the mass of Black people of the Caribbean, or of Africa, were communicating in speech patterns regarded as fragmented, incomplete and characterised or marked by supposedly faulty syntax and inappropriate diction, was widely applied by white society to African-American folk language. Within the USA there exists a sizeable history of scholarly attempts to deal with the ways in which everyday speech patterns by many African-Americans were frequently held to be sub par compared with *standard* American English. See for example books such as J. L. Dillard, *Black English*, (New York: Random House,Vintage, 1973) and, more recently, John Russell Rickford and Russell John Rickford, *Spoken Soul: The Story of Black English*, (New York: John Wiley and Sons, 2000), and H. Samy Alim and Geneva Smitherman, *Articulate While Black: Barack Obama, Language, and Race in the U.S.*, (New York: Oxford University Press, 2012). This last book focuses on complications around language in the age of Obama, not least the speech patterns of the president himself.

14 This was a foundational text about the complexities and credibility of patwa: 'A discussion of the range of Caribbean English as revealed in its literature: the slightly adapted text of a lecture given in London in 1992, organised by the British Library's "Centre for the Book" ' (Mervyn Morris, 'Is English We Speaking', *English Today*, 36, 9, No. 4, October 1993, 18–26).

15 James Berry, 'Introduction,' *Bluefoot Traveller*, London: Harrap, 1981, pp. 7–8.

16 Berry, 'Introduction' to *Bluefoot Traveller* [first edition], Limestone Publications, London, 1976, p. 10.

17 Mark Sebba, 'London Jamaican and Black London English', in David Sutcliffe and Ansel Wong (eds), *The Language of the Black Experience: Cultural Expression through Word and Sound in the Caribbean and Black Britain*, (Oxford: Basil Blackwell, 1986), pp. 155–56.

18 Ibid, p. 156.

19 Ibid, p. 157.

20 Ibid.

21 Frederic G. Cassidy, *Jamaica Talk: Three Hundred Years of the English Language in Jamaica*, (London: Macmillan & Co Ltd, 1961).

22 Habekost, *Dub Poetry*, p. 20.

23 Ibid, pp. 13–14.

24 Listen, for example to 'President Mash Up the Resident', by Shorty (written and produced by R. Edwards, Green Door/Trojan label, 1972), also known as Shorty the President, cited by Linton Kwesi Johnson as one of the DJ-turned-poet performers he greatly admired and to whom he attributed great cultural significance.

25 Habekost, *Dub Poetry*, p. 25.
26 Michael Smith, 'Long Time', *It a Come: Poems by Michael Smith*, (London: Race Today Publications, 1986), p. 34.
27 Habekost, *Dub Poetry*, p. 24.
28 This was the title of a compilation of dub poetry, *Word, Sound 'Ave Power: Reggae Poetry*, Heartbeat Records label, 1983.
29 Habekost, *Dub Poetry*, p. 14.
30 Bradley, 'The Whole World Loves a Lover, p. 227.
31 Ibid, p. 218. It wasn't long before Jamaica, as far as many younger Britons in the African Diaspora were concerned, became synonymous with sufferation, a synonymity that was expressed *ad infinitum*, in songs such as 'Tings Change' by Warrior Queen & Heatwave, on *An England Story: The Culture of the MC in the UK 1983–2008*, Soul Jazz Records, 2008: 'Down in Jamaica whe me born and grow, pure sufferation is all I know...'
32 Habekost, *Dub Poetry*, p. 14.
33 Sherry Turner, 'An Overview of the New Black Arts', *Freedomways Journal*, 9, No. 2, New York, Spring 1969, p. 156.
34 Habekost, *Dub Poetry*, p. 18.
35 Except in the case of poets such as Pam Ayres, though records such as *Some of Me Poems and Songs* and *Some More of Me Poems and Songs* presented themselves as novelty records, more than anything else.
36 Habekost, *Dub Poetry*, p. 22.
37 Ibid. As noted in Chapter 7 (in relation to the Blk. Art Group), this strategy of radically altering words, and their consequent meanings and inflections, was enacted by Black people in different parts of the world. See for example, Sun Ra's Arkestra, or Horace Tapscott's record, 'The Call' (Interplay Music, 1978) conducted by the Pan-Afrikan Peoples Arkestra.
38 'Discrimination', written and recorded by Ras Karbi, Ital Sounds Records, nd.
39 See for example L. Mike Henry and Devis S. Harris, *LMH Official Dictionary of Jamaican Words and Proverbs*, (Kingston: LMH Publishing, 2002).
40 Habekost, *Dub Poetry*, p. 18.
41 British reggae also contained such references. Aswad's 'Tuff We Tuff', a track on their *New Chapter* album (CBS Records, 1981) contained the lyrics, 'Standing here and waiting in the labour queue...' 'Labour queue' was a shorthand reference to waiting in line at the 'Ministry of Labour, Employment Exchange', the mid-twentieth-century government town centre offices charged with administering unemployment relief and disseminating opportunities for employment, which had originally been the vision of politicians such as Winston Churchill and William Beveridge.
42 Gordon Burn, 'The Talking Brixton Blues', *Sunday Times Magazine*, 3 August 1980, p. 54.
43 Ibid.
44 Such works included Joyce Eggington, *They Seek a Living*, (London: Hutchinson, 1957); Sheila Patterson, *Dark Strangers: A Study of West Indians in London*, (London: Tavistock Publications, 1963); Nancy Foner, *Jamaica Farewell: Jamaican Migrants to London*, (London and Henley: Routledge & Kegan Paul, 1979); David Sutcliffe, *British Black English*, (Oxford: Basil Blackwell, 1982); Roy Kerridge, *Real Wicked, Guy: A View of Black Britain*, (Oxford: Basil Blackwell, 1983).
45 Burn, 'The Talking Brixton Blues', *Sunday Times Magazine*, p. 54.
46 See George Breitman (ed), *By Any Means Necessary*, (New York: Pathfinder Press, 1970), which includes previously unpublished writings and speeches prepared by Malcolm X during the last year of his life.
47 Linton Kwesi Johnson, 'Jamaican Rebel Music', *Race and Class*, Vol. XVII, No. 4, 1976, p. 409.
48 Ibid., 'Reggae Sounds', from the album *Bass Culture*, Island Records, 1980.

49 Steel Pulse, 'Handsworth Revolution', from the album of the same name, Island Records, 1978.

50 Black Roots, 'Juvenile Delinquent', written by Black Roots, Kick Records, 1984.

51 Aswad, 'Not Satisfied' from the album of the same name, CBS Records, 1982. The song went on to suggest a certain futility of the strategy: 'Every day them a-hustle, still half of the time, can't even make two ends meet...'

52 Burn, 'The Talking Brixton Blues', *Sunday Times Magazine*, p. 54.

53 'Want Fi Goh Rave' was the opening poem on Linton Kwesi Johnson's album *Forces of Victory*, Island Records, 1979. In the poem, speaking in the first person, Johnson encounters a range of young men who casually bemoan their constrained and straitened circumstances, even as they declare an intention to move on with their lives, and seize moments of enjoyment. One of the 'yout-man' Johnson encounters chronicles his criminal activities:

> I woz waakin doun di road
> Yet annadah day
> Wen ah hear annadah yout-man say
> Him she
> Mi haffi pick a packit
> Tek a wallit fram a jackit
> Mi haffi dhu it real crabit
> An if a lackit mi haffi pap it
> An if a safe mi haffi crack it
> Ar chap it wid mi hatchit

54 In its most unvarnished form, this pathology was reflected in texts such as Hilde Marchant's 'Thirty-Thousand Colour Problems' *Picture Post, Hulton's National Weekly*, 9 June 1956, 28–9, 38.

55 Eggington, *They Seek a Living*, flyleaf.

56 Jean Binta Breeze was to take up residence in Britain.

57 Michael Smith (14 September 1954–17 August 1983), was one of the most brilliant and original of the dub poets. A strong believer in the power and legitimacy of patwa, his posthumously published book of poems, *It a Come*, (London: Race Today, 1986) and his recorded album of poetry *Mi Cyaan Believe It* (Island Records, 1982) stand as towering monuments to an electrifying poet murdered by supporters of the right-leaning Jamaican Labour Party in August 1983. Smith was on the threshold of a brilliant career, and joined a sizeable list of musicians, singers and performers cut down in their prime in Jamaica.

58 As well as being a poet, Shakka Dedi was a graphic designer, artist and cultural activist. In the early 1980s, with several other like-minded individuals, he established a group known as OBAALA – the Organisation for Black Arts Advancement and Leisure/Learning Activities. It was this body that, in 1983, established The Black-Art Gallery in Finsbury Park, North London. For more on this, see 'The Rise and Fall of The Black-Art Gallery', in Eddie Chambers, *Black Artists in British Art: A History Since the 1950s*, (London and New York: I.B.Tauris & Co., 2014). For Dedi's poetry, see Shakka Gyata Dedi, *Afrikan Hartbeet: Songs of Unity, Love and Struggle*, (London: Nubia Publications, 1982).

59 Formerly known as Sebastian Clarke, he wrote an important book, *Jah Music: The Evolution of the Popular Jamaican Song*, (London: Heinemann Educational Books, 1980).

60 Johnson, 'Jamaican Rebel Music', *Race and Class*, p. 398.

61 Ibid.

62 Ibid. Italics in the original text.

63 Bradley, 'The Whole World Loves a Lover', *Sounds Like London*, p. 218.

64 Ibid, p. 242 In his film released in 2011, *The Story of Lover's Rock* (sic), director Menelik Shabazz argued that this was a genre of music that enabled young Black Britons to pursue and achieve a type of intimacy that insulated and sustained them, enabling a type of hitherto unacknowledged political and social resilience. Further, that this was a type of music through which young women's personal experiences could be articulated, and their voices heard.

65 Ibid.

66 Ibid.

67 Ibid, p. 219.

68 Ibid.

69 Ibid.

70 Ibid, p. 246.

71 'POET', November 1977.

72 Ibid.

73 Ibid.

74 Ibid.

75 Ibid.

76 Johnson, 'Jamaican Rebel Music', *Race and Class*, p. 400.

77 The press release slightly mangled itself by making mention of 'the police's anti-sus campaign against black youth'. In actuality, it was the police who employed sus as a stop and search tactic against Black people, and it had been Black organisations that had led the anti-sus campaign.

78 'POET', November 1977.

79 Johnson, 'Jamaican Rebel Music', *Race and Class*, p. 403.

80 Ian Dieffenthaller, 'News for Babylon and the Role of the Anthology in the Nineteen Seventies and Eighties', *Snow on Sugarcane: The Evolution of West Indian Poetry in Britain*, (Newcastle upon Tyne: Cambridge Scholars Publishing, 2009), p. 143. As mentioned in the Introduction to this book, the Caribbean Artists Movement was founded in the mid 1960s by Caribbean-born, London-based artists and writers, in particular, 'Barbadian poet, Edward Kamau Brathwaite, the Jamaican novelist Andrew Salkey and John La Rose, the Trinidadian activist and poet.' As referenced by John Lyons (see his essay 'Denzil Forrester's Art in Context', in *Denzil Forrester: Dub Transition, A Decade of Paintings 1980–1990* (the exhibition first shown at Harris Museum & Art Gallery, Preston, 22 September–3 November 1990, exhibition catalogue p. 17), the CAM was 'a coterie which, in the fostering of mutual respect and support, created confidence by maintaining cultural identity in a Eurocentric milieu fraught with numerous dangers of misappropriation. It also attempted to establish for Caribbean peoples in Britain a point of cultural reference.'

81 Ibid, p. 144. Dieffenthaller reiterated the understanding that 'The UK 'Bluefoot' traveller is akin to the poor, rural Jamaican 'Bluefoot man,' an outsider, a barefooted peripatetic who wanders from village to village over long hot roads, with blistered feet that remain blue however long he remains at his latest stop.'

82 Alison Donnell and Sarah Lawson Welsh (eds), *The Routledge Reader in Caribbean Literature*, (London and New York: Routledge, 1996), p. 363.

83 David Sutcliffe, 'Language, Culture and Identity', *British Black English*, (Oxford: Basil Blackwell, 1982), p. 62. Italics in original text.

84 Berry, 'Introduction', *Bluefoot Traveller*, p. 6.

85 James Proctor, 'Literature 2: Fiction and poetry, 3. The Caribbean Artists' Movement', *Oxford Companion to Black-British History*, David Dabydeen, John Gilmore and Cecily Jones (eds), (Oxford: Oxford University Press, 2010), p. 264.

86 Burn, 'The Talking Brixton Blues', *Sunday Times Magazine*, p. 54.
87 The work took as its inspiration a line from Burning Spear's 'Black Soul' (from the album *Man in the Hills*, Island Records, 1976), 'who nuh black nah guh black agen', meaning that either through the raising of consciousness or a fortuitous accident of birth, 'if you're not Black now, you never will be.'
88 See note 44.
89 Frederick Williams, 'A Pressure Reach Dem', *Leggo De Pen*, (London: Akira Press, 1985), p. 14.

Chapter 5 Africa: The Call of the Continent

1 Blyden (1832–1912) was an astonishing figure, even in an era that threw up many singular characters who had pledged their lives to the ending of Black suffering. Blyden was a Caribbean-born educator, writer, diplomat, and politician who came to be primarily associated with the West African countries of Sierra Leone and Liberia – countries very much linked with fascinating programmes of repatriation and the free settlement of Black people, from the United States and elsewhere. Like the better-known personality Marcus Garvey Blyden regarded aspects of the nascent philosophy of Zionism as directly relevant to Black people. It's not difficult to see or imagine the ways in which Blyden's *Ethiopianism* could be linked to the prophetic figure of Garvey, who in turn is linked to the rise of Rastafari and the belief that African-Americans, African Caribbeans and others throughout the diaspora could return to Africa and in so doing redeem both themselves and the continent itself. Blyden's enduring biography is Hollis R. Lynch, *Edward Wilmot Blyden: Pan-Negro Patriot 1832–1912*, (London: Oxford University Press, 1967). See also Benyamin Neuberger, 'Early African Nationalism, Judaism and Zionism: Edward Wilmot Blyden', *Jewish Social Studies* Vol. 47, No. 2 (Spring, 1985), pp. 151–66.
2 Alex Haley, *Roots*, (New York: Doubleday, 1976).
3 Helen Taylor, 'Everybody's Search for Roots: Alex Haley and the Black and White Atlantic', *Circling Dixie: Contemporary Southern Culture Through a Transatlantic Lens*, (New Brunswick, NJ: Rutgers University Press, 2001), p. 63.
4 Ibid, pp. 63–4.
5 Ibid, p.64.
6 Isaac Julien (Director), *Black and White in Colour* (Part Two: 1969–92), a British Film Institute TV Production for BBC Television, BBC 1992.
7 Taylor, 'Everybody's Search for Roots', *Circling Dixie*, p. 67.
8 Julien, *Black and White in Colour*, BBC.
9 'Roots', written by Bob Marley, performed by Bob Marley and the Wailers, Island Records, 1977. By way of sharp contrast, the iconoclastic Jamaican poet Michael Smith, in his highly theatrical poem *Roots*, offered an expression of dissatisfaction and cynicism that cautioned against expectations of uncovering familial roots, with Alex Haley's happy ending.

> Some a seh
> which roots
> when de only roots dem can trace
> start wid dem modder
> an end wid dem granmodder

('Roots', *It a Come: Poems by Michael Smith*, (London: Race Today Publications, 1986), p. 53.)
10 Elizabeth M Williams, *The Politics of Race in Britain and South Africa: Black-British solidarity and the Anti-Apartheid Struggle*, (London: I.B.Tauris, 2012), p. 195.
11 'Jah Pickney R.A.R.', written by David Hinds, from the album *Tribute to the Martyrs*, Steel Pulse, Island Records, 1978.

12 'Ku Klux Klan', written by David Hinds, from the album *Handsworth Revolution*, Steel Pulse, Island Records, 197.

13 John Plummer, *Movement of Jah People: The Growth of the Rastafarians*, (Birmingham, UK: Press Gang, 1978), p. 40.

14 The Sharpeville Massacre took place on 21 March 1960, at the police station in the South African township of Sharpeville. The South African police opened fire, with extreme prejudice, on peaceful and unarmed demonstrators protesting against the Pass laws, which severely curtailed one of the most basic of human rights – freedom of movement. Some sixty-nine of these demonstrators were killed, making the day one of the single most violent episodes in the implementation of apartheid and the activities of those Black South Africans who sought to oppose it.

15 Steve Biko, *I Write What I Like*, (London: Bowerdean Press, 1978).

16 Steve Biko, 'I Write What I Like: Black Souls in White Skins', *I Write What I Like*, pp. 19–20.

17 David Harrison, 'You Can Carry on Interrogating My Dead Body' (p. 226) and 'It's Known as the Persian Solution' (p. 227), *The White Tribe of Africa: South Africa in Perspective*, British Broadcasting Corporation, 1981.

18 The Deptford fire occurred early in 1981 and was a tragedy in which thirteen young Black people lost their lives under highly suspicious circumstances. For a discussion of the tragedy, see *The New Cross Massacre Story: Interviews with John La Rose*, published by the Alliance of the Black Parents Movement, Black Youth Movement and the Race Today Collective, 1984; 'The Deptford Fire, Accident or Arson?' *Unsolved* 42 (1984), pp. 829–48. Aspects of the significance of the tragedy are discussed in Chapter 6 of this book.

19 Tapper Zukie, 'Tribute to Steve Biko', from the album *Peace in the Ghetto*, Virgin Front Line Records, 1978.

20 Ibid. Rather than having been assassinated or retributively hanged by the British colonial authorities in Jamaica, which were the fates of Reverend Dr. Martin Luther King and Paul Bogle respectively, Marcus Garvey's cause of death was a stroke, at the relatively young age of 53.

21 See for example the album sleeve for I-Roy's *Crisus Time* of 1976. The front of the sleeve features a celebrated image of what Magubane himself described as 'students running boldly through the streets near the Vocational Training College in White City Jabavu, a part of deep Soweto.' (*Magubane's South Africa*, (New York: Alfred A. Knopf, 1978), p. 103). The rear of *Crisus Time* featured another of Magubane's dramatic photographs, taken in Alexander township. Neither the photographer nor the images were credited on the sleeve itself.

22 'Biko's Kindred Lament', written by David Hinds, performed by Steel Pulse, from the album, *Tribute to the Martyrs*, Island Records 1979.

23 The *First World Black and African Festival of Arts and Culture* was held in Dakar, Senegal in 1966. At that time, reflecting the acceptable terminology of the era, it was known simply as the World Festival of Negro Arts. For a study of *Festac '77*, see Andrew Apter, *The Pan-African Nation: Oil and the Spectacle of Culture in Nigeria*, (University of Chicago Press, 2005).

24 An indication of the Nigerian government's largesse could be gleaned from passages on Festac'77 in a feature in *Ebony* magazine, May 1977. Wrote Alex Poinsett,

> Indeed, the oil-rich Nigerian government had deemed Festac's staging so important that it had long decided it could not spend too much money to bring the world's blacks together. Accordingly, the government built expensive new expressways to relieve ever-present traffic jams in Lagos, the capital, and supplied Festac guests with 500 buses and autos equipped with free gasoline and drivers. The government also spent $60 million for a magnificent new National Theater to showcase many

of Festac's cultural events. And another $80 million underwrote Festac Village, a sprawling housing complex six miles outside of Lagos where guests – housed and fed at government expense – staged impromptu, mini-festivals nightly near their barrack-like quarters. ['Festac '77: Second World Black and African Festival of Arts and Culture draws 17,000 participants in Lagos', *Ebony*, XXXII No. 7, May 1977, pp. 38–40.]

25 Festac'77 took place towards what was to be the end of the first protracted phase of military intervention into the running of the state, an intervention that began in early 1966, when a group of majors, headed by Major Chukwuma Nzeogwu, overthrew the then Prime Minister Alhaji Sir Abubakar Tafawa Balewa in a coup d'état. Thus began a violent merry-go-round of overthrows and murders, in which one military clique after another took power. This macabre merry-go-round saw Major General Johnson Aguiyi-Ironsi made the Head of the Federal Military Government of Nigeria, only to be overthrown and murdered in a coup a few months later, and succeeded by General Yakubu Gowon, who held power for nearly a decade, until 1975, when he was overthrown in another coup. Brigadier (later General) Murtala Mohammed succeeded General Gowon, only to be assassinated in a violent coup a year later, in 1976. Mohammed was then succeeded by Lt-General Olusẹgun Ọbasanjọ, under whose government *Festac '77* was held. Military government was to continue until the 1979 handover by Obasango to a civilian government, though Nigeria had by no means seen the last of the military in government.

26 FESTAC '77 Souvenir Book of the *Second World Black and African Festival of Arts and Culture*, Lagos Nigeria. Published by Africa Journal Ltd. and the International Festival Committee, London, 1977, p. 6.

27 Ibid, p. 7.

28 Ife Enohoro, 'The Second World Black and African Festival of Arts and Culture: Lagos, Nigeria', *The Black Scholar: Journal of Black Studies and Research*, 9, No. 1, September 1977, p. 28. Négritude was an important literary and ideological philosophy, decidedly Francophone in its construction and orientation. It was developed during the 1930s by French-speaking intellectuals, poets, writers, and politicians from Francophone Africa and its diaspora. In much the same way that London existed as a locus, a meeting point for African and Caribbean intellectuals, activists, artists, and students during the early decades of the twentieth century, so too did Paris, which also existed as a destination of choice for many African-Americans who sought to come to Europe. Négritude emerged out of the fascinating spaces of intellectual and artistic exchange created when brilliant minds from across the world met and shared ideas. Its initiators included Martinican poet Aimé Césaire, Léopold Sédar Senghor (as mentioned, the President of Senegal under whose auspices the *First World Festival of Black Arts* was convened), and Léon Damas of French Guiana. Enohoro's text included a footnote describing Négritude as:

> the whole complex of civilized values – cultural, economic, social and political – which characterises the black peoples, or more precisely, the Negro African world. Walter A. C. Skurnik, *The Foreign Policy of Senegal*, (Northwestern University Press, 1972), p. 201.

29 FESTAC '77 Souvenir Book, p. 136.

30 Caution should perhaps be exercised about this number. McMillan also claimed that some 2,000 delegates attended from the USA, though the perhaps more reliable figure of 444 persons from the USA was reported in a feature on *Festac'77* carried in *Ebony* magazine, May, 1977. Those Black-British people who attended included Len Garrison,

256

the sociologist who wrote *Black Youth, Rastafarianism and the Identity Crisis in Britain*, (London: An Acer Project Publication, 1979), Armet Francis, and a number of other individuals active within Black arts/visual arts communities in London.

31 Poinsett, 'festac '77' *Ebony*, p. 46.

32 Enohoro, 'The Second World Black and African Festival of Arts and Culture: Lagos, Nigeria', *The Black Scholar*, p. 29.

33 Poinsett, 'festac '77', *Ebony*, p. 33.

34 Discussed in Chapter 7.

35 Yinka Odunlami, 'Introduction', Catalogue for *Festac '77: The Work of the Artists from the United Kingdom and Ireland*. (UKAFT, London, 1977), p. 5.

36 See https://www.mixcloud.com/chimurenga/michael-mcmillan-festac/, accessed 5 March 2016.

37 Arthur Monroe, 'Festac 77 – The Second World Black and African Festival of Arts and Culture: Lagos, Nigeria', *The Black Scholar: Journal of Black Studies and Research*, Vol. 9, No. 1, September 1977, p. 34.

38 Ibid, p. 36.

39 Keith Piper 'Step into the Arena: Black Art & Questions of Gender', in exhibition catalogue for *Step Into the Arena: Notes on Black Masculinity & The Contest of Territory*, Rochdale Art Gallery, 3 May–1 June 1991, p. 1.

Chapter 6: Fyah!

1 Linton Kwesi Johnson, 'Bass Culture', from the album *Bass Culture*, Island Records 1980.

2 Gordon Burn, 'The Talking Brixton Blues', the *Sunday Times Magazine*, 3 August 1980, p. 54.

3 Ibid.

4 Ibid.

5 Terminology such as *riot* and *rioting* is of considerable importance. One struggles, more often than not, to identify an alternative word that is free from the media's notion of a riot. Mainstream press coverage of riots inevitably casts them as mindless anarchic sprees of criminality in which the mob, consisting by and large of incorrigibly feral youth, goes on the rampage. This seemingly indelible association with mindless violence ensures that the word *riot* is in essence, hugely problematic. Even dictionary definitions of *riot* can be found wanting. A supposedly innocuous definition, such as 'a violent disturbance of the peace by a crowd' is ultimately politically loaded, as it presupposes the existence of a credible, just 'peace'. For Black people in many parts of the world, no such 'peace' exists; hence, while the dominant slogan of people involved in riots in the USA in the 1960s was 'Burn, Baby, Burn', the riots of the early 1990s that took place in the wake of the acquittal of the police officers charged in the Rodney King beating threw up the much more politically nuanced slogan, 'No Justice No Peace'. Yet one runs into great difficulties when reaching for alternative, widely understood adjectives and nouns to replace rioting and riot. The thesaurus is flummoxed, weakly suggesting alternatives such as *uproar, rampage, furore, tumult, commotion, upheaval, disturbance*, etc. But in and of themselves, none of these will suffice. As Martin Kettle and Lucy Hodges (two researchers into the riots of the early 1980s) asserted,

> [t]he use of the word riot is therefore a problem. But none of the other words that have been used cause any less difficulty. Hooliganism, public disorder, protest, rebellion, uprising – all present their own problems. In the circumstances, 'riot' will have to do.' (Martin Kettle and

Lucy Hodges, *UPRISING!: The Police, the People and the Riots in Britain's Cities*, (London: Pan Books, 1982), p. 10.)

It is in this spirit of nomenclatural defeat that this chapter, indeed, this book, uses the words riot and rioting.

6 Ken Pryce, *Endless Pressure*, (Harmondsworth: Penguin Books, 1979).

7 Kettle and Hodges *UPRISING!*, p. 23.

8 Peter Fryer, *Staying Power: The History of Black People in Britain*, (London: Pluto Press, 1984), p. 398.

9 Ibid.

10 'The Riots', *Race & Class*, 23, Nos. 2–3, 1981, 223 (full text pp. 223–32).

11 Evan Smith, 'Once as History, Twice as Farce? The Spectre of the Summer of '81 in Discourses on the August 2011 Riots', synopsis, *Journal for Cultural Research*, DOI: 1080/14797585.2012.756243. See http://www.academia.edu/2464695/Once_as_History_Twice_as_Farce_The_Spectre_of_the_Summer_of_81_in_Discourses_on_the_August_2011_Riots, accessed 10 September 2015.

12 Lord Scarman, the *Scarman Report: The Brixton Disorders, 10–12 April 1981*, (London: Penguin Books, 1982), p. 196.

13 The year 1976 saw major violent street confrontations between Black youth and the police during the course of the annual Notting Hill Carnival. As mentioned in Chapter 2, the *Observer Review* of 5 September 1976 attempted to explore and articulate the frustrations of those it termed 'Young Bitter and Black', in a substantial feature which sought to 'look behind the Notting Hill violence at the deeper causes of the hostility between the police and the West Indian community'.

14 Keith Piper 'Step into the Arena: Black Art & Questions of Gender', in exhibition catalogue for *Step into the Arena: Notes on Black Masculinity & The Contest of Territory*, Rochdale Art Gallery, 3 May–1 June 1991, p. 1.

15 The pathology whereby the riot becomes raced is perhaps most explicit in the American terminology, *race riot*. When a percentage of those caught up in urban unrest in American cities are perceived to be Black, the mainstream media tend to label such disturbances as *race riots*. There is, though, no equivalent or corresponding term for when whites riot, such behaviour is sometimes simply ignored by the mainstream media, or labelled as exuberance, or individual (as in, non-collective) acts of vandalism. As noted in Harris, Wallace and Booth's *To Ride the Storm: The 1980 Bristol 'Riot' and the State* (1983), 'The inter-communal racial violence of the pre-war era did not have any more right to the descriptive category 'race riot', than the police/black community violence of the 1970's and more recently.' (London: Heinemann Educational Books, p. 186.)

16 For an anatomy of the opportunistic, calculating and often farcical nature of the charging, conviction and/or acquittal of those arrested in relation to the riots in St Paul's, Bristol in 1980, see for example 'Charged with Riot', Chapter 5 of *To Ride the Storm*.

17 Barry Troyna asserts that, 'The characterization of the Brixton and July 1981 episodes as "riots" ensured that the thrust of political debate and policy prescriptions would be firmly within a 'law and order' framework.' (Barry Troyna, 'Riots: UK, 1981', *Dictionary of Race and Ethnic Relations*, Second Edition, E. Ellis Cashmore (ed), (London: Routledge, 1988), p. 264.)

18 Ibid., p. 262.

19 Fryer, *Staying Power*, p. 399.

20 Ibid.

21 Ibid.

22 Troyna, 'Riots: UK, 1981', *Dictionary of Race and Ethnic Relations*, p. 263.

23 Ellis Cashmore and Barry Troyna, 'Babylon's Burnin'', Ethnicity-Youth-Resistance, *Introduction to Race Relations*, (Basingstoke: Falmer Press, 1990), pp. 157.

24 A. Sivanandan, 'From Resistance to Rebellion', *A Different Hunger: Writings on Black Resistance*, (London: Pluto Press, 1982), pp. 37–8.

25 Ibid, p. 38.

26 Linton Kwesi Johnson, 'All Wi Doin Is Defendin'' from *Dread Beat an' Blood*, the first album of poetry released by this British Jamaican-born poet, then styling himself 'Poet and the Roots' (Front Line Records/Virgin Records, released in 1978).

27 Though others have laid claim to it, the phrase is said to have originated with H. 'Rap' Brown, Student Nonviolent Coordinating Committee (SNCC) national director, who coined the phrase when race riots erupted in the mid 1960s. See Bruce J. Dierenfield, *The Civil Rights Movement*, (New York: Pearson Longman, 2004), p. 166.

28 Peter Fryer, 'The New Generation', *Staying Power: The History of Black People in Britain*, (London: Pluto Press, 1984), p. 398. The following people lost their lives: Humphrey Brown (4 Jul. 1962–18 Jan. 1981); Peter Campbell (23 Feb. 1962–18 Jan. 1981); Steve Collins (2 May. 1963–18 Jan. 1981); Patrick Cummings (24 Sep. 1964–18 Jan. 1981); Gerry Paul Francis (21 Aug. 1963–18 Jan. 1981); Andrew Gooding (18 Feb. 1966–18 Jan. 1981); Lloyd Hall (29 Nov. 1960–19 Jan. 1981); Lillian Rosalind Henry (23 Aug. 1964–18 Jan. 1981); Patricia Johnson (16 May. 1965–18 Jan. 1981); Glen Powell (19 Jan. 1965–25 Jan. 1981); Paul Ruddock (19 Nov. 1958–9 Feb. 1981); Yvonne Ruddock (17 Jan. 1965–24 Jan. 1981); Owen Wesley Thompson (11 Sep. 1964–18 Jan. 1981).

29 Stephen Cook, 'The Deptford Fire, Accident or Arson?' *Unsolved* 42 (1984), 829.

30 See Stephen Cook, 'The families in mourning began to feel that no one cared for their distress', 'The Deptford Fire, Accident or Arson?' *Unsolved* 42 (1984), pp. 832–33.

31 For a discussion of the tragedy, see *The New Cross Massacre Story: Interviews with John La Rose*, published by the Alliance of the Black Parents Movement, Black Youth Movement and the Race Today Collective, 1984 and Cook, 'The Deptford Fire, Accident or Arson?' *Unsolved* 42 (1984), pp. 829–48.

32 Cook, 'The Deptford Fire, Accident or Arson?' *Unsolved*, pp. 832–33.

33 Fryer, 'The New Generation', *Staying Power*, p. 398.

34 The only other occasions during which Black people conspicuously gathered in large numbers were the annual Notting Hill Carnival, though this was both a presence dissipated by visitors to the event from the wider community, and one accompanied by seemingly ever-greater numbers of police. Large numbers of police were of course present on the Black People's Day of Action, leading to skirmishes and accusations that the police sought to disrupt the demonstration.

35 Cook, 'The Deptford Fire, Accident or Arson?' *Unsolved*, p. 837.

36 In a brief sub-section, *The Rastafarians*, itself in a section on *The Nature of the Disorders*, Lord Scarman concluded,

> It is convenient to consider at this point whether the Rastafarians played any part in organizing or leading the riots. There was no suggestion in argument, nor any indication in evidence, that the Rastafarians, as a group or by their doctrines, were responsible for the outbreak of disorder or the ensuing riots. (*Scarman Report*: p. 76.)

37 Cashmore and Troyna, 'Babylon's Burnin'', *Introduction to Race Relations*, pp. 157–58.

38 Ibid, p. 159.

39 'Burnin' and Lootin'' written by Bob Marley and performed by the Wailers on the album *Burnin*, Island Records Ltd, 1973.

40 '77' written by Michael Dan, Barry Ford and Winston Bennett and performed by Merger on the album *Exiles in a Babylon*, Sun Star Muzik Co., 1977.

41 According to a vicar who gave evidence to the Scarman Inquiry, he witnessed the attack on, and destruction of The George public house and the trashing of a nearby newsagent. On witnessing this destruction, the vicar apparently protested but was rebutted with the sentiments 'the police had been harassing the black and homosexual communities and that they could stand it no longer'. (Lord Scarman, *Scarman Report*, p. 75.)

42 Compelling evidence of this exists in the form of *An England Story: The Culture of the MC in the UK 1984–2008*, Soul Jazz Records, 2008.

43 From Steel Pulse's 'Bun Dem', to 'Burn Babylon' by Sylford Walker; from 'Fire Fe the Vatican' by Max Romeo, to 'Blood and Fire' by Niney, such tracks were extraordinarily evocative.

44 Donald Rodney in conversation with Lubaina Himid, *State of the Art*, Illuminations Films, Channel 4, 1986.

45 One of the most celebrated songs on the album was 'Slave Driver', with its haunting music and pressing lyrics that located the plight of the Jamaican sufferer in the legacy of slavery: 'Slave Driver, your table is turned. Catch a fire, you're gonna get burned.'

46 Mutabaruka, 'Bun Dung Babylon', *The Mystery Unfolds*, Sanachie label, 1986.

47 The Preface to this book posited the view that ultimately, when appraising the evolution of a distinct Black-British cultural identity, it may not be possible to entirely separate that which is *social* and *political* from that which is *cultural*. This is particularly so when certain cultural practices in which a number of Black-British youngsters were engaged had direct and sometimes severe judgmental consequences. The smoking of marijuana was one such instance.

Chapter 7: Picture on the Wall

1 Mel Gooding, 'Dying Swans and a Spiral Staircase: Images of Crisis', *Frank Bowling*, Royal Academy of Art, 2011, p. 41.

2 See http://www.telegraph.co.uk/culture/art/artsales/9923044/Victory-for-a-gifted-artist-of-colour-79.html, accessed 11 June 2015.

3 Ibid.

4 James Berry, 'Introduction', *Bluefoot Traveller*, (London: Harrap, 1981), p. 6.

5 Rasheed Araeen, 'Chronology', *The Essential Black Art* exhibition catalogue. Published by Chisenhale Gallery, London in conjunction with Black Umbrella, London, 1988, p. 20.

6 Irene McManus, 'Black Art an' Done', *Guardian*, 17 June 1981, p. 10.

7 The racist cry is widely quoted in a wide range of books; see for example Susan Kingsley Kent, 'The Twentieth Century', *Gender and Power in Britain, 1640–1990*, (London and New York: Routledge, 1999), p. 352 and A. Sivanandan, 'From Resistance to Rebellion', *A Different Hunger: Writings on Black Resistance*, (London: Pluto Press, 1982), p. 16.

8 Chris Abbott, '*Rivers of Blood*, Enoch Powell (1968)', *21 Speeches That Shaped Our World*, Part 1: All the World is Human, (London: Rider, 2012), p. 43.

9 Ibid, p. 43.

10 Ibid, p. 47.

11 Ibid, pp. 49–50.

12 Ibid, p. 49.

13 Rasheed Araeen, 'The Success and the Failure of Black Art', *Third Text*, 18:2, 2004, p. 135.

14 Keith Piper, 'Black Art/Black Church', catalogue essay for *A Ship Called Jesus*. Exhibition catalogue produced to accompany the exhibition at Ikon Gallery, Birmingham 17 January–23 February 1991, unpaginated.

15 Ibid.

16 Press release for *Black Art an' done*, Wolverhampton Art Gallery, 9–27 June 1981.

17 Rasheed Araeen, 'Confronting the System', *The Other Story*, (Hayward Gallery, South Bank Centre, London, 1989), p. 76.

18 Ibid, pp. 75–6.

19 The exhibition featured work by the following artists: Rasheed Araeen, Saleem Arif, Frank Bowling, Sonia Boyce, Eddie Chambers, Avinash Chandra, Avtarjeet Dhanjal, Uzo Egonu, Iqbal Geoffrey, Mona Hatoum, Lubaina Himid, Gavin Jantjes, Balraj Khanna, Donald Locke, David Medalla, Ronald Moody, Ahmed Parvez, Ivan Peries, Keith Piper, A. J. Shemza, Kumiko Shimizu, F. N. Souza, Aubrey Williams and Li Yuan Chia.

20 Araeen, 'Confronting the System', *The Other Story*, p. 72.

21 Ibid.

22 Ibid.

23 Samella S. Lewis and Ruth G. Waddy, *Black Artists on Art*, Vol. 2, Contemporary Crafts, Inc. Los Angeles, California, 1971. p. vii.

24 Shakka Dedi, 'Black Art in Britain Today', *Arts Review*, 9 November 1984, p. 557.

25 Ron Karenga, 'Black Art: Mute Matter Given Force and Function', *Black Poets and Prophets*, Woodie King and Earl Anthony (eds), (New York: Mentor/New American Library, 1972), p. 175.

26 Una Howe, 'Errol Lloyd: An Exhibition of Errol Lloyd's Paintings Held at the Jamaican High Commission from 19 May to 9 June [1978]', *Race Today*, July/August 1978, p. 119.

27 Bradley, 'The Whole World Loves a Lover', *Sounds Like London*, p. 218. It wasn't long before Jamaica, as far as many younger Britons in the African Diaspora were concerned, became synonymous with sufferation, a synonymousness or synonymity that was expressed *ad infinitum* in songs such as 'Tings Change' by Warrior Queen & Heatwave, on *An England Story: The Culture of the MC in the UK 1983–2008*, (Soul Jazz Records, 2008): 'Down in Jamaica whe me born and grow, pure sufferation is all I know...'

28 Twinkle Brothers, 'Dread in the Ghetto', from the album *Praise Jah*, Virgin Frontline, 1979.

29 Burning Spear, 'Marcus Children Suffer', from the album *Marcus' Children*, Burning Music label, Jamaica, 1978.

30 Linton Kwesi Johnson, 'Jamaican Rebel Music', *Race and Class*, XVII, 4, 1976, p. 402.

31 Piper used the British spelling of Defence, rather than Defense, used in the original spelling of the *Black Panther Party for Self-Defense*.

32 Karenga, 'Black Art', *Black Poets and Prophets*, p. 175.

33 *Adventures Close to Home: An Exhibition by Piper & Rodney*, Pentonville Gallery, London, 6 August–5 September 1987.

34 Donald Rodney in conversation with Lubaina Himid, 'State of the Art', Channel 4/ Illuminations (Television) Ltd. Television programme, 1987.

35 These artists deliberately chose to spell Afrika with a K, a strategy increasingly employed by Black cultural nationalists in Britain, having been copied from the Black Power advocates in the United States where it had been introduced years earlier. Chester Morrison offered a particularly useful summary of the thinking behind this strategy. In an article titled 'Why It is Important to Spell Afrika with a K', he listed five points, the final one being:

> It is not sufficient merely to change 'C' to 'K' when spelling Afrika. It must be understood that it is only a small, though important part of the struggle for nationhood and cultural and historical assertiveness. The reinstatement of 'K' is part of the process of reclaiming our languages and developing a political frame of reference which is centred on Afrikan principles and values.' (*Flava* magazine, E.M.A.C.A.N Publications, October 1995, p. 20.)

261

36 In 1983, in what proved to be the final, relatively brief iteration of this group of young Black artists, they adopted as their name the Blk Art Group. This reflected the strategy of transforming and reappropriating words such as 'Black' and 'Africa', thereby seeking to both critique existing use of such words, and advance new meanings. This directly referenced Black Power activists like LeRoi Jones who had taken to writing 'Black' as Blk, in part to infuse the word with a new, defiant resonance that set it apart from and above what Jones saw as its debased, oppressive and depoliticised usage. See LeRoi Jones, 'The Need for a Cultural Base to Civil Rites & Bpower Mooments', Floyd B. Barbour (ed.), *The Black Power Revolt*, (Boston, MA: Extending Horizons Books/ Porter Sargent, 1968), pp. 119–26. Such a strategy was both reflected and advanced in an exhibition of work by contemporary Aboriginal artists, *Blakness: Blak City Culture!*, which featured work by Destiny Deacon, Brook Andrew, Joanne Currie, Rea, Peter Noble, and Clinton Petersen (Australian Centre for Contemporary Art, 8 October– 6 November 1994, curated by Claire Williamson and Hetti Perkins). In the accompanying catalogue, Perkins wrote,

> It is this complex and often contradictory urban environment that is the site for the work of an increasing number of young and/or emerging black artists. Blakness postulates the emergence of Blak City Culture – invented terms using Destiny Deacon's classic reclaiming of the meaning and spelling of the word 'black'. Fundamental to Blak City Culture is the assertion and exploration of the possibilities of identity, of Blakness. In the manner that Destiny has refigured and redefined the English colonisers' language, so too the artists in this exhibition refigure and redefine their identity. (page 6) Later on in the catalogue, a footnote states that 'The term 'Blak' was developed by Destiny Deacon as part of a symbolic but potent strategy of reclaiming colonialist language to create means of self-definition and expression. (page 20.)

37 Artist's catalogue statement, *The Pan-Afrikan Connection: An Exhibition of Work by Young Black Artists*, Midland Group, Nottingham, 15 January–12 February 1983, unpaginated.
38 Nigel Pollitt, 'Exhibitions', City Limits, 28 May–3 June 1982, pp. 62–3.
39 *The Devil's Feast*, Zarina Bhimji, Chila Burman, Jennifer Comrie, Allan de Souza, and Keith Piper and Donald Rodney, 27 April–8 May 1987. For a review of the exhibition, see Eddie Chambers, 'Problematic Space', *Race Today*, 17 No. 5, June/July 1987, p. 27.
40 For more on this photograph of Cynthia Jarrett, see Eddie Chambers, 'Through the Wire', *Nka Contemporary African Art Journal*, Issue 36, Spring 2015, pp. 6–15.
41 Stuart Hall, 'Black Diaspora Artists in Britain: Three 'Moments' in Post-War History', *History Workshop Journal*, Issue 61, Spring 2006, pp. 1–24.
42 Ibid, Abstract.
43 Ibid, p. 16.
44 Ibid.
45 Ibid, pp. 16–17.
46 Ibid, p. 17.
47 Araeen, 'The Success and the Failure of Black Art', *Third Text*, p. 135.
48 Ibid, p. 136.
49 'World in Action,' 30 January 1978, quoted in Trevor Russel, *The Tory Party: Its Policies, Divisions and Future*, (Harmondsworth, UK: Penguin, 1978), p. 115.
50 Abbott, 'Rivers of Blood,' *21 Speeches That Shaped Our World*, p. 47.
51 Araeen, 'The Success and the Failure of Black Art', *Third Text*, p. 136.

52 Ibid. The work in question was Eddie Chambers' *Destruction of the National Front* (1979/80, 4 sections of paper on card, 827 x 2392 mm, Collection of Tate Britain, Acquisition Presented by Tate Members 2013) and was on display at Tate Britain, in the BP Walk through British Art galleries, Room: 1970 and 1980.

53 Araeen, 'The Success and the Failure of Black Art', *Third Text*, p. 143.

54 Hall, 'Black Diaspora Artists in Britain', *History Workshop Journal*, p. 17.

55 Johnson, 'Jamaican Rebel Music', *Race and Class*, p. 400.

56 Hall, 'Black Diaspora Artists in Britain', *History Workshop Journal*, p. 17.

57 Ibid, pp. 17–18.

Chapter 8: Failing the Cricket Test

1 Ali Rattansi, 'The Pitfalls of 'Integration'', *Multiculturalism: A Very Short Introduction*, (Oxford: Oxford University Press, 2011), p. 95. In actuality, Tebbitt proposed his cricket test in 1990.

2 Colin Babb, 'The Arrival of the Empire Windrush, Emerging Caribbean Migration to Britain and Cricket, Lovely Cricket', *They Gave the Crowd Plenty Fun: West Indian Cricket and its Relationship with the British-Resident Caribbean Diaspora*, (London and Hertfordshire: Hansib, 2012), p. 17.

3 Ibid.

4 Ibid.

5 Robert Lipsyte, Introduction to the American Edition of C L R James, *Beyond a Boundary*, (New York: Pantheon Books, 1983), p. vii.

6 Ibid, p. viii.

7 Babb, 'The Origins of West Indian Cricket', *They Gave the Crowd Plenty Fun*, p. 26.

8 Average deliveries by a fast bowler have speeds in the range of 137–153 km/h (85–95 mph).

9 Macka B, 'Black Man', written by MacFarlane, from the album *Natural Suntan*, Ariwa label, 1990.

10 Babb, 'The Rise of West Indian Cricket: An England Captain is Made to Grovel, Cricket's Link to Diaspora Self-Esteem and the Emergence of the Caribbean-Born English cricketer', *They Gave the Crowd Plenty Fun*, p. 39.

11 Given the horrific, brutal and dehumanising ways in which apartheid South Africa treated its Black citizens and the peoples of the frontline states, it was certainly inevitable that when the West Indies faced South Africa, the game itself took on a wholly different character. Frequently cast as a pariah state during much of the 1960s, 1970s, and 1980s, South Africa was subject to both sporting boycotts and calls for such boycotts. Renegade teams playing in South Africa (including, infamously, certain West Indian players), together with offensive, intemperate and ill-judged comments by white South African-born cricketer Tony Greig, declaring an intention to make the West Indies team 'grovel', served to create and exacerbate tensions. And it was the supposed, perceived or actual racial dimensions of these tensions that served to reorient cricket towards social and political realms. Since CLR James first posed the question, in 1963, 'What do they know of cricket who only cricket know?' – the pithy question appearing in a brief preface to his seminal publication, *Beyond a Boundary* – a range of developments served to confirm to all but the most introspective of cricket fans that the game had come to symbolise (indeed, in some respects, had always been) a vehicle for and a means of understanding history and ongoing tensions born of history.

12 Defender Viv Anderson was the first Black-British footballer to receive a full England senior cap, when he played in a friendly between England and Czechoslovakia in

November 1978. Cunningham did, though, subsequently earn a full England cap, making his debut against Wales in 1979. Cunningham went on to win a total of six caps for England. Paul Ince was the first Black-British footballer to captain the full international England team, in 1995.

13 For example, midfielder Robbie Earle, one of the key players in the 1998 Reggae Boyz squad, was English by birth, having been born in Newcastle-under-Lyme. Another such player was defender Frank Sinclair, also an important member of the 1998 Jamaica team, who was born in Lambeth.

14 Macka B, 'Allez the Reggae Boyz', written by MacFarlane, from the album *Roots & Culture*, Ariwa label, 1991.

15 Macka B, 'Pam Pam Cameroun', written by MacFarlane, from the album *Peace Cup*, Ariwa label, 1991.

16 Brian Glanville, 'The Black Goal', *Sunday Times Magazine*, 21 March 1976, p. 36.

17 See news reports such as http://www.telegraph.co.uk/news/politics/david-cameron/11804861/David-Cameron-says-describing-migrants-as-a-swarm-wasnt-dehumanising.html, accessed 23 October 2015.

18 Glanville, 'The Black Goal', *Sunday Times Magazine*, p. 36.

19 Ibid, p. 39.

20 Ibid, p. 36.

21 Ibid, p. 39.

22 Ibid.

23 Ibid, p. 40.

24 10cc, 'Dreadlock Holiday', single, Mercury Label, 1978, written by E. Stewart and G. Gouldman.

25 Babb, 'The Rise of West Indian Cricket: An England Captain is Made to Grovel', *They Gave the Crowd Plenty Fun*, p. 55.

26 Jack Williams, 'Spectators and Jungle Drumming', section of ' "Fast and Brutish": Reactions to the West Indian Pace Attack', *Cricket and Race*, (Oxford: Berg, 2001), p. 131.

Conclusion: (Dawning of a) New Era

1 Paul Gilroy, "Renegades of Funk and the Cockney Translation", in 'Diaspora, Utopia and the Critique of Capitalism', *'There Ain't No Black in the Union Jack': The Cultural Politics of Race and Nation*, (The University of Chicago Press, 1991), p. 194.

2 A distillation of Raspberry's report was written by Osei Yaw-Akoto, and appeared as 'Racism Reigns in England', *The Heritage*, University of Michigan-Dearborn, 1 No. 1, November 1976, p. 4.

3 Colin Babb, 'The Decline of West Indian Cricket Dominance: West Indian Cricket's Downward Slide, Challenges to Cricket as a Social Force and the Changing Nature of Caribbean Identity in Britain', *They Gave the Crowd Plenty Fun: West Indian Cricket and its Relationship with the British-Resident Caribbean Diaspora*, (London and Hertfordshire: Hansib: 2012), p. 72.

4 Gilroy, 'Renegades of Funk and the Cockney Translation', p. 194.

5 Ibid, pp. 194–95.

6 Ibid, p. 196.

7 Nancy Foner, 'The Jamaicans: Cultural and Social Change among Migrants in Britain', *Between Two Cultures: Migrants and Minorities in Britain*, James L. Watson (ed.), (Oxford: Basil Blackwell, 1977), pp. 145–46 (Foner was quoting Midgett 1975, p. 75).

8 'Now we buy homes in unfamiliar places' was a line from the track 'I Love the Dough' by the Notorious B. I. G. Meaning that, though people like him declared themselves to have grown up in poor, socially and economically marginalised areas of Brooklyn and cities across the USA, their newly-acquired wealth enabled them to purchase and rent new homes in desirable, upscale and more wealthy neighbourhoods. ('I Love the Dough', Notorious B.I.G., *Life After Death*, Bad Boy Entertainment Label, 1997, written by A. Winbush, O. Harvey, R. Moore, and S. Carter.)

9 According to the Office of National Statistics' *Ethnicity and National Identity in England and Wales* 2011, London was the most ethnically diverse area of England and Wales.

10 Lloyd Bradley, 'Who Needs a Record Company?', *Sounds Like London: 100 Years of Black Music in the Capital*, (London: Serpent's Tail, 2013), p. 345.

11 Stuart Hall, 1988: 'New Ethnicities' in Black Film British Cinema. British Film Institute/Institute for Contemporary Arts, Document 7 [Based on an ICA Conference, February 1988], pp. 27–31.

Bibliography

Publications

Abbott, Chris, '*Rivers of Blood*, Enoch Powell (1968)', *21 Speeches That Shaped Our World*, London: Rider, Penguin Random House, 2012.

Alexander, Ziggy and Audrey Dewjee (eds), *Wonderful Adventures of Mrs Seacole in Many Lands*, Bristol: Falling Wall Press, 1984.

Alim, H. Samy, and Geneva Smitherman, *Articulate While Black: Barack Obama, Language, and Race in the U.S.*, New York: Oxford University Press, 2012.

Apter, Andrew, *The Pan-African Nation: Oil and the Spectacle of Culture in Nigeria*, University of Chicago Press, 2005.

Araeen, Rasheed, 'Chronology', *The Essential Black Art* Exhibition Catalogue. Published by Chisenhale Gallery, London in conjunction with Black Umbrella, London, 1988.

———, 'Confronting the System', *The Other Story*, Hayward Gallery, South Bank Centre, London, 1989.

———, 'The Success and the Failure of Black Art', *Third Text*, 18, p.2, 2004.

Babb, Colin, *They Gave the Crowd Plenty Fun: West Indian Cricket and its Relationship with the British-Resident Caribbean Diaspora*, London and Hertfordshire: Hansib, 2012.

Bair, Barbara, 'Amy Ashwood Garvey', *Dictionary of African Biography*, Emmanuel K. Akyeampong and Henry Louis Gates, Jr., (eds in Chief), New York: Oxford University Press, 2012 (Vol. 2).

Baker, Stuart, 'Rastafari: The Dreads Enter Babylon 1955–83' CD, booklet essay, Soul Jazz Records, 2015.

Barbour, Floyd B. (ed.), *The Black Power Revolt*, Boston Extending Horizons Books/Porter Sargent, 1968.

Barrett, Leonard, *The Rastafarians*, Boston: Beacon Press, 1977.

Berry, James (ed.), *Bluefoot Traveller* [first edition], London: Limestone Publications, 1976.

———, *Bluefoot Traveller*, London: Harrap, 1981.

———, *News for Babylon: The Chatto Book of Westindian-British Poetry*, London: Chatto & Windus – The Hogarth Press, 1984.

Biko, Steve *I Write What I Like*, London: Bowerdean Press, 1978.

Bishton, Derek and Homer, Brian, *Talking Blues: the Black Community Speaks About its Relationship with the Police*, Birmingham: AFFOR, 1978.

Bourne, Stephen, 'The Uncle Tom Show', *Black in the British Frame: The Black Experience in British Film and Television*, London: Continuum, 2001.

———, *The Motherland Calls: Britain's Black Servicemen & Women*, Stroud: the History Press, 2012.

Bradley, Lloyd, *Bass Culture: When Reggae Was King*, London: Penguin, 2000.

———, *Sounds Like London: 100 Years of Black Music in the Capital*, London: Serpent's Tail, 2013.

Breitman, George (ed), *By Any Means Necessary*, New York: Pathfinder Press, 1970.

Bryan, Beverley, Stella Dadzie and Suzanne Scafe, *Heart of the Race: Black Women's Lives in Britain*, London: Virago, 1985.

Bibliography

Burn, Gordon, 'The Talking Brixton Blues', *Sunday Times magazine*, 3 August 1980, p. 54.

Carter, Trevor, *Shattering Illusions: West Indians in British Politics*, London: Lawrence & Wishart, 1986.

Cashmore, E Ellis, (ed.), *Dictionary of Race and Ethnic Relations*, London: Routledge, 1988.

—— and Barry Troyna, *Introduction to Race Relations*, Basingstoke: Falmer Press, 1990.

Cashmore, Ernest, *Rastaman: The Rastafarian Movement in England*, London: George Allen & Unwin, 1979.

Cassidy, Frederic G., *Jamaica Talk: Three Hundred Years of the English Language in Jamaica*, London: Macmillan & Co Ltd, 1961.

Chabal, Patrick, *Amilcar Cabral: Revolutionary Leadership and People's War*, Cambridge: Cambridge University Press, 1983.

Chamberlain, Mary (ed), *Caribbean Migration: Globalised Identities*, London: Routledge/ Taylor & Francis, 2002, p. 26.

Chambers, Eddie, 'Problematic Space', *Race Today*, Vol. 17, No. 5, June/July 1987.

——, *Black Artists in British Art: A History Since the 1950s*, London and New York: I.B.Tauris & Co., 2014.

——, 'Through the Wire', *Nka Contemporary African Art*, No. 36, Spring 2015, pp. 6–15.

Chater, Anthony, *Race Relations in Britain, Socialism Today Series*, London: Lawrence and Wishart, 1966.

Clarke, John Henrik (ed.), *Marcus Garvey and the Vision of Africa*, New York: Vintage Books, 1974.

Clarke, Sebastian, *Jah Music: The Evolution of the Popular Jamaican Song*, London: Heinemann Educational Books, 1980.

Cook, Stephen, 'The Deptford Fire, Accident or Arson?' *Unsolved* 42 (1984).

Cronon, E. David, *Black Moses: The story of Marcus Garvey and the Universal Negro Improvement Association*, Madison, Winsconsin: University of Wisconsin Press, Second Edition, 1972.

Dabydeen, David, John Gilmore and Cecily Jones (eds), *Oxford Companion to Black British History*, Oxford: Oxford University Press, 2010.

Dedi, Shakka Gyata, *Afrikan Hartbeet: Songs of Unity, Love and Struggle*, London: Nubia Publications, 1982.

——, 'Black Art in Britain Today', *Arts Review*, 9 November 1984.

Dieffenthaller, Ian, *Snow on Sugarcane: The Evolution of West Indian Poetry in Britain*, Newcastle upon Tyne: Cambridge Scholars Publishing, 2009.

Dierenfield, Bruce J., *The Civil Rights Movement*, New York: Pearson Longman, 2004.

Dillard, Joey Lee, *Black English*, New York: Random House, Vintage, 1973.

Dodgson, Elyse, *Motherland: West Indian Women to Britain in the 1950s*, London: Heinemann, 1984.

Donnell, Alison, and Sarah Lawson Welsh (eds), *The Routledge Reader in Caribbean Literature*, London and New York: Routledge, 1996.

Earle, Robbie and Daniel Davies, *One Love: The Story of Jamaica's Reggae Boyz and the 1998 World Cup*, London: Andre Deutsch, 1998.

Edmonds, Ennis, 'I: Dread 'I' In-a-Babylon: Ideological Resistance and Cultural Revitalization', in Nathaniel Samuel Murrell, William David Spencer and Adrian Anthony McFarlane (eds), *The Rastafari Reader: Chanting Down Babylon*, Philadelphia: Temple University Press, 1998.

Eggington, Joyce, *They Seek a Living*, Hutchinson, London, 1957.

Enohoro, Ife, 'The Second World Black and African Festival of Arts and Culture: Lagos, Nigeria', *The Black Scholar: Journal of Black Studies and Research*, Vol. 9, No. 1, September 1977.

Bibliography

FESTAC '77 Souvenir Book of the *Second World Black and African Festival of Arts and Culture*, Lagos Nigeria. Published by Africa Journal Ltd. and the International Festival Committee, London, 1977.

Foner, Nancy, 'The Jamaicans: Cultural and Social Change among Migrants in Britain', in *Between Two Cultures: Migrants and Minorities in Britain*, James L. Watson (ed.), Oxford: Basil Blackwell, 1977.

———, *Jamaica Farewell: Jamaican Migrants to London*, London and Henley: Routledge & Kegan Paul, 1979.

Fraser, Douglas, *Impressions: Nigeria 1925*, London: Herbert Jenkins Ltd., 1926.

Fryer, Peter, 'The New Generation', *Staying Power: The History of Black People in Britain*, London: Pluto Press, 1984.

Garrison, Len, *Black Youth, Rastafarianism, and the Identity Crisis in Britain*, London: Acer Project, 1979.

Gillman, Peter, 'On the Edge of the Ghetto: The Way They See It', *Sunday Times magazine*, 30 September 1973, pp. 28–44 and 47–49.

Gilroy, Paul, '*There Ain't No Black in the Union Jack*': *The Cultural Politics of Race and Nation*, the University of Chicago Press, 1991.

Glanville, Brian, 'The Black Goal', *Sunday Times Magazine*, 21 March 1976.

Goldman, Vivien, 'Linton Kwesi Johnson, Poet of the Roots', *sounds*, 2 September 1978, pp. 23–25.

Gooding, Mel, *Frank Bowling*, Royal Academy of Art, 2011.

Grant, Colin, *Negro with a Hat: The Rise and Fall of Marcus Garvey*, Oxford: Oxford University Press, 2008.

Habekost, Christian, *Dub Poetry*, Publishers Michael Schwinn, 1986.

Haley, Alex, *Roots*, New York: Doubleday, 1976.

Hall, Stuart, 'New Ethnicities', ICA Documents 7, *Black Film British Cinema*, London: A BFI Production Special, 1988.

———, 'Black Diaspora Artists in Britain: Three 'Moments' in Post-war History', *History Workshop Journal*, 61, Spring 2006.

Harris, Joshua, Tina Wallace, and Heather Booth, *To Ride the Storm: The 1980 Bristol 'Riot' and the State*, London: Heinemann Educational Books, 1983.

Harrison, David, *The White Tribe of Africa: South Africa in Perspective*, British Broadcasting Corporation, 1981.

Haskin, Frederic J., *The Panama Canal*, New York: Doubleday, Page & Company, 1913.

Henry, L. Mike and Devis S. Harris, *LMH Official Dictionary of Jamaican Words and Proverbs*, Kingston: LMH Publishing, 2002.

Hinds, Donald, *Journey to an Illusion: The West Indian in Britain*, London: Heinemann, 1966.

Hooper, Richard, 'Britain's Coloured Immigrants', *The Listener*, 25 February 1965, Vol. LXXIII No. 1874.

Howe, Una, 'Errol Lloyd: An Exhibition of Errol Lloyd's Paintings Held at the Jamaican High Commission from May 19, to June 9 [1978]', *Race Today*, July/August 1978, p. 119.

Humphry, Derek, *Police Power and Black People*, London: Panther, 1972.

Institute of Race Relations, *Policing Against Black People*, London: Institute of Race Relations, 1987.

Irele, F. Abiola, and Biodun Jeyifo (eds), *The Oxford Encyclopedia of African Thought*, USA: Oxford University Press, 2010.

Jamaican Weekly Gleaner, "Black Art' Message Praised', 2 June 1982, p. 5.

James, C. L. R., *Beyond a Boundary*, New York: Pantheon Books, 1983

James, Winston and Clive Harris (eds) *Inside Babylon: The Caribbean Diaspora in Britain*, London: Verso, 1993.

Johnson, Buzz (ed.), *Claudia Jones: I Think of My Mother*, London: Karia Press, 1985.

Johnson, Linton Kwesi, 'Jamaican Rebel Music', *Race and Class*, Vol. XVII, No. 4, 1976.

Jones, Claudia, 'The Caribbean Community in Britain', *Freedomways: A Quarterly Review of the Negro Freedom Movement, The People of the Caribbean Area*, Vol. 4, No. 3 (Third Quarter), Summer, 1964.

Kai, Nubia, 'Africobra Universal Aesthetics', *Africobra: The First Twenty Years*, Atlanta, Georgia: Nexus Contemporary Art Center, 1990.

Kapo, Remi, *A Savage Culture: Racism – A Black British View*, London: Quartet Books, 1981.

Karenga, Ron, 'Black Art: Mute Matter Given Force and Function', *Black Poets and Prophets*, Woodie King and Earl Anthony (eds), New York: Mentor/New American Library, 1972.

Kee, Robert, 'Is There a British Colour Bar?' *Picture Post: Hulton's National Weekly*, Vol. 44, No. 1, 2 July 1949, pp. 23–28.

Kent, Susan Kingsley, *Gender and Power in Britain, 1640–1990*, London and New York: Routledge, 1999.

Kerridge, Roy, *Real Wicked, Guy: A View of Black Britain*, Oxford: Basil Blackwell, 1983.

Kettle, Martin and Lucy Hodges, *UPRISING!: The Police, the People and the Riots in Britain's Cities*, London: Pan Books, 1982.

Kirkham, Pat and David Thoms (eds), *War Culture: Social Change and Changing Experience in World War Two*, London: Lawrence and Wishart, 1995.

Koss, Richard, *Jamaica*, Oakland, California: Lonely Planet, 2008.

La Rose, John, *The New Cross Massacre Story: Interviews with John La Rose*, London: the Alliance of the Black Parents Movement, Black Youth Movement and the Race Today Collective, 1984.

La Rose, Michael (ed), *Mas in Notting Hill: Documents in the Struggle for a Representative and Democratic Carnival, 1989–1990*, London: New Beacon Books Ltd, 1990.

Layton-Henry, Zig, *The Politics of Race in Britain*, London: Allen & Unwin, 1984.

Lee, Hélène, *The First Rasta: Leonard Howell and the Rise of Rastafarianism*, Chicago: Lawrence Hill Books, an imprint of Chicago Review Press, 2005.

Lewis, Roy, 'The Half-Open Door', *The British Empire, The Loose Ends of Empire*, BBC TV Time-Life Books, No. 95, 1973.

Lewis, Samella S., and, Ruth G. Waddy, *Black Artists on Art*, Vol. 2, Contemporary Crafts, Inc. Los Angeles, California, 1971

Little, K. L. 'The Coloured Man's Reaction to the English', *Negroes in Britain: A Study of Racial Relations in English Society*, London: Kegan Paul, Trench, Trubner & Co., Ltd, 1947.

Lynch, Hollis R., *Edward Wilmot Blyden: Pan-Negro Patriot 1832–1912*, London: Oxford University Press, 1967.

Lyons, John, 'Denzil Forrester's Art in Context', essay in *Denzil Forrester: Dub Transition, A Decade of Paintings 1980–1990* (the exhibition first shown at Harris Museum & Art Gallery, Preston, 22 September–3 November 1990, exhibition catalogue, p. 17.

Magubane, Peter, *Magubane's South Africa*, New York: Alfred A. Knopf, 1978.

Marchant, Hilde, 'Breeding a Colour Bar?', *Picture Post: Hulton's National Weekly*, Vol. 56, No. 10, 6 September 1952.

———, 'Thirty-Thousand Colour Problems' *Picture Post, Hulton's National Weekly*, 9 June 1956, pp. 28, 29, 38.

Margolis, Jonathan, *Lenny Henry: A Biography*, London: Orion 1995.

McManus, Irene, 'Black Art aan' Done', *Guardian*, 17 June 1981, p. 10.

Monroe, Arthur, 'Festac 77-The Second World Black and African Festival of Arts and Culture: Lagos, Nigeria', *The Black Scholar: Journal of Black Studies and Research*, Vol. 9, No. 1, September 1977.

Morris, Mervyn, 'Is English We Speaking', *English Today*, Vol. 9, No. 4, October 1993.

Morrison, Chester, 'Why It is Important to Spell Afrika with a K', *Flava* magazine, E.M.A.C.A.N Publications, October 1995.

Mullard, Chris, *Black Britain*, London: George Allen & Unwin Ltd, 1973.

Murrell, Nathaniel Samuel, William David Spencer and Adrian Anthony McFarlane (eds), *The Rastafari Reader: Chanting Down Babylon*, Philadelphia: Temple University Press, 1998.

Partridge, Christopher, *The Lyre of Orpheus: Popular Music, the Sacred, and the Profane*, New York: Oxford University Press, 2014.

Narayan, Rudy, *Black England: A Reply to Enoch Powell*, London: Doscarla Publications, 1977.

Neal, Larry, 'Black Art and Black Liberation', *The Black Revolution: An Ebony Special Issue*, (no ed stated), Chicago: Johnson Publishing Company Inc., 1970, pp. 31–53.

Neuberger, Benyamin, 'Early African Nationalism, Judaism and Zionism: Edward Wilmot Blyden , *Jewish Social Studies*, Vol. 47, No. 2 (Spring, 1985), pp. 151–66.

Newton, Huey P., *Revolutionary Suicide*, New York: Harcourt Brace Jovanovich, 1973.

Odunlami, Yinka, 'Introduction', *Festac'77*: The Work of the Artists from the United Kingdom and Ireland (Winston Branch, Mercian Carrena, Uzo Egonu, Armet Francis, (Emmanuel) Taiwo Jegede, Neil Kenlock, Donald Locke, Cyprian Mandala, Ronald Moody, Ossie Murray, Sue Smock, Lance Watson and Aubrey Williams), United Kingdom African Festivals Trust, London, nd.

Office of National Statistics' *Ethnicity and National Identity in England and Wales* 2011.

Owens, Joseph, *Dread: The Rastafarians of Jamaica*, Kingston: Sangster's, 1976.

Owusu, Kwesi and Jacob Ross, *Behind the Masquerade: Story of Notting Hill Carnival*, London: Arts Media Group, 1988.

Parry, Jan, 'The New Britons: Black Britons', *Observer* magazine, 28 November 1971, pp. 17–25.

Patterson, Sheila, *Dark Strangers: A Study of West Indians in London*, London: Tavistock Publications, 1963.

Perkins, Hetti, 'Introduction', exhibition catalogue, 'Blakness: Blak City Culture!', work by Destiny Deacon, Brook Andrew, Joanne Currie, Rea, Peter Noble, Clinton Petersen, Australian Centre for Contemporary Art, Melbourne, 8 October – 6 November 1994.

Phillips, Mike and Trevor Phillips, *Windrush: The Irresistible Rise of Multi-Racial Britain*, HarperCollinsLondon, 1998.

Piper, Keith, 'Black Art/Black Church', catalogue essay for *A Ship Called Jesus*, Ikon Gallery, Birmingham, 17 January–23 February 1991.

——, 'Step Into the Arena: Black Art & Questions of Gender', catalogue essay for *Step Into the Arena: Notes on Black Masculinity & The Contest of Territory*, Rochdale Art Gallery, 3 May–1 June 1991.

Plummer, John, *Movement of Jah People: The Growth of the Rastafarians*, Birmingham, UK: Press Gang, 1978.

Poinsett, Alex, 'festac '77: Second World Black and African Festival of Arts and Culture draws 17,000 participants in Lagos', *Ebony*, Vol. XXXII, No. 7, May 1977.

Pollitt, Nigel, 'Exhibitions', *City Limits*, 28 May–3 June 1982, pp. 62–63, 1982.

Pope-Hennessy, James, *Sins of the Fathers: A Study of the Atlantic Slave Traders, 1441–1807*, London: Weidenfeld and Nicolson, 1967.

Pryce, Ken, *Endless Pressure: A Study of West Indian Life-Styles in Bristol*, Harmondsworth: Penguin Books, 1979.

Race & Class, 'The Riots', Vol. 23, Nos. 2–3, 1981, pp. 223–232.

Ransford, Oliver, *The Slave Trade: The Story of Transatlantic Slavery*, London: John Murray, 1971.

Raspberry, William, 'Young Bitter and Black', *Observer Review*, 5 September 1976, p. 19.

Rattansi, Ali, 'The Pitfalls of 'Integration'', *Multiculturalism: A Very Short Introduction*, Oxford: Oxford University Press, 2011

Rickford, John Russell and Russell John Rickford, *Spoken Soul: The Story of Black English*, New York: John Wiley and Sons, 2000.

Rodney, Donald, artist's statement in the catalogue for *The Pan-Afrikan Connection: An Exhibition of Work by Young Black Artists*, Midland Group, Nottingham, 15 January–12 February 1983.

Russel, Trevor, *The Tory Party: Its Policies, Divisions and Future*, Harmondsworth, UK: Penguin, 1978.

Scarman, Lord, the *Scarman Report: the Brixton Disorders, 10–12 April 1981*, London: Penguin Books, 1982.

Schlote, Christiane, 'Oil, Masquerades, and Memory: Sokari Douglas Camp's Memorial of Ken Saro-Wiwa' *Cross/Cultures No. 148: Engaging with Literature of Commitment. Volume 1: Africa in the World*, Gordon Collier, Marc Delrez, Anne Fuchs, and Bénédicte Ledent (eds), Amsterdam/New York: Brill/Rodopi, 2012.

Seacole, Mary, *Wonderful Adventures of Mrs. Seacole in Many Lands*, London: James Blackwood Paternoster Row, 1857.

Sivanandan, A., 'From Resistance to Rebellion', *A Different Hunger: Writings on Black Resistance*, London: Pluto Press 1982.

Smethurst, James, 'Malcolm X and the Black Arts Movement', in Robert E. Terrill (ed.), *The Cambridge Companion to Malcolm X*, Cambridge: Cambridge University Press, 2010.

Smith, Michael, *It a Come: Poems by Michael Smith*, London: Race Today Publications, 1986.

Solomos, John, and Les Black, 'Parties, Black Participation and Political Change', *Race, Politics and Social Change*, London: Routledge 1995.

Sutcliffe, David, *British Black English*, Oxford: Basil Blackwell, 1982.

——— and Ansel Wong (eds), *The Language of the Black Experience: Cultural Expressions through Word and Sound in the Caribbean and Black Britain*, Oxford: Basil Blackwell, 1986.

Taylor, Helen, 'Everybody's Search for Roots: Alex Haley and the Black and White Atlantic', *Circling Dixie: Contemporary Southern Culture Through a Transatlantic Lens*, New Brunswick, NJ: Rutgers University Press, 2001.

Turner, Sherry, 'An Overview of the New Black Arts', *Freedomways*, Vol. 9, No. 2, New York, Spring 1969.

Williams, Elizabeth M, *The Politics of Race in Britain and South Africa: Black British Solidarity and the Anti-apartheid Struggle*, London: I.B.Tauris, 2012.

Williams, Eric, *Capitalism and Slavery*, University of North Carolina: Chapel Hill, 1944.

Williams, Frederick, *Leggo De Pen*, London: Akira Press, 1985.

Williams, Jack, *Cricket and Race*, Oxford: Berg, 2001.

Wilson, Amber, *Jamaica: The People*, New York: Crabtree Publishing, 2004.

Winder, Robert, *Bloody Foreigners: The Story of Immigration to Britain*, London: Little Brown, 2004.

Yaw-Akoto, Osei, 'Racism Reigns in England', *The Heritage*, University of Michigan-Dearborn, Vol 1, No, 1, November 1976.

Songs and music

Ras Karbi, 'Discrimination', Ital Sounds Records, nd.

Lord Creator, 'Independent Jamaica', Island Records, 1962.

Prince Buster, 'One Hand Washes the Other', Blue Beat Melodisc Records, 1962.

Derrick Morgan, 'Blazing Fire', Island Records, 1963.

Niney, 'Blood and Fire', Big Shot label, 1971.

Shorty (aka Shorty the President), 'President Mash up the Resident', Green Door/Trojan label, 1972.

The Wailers, 'Slave Driver', from the album *Catch a Fire*, Island Records Ltd, 1973.

The Wailers, 'Burnin' and Lootin'', from the album *Burnin*, Island Records Ltd, 1973.

Burning Spear, 'Slavery Days', from the album *Marcus Garvey*, Island Records, 1975.

Sylford Walker, 'Burn Babylon', Belmont Records, 1975.

Max Romeo, 'Fire Fe the Vatican', Mango label, 1976.

Steel Pulse, *Kibudu – Mansatta – Abuku*, Concrete Jungle label, 1976.

Aswad, 'Back to Africa', Island Records, 1976.

I-Roy, *Crisus Time*, Caroline/Virgin Records, 1976.

Pam Ayres, *Some of Me Poems and Songs*, Galaxy, 1976 and *Some More of Me Poems and Songs*, Galaxy, 1976.

Burning Spear, 'Black Soul', from the album *Man in the Hills*, Island Records, 1976.

Bob Marley and the Wailers, 'Roots', Island Records, 1977.

Merger, 'Understanding', from the album *Exiles in a Babylon*, Sun-star Muzik Co., 1977.

Merger, '77', from the album *Exiles in a Babylon*, Sun Star Muzik Co., 1977.

Steel Pulse, 'Bun Dem', Tempus Records, 1977.

Poet and the Roots, 'All Wi Doin Is Defendin'', from the album *Dread Beat an' Blood*, Front Line Records/Virgin Records, 1978.

Poet and the Roots, 'It Dread Inna Inglan (for George Lindo)', Virgin label, 1978.

Steel Pulse, 'Prodigal Son', from the album *Handsworth Revolution*, Island Records, 1978.

Steel Pulse, 'Handsworth Revolution', from the album of the same name, Island Records, 1978.

Matumbi, 'Go Back Home', Trojan Records, 1978.

10cc, 'Dreadlock Holiday', Mercury label, 1978.

In Crowd, 'Back a Yard', Cactus label, 1978.

Tapper Zukie, 'Tribute to Steve Biko', from the album *Peace in the Ghetto*, Virgin Front Line Records, 1978

Burning Spear, 'Marcus Children Suffer', from the album *Marcus' Children*, Burning Music label, Jamaica, 1978.

Horace Tapscott, 'The Call', Interplay Music, conducted by the Pan-Afrikan Peoples Arkestra, 1978.

The Regulars, 'Victim', from the album of the same title, CBS Records, 1979.

Tabby Cat Kelly, 'Don't Call Us Immigrants', Arawak Records, 1979.

Steel Pulse, 'Jah Pickney R.A.R.', from the album *Tribute to the Martyrs*, Island Records, 1979.

Steel Pulse, 'Ku Klux Klan', from the album *Handsworth Revolution*, Island Records, 1979.

Linton Kwesi Johnson, 'Want Fi Goh Rave' from the album *Forces of Victory*, Island Records, 1979.

Black Uhuru, 'Leaving to Zion', from the album *Showcase*, Taxi label, 1979.

Twinkle Brothers, 'Dread in the Ghetto', from the album *Praise Jah*, Virgin Frontline, 1979.

Steel Pulse, 'Biko's Kindred Lament', from the album *Tribute to the Martyrs*, Island Records, 1979.

Bibliography

Burning Spear, 'Columbus', from the album *Hail H. I. M.*, Rondor Music, 1980.

Linton Kwesi Johnson, 'Inglan is a Bitch', from the album *Bass Culture*, Island records label, 1980.

Ibid, 'Reggae Sounds', from the album *Bass Culture*, Island Records, 1980.

Ibid, 'Bass Culture', from the album *Bass Culture*, Island Records 1980.

Prince Lincoln & the Rasses, 'Mechanical Devices', from the album *Natural Wild*, United Artists Records, 1980.

Stevie Wonder, 'Cash in Your Face', from the album *Hotter Than July*, Tamla label, 1980.

Basement 5, 'Immigration', from the album *Basement 5: 1965-1980*, Island Records, 1980.

Aswad, 'African Children', from the album *New Chapter*, CBS Records, 1981.

Ibid, 'Tuff we Tuff', from the album *New Chapter*, CBS Records, 1981.

Felá Aníkúlapo-Kuti, 'Original Sufferhead', Arista label, 1981.

Steel Pulse, 'Blues Dance Raid', from the album *True Democracy*, Elektra label, 1982.

Dennis Brown/Aswad, 'Promised Land', Simba Records, circa 1982.

Aswad, 'Not Satisfied' from the album of the same name, CBS Records, 1982.

Michael Smith, *Mi Cyaan Believe It*, Island Records, 1982.

Benjamin Zephaniah, 'No Politicians', from the album *Rasta*, Uptight Records, 1983.

Various Artists, *Word, sound 'ave power: Reggae poetry*, Heartbeat Records label, 1983.

Papa Levi, 'Mi God, Mi King', Level Vibes! Records, 1984.

Ibid, 'In-A-Mi-Yard', Level Vibes! Records, 1984.

Black Roots, 'Juvenile Delinquent', Kick Records, 1984.

Tippa Irie, 'Complain Neighbour', Greensleeves UK Bubblers label, 1985.

Mutabaruka, 'Bun Dung Babylon', from the album *The Mystery Unfolds*, Sanachie label, 1986.

Macka B, 'Black Man', from the album *Natural Suntan*, Ariwa label, 1990.

Ibid, 'Allez the Reggae Boyz', from the album *Roots & Culture*, Ariwa label, 1991.

Ibid, 'Pam Pam Cameroun', from the album *Peace Cup*, Ariwa label, 1991.

Notorious B.I.G., 'I Love the Dough', from the album *Life After Death*, Bad Boy Entertainment label, 1997.

Lord Kitchener, 'London is the Place for Me', from the album *London is the Place for Me: Trinidadian Calypso in London, 1950-1956*, Honest Jon's Records, 2002.

Young Tiger, 'I was there (at the coronation)...', from the album *London is the Place for Me: Trinidadian Calypso in London, 1950-1956*, Honest Jon's Records, 2002.

Warrior Queen & Heatwave, 'Tings Change', from the album *An England Story: The Culture of the MC in the UK 1983-2008*, Soul Jazz Records, 2008.

Various Artists, *An England Story: The Culture of the MC in the UK 1984-2008*, Soul Jazz Records, 2008.

Morgan Heritage, 'Politician', from the album *Mission in Progress*, VP Records, 2008.

Various Artists, 'Rastafari: The Dreads Enter Babylon 1955-83', Soul Jazz Records, 2015.

Exhibitions

Caribbean Artists in England, Commonwealth Institute Art Gallery, Kensington High Street, London, 22 January-14 February 1971.

Five Black Women Artists: Sonia Boyce, Lubaina Himid, Claudette Johnson, Houria Niati and Veronica Ryan, Africa Centre, 6 September-14 October 1983.

Into the Open: New Paintings Prints and Sculpture by Contemporary Black Artists, Mappin Art Gallery, Sheffield, 4 August-9 September 1984.

The Devil's Feast: Zarina Bhimji, Chila Burman, Jennifer Comrie, Allan de Souza, and Keith Piper and Donald Rodney, Chelsea School of Art Gallery, 27 April-8 May 1987.

Adventures Close to Home: An Exhibition by Piper & Rodney, Pentonville Gallery, London, 6 August-5 September 1987.

Keith Piper, *A Ship Called Jesus*, Ikon Gallery, Birmingham, 17 January–23 February 1991.

Keith Piper, *Step into the Arena: Notes on Black Masculinity & The Contest of Territory*, Rochdale Art Gallery, 3 May–1 June 1991.

Donald Rodney, *9 Night in Eldorado*, South London Gallery, 10 September–12 October 1997.

Re-imagine: Black Women in Britain, Black Cultural Archives, London, 24 July–30 November 2014.

Websites

www.blackeconomics.co.uk/partner.htm (accessed 10 May 2015).

www.blackplaysarchive.org.uk/explore/productions/nine-night (accessed 10 May 2015).

www.georgepadmoreinstitute.org/archive/collection/black-parents-movement (accessed 10 May 2015).

www.fsmitha.com/h2/ch14-africa2.htm (accessed 27 May 2015).

www.discogs.com/artist/119558-Basement-5 (accessed 16 April 2015).

www.telegraph.co.uk/culture/art/artsales/9923044/Victory-for-a-gifted-artist-of-colour-79.html (accessed 11 June 2015).

www.telegraph.co.uk/news/politics/david-cameron/11804861/David-Cameron-says-describing-migrants-as-a-swarm-wasnt-dehumanising.html (accessed 23 October\2015).

www.academia.edu/2464695/Once_as_History_Twice_as_Farce_The_Spectre_of_the_Summer_of_81_in_Discourses_on_the_August_2011_Riots (accessed 10 September 2015).

https://www.mixcloud.com/chimurenga/michael-mcmillan-festac/ (accessed 5 March 2016).

Press releases

Virgin information, 'POET', November 1977.

Black Art an' done, Wolverhampton Art Gallery, 9–27 June 1981.

Donald Rodney, *9 Night in Eldorado*, South London Gallery, 10 September–12 October 1997.

Television

Roots, miniseries, (screened on) BBC Television, 1977.

Mind Your Language, London Weekend Television 1977–81.

The Black and White Minstrel Show, BBC Television, 1958–78.

State of the Art, Channel 4/Illuminations (Television) Ltd., 1987.

Isaac Julien (Director), *Black and White in Colour* (Part Two: 1969–92), a British Film Institute TV Production for BBC Television, 1992.

Film

Menelik Shabazz (director), *The Story of Lover's Rock*, 2011.

Index

Index

Index

Index

Index

Index

281

Index